CONTENTS

MODEL GUINEVERE VAN SEENUS WORE
A SHOCKING-PINK EVENING LOOK BY
ELSA SCHIAPARELLI—ORIGINATOR OF
SURREALISM AS CHIC—PHOTOGRAPHED
BY STEVEN MEISEL, *VOGUE,* MAY 2012,
IN ANTICIPATION OF "SCHIAPARELLI &
PRADA: IMPOSSIBLE CONVERSATIONS,"
THE HEADLINING COSTUME EXHIBITION
AT THE METROPOLITAN THAT YEAR.

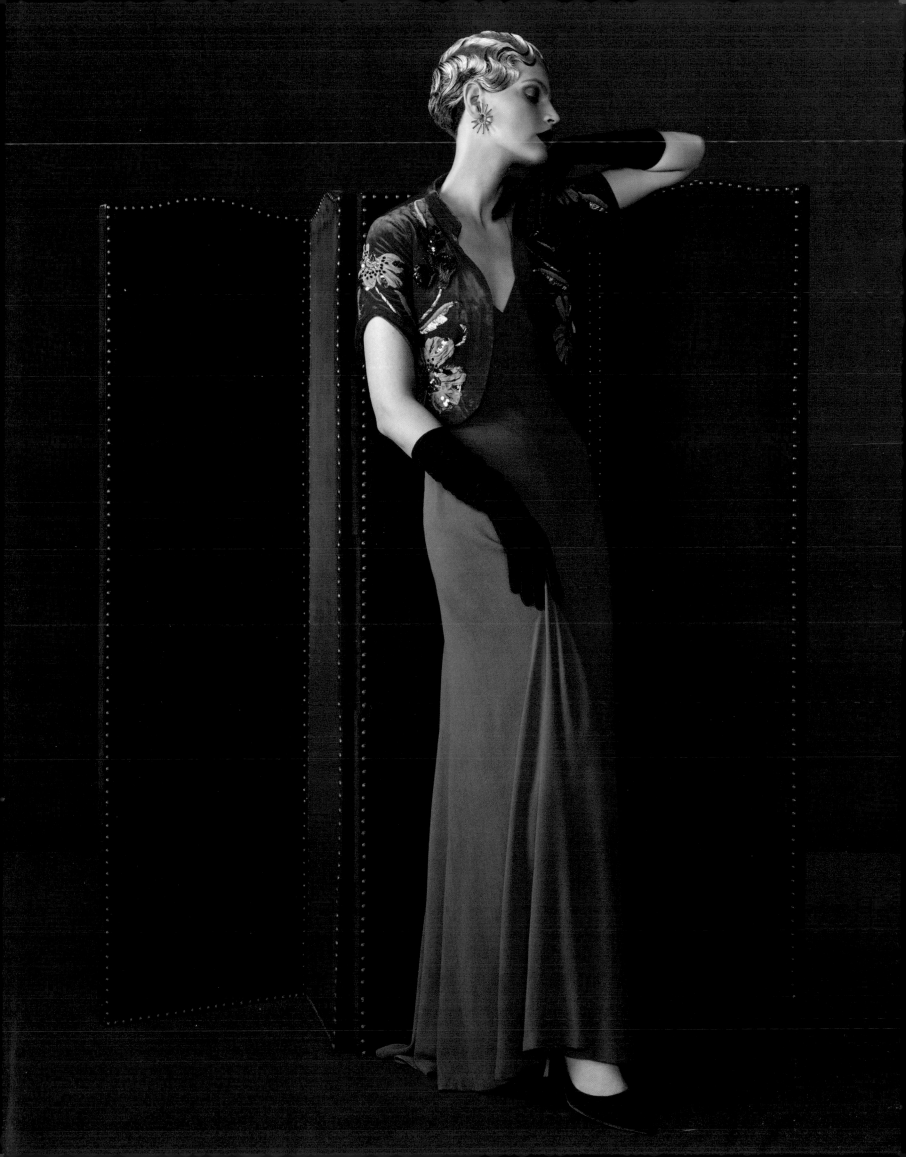

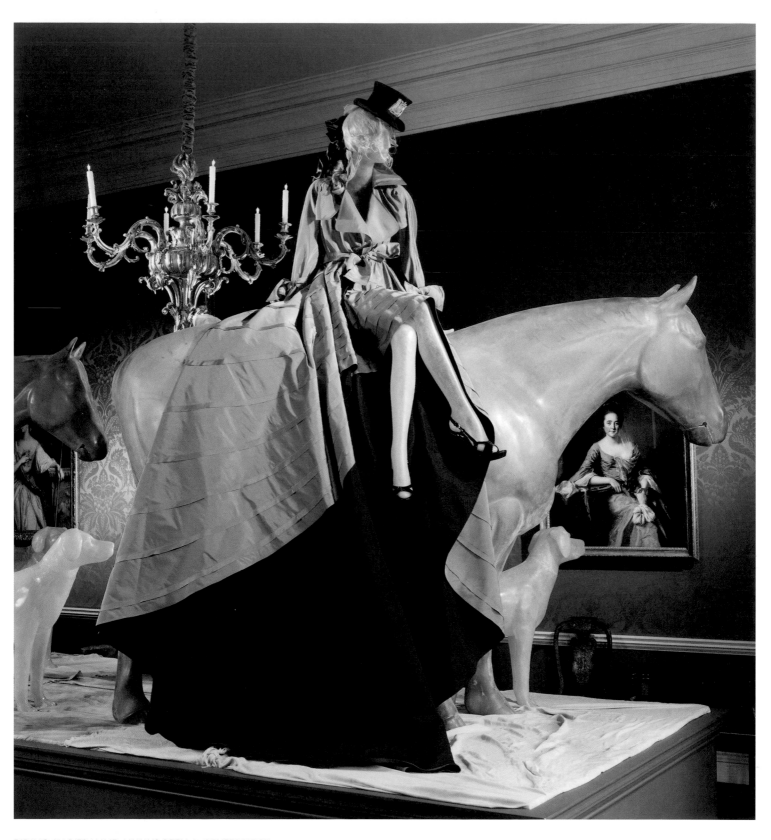

RIDING HABITS HAVE ALWAYS BEEN A CENTERPIECE OF BRITISH STYLE. AT THE "ANGLOMANIA" EXHIBIT IN 2006, A MANNEQUIN IN A LILAC SILK-FAILLE REDINGOTE DRESS (WITH LINING OF TRADITIONAL HUNTING SCARLET) BY CHRISTOPHER BAILEY FOR BURBERRY SAT SIDESADDLE BESIDE PORTRAITS BY SIR JOSHUA REYNOLDS AND THOMAS GAINSBOROUGH.

FOREWORD

BY THOMAS P. CAMPBELL
DIRECTOR AND CEO
THE METROPOLITAN MUSEUM OF ART

F● Scott Fitzgerald romantically described Jay Gatsby's parties as where "men and girls came and went like moths among the whisperings and the champagne and the stars." The same words could describe the swirl of The Met's annual Costume Institute Benefit—though in that context the stars would be people rather than glittering lights in the evening sky.

At first glance, The Costume Institute Benefit is a glorious pageant of fashion icons, movie stars, politicians, sports figures, artists, and social titans. But behind that sparkle of celebrity and fashion is a night that plays a critical role in funding one of The Metropolitan Museum's outstanding curatorial departments.

In 1948, two years after The Museum of Costume Art became part of The Met and was renamed The Costume Institute, the fashion publicist Eleanor Lambert organized the first benefit party to support its yearly expenses—a midnight supper at the Rainbow Room immediately dubbed "The Party of the Year." And so an extraordinary annual tradition began. One can imagine the momentum these events gathered under the legendary Diana Vreeland, special consultant to The Costume Institute from 1972 until her death in 1989. Mrs. Vreeland's exhibitions—including such iconic shows as "The World of Balenciaga" (1973) and "The Glory of Russian Costume" (1976)—broke all conventions, and the benefit dinners followed suit. With cochairs like Jacqueline Kennedy Onassis (1977–1978) and the indomitable Pat Buckley (1979–1995), the parties attracted everyone from Lily Auchincloss to Andy Warhol.

This volume covers the exhibitions and galas of the twenty-first century, starting in 2001, the year that *Vogue* editor Hamish Bowles served as guest curator for the beautiful exhibition "Jacqueline Kennedy: The White House Years." In the thirteen years since that show, Costume Institute curators Harold Koda and Andrew Bolton have changed the way we think about fashion, pushing us to explore its sources and conceptual narratives with projects that provoke and inspire. Who could forget the eighteenth-century seduction in the Wrightsman Galleries, the punk rebellion in the Lansdowne House Dining Room, the tragic poetry of Alexander McQueen, or the evocative Surrealism of Schiaparelli?

The book ends with the 2014 exhibition, "Charles James: Beyond Fashion," which heralded the reopening of the Costume Institute galleries after a two-year renovation. Anchored by the Lizzie and Jonathan Tisch Gallery, this new space has been named the Anna Wintour Costume Center in honor of The Costume Institute's great advocate and supporter.

The millions raised year after year by *Vogue* and Anna Wintour through the benefit allow The Costume Institute to thrive. These funds not only produce the groundbreaking exhibitions and publications we have come to expect, but they support the Costume Institute staff and their research, and enable us to expand and conserve one of the greatest collections of historic and contemporary dress in the world—more than 35,000 objects spanning five centuries. As you explore these pages and enjoy the splendor of these exhibitions and celebrations, I hope you'll be inspired to visit The Met and see just what The Costume Institute Benefit has made possible. That critical contribution may not be the first thing on everyone's mind as they ascend the steps of The Museum for The Party of the Year, but it is the lasting legacy of those magical evenings. □

INTRODUCTION

BY ANNA WINTOUR

Long before *Vogue* became involved with The Metropolitan Museum of Art's Costume Institute, and even before I came to work at the magazine in 1983, I knew the singular place that the annual gala held in New York's social calendar.

I myself first received an invitation to attend when I was a fashion editor at *New York* magazine in the early eighties. I went with my colleague Henry Post and wore an Yves Saint Laurent dress from Bergdorf Goodman bought specially for the occasion. The dress was bare and black and, might I add, daringly brief for an event that was traditionally long on hemlines and short on risks. Carrie Donovan, then the fashion critic of *The New York Times,* told me how much she liked what I was wearing. The next day she pronounced, in print, that my YSL was a hit. (Needless to say, I was thrilled.)

To many people, seeing who attends the gala—and what they're wearing—is the thrill of the evening, on a par with getting the first glimpse of the exhibition. It's become one of the rare occasions when movie stars, models, designers, society swans, rock legends, athletes, politicos, and rappers, not to mention a cultural icon or two, come together to celebrate fashion—and get to spend a night at the museum.

I've always thought that planning each year's gala is a lot like producing a Hollywood blockbuster, from the initial idea, through strategizing, scripting, and casting, to scrutinizing every last detail. We think about who should be the marquee names—or hosts—given the theme of a particular year. Who better to lead a celebration of American womanhood than Oprah Winfrey? Or Burberry's Christopher Bailey to champion the relationship between tradition and subversion in British fashion? As with all major productions, we have our fair share of on-set dramas, such as when a pride of peacocks intended to add a suitably decorous note to the Paul Poiret tribute instead made a bid to head to the wilderness—well, Central Park.

The real joy of working with The Metropolitan Museum of Art, though, is what you see here in this book, an opportunity to go behind the scenes and experience firsthand the last fourteen years of exhibitions. Whether focusing on the outlandish glory of comic-book superheroes or the roar of punk on both sides of the Atlantic, these shows offer a breathtaking sweep of all that fashion can be: provocative, culture-defining, and, not least of all, spectacularly beautiful. Of course, all of these extraordinary exhibitions require deep reserves of funding. To take that Hollywood-blockbuster analogy a step further, the opening gala is our once-a-year chance to raise enough funds to secure an expansive future for what's now considered the preeminent fashion museum in the world.

Since *Vogue* and The Metropolitan Museum of Art joined forces, we've learned to play to each other's strengths. For The Museum's part, there's the curatorial freedom to make ambitious intellectual statements with every exhibition. And from our side, there's been the incredible opportunity to create a conduit between a globally renowned cultural institution and the world of fashion. I have always believed that one of the reasons designers are so quick to support The Costume Institute is that they know it's a place where their work is treated with the utmost respect and consideration. This is due in no small part to the amazing work carried out by two men at The Costume Institute whom I hold in huge admiration, curator-in-charge Harold Koda and curator Andrew Bolton. Harold and Andrew have evolved The Costume Institute with their profound understanding of fashion as material culture and historical catalyst; so much of what is contained in these pages would not have happened were it not for their brilliance and dedication. It helps, of course, that their work has been championed by such gifted visionaries of The Museum as director Thomas P. Campbell and president Emily Rafferty; thank you both for making Harold's and Andrew's visions a reality as well as for your immeasurable support of *Vogue*.

Closer to home, there are two others I would like to single out. Chloe Malle, *Vogue*'s Social Editor, bravely took on the role of the book's editor, overseeing the collation of The Costume Institute shows in chronological order, a task she proved immensely capable of taking on her young shoulders. And I could not write an introduction without mentioning Hamish Bowles, with whom I have been very lucky and honored to have worked for more than 20 years now. He is a force of nature, and his erudite, witty, and always insightful essays—reproduced here virtually unchanged from the pages of *Vogue*—on almost every show are to be savored as much as the astonishing images. Hamish can bring to life like no other why these exhibitions matter. Reading him is just one more thrill I associate with our work with The Met. □

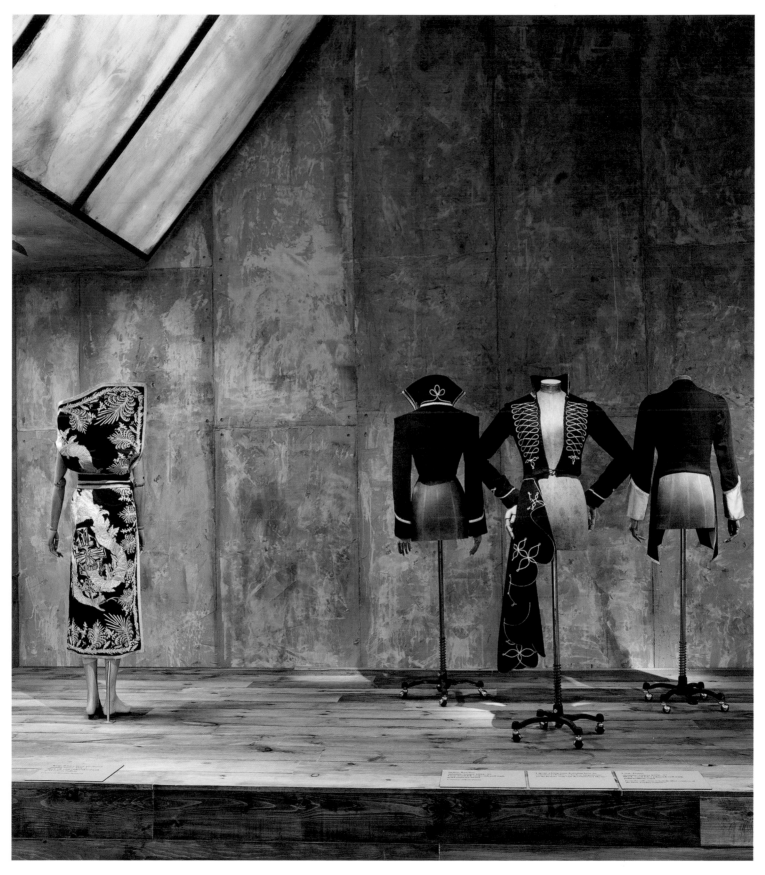

IN 2011, "ALEXANDER McQUEEN: SAVAGE BEAUTY" BROKE ATTENDANCE RECORDS, WITH 661,509 VISITORS—SOME 80,000 IN THE FINAL WEEK ALONE—CRUSHING THROUGH THE DOORS. BULLION AND MILITARY BRAIDING TRIMMED McQUEEN LOOKS FROM 2001, 1994, AND 1996 (INCLUDING A JACKET, CENTER RIGHT, WORN BY HIS FRIEND AND MUSE ISABELLA BLOW). **OVERLEAF:** PAUL POIRET'S PERSONAL EMBLEM WAS THE ROSE; AND, OF COURSE, HE MADE EXTRAVAGANT USE OF FEATHERS. HENCE, THE MUSEUM'S 2007 GALA FEATURED FOUR PEACOCKS PERCHED IN A GILDED CAGE FRINGED BY A HEDGE OF MORE THAN 12,000 LONG-STEMMED RED ROSES.

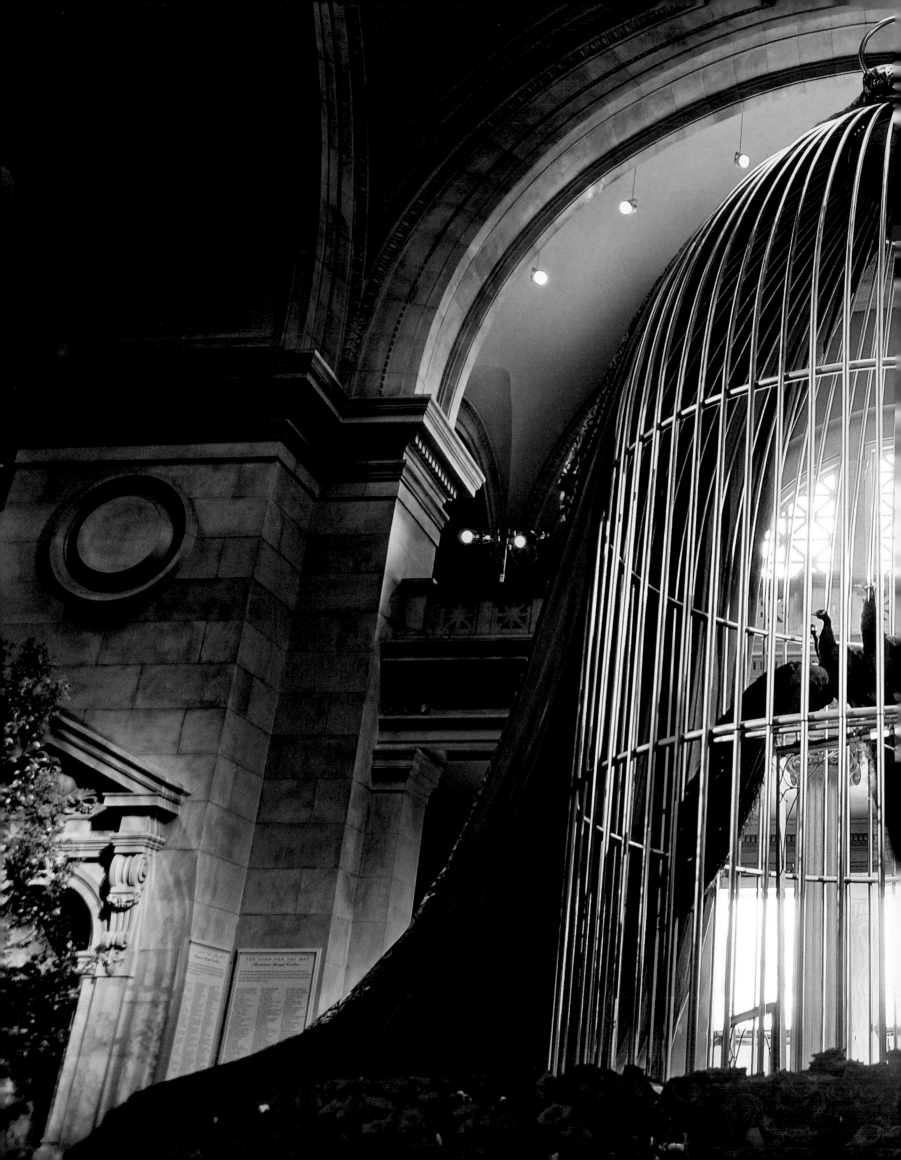

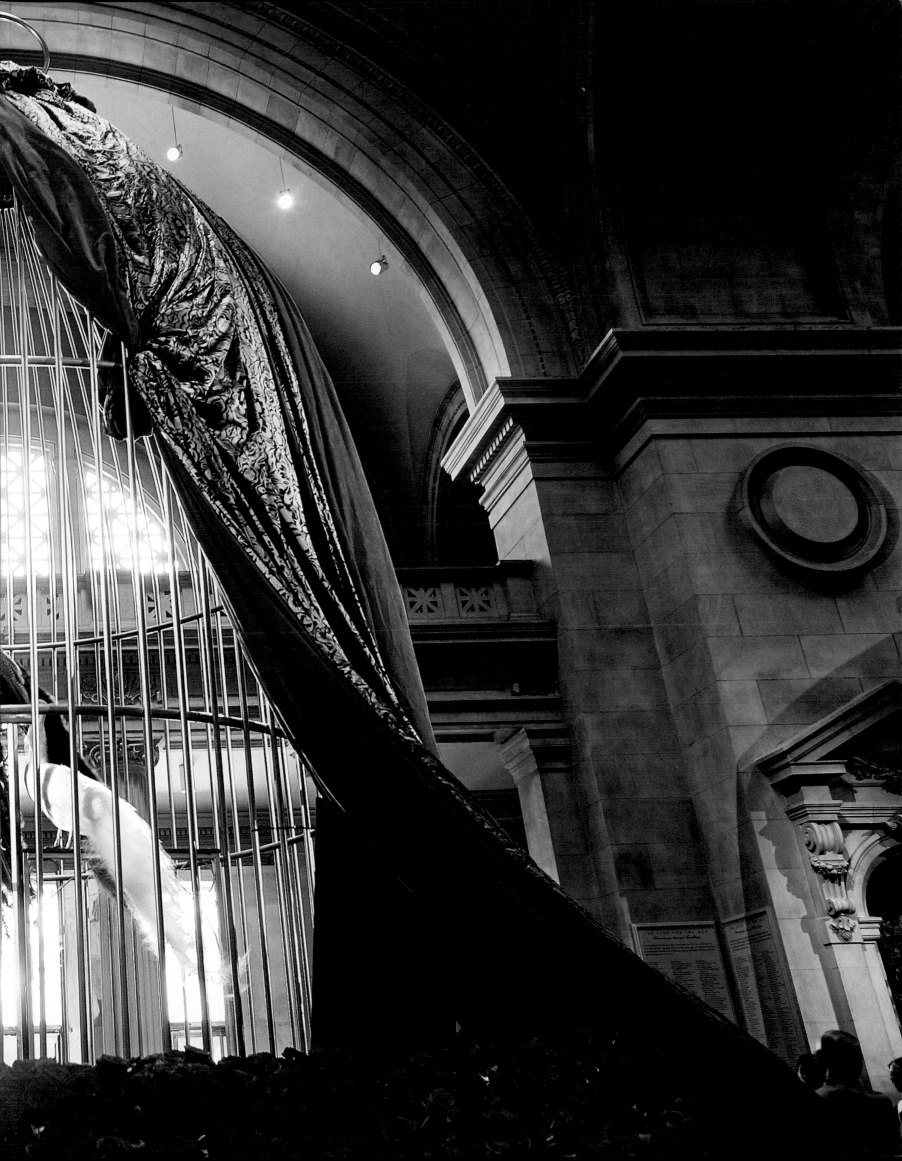

JACQUELINE KENNEDY

THE WHITE HOUSE YEARS

2001

JOHN F. KENNEDY, DEMOCRATIC NOMINEE, RODE UP NEW YORK'S CANYON OF HEROES ALONGSIDE HIS WIFE SHORTLY BEFORE THE 1960 ELECTION. SHE WORE A SWING COAT AND PILLBOX HAT BY HUBERT DE GIVENCHY. AFTER HER HUSBAND'S TRIUMPH, THE FIRST LADY'S PILLBOXES— WHICH SAT DELICATELY ON HER BOUFFANT BY KENNETH— WERE CUSTOM-MADE BY BERGDORF GOODMAN'S MILLINERY STABLE (WHICH INCLUDED HALSTON).

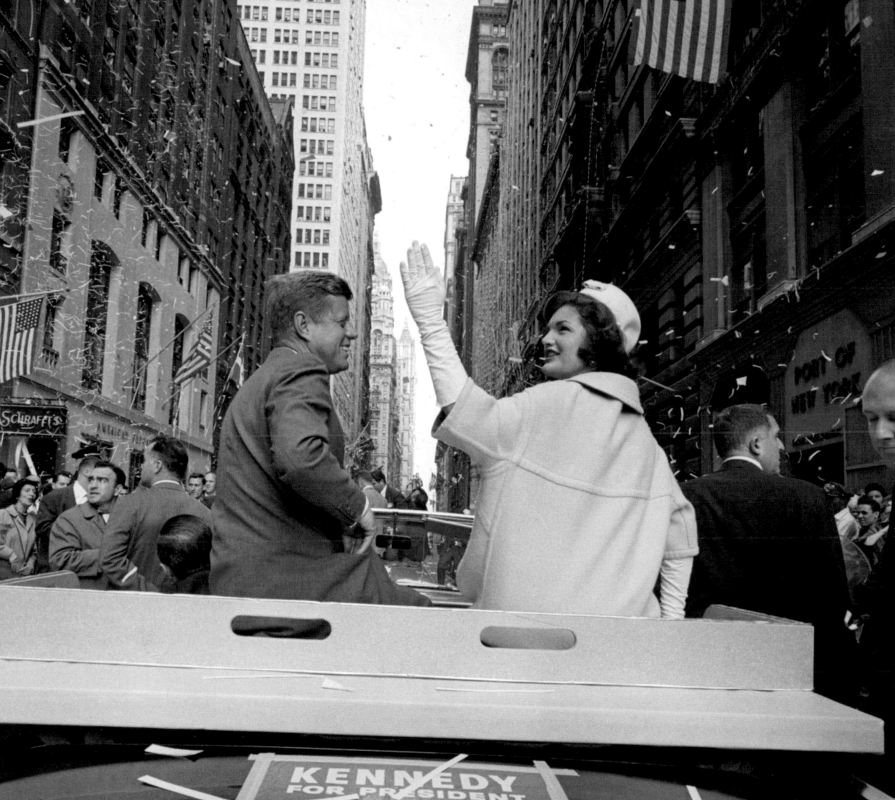

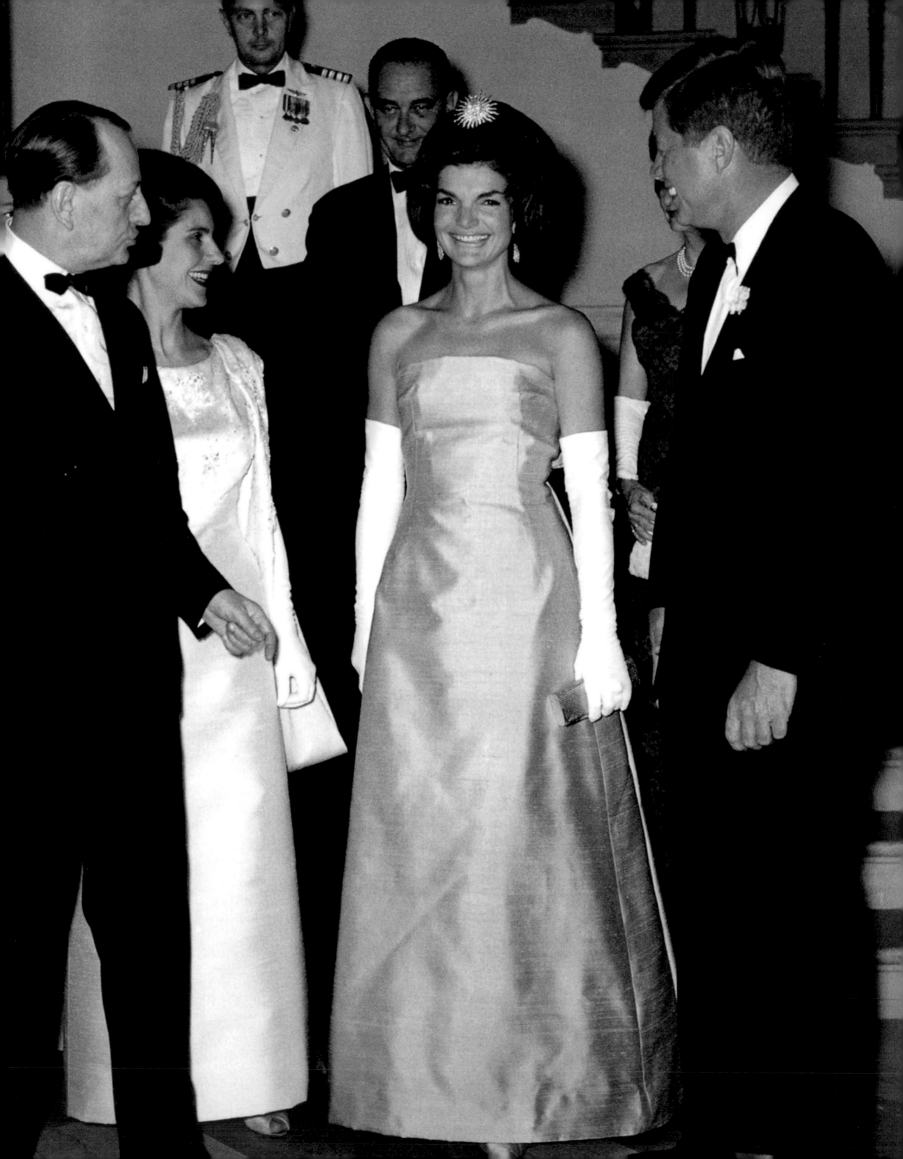

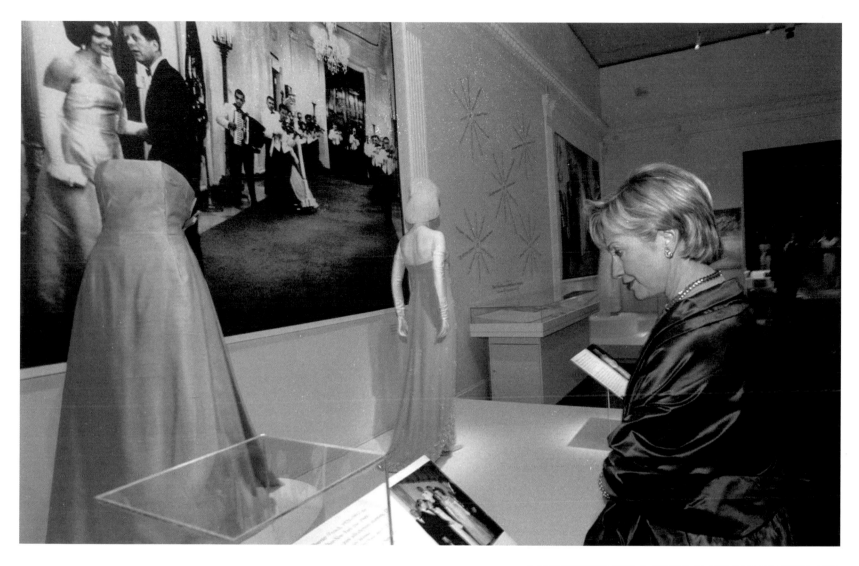

A FRANCOPHILE WITH A DEGREE IN FRENCH LITERATURE, MRS. KENNEDY SUPPORTED AMERICAN DESIGN INFORMED BY A DIALOGUE WITH PARIS. LEFT: TO A WHITE HOUSE DINNER FOR DE GAULLE'S MINISTER OF CULTURE ANDRÉ MALRAUX, SHE WORE A SHANTUNG DRESS BY CHRISTIAN DIOR–NEW YORK. ABOVE: SENATOR HILLARY CLINTON AT THE MET, APRIL 2001. CANDY PINK WAS A FAVORITE HUE IN CAMELOT.

s First Lady, Jacqueline Bouvier Kennedy revolutionized the taste of the nation. Not only did she promote culture and the arts at the highest levels, she also brought to the public's awareness a discriminating style and an expertise in fashion, decorating, and entertaining. In so doing, as biographer Carl Sferrazza Anthony wrote, she became "a symbol of the liberation from the notion that America had to be bourgeois." While the Trumans and the Eisenhowers had projected an air of cozy domesticity and espoused America's middlebrow cultural preferences, the Kennedys, as *Life* magazine noted, "consistently asserted a broad interest in artistic and intellectual distinction."

Mrs. Kennedy's image as First Lady was as carefully constructed as the stage that she set for her husband's presidency by scrupulously restoring the White House—a Herculean task that she accomplished in less than three years. Her personal taste gracefully spanned the divide that separated fifties America from President Kennedy's New Frontier. She was at once a paradigm of old-fashioned dignity and a reluctant pop-culture icon who, like her husband, had an intuitive understanding of the power of image in an age when television was becoming a potent medium. Perhaps Diana Vreeland, her valued friend and fashion mentor, expressed it most eloquently in her autobiography, *D. V.:* Jacqueline Kennedy, she wrote, "put a little style into the White House and into being First Lady of the land, and suddenly 'good taste' became good taste. Before the Kennedys, good taste was never the point of modern America . . . and, since then, we've never gone back." Mrs. Kennedy also had a keen understanding of the semantics of dress and of the ways in which she could use her public image to help communicate the more abstract ideals that were important to her. By projecting a vision of dynamic, modern elegance, in fact, she provided a potent counterpoint to the tenets of the Kennedy administration, with its youthful idealism, ardent internationalism, and dedication to social change.

By the time she joined her husband in the presidential campaign, Jacqueline Kennedy had clearly laid the foundations for the visual presentation that she would build on as First Lady—a reductive elegance that ensured her wardrobe would remain a quiet foil to her personality. Her informal clothing, however, revealed a very different and maverick aspect. During the campaign, her "devil-may-care chic," as *The New York Times* described it, came under relentless scrutiny. In the fall of 1960, *The New York Times Magazine* reported that "when Jacqueline Kennedy, then five days the wife of a presidential nominee, stepped aboard the family yacht in Hyannis Port, Massachusetts, wearing an orange pullover sweater, shocking-pink Capri pants, and a bouffant hairdo that gamboled merrily in the breeze, even those newsmen present who could not tell shocking pink from Windsor Rose knew they were witnessing something of possibly vast political consequence." Her carefree, youthful style was a counterpart to her husband's athleticism.

This blithe elegance might have been a response to her mother's more strictly controlled taste. Janet Lee Auchincloss set exacting standards for her daughters. They were brought up with the manners of a generation trained to write gracious thank-you notes, to appreciate the subtle arts of the great hostess and the management of large households, and to observe correct formality of dress. It was a time, as Peggy Noonan later noted, "when elegance was a kind of statement, a way of dressing up the world, and so a generous act." Mrs. Auchincloss largely prescribed her elder daughter's sartorial choices; she even chose her wedding gown, an uncharacteristically elaborate confection by the African-American designer Ann Lowe.

Jacqueline and her sister, Lee, often patronized local Newport and Washington dressmakers, establishing a pattern of personal involvement in the design of their clothes. Mini Rhea made items for their mother and her circle in Georgetown. Jacqueline brought

Rhea her own "squiggled dress designs," as well as French fashion magazines, for inspiration, a habit she repeated as First Lady in her relationship with Oleg Cassini's studio. Writing in 1962, Rhea remembered that her stylish young client "had a perfect horror of overdressing. . . . Jackie, even then, insisted on cleaner, neater, more compact lines and material with firmer body, so that the garments would hold their shape. . . . All of the fashions which Jackie has favored have suddenly become high fashion."

In 1951, the 21-year-old Jacqueline, then a senior at George Washington University, proved how sophisticated her fashion sensibility was when she entered *Vogue*'s Prix de Paris, a competition that the magazine established to "dissolve the 'no experience' barrier that exists between the young and the professional world." The playful self-portrait, sharply observed essays, knowing style references, and heady fashion critiques that she submitted indicated sophisticated taste and a love of history. Her entry also ensured that she won first prize out of a field of more than 1,000 college seniors.

Throughout the fifties, the output of Seventh Avenue was largely predicated on the dictates of Paris haute couture. The work of designers Coco Chanel and Hubert de Givenchy was closest to Jacqueline Kennedy's then-emerging fashion aesthetic, and they continued to shape her style as First Lady. Coco Chanel had closed down her business at the outbreak of World War II but was so appalled by the exaggerated look of postwar fashions ("Men make clothes in which one can't move") that she reopened in 1954. Although the French fashion press eviscerated her collection, influential American editors felt that the clothes suited the needs of modern women who wanted easy formality without discomfort. Their proselytizing helped to reestablish Chanel's influence, which was soon reflected at all levels of the American fashion industry. In many ways, Jacqueline Kennedy was the paradigm of the Chanel client. The designer's clothes, fitted lightly so as to skim the body, were made with a sense of comfort and ease that nevertheless did not contradict their couture status.

During that time, however, Mrs. Kennedy's style most clearly followed the trajectory of Givenchy's career. He began by presenting youthful garments, often in humble cottons with interchangeable pieces, that redefined the nature of couture, which until then had largely responded to the needs of a mature, worldly clientele. A year after he opened his house in Paris in 1952, however, Givenchy experienced a professional epiphany—he met Cristóbal Balenciaga, the Spanish designer who was then acknowledged as the greatest of his time. The two men became friends, and Balenciaga's ideas helped redefine Givenchy's approach.

Givenchy was soon blending his mentor's austere Spanish aesthetic with his own lighthearted French tastes. For many elegant young Americans, the luxurious simplicity of these clothes and the glamour that the wearer seemed to share with Givenchy's symbiotic muse, Audrey Hepburn (whom he had been dressing since *Sabrina,* in 1954), made him the Parisian couturier of choice. For Jacqueline Kennedy, Givenchy's reductive approach was appealing: It featured subtleties of construction that attracted the connoisseur's eye but remained deceptively simple enough to emphasize the wearer rather than the garment. Siriol Hugh-Jones characterized the First Lady's style for *Town & Country* in 1962 as "the look that fashion magazines, with awful perseverance, used to call uncluttered and that gives the impression that after fully dressing, someone has neatened you up with a sharp razor blade and finished off the whole effect with a small mathematical bow."

As First Lady, Mrs. Kennedy succeeded in converting the nation to an appreciation of her refined and sophisticated Francophile tastes, but it required some deft maneuvering on her part. What she chose to wear, she found out on the campaign trail with her husband,

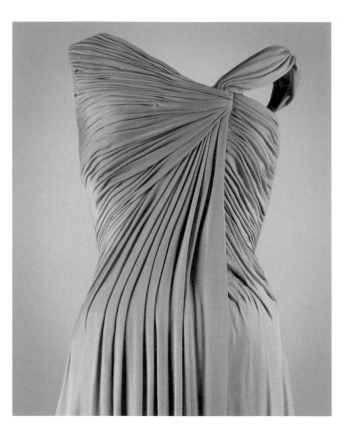

OLEG CASSINI, A LADY-KILLING RUSSIAN-ITALIAN ARISTOCRAT, WAS A DESIGNER AT PARAMOUNT PICTURES BEFORE HE ESTABLISHED HIS SELF-TITLED FASHION HOUSE. HE WAS MRS. KENNEDY'S OFFICIAL WHITE HOUSE DESIGNER, RESPONSIBLE FOR ONE OF HER ALL-TIME FAVORITES. ABOVE, FROM THE EXHIBITION, HIS IS THE CELADON SILK-JERSEY GRECIAN DRESS THAT SHE WORE TO AN EVENT HONORING NOBEL PRIZE WINNERS IN APRIL 1962. RIGHT: SHE CHATTED WITH ROBERT FROST, WHO HAD CAPTURED THE NATION'S IMAGINATION WITH HIS READING OF "THE GIFT OUTRIGHT" AT THE INAUGURATION.

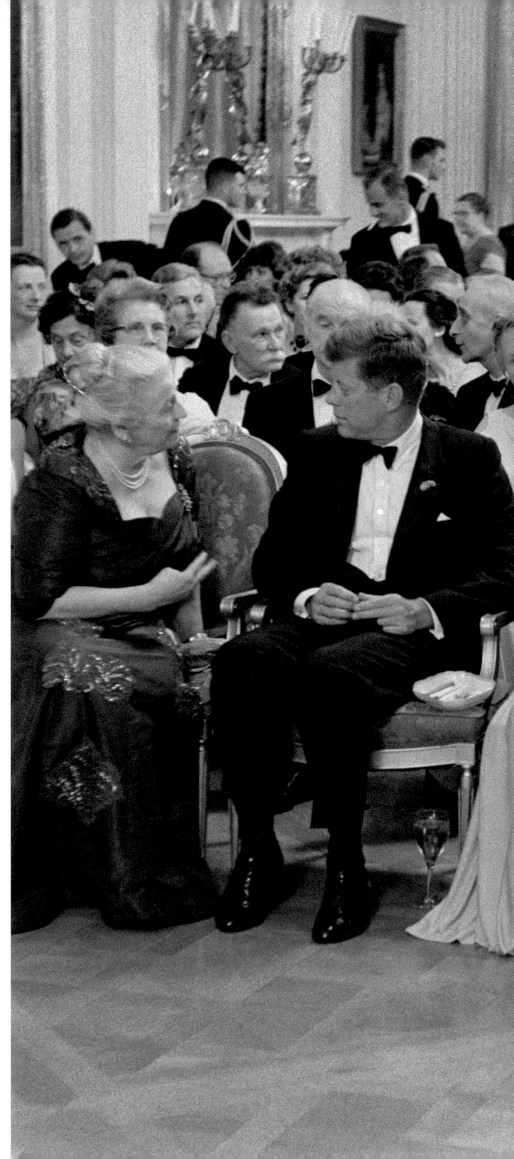

not only had political ramifications but also prompted a new trend in fashion reporting. When John Fairchild took over the editorship of *Women's Wear Daily* in 1960, he set about transforming its existing editorial focus on garment-industry business news and adopting a more aggressive, gossipy tone. The newspaper's publisher, James Brady, wrote, "*WWD* was a profitable, respected, and obscure little trade newspaper when John F. Kennedy came to the White House. . . . It was Jacqueline Kennedy who gave us our opening."

In a front-page editorial around the same time, Fairchild wrote, "Those smart and charming Kennedys—Jacqueline, wife of the senator, and his mother, Mrs. Joseph P. Kennedy—are running for election on the Paris Couture fashion ticket. . . . Together, the two Kennedys spend an estimated $30,000 per year for Paris clothes and hats—more than most United States professional buyers." The Associated Press compounded the article's sensationalism by suggesting that Fairchild's figure represented Jacqueline Kennedy's personal wardrobe expenditure. When *The New York Times* questioned her about it, she memorably responded, "I couldn't spend that much unless I wore sable underwear." But the Republicans nevertheless stepped swiftly into the fray. "I like American designers," Pat Nixon announced. "I think they are the best in the world. I buy most of my clothes off the racks in different stores around Washington."

Pat Nixon's cloth-coat frugality aside, there were even more pressing political reasons for Jacqueline Kennedy to wear an American-made wardrobe. Significant support for her husband's presidential campaign had come from the International Ladies' Garment Workers' Union (ILGWU) in the form of hundreds of thousands of dollars and votes. Under the presidency of David Dubinsky, whom the *Times* called "the most imaginative and creative labor leader in America," the union had become a powerful lobbying force. "No one in the industry," wrote Phyllis Lee Levin in *The Wheels of Fashion,* "no designer, manufacturer, or operator would not readily admit that Dubinsky was emperor and arbiter of American fashion." Dubinsky pressed Kennedy on the issue of his wife's unpatriotic wardrobe. Julius Hochman, director of the Union Label department of the ILGWU, added his voice by writing to Eleanor Lambert, the doyenne of fashion publicists who had been advising Jacqueline Kennedy: "I think that you will do Mrs. Kennedy and the entire country a great service if you will convince [her] that her Inauguration wardrobe be American-made in every way."

To develop a wardrobe focused on the work of American designers, Jacqueline Kennedy turned to Diana Vreeland, the hieratic and fantastically original fashion editor of *Harper's Bazaar.* In spite of Mrs. Vreeland's decidedly French instincts, she covered the American fashion market for the magazine. With every fashion purchase scrupulously, but often inaccurately, recorded by the press, there was clearly a need to focus on a limited field of designers. On August 1, 1960, Diana Vreeland received a ten-page handwritten letter from Jacqueline Kennedy asking her advice to help "solve an enormous problem which is clothes! . . . I must start to buy American clothes and have it known where I buy them. . . . Just remember I like terribly simple, covered up clothes. . . . the nearest to Balenciaga & Givenchy," or "Chanel velvet suits." And, she added firmly, "I hate prints."

Diana Vreeland responded by suggesting an intriguing triumvirate of designers: Stella Sloat, Ben Zuckerman, and Norman Norell. Sloat defined the signature simplicity of her well-made sportswear separates as "what is left after you take everything away." Despite the thoroughly American feeling of her clothes, at times she included copies of Givenchy originals in her line. The Romanian-born Zuckerman was a fashion-industry stalwart working with his designer, Henry Shacter, to produce "the only clothes made in America that look as though Dior or Balenciaga made them." It was Zuckerman's line-for-line copy of a Pierre Cardin coat in purple wool that Jacqueline Kennedy had at first decided to wear for the Inauguration Day ceremonies (she wore it instead to tour the White House with Mamie Eisenhower). "It was natural the First Lady should go to America's First Designer," John Fairchild observed of her early choice of Norell, who had declared, "I don't like overdesigned anything." (Mrs. Vreeland would continue to bring to the First Lady's attention fashion ideas and designers, including Guy Douvier at Christian Dior–New York, and Gustave Tassell, a West Coast protégé of James Galanos. She also coordinated designs with Emilio Pucci, whose bravura sports clothes the First Lady chose for a holiday in Italy.)

Jacqueline Kennedy experimented with fashionable resources of the moment, such as the Manhattan boutique A La Carte. It was run by Joan Morse, who later became a Warhol acolyte and who endearingly admitted, "I can't sew, drape, or cut a pattern. But I play with a piece of fabric and it comes up wild and it sells." At the opposite end of the spectrum was Chez Ninon, a couture salon established by socially connected Nona Park and Sophie Shonnard in the late 1920s. "They were two wonderful, pixilated ladies," remembers Babs Simpson, a *Vogue* fashion editor at the time. "They'd go to Paris and terrorize everybody even though they had the tiniest shop!" Through Chez Ninon, the First Lady acquired clothing that was legitimately made in America, although designed in Paris.

In addition to Mrs. Vreeland's choices, the designer Oleg Cassini, a Kennedy family friend, proposed himself as a candidate, apparently at the suggestion of his brother Igor, the influential Hearst gossip columnist who had once named Jacqueline Bouvier "debutante of the year." Before the November 8 election, Oleg Cassini wrote to Mrs. Kennedy with the assurance that "naturally, the dresses you would get here will be specially made for you, with your counsel and direction and in keeping with your marvelous sense of personal fashion."

In response, Mrs. Kennedy asked Cassini to "get started designing me something, then send me some sketches and, if I like them, I can give you credit for doing most of my Spring wardrobe." The urbane Cassini, born in Paris to Russian parents and raised in Florence, had come to America in the 1930s and soon after came to know Joseph P. Kennedy. As Cassini has recalled, it was Ambassador Kennedy who encouraged him to leave the Hollywood studio system—where he gained a reputation for the costumes he designed for his wife, Gene Tierney, in *The Razor's Edge* and *The Shanghai Gesture*—to establish his own Seventh Avenue fashion house in 1950.

Since Mrs. Kennedy had already asked Bergdorf Goodman to work with her on designs for her inaugural-ball gown (partly inspired by a dress by London designer Victor Stiebel), Cassini undertook the dress for the inaugural gala. "Now I know how poor Jack feels when he has told 3 people they can be Secy. of State," she wrote Cassini on December 13, 1960, in a letter that spelled out her expectations. "Are you sure you are up to it, Oleg? Please say yes—there is so much detail about one's wardrobe once one is in the public eye. . . . I am counting on you to be a superb Wardrobe Mistress—every glove, shoe, hat, etc. and all delivered on

time." Under the heading "publicity" she counseled discretion, adding, "I know that I am so much more of fashion interest than other First Ladies—I refuse to have Jack's administration plagued by fashion stories of a sensational nature—and to be the Marie Antoinette or Joséphine of the 1960s."

The fashion world greeted Mrs. Kennedy's choice of Cassini with some skepticism. "Everyone was surprised," wrote John Fairchild in *The Fashionable Savages*. "He was debonair, amusing, social, but none of the fashion intellectuals had considered him an important designer." Cassini's provocatively formfitting, glamorous clothes owed more to his background as a Hollywood designer than to the dictates of Paris. His fashion shows had a nightclub ambience, with the designer himself addressing the audience with an often risqué comic monologue. "I like the alluring way women look in clothes that accentuate their femininity," he told one magazine. "I firmly believe it is an offense against nature to flatten, rather than flatter, their provocative curves. When I design a dress, I visualize a stunning girl wearing it on a date with me, and I don't want her to be mistaken for a prison matron." The Hollywood stars who responded to Cassini's high-voltage effects included Joan Crawford, Joan Fontaine, and Janet Leigh.

As she had done with other designers, Mrs. Kennedy sent the Cassini workrooms pages from fashion magazines, often with her own annotations or sketches suggesting adaptations, specifying the material that she wanted by including swatches or a length of fabric. At times she also submitted tracings of sketches from the Paris couture houses that her famously chic sister, Lee Radziwill, or stylish friends such as Jayne Wrightsman, sent to her—or that she inquired about herself. (On January 2, 1962, for instance, the First Lady's social secretary wrote to Letizia Mowinckel, who was consulted as a fashion scout: "JBK is dying to know what Philippe Venet's collection of suits and coats looks like. He was Givenchy's tailor and evidently this is his first collection. If you can get a hold of any sketches for your 'cousin' plus prices, she would be thrilled.") Jacqueline Kennedy also sent original Paris couture clothing—items already in her wardrobe or borrowed from her sister—to serve as starting points for an element of design or, in some instances, to be copied line-for-line in different fabrics.

Although the First Lady and Cassini discussed ideas together, he maintained a distance from the mechanics of producing her clothes, cherishing instead his position as a family friend. His showroom director, the efficient Kay McGowan, therefore, was put in charge of coordinating the First Lady's clothing and accessories. McGowan also served as liaison with the millinery department of Bergdorf Goodman, where Halston was installed as the designer, along with the shoemaker Mr. Mario at Eugenia of Florence and Koret for evening bags. The First Lady expressed her thanks in a letter to McGowan: "Please tell Oleg I think we have done the most marvelous work together—it isn't just copying—but my ideas for what I need—plus his and your excellent workmen—We work together better than Gloria Guinness and Balenciaga ever did."

For the Kennedys' tour of Europe in 1961, which would prove to be the First Lady's defining moment on the world stage, she again consulted various women she considered to be infallible fashion guides, including Nicole Alphand, the wife of the French ambassador to Washington during the Kennedy administration, who was a conduit to news of French couture. At one time a Dior mannequin, Alphand was the paradigmatic ambassador's wife. She did much to promote French couture and its related arts in Washington and would eventually return to the fashion world as the director of Pierre Cardin's house. Radziwill was also involved in the elaborate sartorial preparations for Jacqueline Kennedy's tour of Europe. Her sister helped select and adapt a model from Givenchy's collection for the First Lady to wear to Versailles, and Alphand served as a liaison with Alexandre, the most celebrated hairdresser of his day. Alexandre recalls telling Mrs. Kennedy, "Madame, you are going chez Louis Quatorze; I will dress you like a queen!"

In France, the Givenchy clothes that Jacqueline Kennedy chose to augment her Cassini wardrobe were seen as a gesture of respect to the host nation. The painstaking image that she cultivated had a resounding impact on fashion as well as politics. As the First Lady's stepbrother Yusha Auchincloss observed, she set off for Paris "with the thought of her husband and de Gaulle as sort of a continuation of the historic association between George Washington and General Lafayette." Ambassador Hervé Alphand noted, "I think her influence was extremely efficient as far as Franco-American relations were concerned. . . . Jacqueline helped [President Kennedy] very much to understand France." And Pearl Buck wrote, "It was a source of pride to me that she appeared in France simply but well dressed and that she spoke to the French people in their own tongue."

The First Lady's appeal in France was such that the following year she made a goodwill tour to India and Pakistan, this time without the president. "This is Mrs. Kennedy's first semiofficial trip by herself," her press secretary announced on the eve of her departure. "She feels, and hopes, that it will be more memorable than just a group of fashion stories."

This was a vain hope. From the shocking-pink Cassini coat that she wore on her arrival in India to the shining-yellow Tassell dress that she chose for an elephant ride, Mrs. Kennedy's every outfit was a dazzling photo opportunity that helped to reinforce a positive world view of America. John Kenneth Galbraith, who was then ambassador to India, humorously lamented in a telegram to the president: "Plan to soft-pedal on clothes rivalling success of Stassen's efforts to ditch Nixon. Now they are asking who designed mine." *Life*'s Anne Chamberlain wrote that "despite her best efforts her every seam has been the subject of hypnotized attention from the streets of Delhi to the Khyber Pass."

Although the First Lady's overseas tours were culturally oriented, they also served a deeper political purpose. The Cold War was raging, and the Kennedy administration was wary of Soviet interest in India and in Latin America, where President Kennedy sought to improve relations. When she accompanied her husband on these trips, the First Lady once more proved a powerful and potent asset, and, as the president noted, her presence ensured a big crowd and safe treatment.

Just a year later, on the tragic occasion of the president's assassination, Hugh Sidey wrote in *Life* magazine that Jacqueline Kennedy had shown "the world that there was unimagined strength beneath the silk." He might just as well have been describing the whole of her brief but dazzling tenure as First Lady.—HAMISH BOWLES, *VOGUE*, MARCH 2001

Excerpted from Jacqueline Kennedy: The White House Years, Selections from the John F. Kennedy Library and Museum. *Text © 2001 by The Metropolitan Museum of Art, New York. Reprinted by permission.*

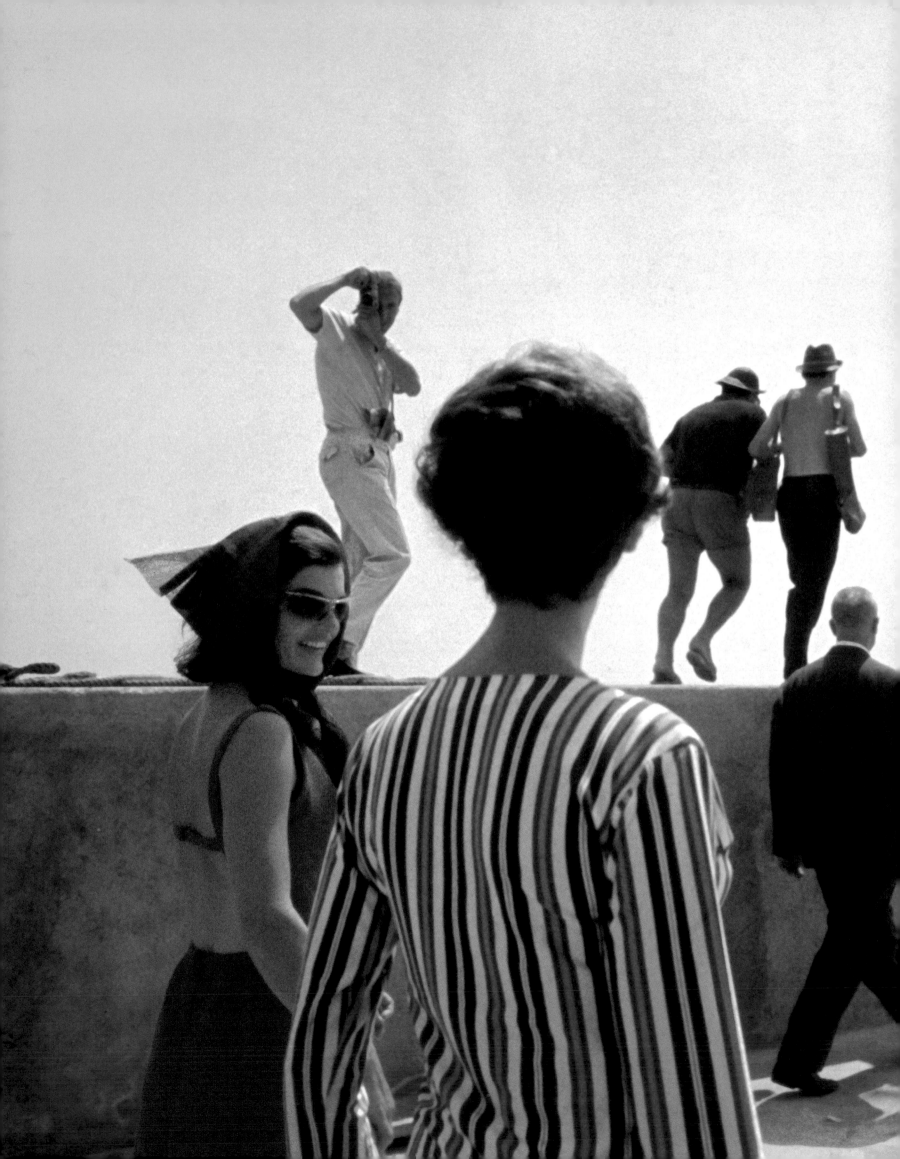

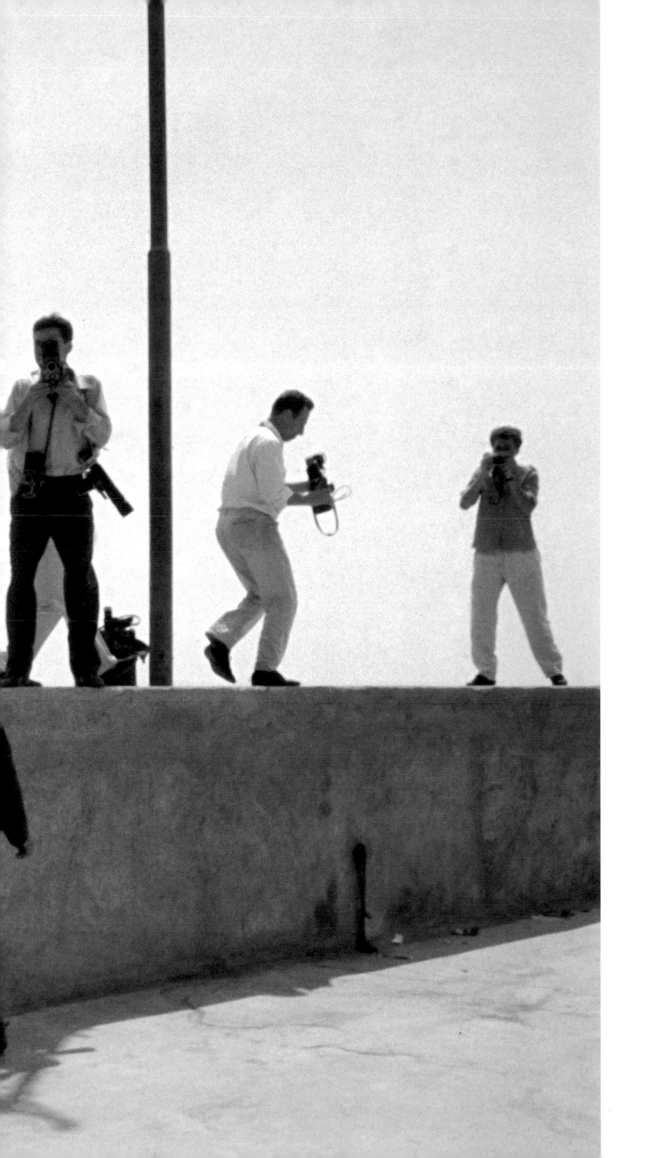

PURSUED BY PAPARAZZI IN RAVELLO, ITALY, IN 1962, MRS. KENNEDY WAS ACCOMPANIED BY MARELLA AGNELLI—ANOTHER FREQUENT *VOGUE* SUBJECT— AND WORE SUNGLASSES BY RENAULD OF FRANCE WITH A YOUTHFUL BACKLESS SUNDRESS AND HEADSCARF. THIS IMAGE BY MARK SHAW WAS AMONG THOSE BLOWN UP TO SERVE AS PHOTOMURALS IN THE COSTUME INSTITUTE GALLERIES IN 2001, AND BECAME A BACKDROP FOR THE MANNEQUINS.

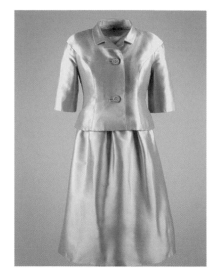

ICY SILK FOR A VISIT TO INDIA,
GUSTAVE TASSELL, 1962.

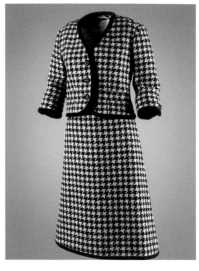

HOUNDSTOOTH TWEEDS FOR THE
CAMPAIGN TRAIL, FRENCH, 1959.

OFF-THE-RACK SHANTUNG SHIFT
FROM TOWNLEY FROCKS, 1962.

GIVENCHY DAISY DRESS (WORN
FOR AN AVEDON PORTRAIT), 1960.

OLEG CASSINI, WORN ON A
MAHARANA'S BARGE, INDIA, 1962.

NEHRU COAT BY CASSINI, FOR
ARRIVAL IN NEW DELHI, 1962.

JOAN MORSE DRESS OF SAUDI
BROCADE, FROM A LA CARTE, 1962.

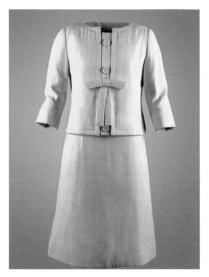

OLEG CASSINI'S AMERICAN
TAKE ON NINA RICCI, 1962.

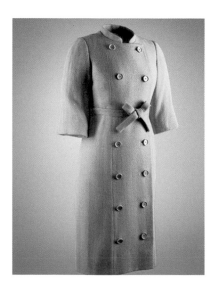

PISTACHIO COAT BY
GUSTAVE TASSELL, 1961.

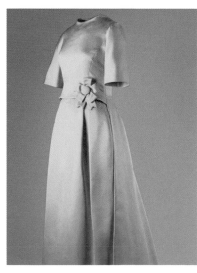

CASSINI'S IVORY COCKADE GOWN
FOR THE 1961 INAUGURAL GALA.

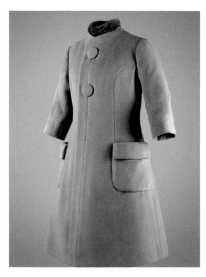

MINIMAL, MODERN INAUGURATION-
DAY COAT, CASSINI, 1960.

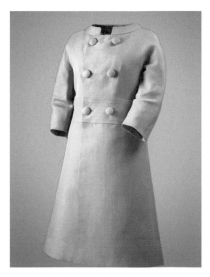

LEAF-GREEN SILK-GAZAR BY
CASSINI, FOR MEXICO TRIP, 1962.

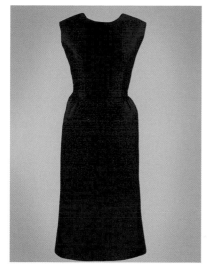

WHITE HOUSE STAFF–CHRISTMAS
PARTY DRESS, GIVENCHY, 1960.

SILVER-SPANGLED VELVET-AND-
TULLE GOWN, OLEG CASSINI, 1962.

A FAVORITE CASSINI,
WORN REPEATEDLY.

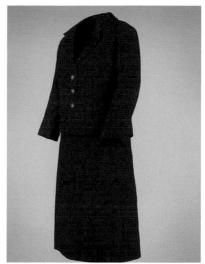

SILK-VELVET RECEPTION
SUIT, CASSINI, 1963.

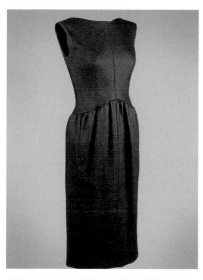

NORMAN NORELL BACK-BUTTON DAY
DRESS, WORN TO ATHENS, C. 1960.

MAUVE CASSINI SHIFT WORN
ON EASTER SUNDAY, 1963.

FROCK FOR AN ELEPHANT RIDE IN
JAIPUR, GUSTAVE TASSELL, 1962.

PETTICOAT DRESS FOR AN
AUDIENCE WITH THE POPE, 1962.

WORN TO SHALIMAR GARDENS
IN LAHORE, PAKISTAN, 1962.

PALM BEACH DRESS OFF THE RACK
FROM HERBERT SONDHEIM, C. 1960.

CASSINI'S INTERPRETATION OF A
GIVENCHY SARI DRESS, 1962.

FOR EDWARD KENNEDY'S WEDDING,
BERGDORF GOODMAN, 1958.

EXTREME BEAUTY
THE BODY TRANSFORMED
2002

NAOMI CAMPBELL TOOK A FALL WITH GOOD HUMOR ON THE VIVIENNE WESTWOOD RUNWAY, 1993. PLATFORMS HAVE COME IN AND OUT SINCE THE SIXTEENTH CENTURY, WHEN SERVANTS HELPED VENETIAN LADIES HOBBLE ABOUT ON THEIR TOWERING CHOPINES. A HIGHLY VISIBLE BODY-MORPHER, PLATFORMS ARCH THE BACK, ELEVATE THE BREASTS, LENGTHEN THE LEG, AND ADD VISUAL WEIGHT TO THE BOTTOM OF A SILHOUETTE.

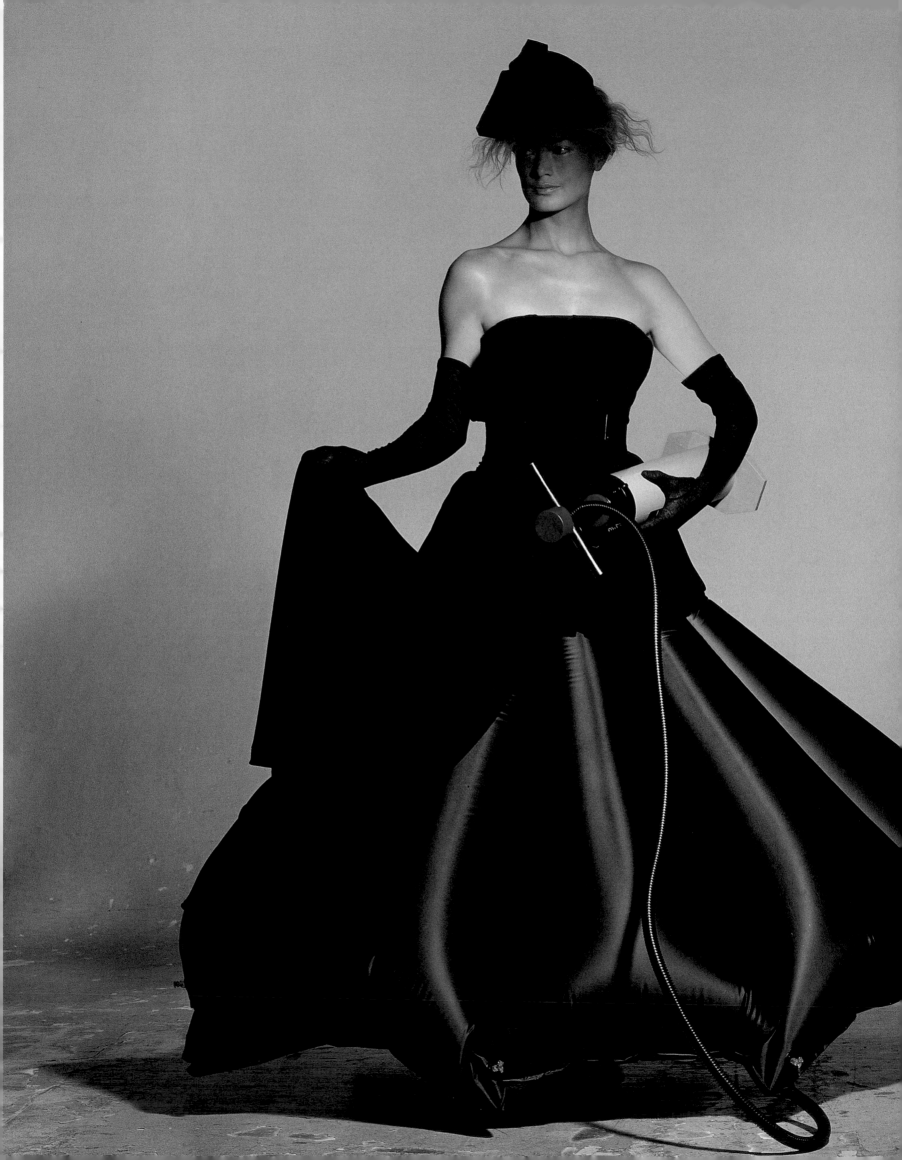

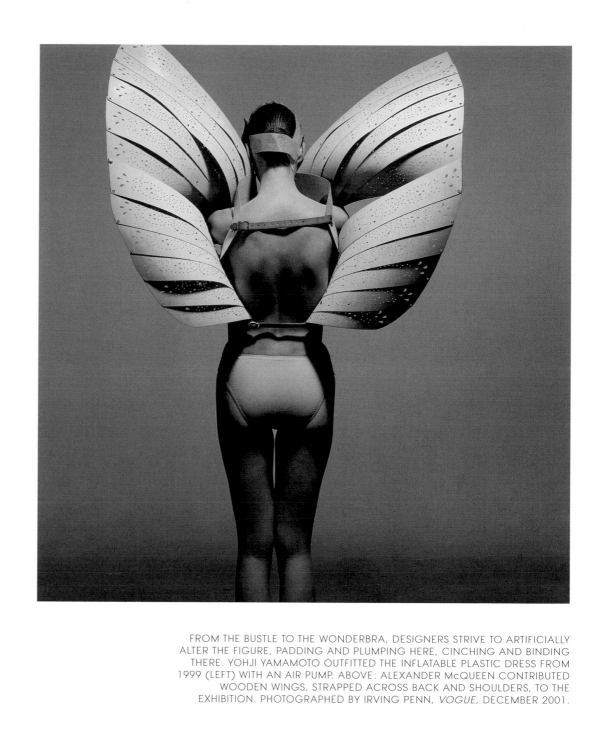

FROM THE BUSTLE TO THE WONDERBRA, DESIGNERS STRIVE TO ARTIFICIALLY
ALTER THE FIGURE, PADDING AND PLUMPING HERE, CINCHING AND BINDING
THERE. YOHJI YAMAMOTO OUTFITTED THE INFLATABLE PLASTIC DRESS FROM
1999 (LEFT) WITH AN AIR PUMP. ABOVE: ALEXANDER McQUEEN CONTRIBUTED
WOODEN WINGS, STRAPPED ACROSS BACK AND SHOULDERS, TO THE
EXHIBITION. PHOTOGRAPHED BY IRVING PENN, *VOGUE*, DECEMBER 2001.

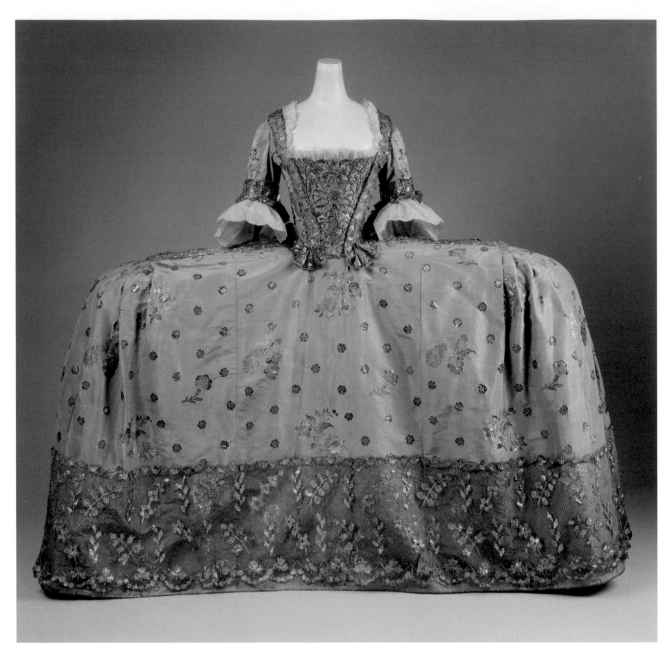

THE STYLE FOREVER ASSOCIATED IN THE PUBLIC MIND WITH THE EXCESSES OF THE COURT OF VERSAILLES WAS A DRESS WITH PANNIERS SO WIDE THAT WOMEN OFTEN HAD TO ENTER A ROOM SIDEWAYS. ABOVE: A BRITISH METALLIC-EMBROIDERED SILK DRESS, C. 1750, FROM THE EXHIBITION. OPPOSITE PAGE: A FRENCH ILLUSTRATION FROM 1777 SHOWS A FINE LADY IN A ROBE À LA FRANÇAISE BIDDING A SIDELONG ADIEU TO AN ADMIRER.

during the spring 2001 collections; next to them, a flamboyant pair of boots designed by the Stetson Company, which Koda found at an auction listed in *The Newtown Bee*. "Extreme Beauty," in fact, began as an exploration of the heel, but before Koda knew it, the entire body came into play, and the show took on grander proportions.

Still, it was in the shoe department that Koda happened upon a fashion epiphany that surprised even him. "What struck me is how something that makes us uncomfortable can slowly become something that's seductive," he explains. In the beginning, he and his research team recoiled at the images of lotus feet in turn-of-the-century Chinese women. But then, he says, "by the third week, after looking at all the material, we couldn't help saying, 'Well, I suppose this foot is really beautiful.' You end up projecting . . . no, not projecting . . . um, . . . *divining* the aesthetics of the time. How did a whole group of us get there in three weeks? That's what was surprising. We could say, 'This is ugly and always will be ugly.' But actually beauty is an issue that is mutable." Indeed, one could call it downright evolutionary.

Not everyone will agree with Koda's theory, of course. Some will be outraged at the body-transforming impracticality of a certain piece; others will be speed-dialing Barneys to get their hands on something that looks like it. Whatever the case may be, Koda is hoping that visitors will let their thoughts brew a little before coming to any conclusion. After all, he says, "When you put extremes of fashion in a historical context, you realize they are not that extreme."—JOANNE CHEN, *VOGUE*, DECEMBER 2001

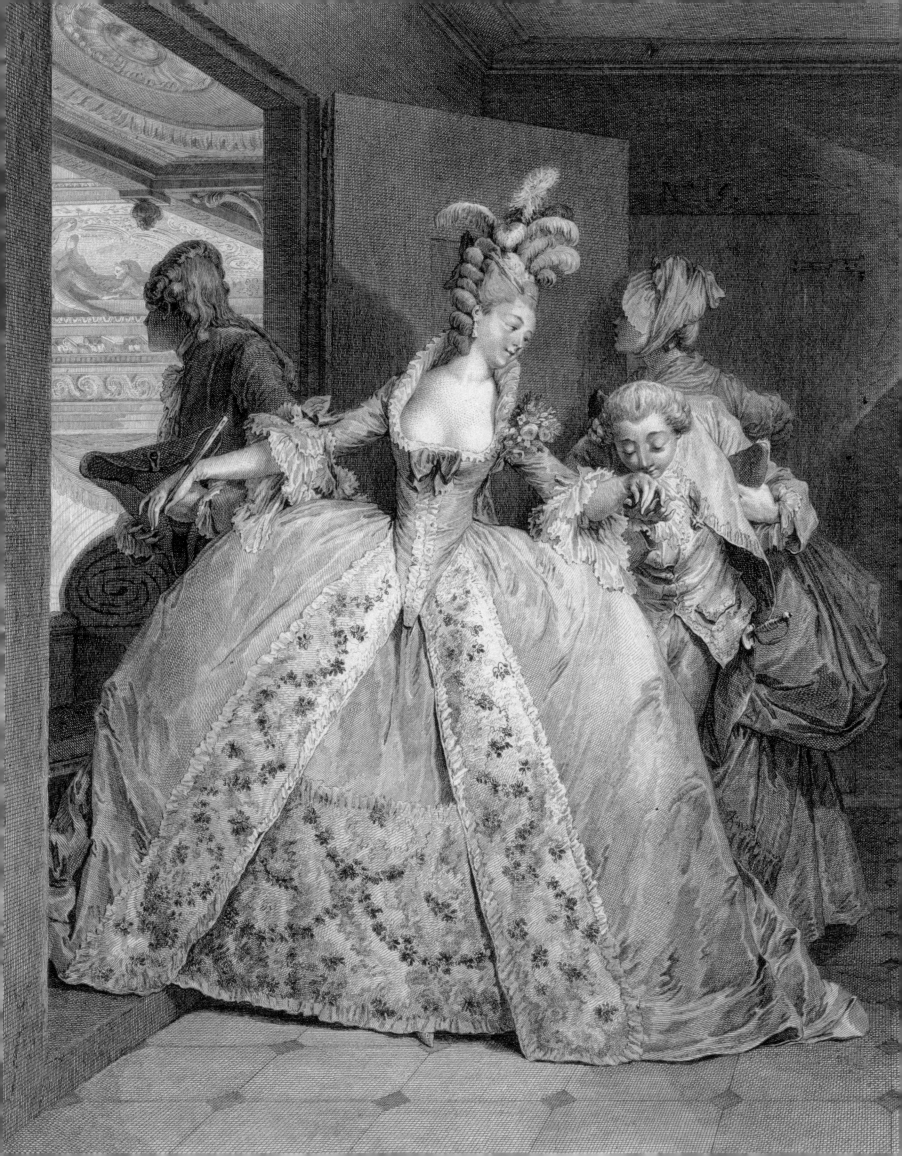

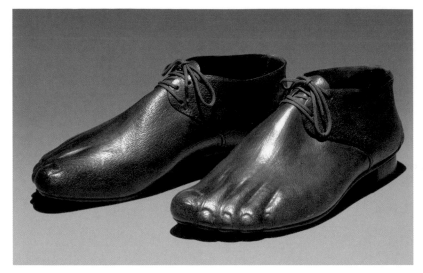

WHIMSICAL MEN'S SHOES BY PIERRE CARDIN AND CARLOS PEÑAFIEL, 1986.

AN UNDERGARMENT TO EXPAND
LEG-OF-MUTTON SLEEVES, 1890s.

MEN'S FRENCH LINEN
UNDERDRAWERS WITH LACING
AT BACK, C. 1830.

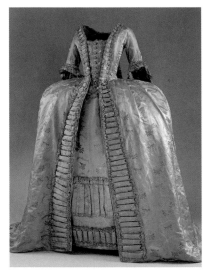

ROBE À LA FRANÇAISE
BROCADED WITH SILVER-METALLIC
FLORAL SPRAYS, C. 1765.

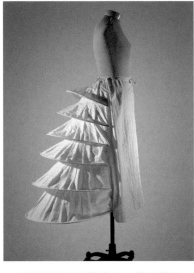

VICTORIAN COTTON-AND-METAL
BUSTLE, BRITISH, C. 1871.

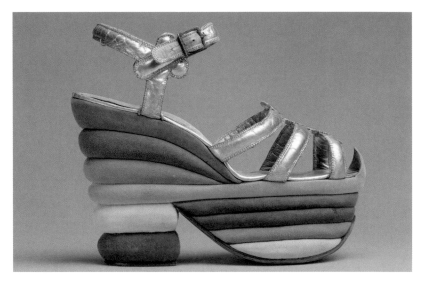

FERRAGAMO'S LANDMARK RAINBOW SANDALS, 1938.

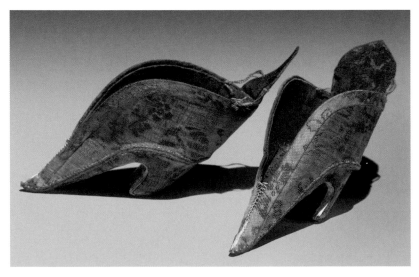

"LOTUS" SHOES FOR A CHILD, CHINA, 1870s–1910.

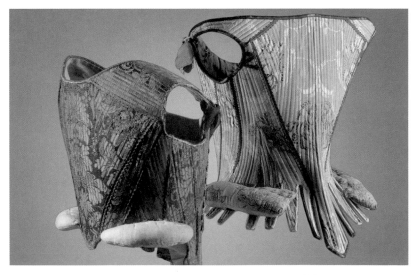

CORSETS WERE TYPICALLY BONED WITH WOOD
OR BALEEN, EUROPE, 1750–75.

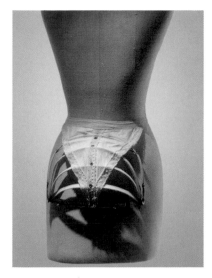

BELLE ÉPOQUE BUSTLE TO ENLARGE THE DERRIERE, 1880s.

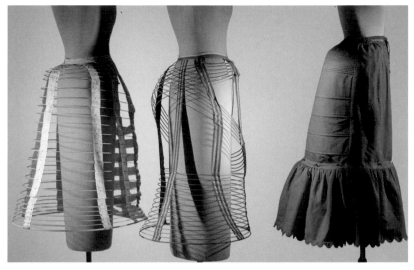

HOOPS AND LOBSTER-POT CRINOLINE (RIGHT), AMERICAN, 1870–80s.

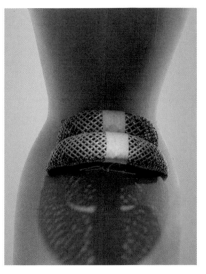

LIGHT CANE-AND-COTTON VARIATION ON THE BUSTLE, AMERICAN, 1880s.

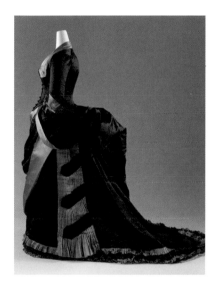

DRESS WITH AN EXTENDED, HEAVILY UPHOLSTERED PERPENDICULAR BUSTLE, 1884–86.

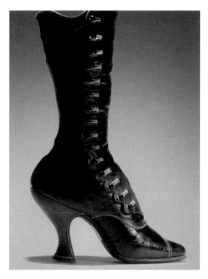

HIGH-HEELED BUTTON BOOT BY COBBLER JACK JACOBUS, 1895–1900.

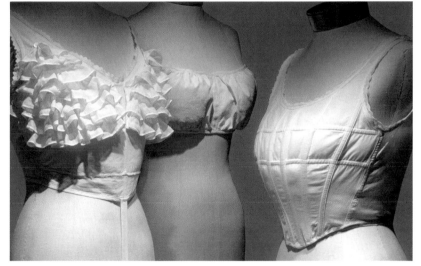

BEFORE THE BRA: BUST-ENHANCER (CENTER) AND CHEMISETTES, 1900–14.

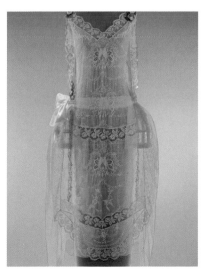

LACE ROBE DE STYLE WITH PANNIERS, FROM BOUÉ SOEURS, C. 1923.

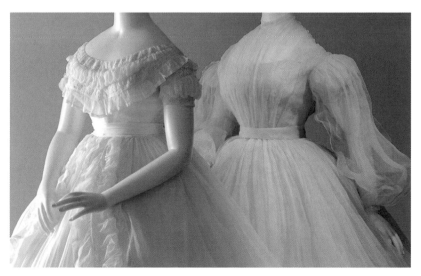

HOOPSKIRTS: A FRENCH WEDDING DRESS (LEFT) AND AN AMERICAN DAY DRESS, MID–19TH CENTURY.

JEAN PAUL GAULTIER DRESS FROM THE BARBÈS COLLECTION, 1984.

GODDESS
THE CLASSICAL
MODE
2003

THE SENSUAL UNDULATIONS OF ANCIENT GREEK DRESS—
SWATHS OF FABRIC DRAPED, GIRDED, FOLDED—ARE REVISITED
TIME AND AGAIN BY CONTEMPORARY DESIGNERS. THIS COULD
BE A HELLENIC MAIDEN IN HER HIMATION, C. 202 B.C., BUT
IT'S AMERICAN SUPERMODEL AMBER VALLETTA IN HER PRADA,
C. 2002 (AS SEEN BY PHOTOGRAPHER STEVEN MEISEL).

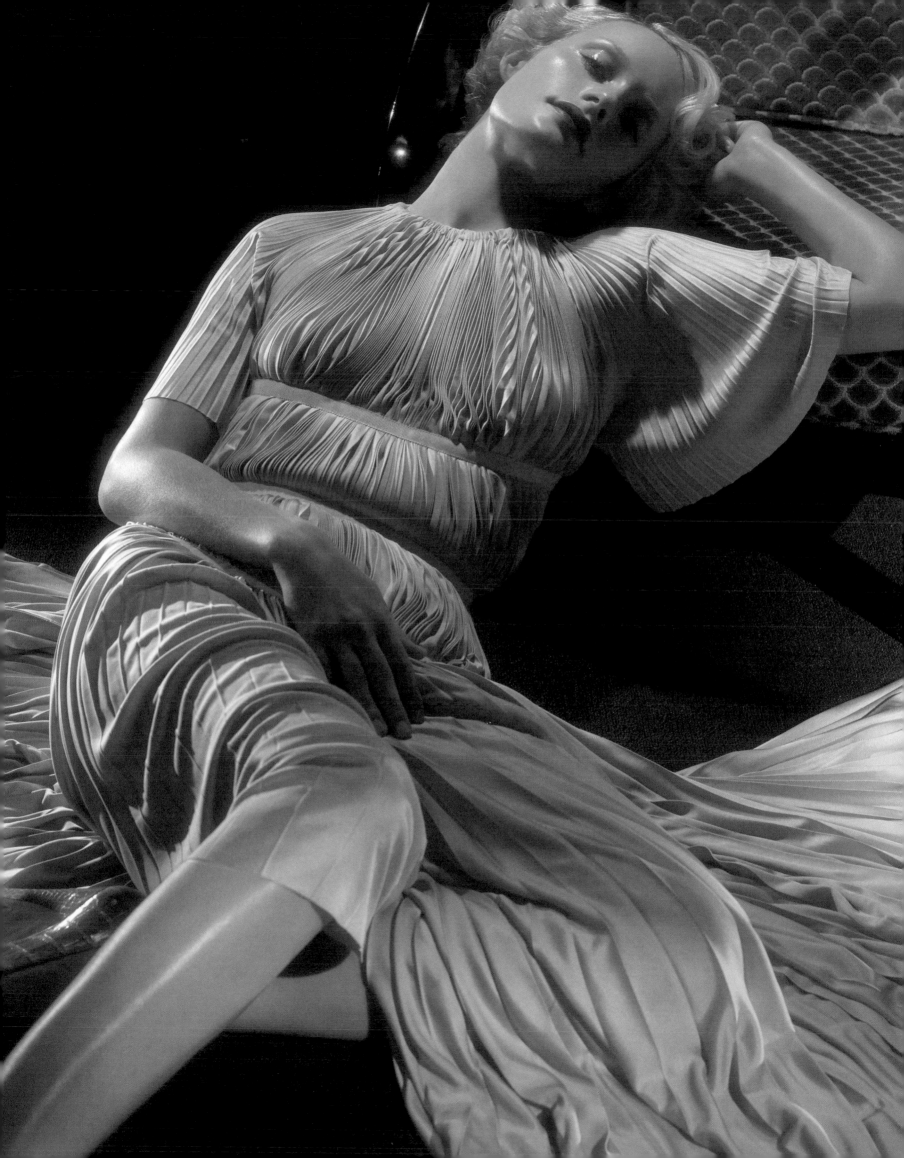

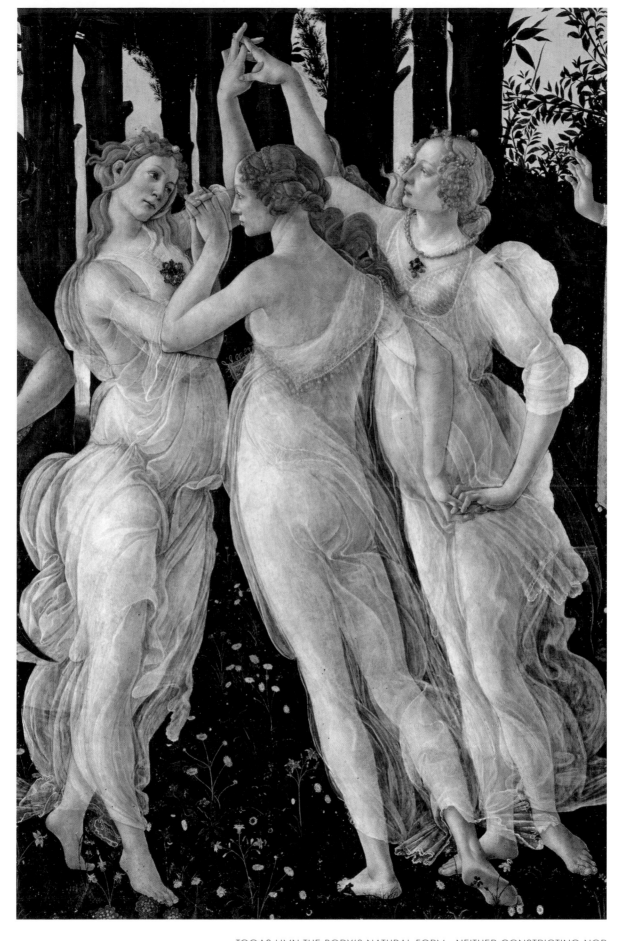

TOGAS LIMN THE BODY'S NATURAL FORM—NEITHER CONSTRICTING NOR
BOLSTERING—AND HAVE BEEN CLAIMED BY FREEDOM-LOVING WOMEN
THROUGH THE CENTURIES (FROM THE REVOLUTIONARY MESDEMOISELLES
OF THE DIRECTOIRE TO DANCER ISADORA DUNCAN). ABOVE: THE THREE
GRACES, BOTTICELLI, C. 1482. LEFT: THE BODICE OF THIS 1984 WATERFALL
DRESS BY ISSEY MIYAKE WAS SOAKED IN A LIQUID POLYMER TO LOOK
CLINGING AND WET, AS IF THE WEARER WERE A WATER NYMPH.

hat is Goddess?" asks Tom Ford. "A goddess is something that we worship. And although you immediately think of classical and Roman dress, of Ingres and of Madame Récamier, a goddess can mean many things. Marilyn Monroe in that white dress standing over the grille in a sidewalk is a goddess. The woman in a Helmut Newton photograph that I love is very goddess to me—she's half-clad, half-undressed. Goddess dressing has been a recurring and enduring thing because it really celebrates the human body."

The Helmut Newton photograph in question (opposite page) appeared on the invitation to the gala opening of "Goddess" at The Costume Institute of The Metropolitan Museum of Art. The exhibition, underwritten by Gucci, celebrates two centuries of perfectly divine clothes. From the thistledown muslin "Roman" gowns of the French Empire to Galliano's bosom-baring Amazonian togas, the dresses on show transcend time and fleeting fashion, reflecting, in the words of the exhibition's curator, Harold Koda, "a classical idea of dress, of clothing that alludes to the natural, unadulterated body."

The 1930s, according to Koda, "were the heyday of goddess dressing." Classicism was all the rage. Society decorator Elsie de Wolfe, seeing the Parthenon for the first time, exclaimed, "My favorite color: beige!" and *Vogue*'s star photographers, among them Horst and Hoyningen-Huene, depicted statuesque beauties like Princess Marina, Duchess of Kent, as latter-day antique sculptures.

Fashion's Praxiteles of the day was Alix Barton, later known simply by her married name, Madame Grès. "For me Madame Grès was really *it,*" says Ford, "the most 'goddess' of all designers." Madame Grès was trained as a sculptor, and her iconic dresses, with their inimitable folds and pleats, were elaborate evocations of simple garments memorialized in stone—the stolas of the Romans, the chitons of ancient Greece. For six decades, their timeless elegance served as a foil to strong-minded style deities from Marlene Dietrich to Jacqueline Kennedy Onassis.

During the Depression, as Koda points out, "it was mostly women designing for women, so the Goddess projected a cool sensuality, not a hot sexuality." Madeleine Vionnet gave Grès a run for her money with her own fluid evening clothes cut on the bias, giving them an elasticity that revealed the body more suggestively than ever before. As Bettina Ballard, *Vogue*'s fashion editor at the time, recalled, these dresses "were so statuesquely beautiful with their asymmetric necklines, their bias cut that revealed a hip and the shadow of a bust but never seemed to cling anywhere, that all I could feel was desire."

Seventy years later, John Galliano—one of the great exponents of contemporary goddess dressing—took inspiration from the superb Vionnet dresses he studied in The Costume Institute. Galliano even plucked up the courage to ask a certain formidable titled British grande dame what she had worn under her own clinging evening dresses when she was a debutante in the thirties. "Nothing—although we had to trim down below!" was her disarming response. Cool as they were, Vionnet's subtle clothes were also undeniably sexy. In the twenties she often showed her dresses à la Isadora Duncan on barefoot models who wore no underwear either.

For Christian Dior's spring 2001 couture, Galliano sent out twentieth-century Amazons in breast-baring silk-jersey draperies. Queen Rania of Jordan ordered a modestly adapted one for a charity gala thrown by Camilla Parker Bowles, but the Nigerian heiress and singer Tinoula Arowolo made an unforgettable entrance at the designer's next Dior show in the runway original, her bosom bared to the Parisian midday sun. The capital hadn't seen anything like it since Napoleon's day, when the notorious Madame Hamelin walked the streets of Paris in her own daring version of antique dress, her breasts fully exposed.

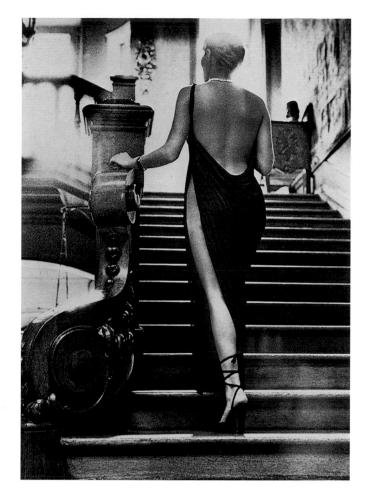

THIS IMAGE BY HELMUT NEWTON, SHOWING A LEGGY 1975 CHLOÉ GODDESS DRESS BY KARL LAGERFELD, APPEARED ON THE INVITATION TO THE COSTUME INSTITUTE GALA IN 2003. THAT NIGHT IN APRIL, SOME 800 GUESTS MOUNTED THE STAIRS TO THE MUSEUM; THE MORNING AFTER, REPORTERS SAID THE PARTY MARKED A PIVOTAL RETURN OF GLAMOUR TO NEW YORK.

In 1790s France, of course, what you wore was more a matter of life and death than personal choice—although if the country's fiery revolutionaries were inspired by the ideals of the ancient Greek democracies and by republican Rome, the fresh-minted beauties of Napoleon's court were probably more turned on to the classics by the recent titivating discoveries at Pompeii. Whatever their motivation, though, the French ruling class certainly invented the idea of liberated modern fashion.

After the scandalous excesses of the French Empire, Victorian prurience kicked in, and women's clothing suffered a backlash, becoming increasingly more elaborate and artificial—the opposite of the classical ideal that glorified the natural body. It wasn't until the eve of World War I that Mariano Fortuny, the artist and inventor, truly liberated women from the restrictions of Victorianism. In about 1907, he created his signature Delphos dress (named for the fourth-century B.C. sculpture *The Charioteer of Delphos*). Fortuny's clothes have proved perhaps the most truly timeless garments created in the twentieth century, as stylish on Belle Époque actress Eleonora Duse and silver-screen 1920s waif Lillian Gish as on socialite designers Gloria Vanderbilt and Tina Chow. Although the secret of Fortuny's miraculous pleats died with him in 1949, their spirit has been revived over the years, most recently in the designs of the hieratic Mary McFadden and of Issey Miyake. Miyake is represented in "Goddess" with his 1984 Waterfall dresses, made from jersey with silicone coated over the torso to imitate clinging, wet drapery, as though the wearer were a nymph emerging from her thermae.

After World War II, a new generation of male couturiers emerged on the scene, and classicism in fashion turned from cool to hot. The Greek-born designer Jean Dessès took his inspiration, in the words of Valentino, who was his protégé in the fifties, from "the classic drapes of the statues of Fidia, which he faithfully reproduced in the finest pleats of his amazing chiffon." Europe's royal ladies couldn't get enough of Dessès, and the Dessès spirit found its way into the Greco-Roman epics that were then stock-in-trade in Hollywood and Cinecittà. Half a century later, Renée Zellweger propelled his name into the limelight once again when she dazzled on the 2001 Oscar red carpet in a statuesque vintage chiffon Dessès gown in canary-yellow.

Valentino left the atelier in 1960 to set up his own couture house in Rome, in the shadow of antiquity. He had absorbed Dessès's teaching but was also dreaming of the movie goddesses he had adored as a young boy, larger-than-life stars like Hedy Lamarr, Lana Turner, and Ava Gardner. "I always have a goddess in mind when I design," Valentino says. "I like big entrances, arrogant attitudes, and women with men at their feet!" The young Valentino didn't have to wait long for a client who fit his brief: In 1961 Elizabeth Taylor made her own big entrance to the *Spartacus* opening wearing his pleated white chiffon gown and looking, as he remembers, "like Pauline Borghese's Bernini sculpture" come to life.

In the sixties, the American designers Galanos and Stavropoulos were both celebrated for classical chiffon draperies that drew on their Greek ancestry. (Nancy Reagan, who certainly understood about image projection, would later choose one-shouldered Galanos gowns—New Age togas—in celestial crystal-splashed white for two of her husband's inaugural festivities, the governorship of California in 1966 and his first presidency in 1980.) In Paris, meanwhile, designers like Paco Rabanne and André Courrèges brought a whole new idea of goddess dressing to the fashion stage, one that looked to the galactic future instead of the past. They were also challenging the way clothes were constructed.

Halston, in the disco seventies, created glamorous clothes in shapes as simple as the antique originals—and these demanded a gym-toned physique beneath. "Goddess dressing was originally based on the assumption of a naturally well-formed body," says

NATURALLY, THE GODDESS LOOK—
ULTIMATE ADORNMENT FOR HEAVENLY
BODIES—IS EMBRACED BY THE
GODDESSES OF GLOSSY MAGAZINES
AND TINSELTOWN. MODEL CHRISTY
TURLINGTON WORE A SILVER SILK
EVENING DRESS BY BILL BLASS WHEN
SHE SHOWED OFF HER YOGA-HONED
PHYSIQUE IN *VOGUE*, OCTOBER 2002.
PHOTOGRAPHED BY STEVEN KLEIN.

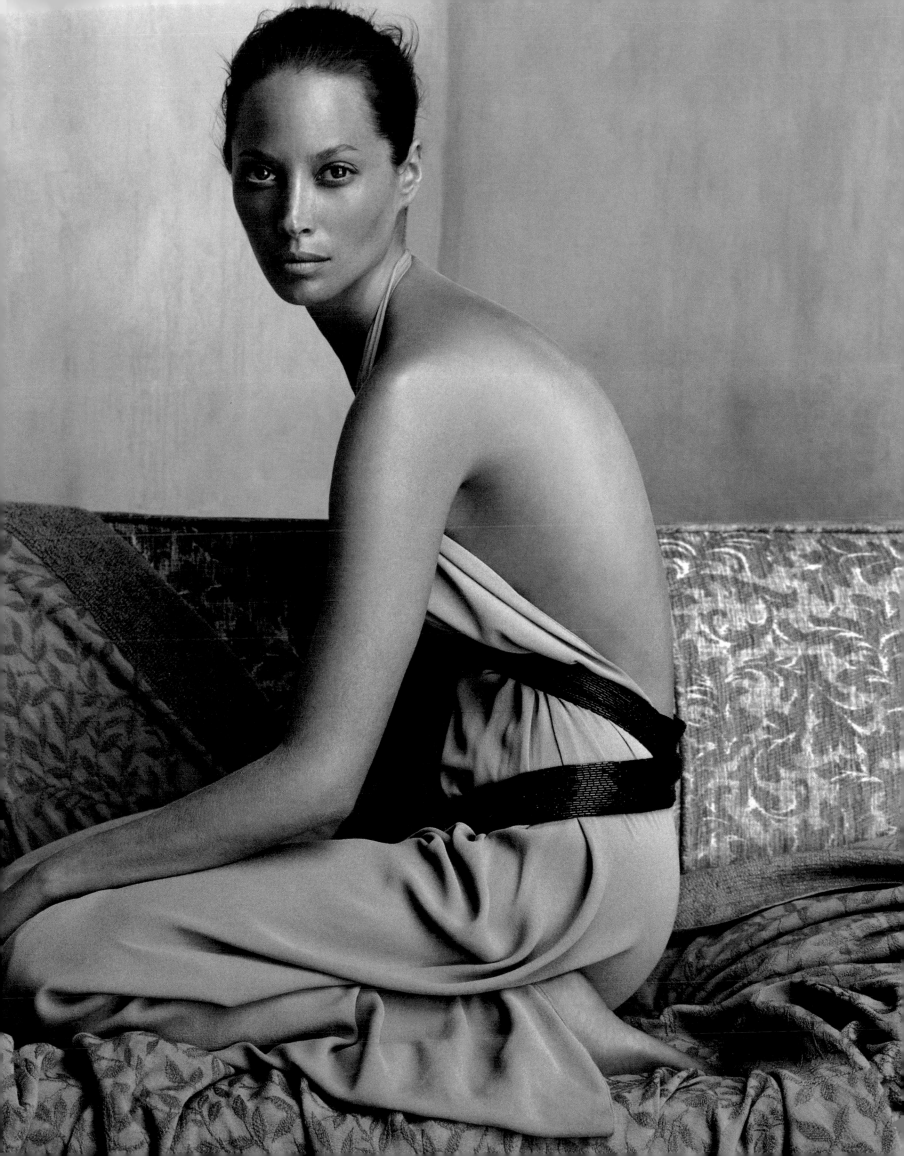

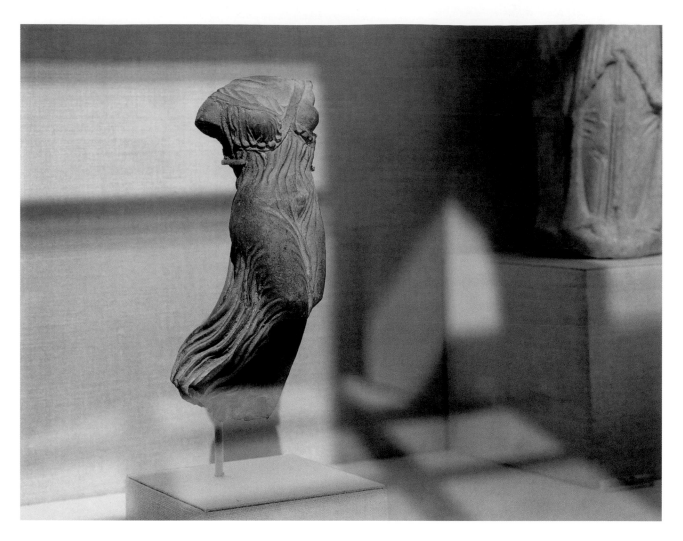

DORIC AND IONIAN PLEATS HAVE BEEN EMULATED TO GREAT ACCLAIM
BY FORTUNY, McFADDEN, ET AL. RIGHT: THE CLASSICAL FORMS OF
THE IONIC CHITON—GIRDLED LOW WITH A BELT, SO THE OVERFOLD
FORMS A PEPLUM—ARE MIRRORED IN A 2002 RED-CARPET DRESS
BY STÉPHANE ROLLAND FOR JEAN-LOUIS SCHERRER IN THE EXHIBITION.
ABOVE: TERRA-COTTA STATUETTE OF NIKE, FIFTH CENTURY, B.C.

Koda. "Later, drapery over a reformative structure [such as a corset] could transform the mortal into a goddess. But the last 20 years or so, it has become more about the transformation of the body itself, through either exercise or intervention. So now the mortal has to transform herself into a goddess!"

By the eighties, this body obsession had given rise to the phenomenon of the supermodel, often dressed in fabulously constructed goddess gowns by Azzedine Alaïa and Gianni Versace. Thierry Mugler's campy taste for fifties biblical epics brought the Dior hourglass back to fashion early in that decade—which in turn appears to have influenced Alexander McQueen's controversial 1997 haute couture collection for Givenchy. For this, McQueen transformed the great atrium of the École des Beaux Arts into a playground for the gods. Reigning male-modeling king Marcus Schenkenberg—a contemporary Icarus complete with vast golden wings—looked down from on high as a parade of arch goddesses dressed in white and gold high-stepped along the runway equipped with centurions' breastplates and gilded ram's-horn helmets. McQueen turned the classics on their head by giving his shapely lovelies corsets, achieving the wasp-waisted figure of Susan Hayward in *Demetrius and the Gladiators* or Deborah Kerr in *Quo Vadis.*

"More recently the opportunity to reveal the naked body has been opened up," Koda says. "Today, clothes can be vestigial parts of a fully draped garment." A case in point: Tom Ford's Yves Saint Laurent Rive Gauche collection, which took the idea of Alaïa's second-skin ribbon dress and slashed away at it, so that style mavens from French *Vogue's* Carine Roitfeld to J.Lo looked like survivors from the wreck of the *Hesperus.*

In another echo of the thirties, women designers today are dreaming of their own ideal goddesses, from Barbra Streisand to Patti Smith, to produce more forgiving garments. Ann Demeulemeester's gravity-defying "falling" toga dress from 1996 could transform any mortal, gym-toned or not, into a deity. "The message I send out," she says, "is that every body is 'holy.'"

"What is a goddess dress?" Donna Karan asks. "It's like taking a piece of fabric and wrapping it around you; it covers you, yet you're exposed. Women are attracted to this way of dressing because women, since Venus, are born to be goddesses."
—HAMISH BOWLES, *VOGUE*, MARCH 2003

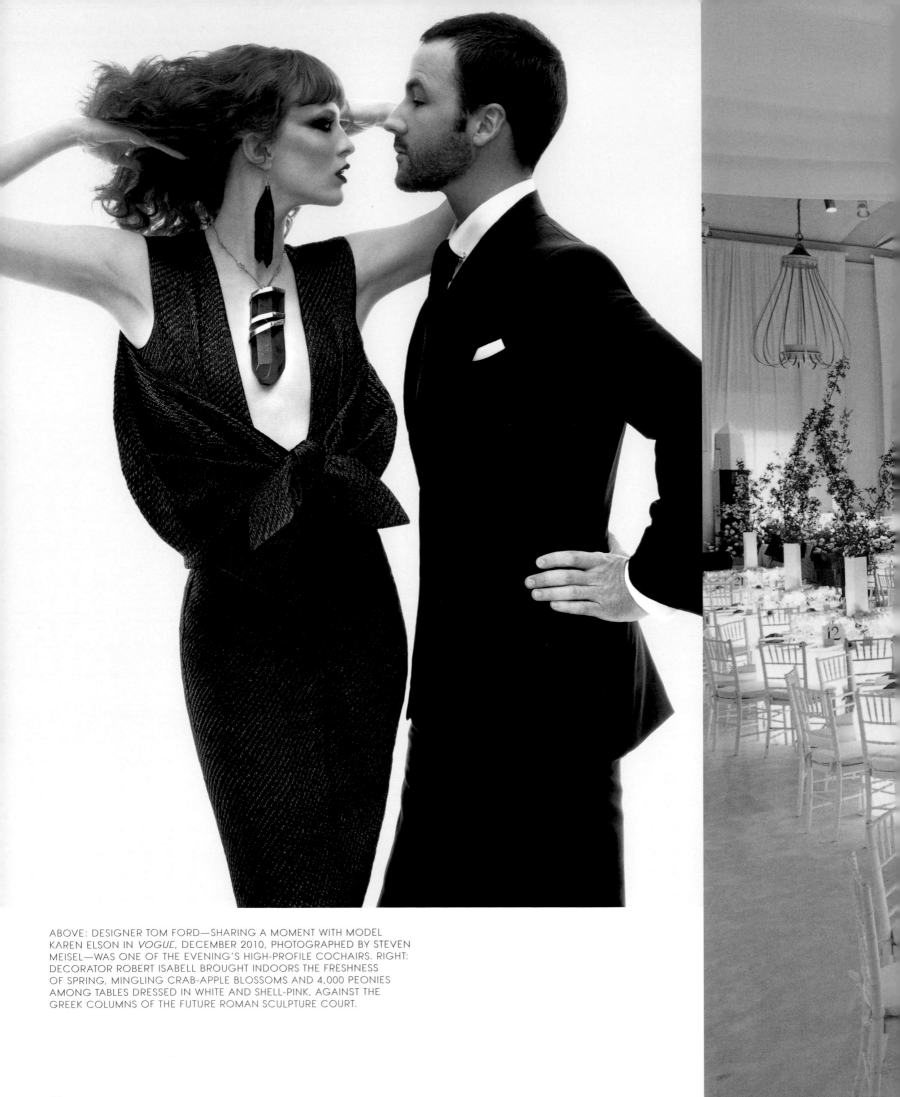

ABOVE: DESIGNER TOM FORD—SHARING A MOMENT WITH MODEL KAREN ELSON IN *VOGUE*, DECEMBER 2010, PHOTOGRAPHED BY STEVEN MEISEL—WAS ONE OF THE EVENING'S HIGH-PROFILE COCHAIRS. RIGHT: DECORATOR ROBERT ISABELL BROUGHT INDOORS THE FRESHNESS OF SPRING, MINGLING CRAB-APPLE BLOSSOMS AND 4,000 PEONIES AMONG TABLES DRESSED IN WHITE AND SHELL-PINK, AGAINST THE GREEK COLUMNS OF THE FUTURE ROMAN SCULPTURE COURT.

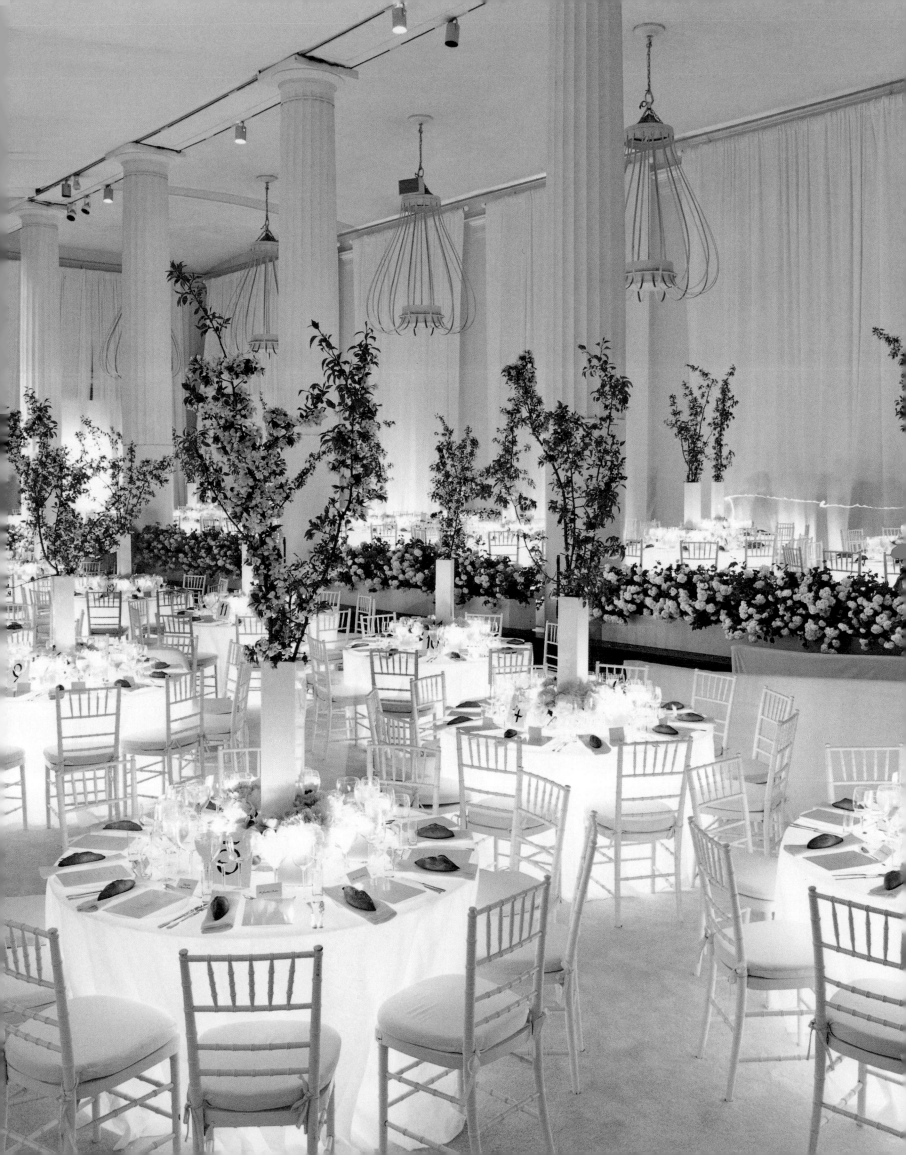

ASYMMETRIC JERSEY MINI
BY JEAN MUIR, C. 1980.

DONNA KARAN: TECHNOGAUZE
AND SILK SATIN, BOTH 2002.

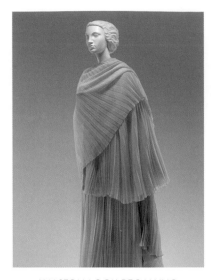

HALSTON LOOK RECALLING
FORTUNY PLEATS, 1974.

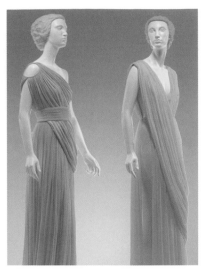

LATE-CAREER GODDESSES BY
MADAME GRÈS, AN ORIGINATOR.

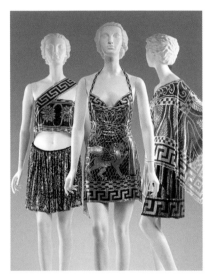

DOUGLAS FERGUSON GREEK-KEY
METAL-MESH PARTY DRESSES, 1985.

EARLY-NINETIES EMANUEL UNGARO,
IN MONOCHROME CHIFFON.

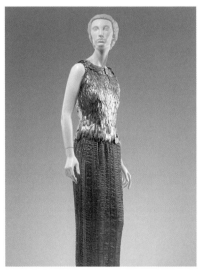

MINERVA DRESS, OSCAR DE LA
RENTA FOR BALMAIN, 2002.

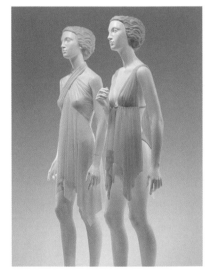

NORMA KAMALI JERSEY DRESS
(1974) AND SWIMSUIT (1989).

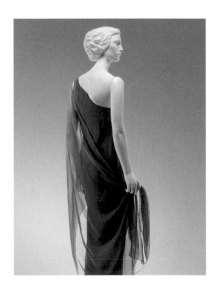

DISCO-ERA HALSTON IN
IRIDESCENT TEAL AND BLACK.

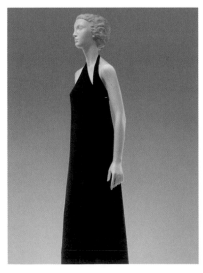

SILK-CHIFFON HALSTON WITH
DRAPED HALTER NECK, 1977.

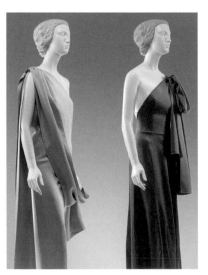

TOGA EFFECTS: BALENCIAGA,
1965; ARMANI, 2002 (RIGHT).

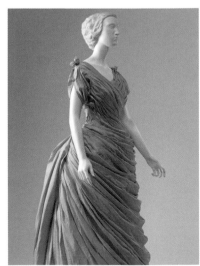

INDIA SILK, 1880s, ATTRIBUTED
TO LIBERTY OF LONDON.

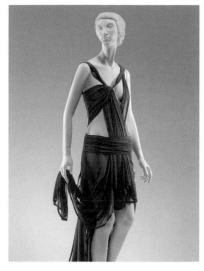

GODDESS UNDRESSED: TOM FORD
FOR SAINT LAURENT, 2002.

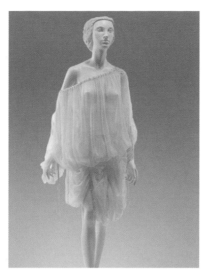

DIAPHANOUS BALLOON DRAPING,
DOLCE & GABBANA, 2003.

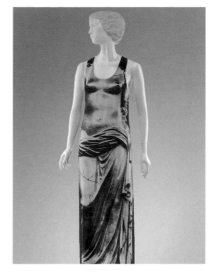

VENUS OF ARLES PHOTO-PRINT
DRESS, GAULTIER, 1999.

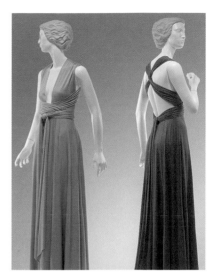

FLOWING SILK-JERSEY PARTY
DRESSES, HALSTON, 1972.

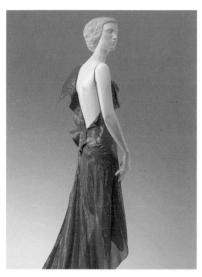

NICOLE KIDMAN'S 2000 DIOR
DRESS BY JOHN GALLIANO.

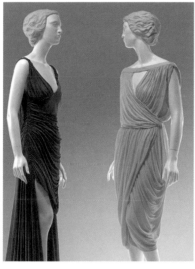

VERSACE FROM C. 1983 (RIGHT);
GUCCI FROM 20 YEARS LATER.

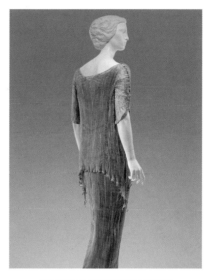

FORTUNY EVENING DRESS
OF PLEATED SILK, 1934.

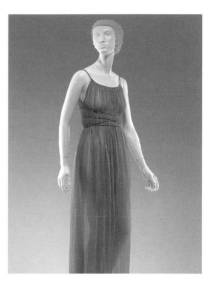

NYLON DRESS BY AMERICAN
GREAT CLAIRE McCARDELL, 1950.

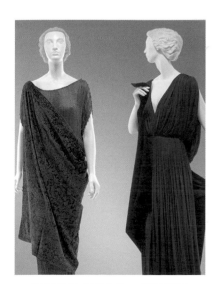

FORTUNY, EARLY 20TH CENTURY;
MADAME GRÈS, 1978 (RIGHT).

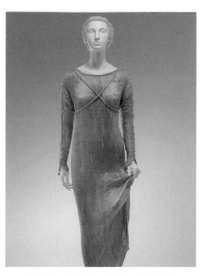

LILLIAN GISH'S GLASS-BEADED
FORTUNY DRESS, 1920s.

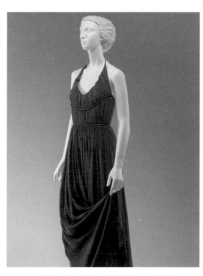

POST–WW II ACETATE-CREPE
DRESS, EDWARD MOLYNEUX.

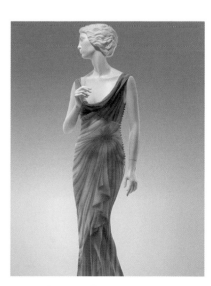

CHRISTIAN DIOR HAUTE COUTURE
BY GALLIANO, 1999.

DANGEROUS LIAISONS
FASHION AND FURNITURE IN THE EIGHTEENTH CENTURY

2004

CURATORS HAROLD KODA AND ANDREW BOLTON CREATED PLAYFUL
VIGNETTES IN THE EXHIBITION THAT EVOKED THE ATMOSPHERE OF
ROMANTIC INTRIGUE AND DECADENT EXCESS THAT PREVAILED IN THE
FRENCH COURT IN THE YEARS PRECEDING THE REVOLUTION. RIGHT:
A NOBLEWOMAN IN THE MUSEUM'S OAK-PANELED ROCOCO ROOM
WORE A LAVISH HAMMERED-SILK ROBE À LA FRANÇAISE (C. 1765)
WHILE PLAYING PEEKABOO BEHIND HER IVORY-AND-PAPER FAN.

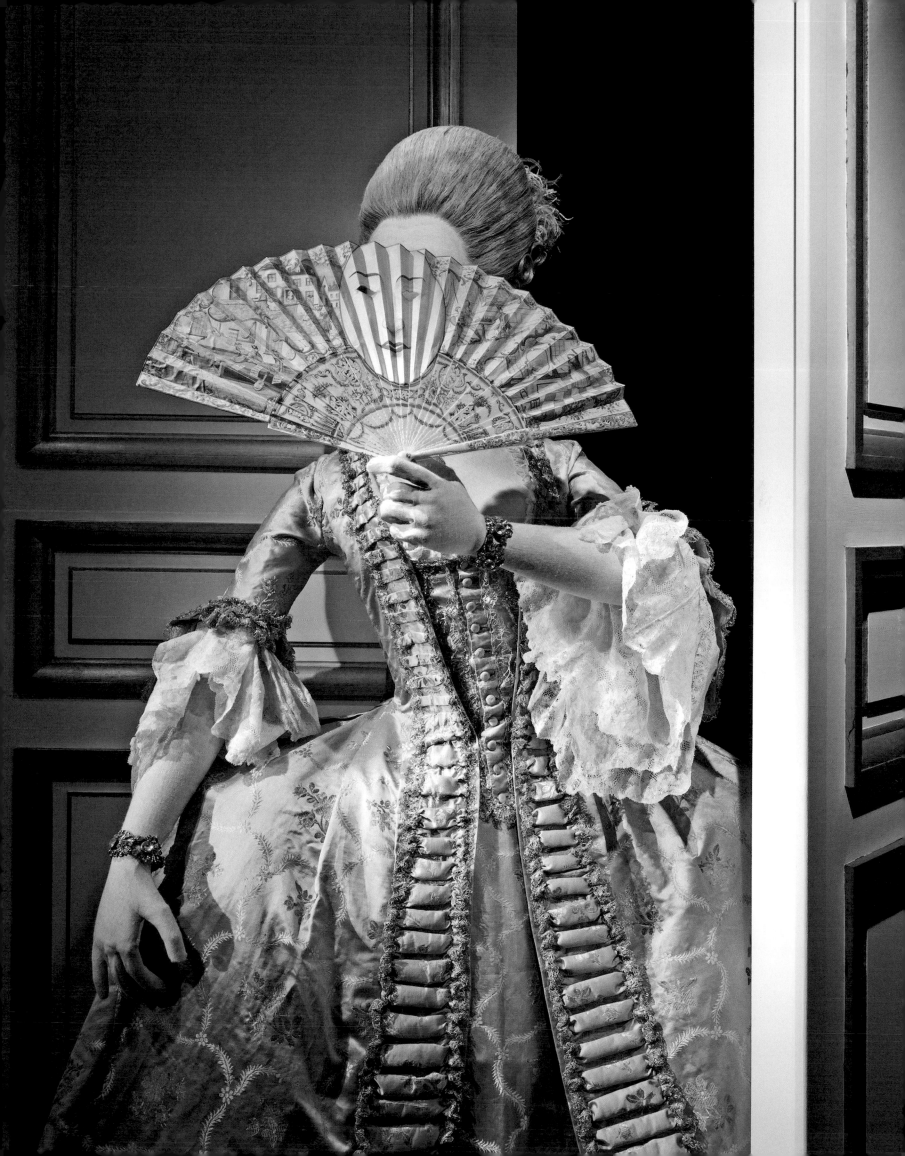

ACCORDING TO KODA, THE SHOW'S CENTRAL CONCEPT
WAS "THE NOTION OF SEDUCTION AS A WAY OF
ENTHRALLING THE VIEWER, AND DRAWING ATTENTION
TO THE RELATIONSHIP BETWEEN FASHION AND
FURNITURE." RIGHT: A LADY IN A ROBE DU MATIN WAS
BEGUILED BY HER HAIRDRESSER. THE MANNEQUINS,
COMMISSIONED BY OPERA DESIGNER AND DIRECTOR
PATRICK KINMONTH FOR THE EXHIBITION, WERE COVERED
IN LINEN AND TOPPED WITH LIFELIKE COIFFURES HAND-
KNOTTED BY MASTER WIGMAKER CAMPBELL YOUNG.

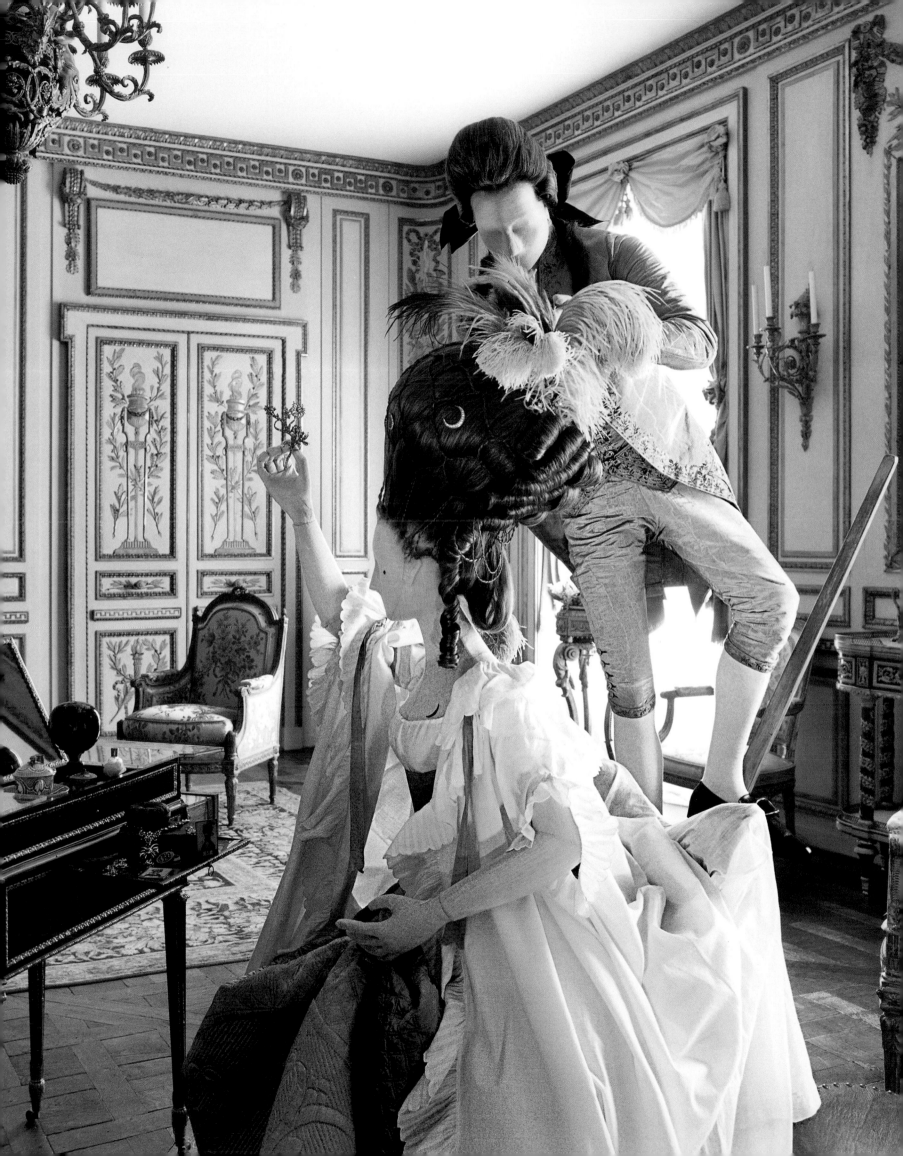

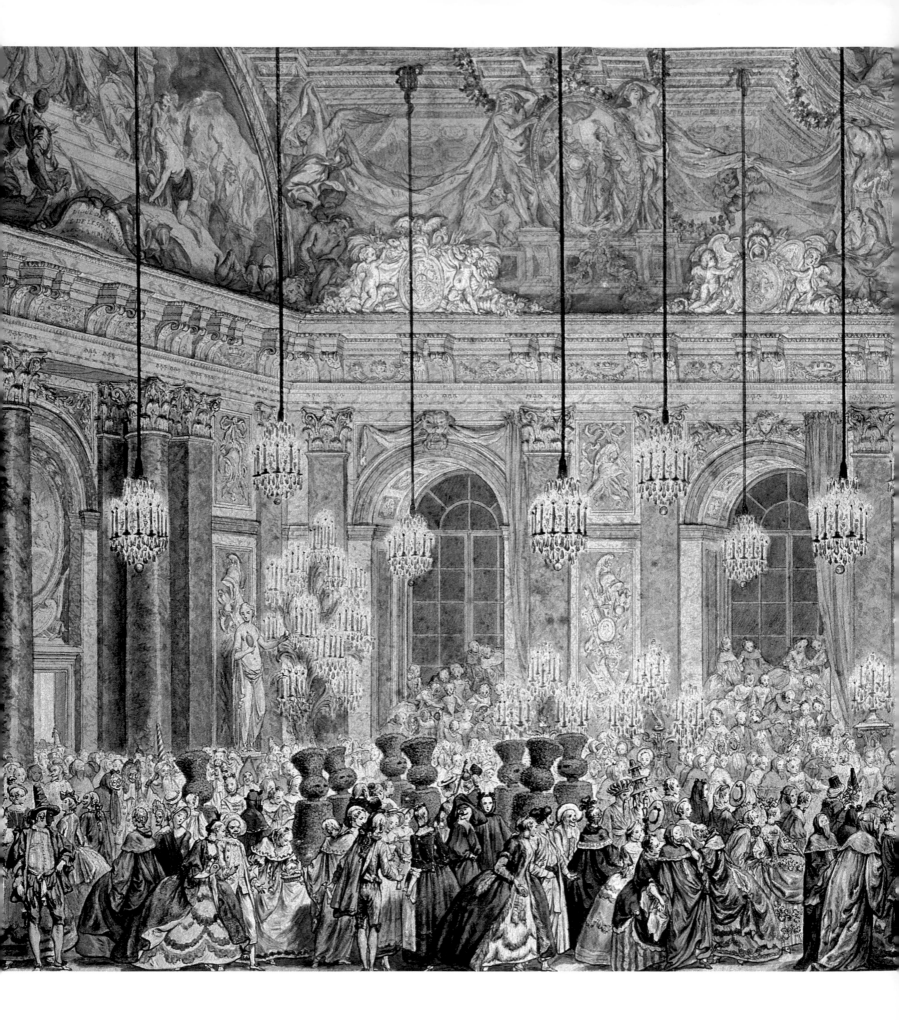

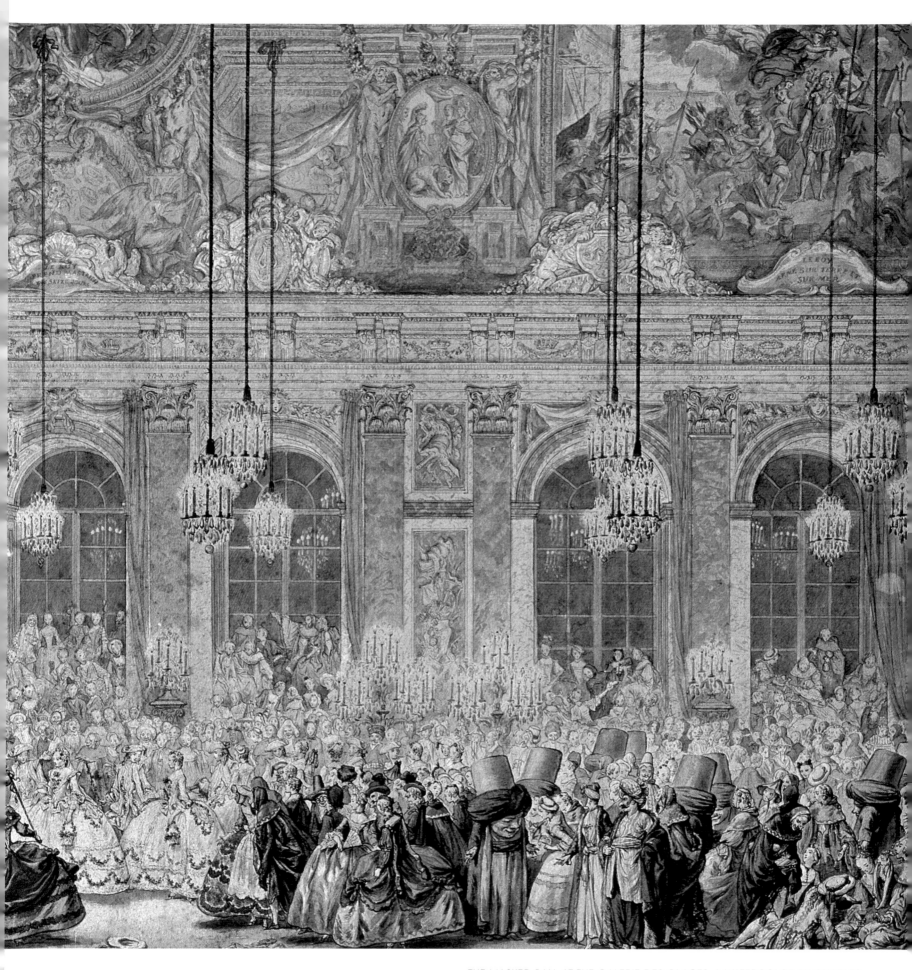

THE MASKED BALL AT THE GALERIE DES GLACES, A WATERCOLOR BY CHARLES-NICOLAS COCHIN II, CAPTURED A 1745 WEDDING CELEBRATION FOR THE FRENCH DAUPHIN AND INFANTA MARIA THERESA OF SPAIN, WAS ONE OF MANY FINE-ART INSPIRATIONS FOR THE EXHIBIT. IN A SOCIETY CONSUMED WITH THE PURSUIT OF PLEASURE, COSTUME PARTIES OFFERED IRRESISTIBLE OPPORTUNITIES FOR LICENTIOUS MISBEHAVIOR WHILE IDENTITY WAS CONCEALED BEHIND A MASK. (LOUIS XV AND HIS ATTENDANTS CAME DRESSED AS THE TOPIARY YEW TREES AT LEFT.)

THE COURT OF LOUIS XVI THRIVED ON
LE SCANDALE. MODEL GISELE BÜNDCHEN
AND GÉRARD DEPARDIEU REENACTED
THE ROLES OF RAVISHED MAIDEN AND
IMPUDENT ADVENTURER AS REPRESENTED IN
FRAGONARD'S 1778 PAINTING *LE VERROU.*
SHE WORE A DRESS BY CHRISTIAN LACROIX
HAUTE COUTURE, PHOTOGRAPHED BY
ANNIE LEIBOVITZ FOR *VOGUE,* MAY 2004.
OVERLEAF: ANOTHER FRENCH ACTOR, LOUIS
GARREL (CENTER), JOINED DEPARDIEU'S
DEBAUCHED SOIREE AROUND THE
HARPSICHORD. LEFT TO RIGHT: KAREN ELSON,
GEMMA WARD, GISELE BÜNDCHEN. THEIR
CLOTHES WERE CHANEL HAUTE COUTURE.

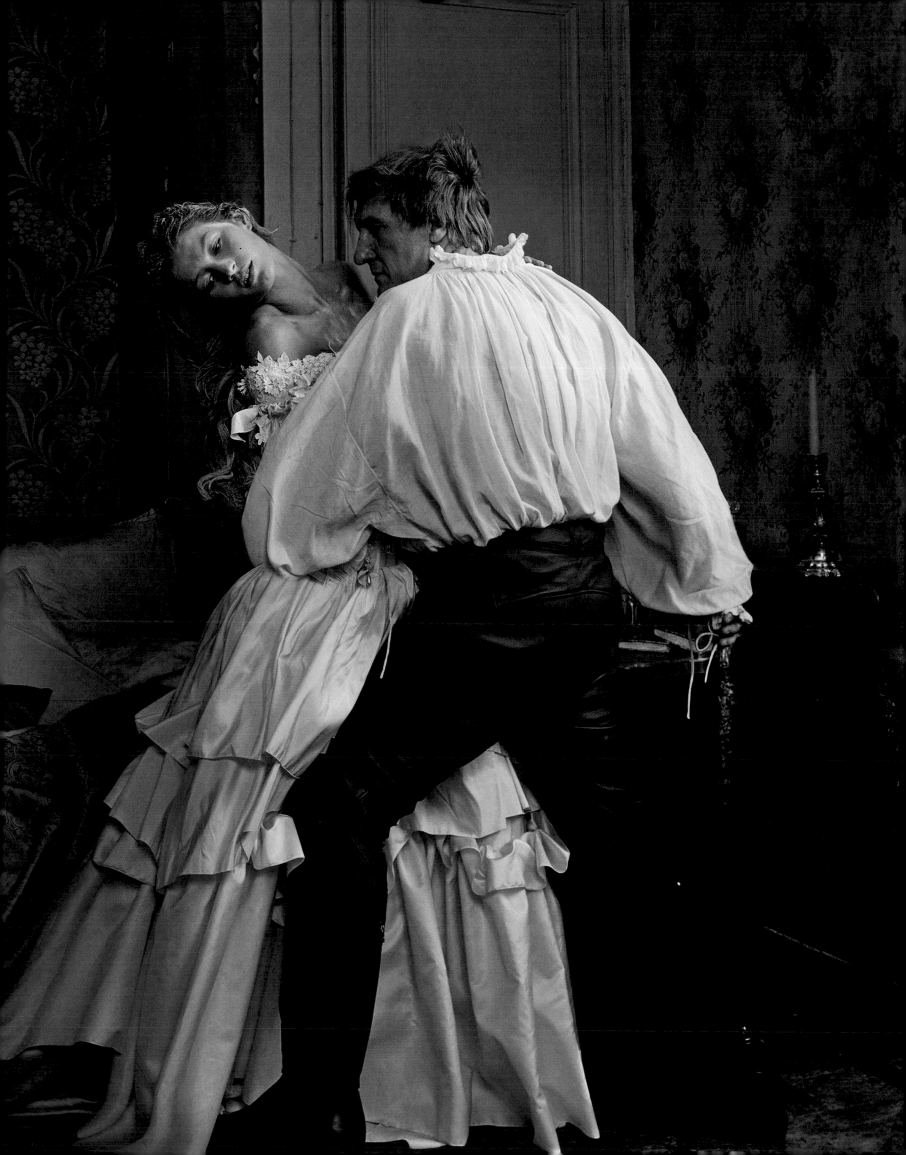

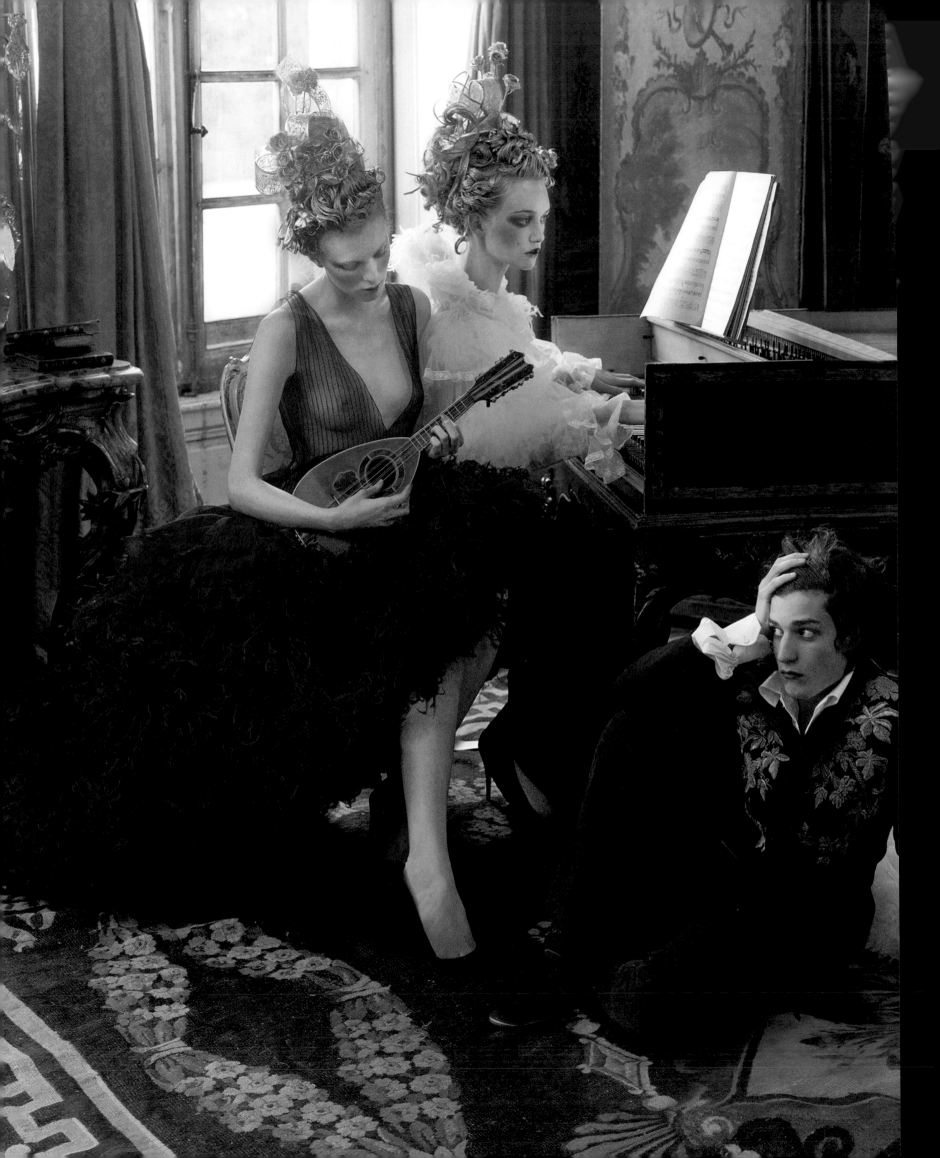

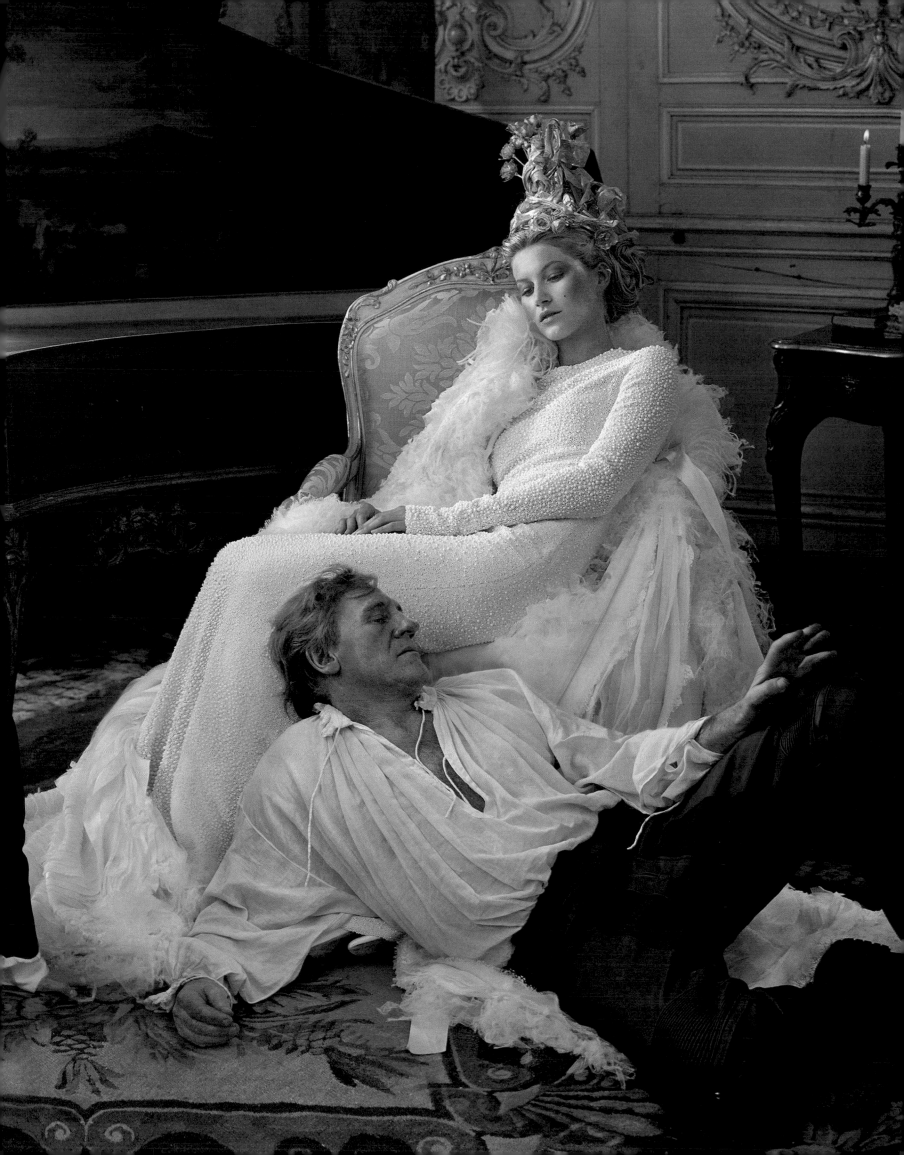

AS IS OFTEN THE CASE, THE 2004 GALA CAPTURED THE ZEITGEIST IN GALVANIZING WAYS. NOT LONG AFTER, KIRSTEN DUNST (RIGHT) BEGAN FILMING SOFIA COPPOLA'S *MARIE ANTOINETTE*, PORTRAYING THE YOUNG QUEEN AS, IN THE WORDS OF *THE NEW YORK TIMES*, "A PARTY GIRL WITH A GAY HAIRDRESSER AND A SHOE FETISH." DUNST APPEARED ON THE COVER OF SEPTEMBER 2006 *VOGUE*, PHOTOGRAPHED BY ANNIE LEIBOVITZ, IN A PINK SILK COSTUME DESIGNED FOR THE SCREEN BY MILENA CANONERO. **OVERLEAF:** THE CAST OF THE FILM, IN FULL REGALIA, IN PARIS. PAGE 66: THE NIGHT OF THE BALL, ZAC POSEN, IN AN 18TH-CENTURY VEST, ESCORTED STELLA SCHNABEL, WHO WORE AN EIDERDOWN DRESS OF HIS DESIGN. PAGE 67: LINDA EVANGELISTA (LEFT) CHOSE JEAN PAUL GAULTIER HAUTE COUTURE, WHILE FELLOW MODEL AMBER VALLETTA PAIRED A MAGGIE NORRIS COUTURE CORSET WITH A JOHN GALLIANO SKIRT.

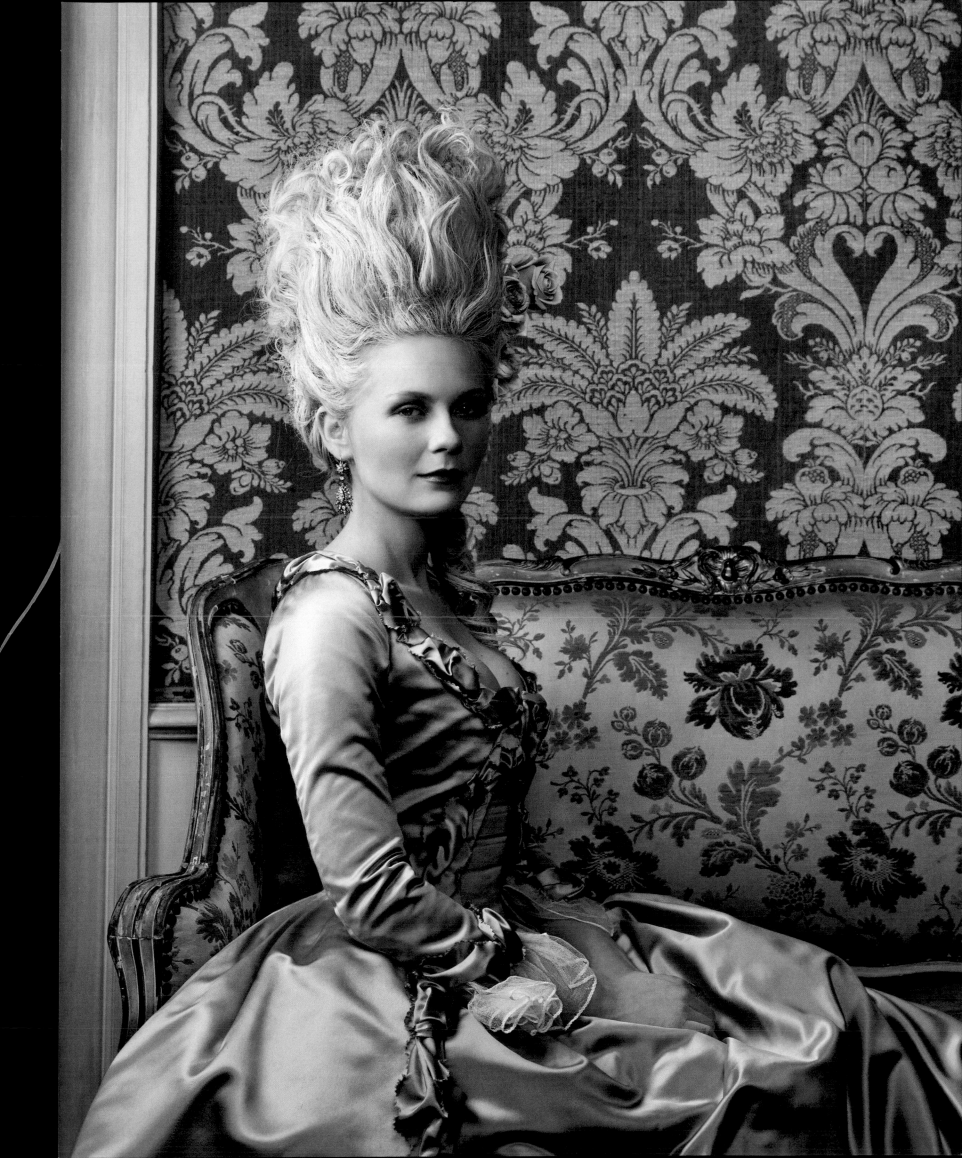

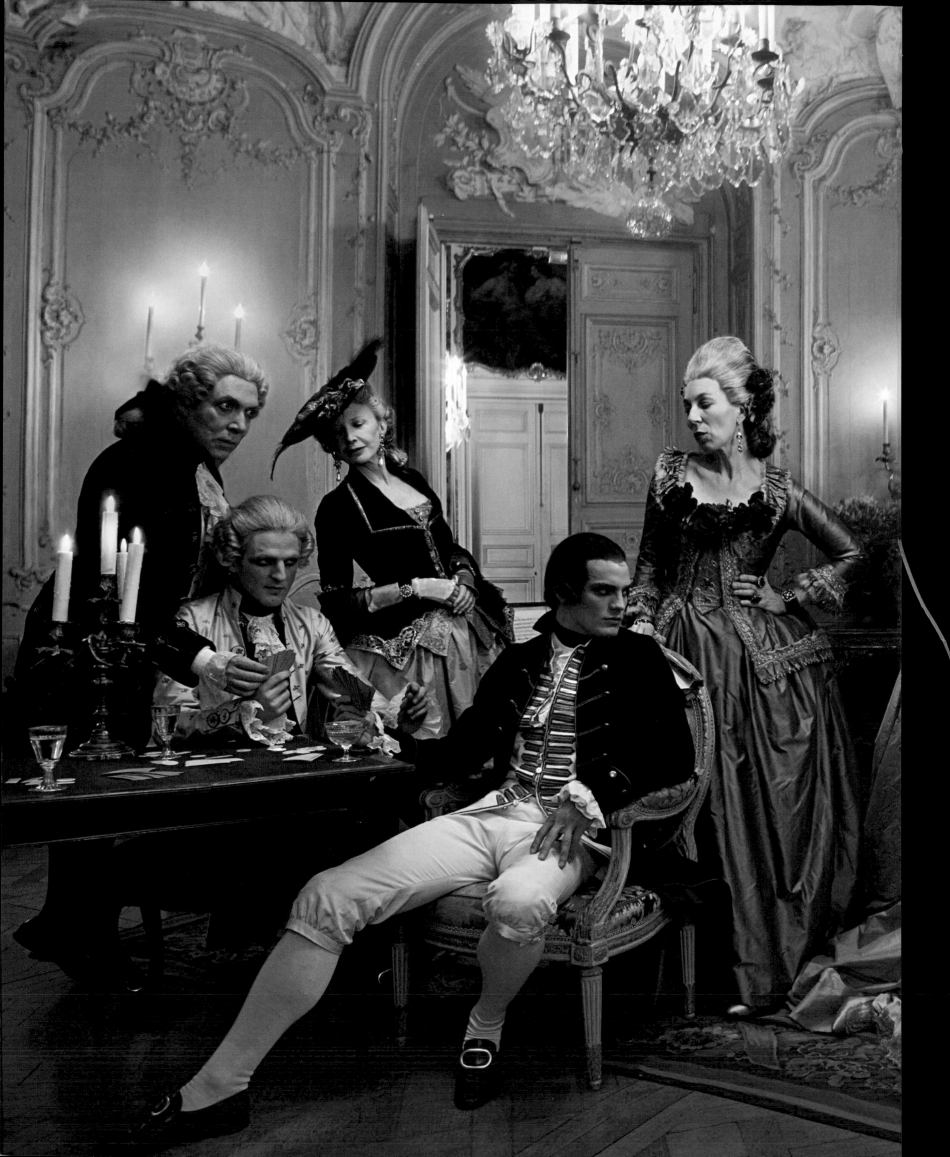

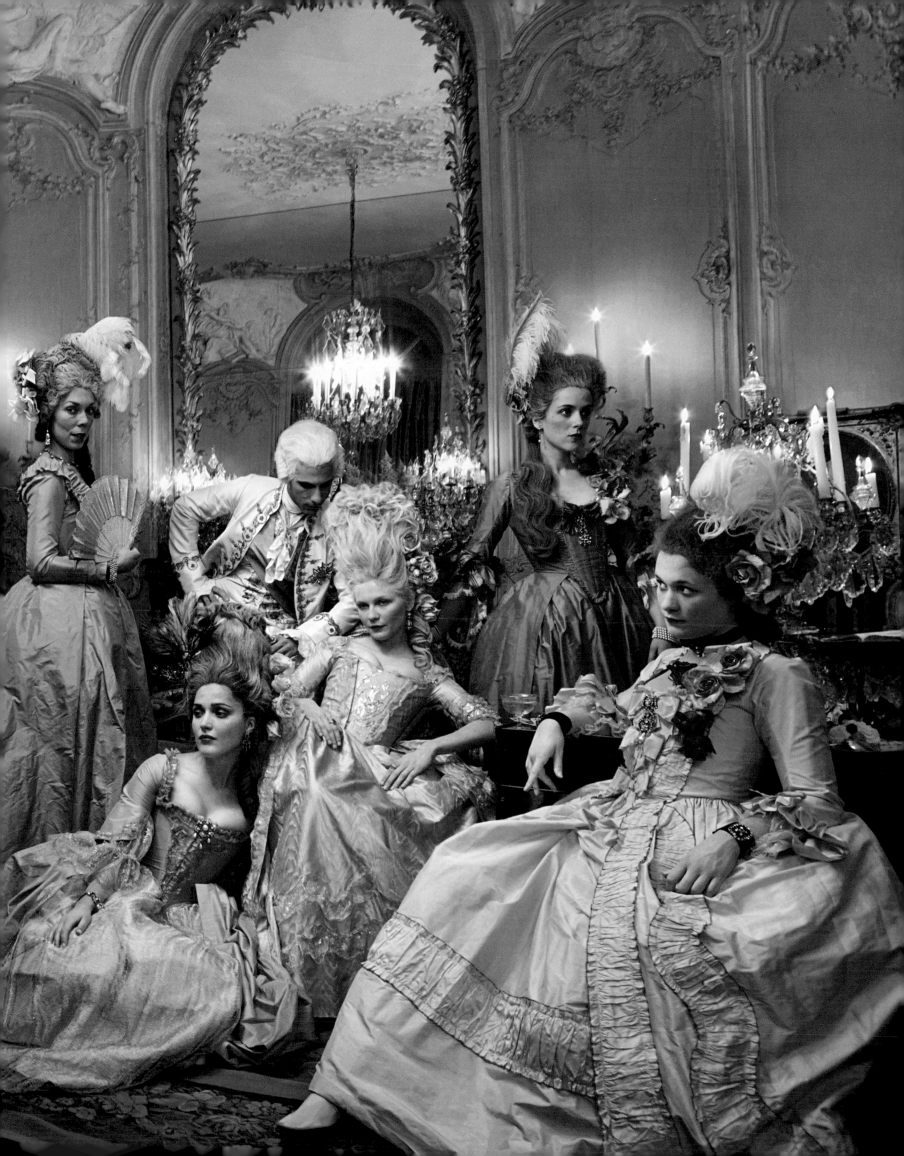

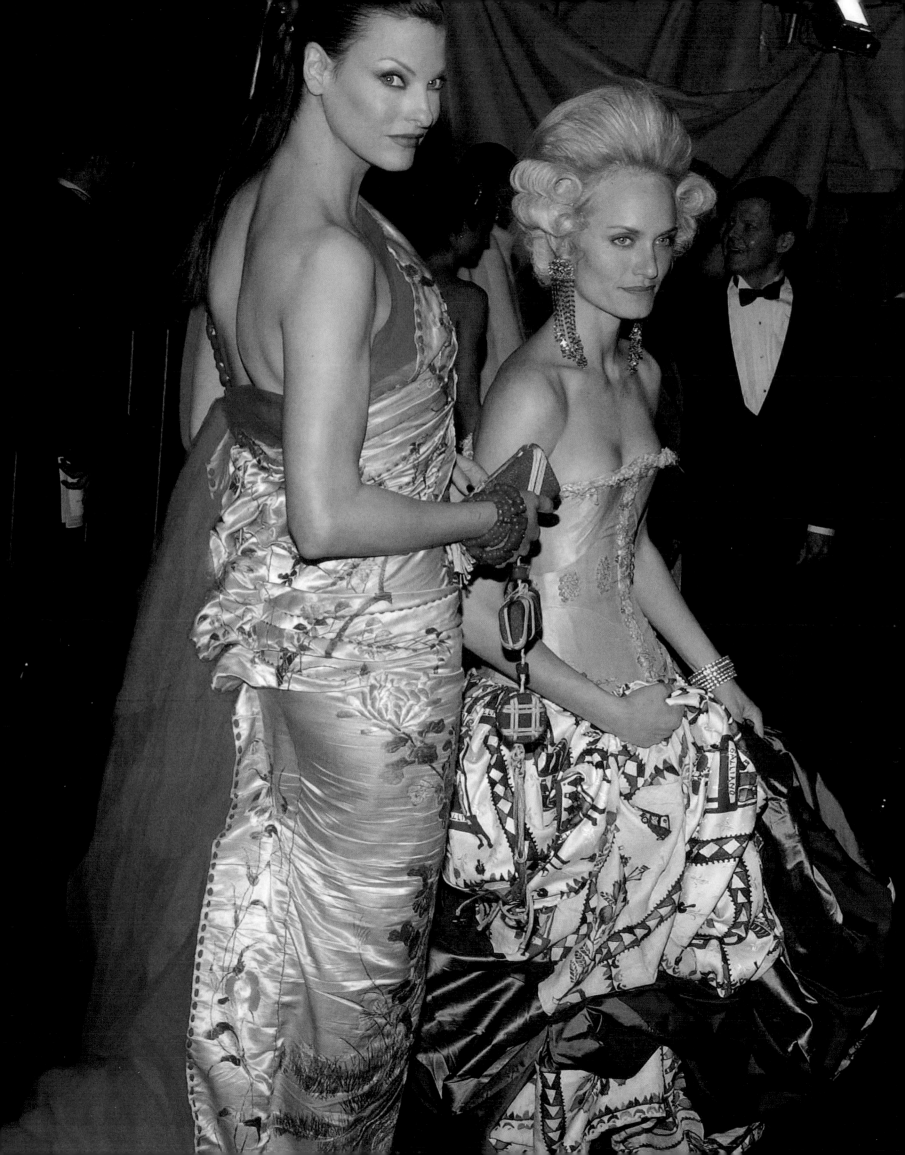

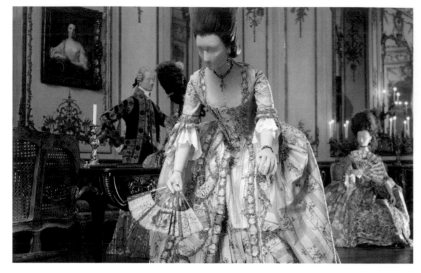

MANNEQUINS IN 18TH-CENTURY CLOTHES PLAYED AT AMOUR AND INTRIGUE.

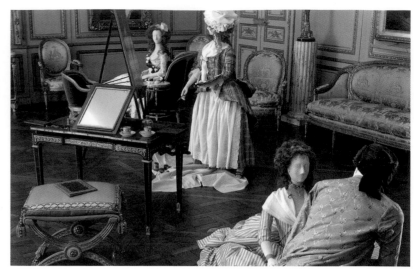

PORTRAIT TIME IN THE CANOPY ROOM OF THE HÔTEL DE TESSÉ, C. 1768–72.

IN THE SALON, A ROBE À L'ANGLAISE OF WHITE COTTON MUSLIN, 1784–87.

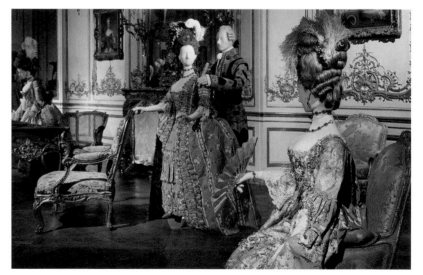

DEEP-PINK SILK BROCADES AMID GILDED FURNISHINGS DATED 1735–99.

CARD PLAYER IN SUIT OF
SILK CANNELÉ, 1778–85.

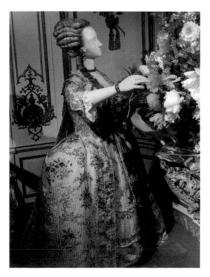

A CHENILLE-TRIMMED ROBE
À LA FRANÇAISE, 1775–79.

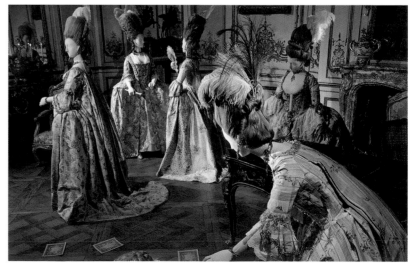

THE SACK BACK, SEEN ON LADIES DRESSED IN THE FRENCH STYLE.

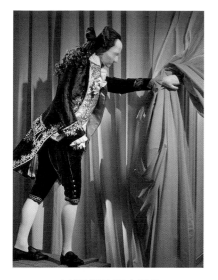

A VOYEUR IN A SILK
VELVET SUIT, 1780–89.

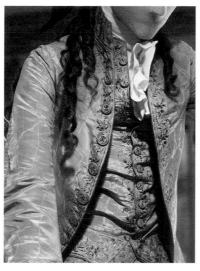

PALE-PINK FAILLE WITH DAINTY
EMBROIDERED SPRAYS, C. 1770.

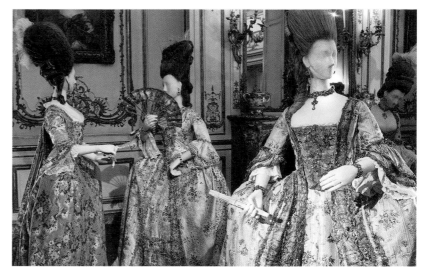

EMBELLISHMENTS: GOLD BOBBIN LACE, SILK BERRIES, PASSEMENTERIE.

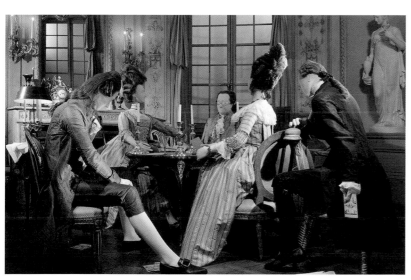

A WELL-DRESSED CHEAT CONCEALED HIS
CARDS IN A GAME OF CAVAGNOLE.

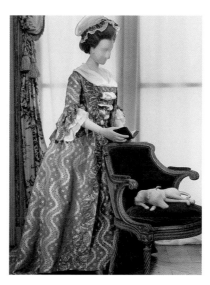

THE CHAPERONE, IN A SLIGHTLY
MORE MUTED FLY-FRINGE DRESS.

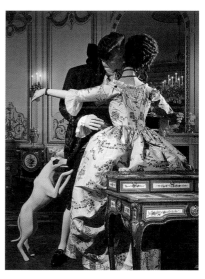

A *MARCHAND MERCIER* EMBRACED
A YOUNG LADY IN CHINESE SILK.

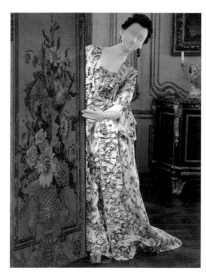

FULL-LENGTH VIEW OF THE
CHINÉ DRESS, C. 1765–75.

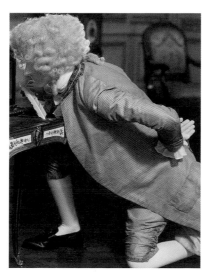

FROM AMERICA, SUIT WITH
SERPENTINE BROCADE, C. 1780.

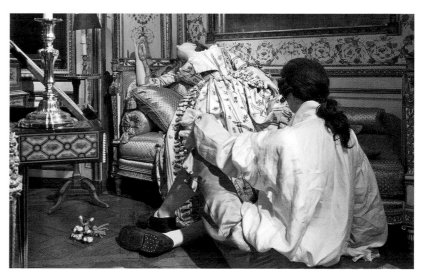

THE VOLUPTUARY AND THE LIBERTINE IN A ROOM
FROM THE HÔTEL DE CRILLON, 1777–80.

CHANEL
2005

THE FIRST BRAID-TRIMMED SUIT WAS INSPIRED IN THE FIFTIES
BY A TYROLEAN JACKET WORN BY THE DESIGNER'S FRIEND
AND ICONOGRAPHER, THE GREAT *VOGUE* PHOTOGRAPHER
HORST P. HORST. HERE, IN THE EXHIBITION, ITERATIONS
BY GABRIELLE CHANEL HERSELF (LEFT, 1963–68; CENTER,
1960; RIGHT, 1964) AND BY HER HEIR AT THE STORIED
MAISON, KARL LAGERFELD (SECOND FROM RIGHT, 1994).

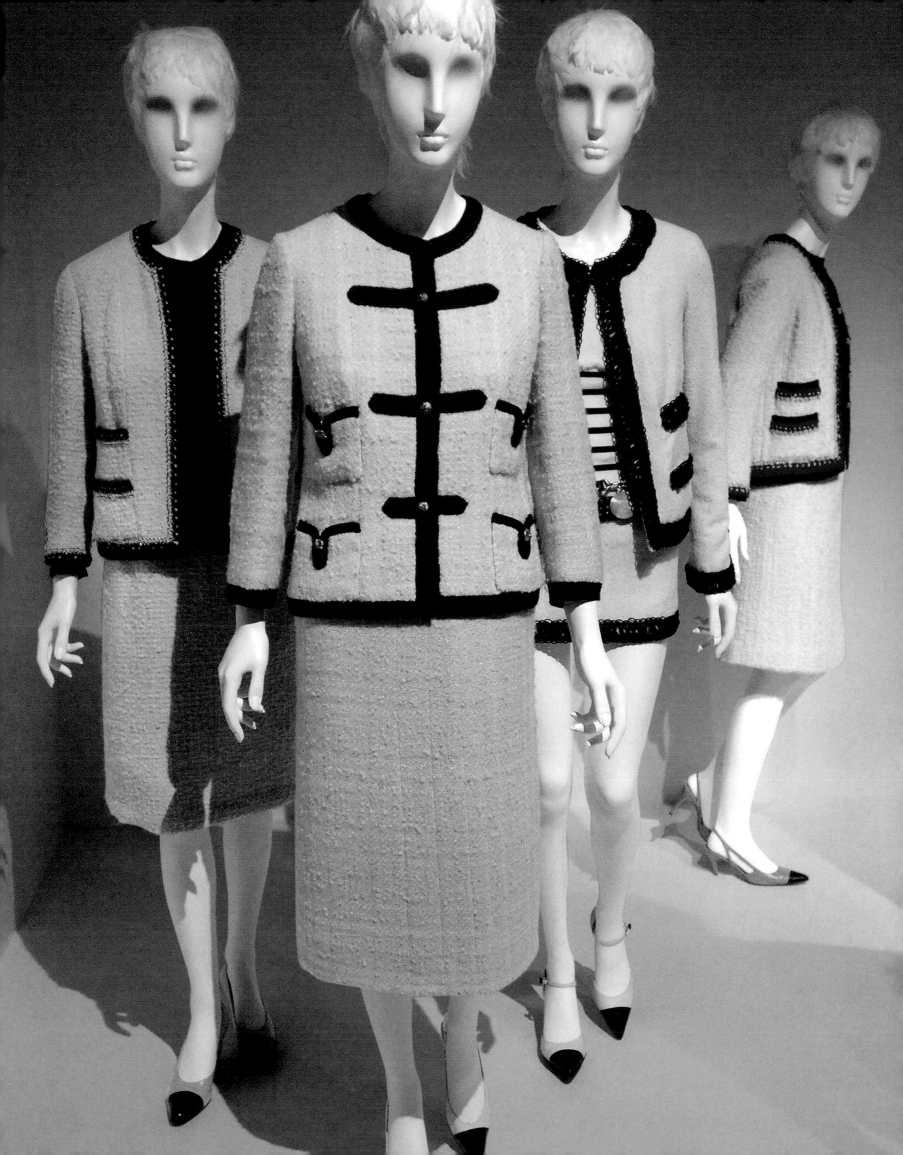

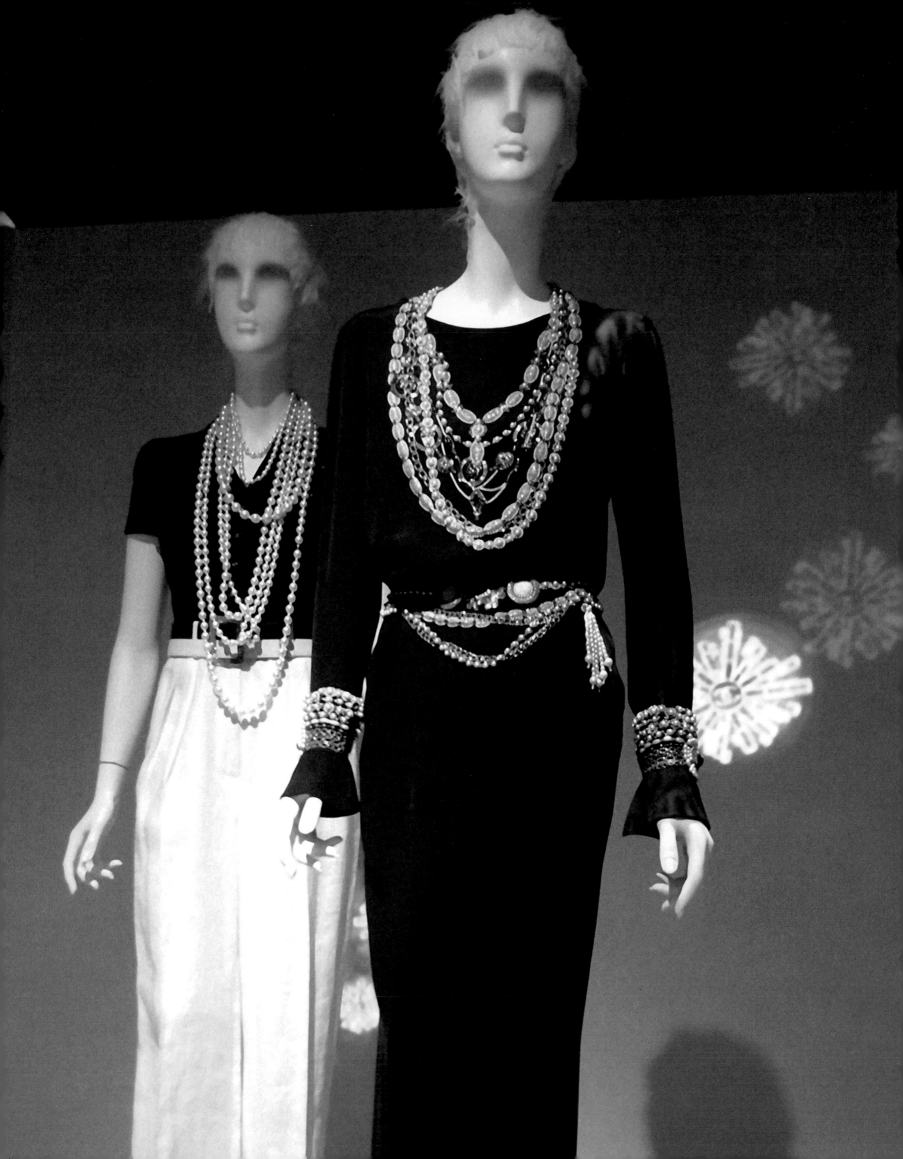

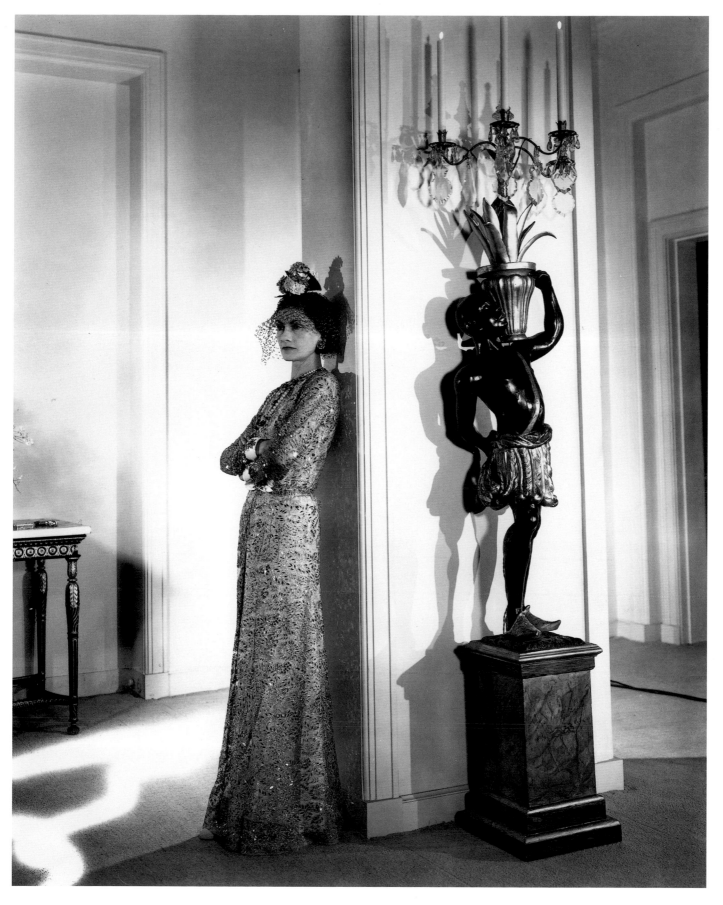

THE ICONOCLASTIC COCO WAS PHOTOGRAPHED IN 1937 BY CECIL
BEATON. LIKE MOST GREAT FEMALE DESIGNERS IN HER WAKE, SHE
CREATED CLOTHING IN HER OWN IMAGE: THINGS SHE WOULD
WEAR HERSELF. OPPOSITE: TWO QUINTESSENTIAL CHANEL LOOKS
IN THE EXHIBITION IN STREAMLINED, SIMPLE BLACK AND WHITE—
BOTH BEDAZZLED WITH BIJOUX (SOME FAUX, SOME TROMPE L'OEIL).
THE ENSEMBLE AT FAR LEFT DATES TO 1995; THE OTHER, TO 1983.

I made fashion simply because I was the first to live in harmony with the century," declared Gabrielle Chanel.

Chanel's work and legacy is celebrated by The Costume Institute of The Metropolitan Museum of Art in "Chanel." In this rigorously edited show, curator Harold Koda reveals "the modernity of the early pieces and the historical acuity of the later history," when Karl Lagerfeld amplified the house's signature gestures with his own subversive wit.

The legendary Chanel was "a character of ice and fire," as her friend writer Paul Morand noted, but during her lifetime she remained "barricaded behind her secrets," as the frustrated biographer Edmonde Charles-Roux (French *Vogue*'s editor in chief in the fifties and sixties) complained. The reality that Chanel worked so hard to conceal is the stuff of legend. She was born out of wedlock to a hapless peddler and a mother who came from landless peasant stock; they eked out a meager living gathering chestnuts in the Auvergne. Chanel's mother, worn out by her hard life, died barely into her 30s, and her roguish father disappeared soon after, leaving an eleven-year-old Chanel and her sisters, Julia-Berthe and Antoinette, to the tender mercies of the provincial orphanage in the Cistercian convent of Aubazine.

Whatever privations Chanel might have lived through at austere Aubazine, the experience and the place came to define her aesthetic; "Chanel demonstrated that nothing was more chic than fine linen, navy-blue serge, and lots of soap," noted Cecil Beaton.

When success brought her the means to create a holiday house fit for a duke—La Pausa in Roquebrunne—she re-created Aubazine's echoing beige stone corridors and arched cloisters. Aubazine's pebbled stone floors were mapped with the stars and constellations that she would recall in diamonds or spangle across tulle evening gowns. Her boutiques and even her product packaging would reflect the convent's dramatic bold black trim on white walls. And the interlocking arcs of the abbey's stained-glass windows are evoked in Chanel's trademark linked *C*s.

When they were too old for Aubazine, the Chanel girls were transferred to an institution at Moulins, a nearby garrison town. Here, to distinguish them from the fee-paying girls, charity cases like the Chanels wore poor little shiny black wool-and-cotton dresses for summer, Scottish tweeds in the winter. "Her revenge was to put all women in a uniform," said her friend the psychoanalyst Claude Delay-Tubiana.

The nuns put Chanel to work at a local haberdashery store. Although not a classical beauty, she was already making the most of her blunt looks—"wide faced, with a snorting nose, just like a little bull," as Diana Vreeland recalled. Chanel later tried her luck as a singer, belting out the two songs in her repertoire—"Qui qu'a vu Coco" and "Ko Ko Ri Ko," from whence her nickname Coco derives. But this career was doomed, and it was the worldly Étienne Balsan, member of the dashing Tenth Cavalry Regiment stationed at Moulins, who provided her with the longed-for escape route from rural drudgery—and eventually helped set her up as a milliner.

From the beginning of her career Chanel understood the power of celebrity, and her hats were soon to be seen crowning fashionable courtesans and actresses. Her assured hand could already be detected in those bold, simple creations that were a foil to the dressmakers' Belle Époque froth.

In 1913 Chanel extended her fledgling empire when she set up a millinery shop in fashionable Deauville, with money supplied by Boy Capel, the handsome, mustachioed, and doomed English polo-playing sportsman who had supplanted Balsan in Chanel's affections and was to remain the love of her life. But she was "not only an innovator," as Carmel Snow wrote, she was "her own best

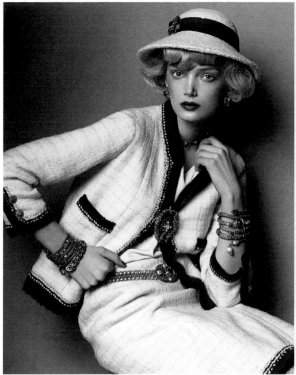
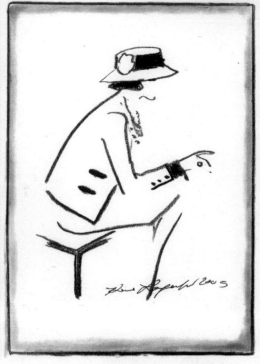

LAGERFELD'S BRISK LITTLE PENCIL SKETCH OF THE HOUSE'S FOUNDER
APPEARED ON THE INVITATION TO THE GALA. IN A FEW STROKES, IT CAPTURED
THE JAUNTINESS OF THE PERENNIALLY INFLUENTIAL BOXY AND ABBREVIATED
CHANEL SUIT. ABOVE LEFT: BRILLIANT FAKE JEWELS BY GOOSSENS ACCENTED
A 1964 VERSION (PHOTOGRAPHED BY STEVEN MEISEL, *VOGUE*, MAY 2005).

model," and before long it was the consummately simple garments that Chanel made for herself that were attracting as much attention as the hats. "By stripping her wardrobe of every embellishment," noted Charles-Roux, "she hoped to escape the reputation she most dreaded; that of kept woman." Chanel's emancipated clothes were revolutionary in their use of jersey—until then, a material that had only been used for gentlemen's unmentionable undergarments. This humble fabric allowed, above all, for a freedom of movement that was little short of revolutionary. "If you don't have clothes you can travel in, you're crippled," Chanel told Charles-Roux, "and if you can't travel you can't live."

In their simplicity, Chanel's clothes were ciphers; it was her attitude that defined her style. "As a dress designer, she was virtually nihilistic," wrote Beaton, "for behind her clothes was an implied but unexpressed philosophy; the clothes do not really matter at all, it is the way you look that counts." For Koda, Chanel's design legacy is "the way she dealt with the body. Through periods of incredible high style—the hobble skirts of Poiret, the padded bosoms and wasp waist of Dior, or the architectonic silhouette of the sixties—she was aware of the Zeitgeist, but no matter what she does to acknowledge her time, what she prizes above all is the luxury of comfort; there is never a body exaggeration. Her work doesn't redefine or mask the natural contours."

The Chanel clothes that exist from the teens and twenties—and they are few and far between, as they were often worn until they fell apart—are indeed astonishing in their modernity. "I freed the body," she said, so even richly embroidered or lace dresses are cut as simply as T-shirts or singlets to slip on over the head.

Not everyone was a fan. The great designer Paul Poiret, famed for his Ballets Russes–like extravaganzas, railed against the perversity of Chanel's "poverty de luxe." "Scheherazade is very easy," sniffed Chanel in return. "A little black dress is very difficult."

Unlike her fellow couturiers, who relentlessly documented and patented their creations against the plagiarists, Chanel gloried in being copied: "Fashion does not exist unless it goes down into the streets—without imitation there is no success." She had no sentimentality about her work—or life. She kept no records, no archives, no documents. "Les trouvailles sont faîtes pour être perdues [discoveries are made to be lost]," she said.

By the thirties, Chanel's once-streamlined clothes were reflecting the neo-romanticism of fashionable artists such as Pavel Tchelitchev and Christian Bérard. With their chiffon, lace, and tulle ruffles and furbelows they recall the elaborate tenues of the orchidaceous Edwardian courtesans who were Chanel's first models, or the creatures from the saccharine romance novellas of Pierre Decourcelle that were her escapist entertainment during her harsh childhood.

Chanel's clothes were a palimpsest of her life, friends, and lovers; she was a brilliant appropriator. As a young kept woman she distinguished herself from the elaborately dressed courtesans of the day by borrowing clothes—overcoats, tweedy jackets, boaters—from her male friends. But even in this gesture can be seen the "elements of coquettishness or seduction" that Koda detects throughout her oeuvre. "She was a very sensuous woman," remembers designer Jackie Rogers, a favorite Chanel mannequin in the early sixties. "The way she made a skirt was supposed to be very sexy. It was stitched and welted inside in the middle so it grabbed our legs and rounded about our thighs. . . . " The iconic suit (which appeared in its most recognizable form some years after her 1954 comeback) takes its boxy form and contrast braiding from a Tyrolean jacket of her friend the photographer Horst. From her lover Grand Duke Dmitri Pavlovich, nephew of the czar, she developed a taste for luxury on a prerevolutionary scale, for sable and golden tissue and Slavic embroidery. From the Duke of Westminster and his English set she "copied the clean turnout of Eton boys and the men at

shoots," noted Vreeland. Chanel's iconic 1955 quilted bag was adapted from a design by Germaine Guerin. The famous cuffs with the Maltese crosses and the Byzantine jewels that became her trademark were concocted for her by the Sicilian aristocrat Fulco di Verdura; the constellation diamonds that she launched in 1932 were sketched by her lover Paul Iribe (who was once, ironically, a protégé of Poiret's). Even her fabled interiors—havens of luxury with their inviting tobacco suede upholstery, firelight catching the glint of bronze, gilding, mirror, and rock crystal, and her famous Coromandel screens—reflected appropriated taste: that of her mentors the celebrated muralist José-Maria Sert and his wife, the artists' muse and sharp-tongued observer of the social world, Misia. It was her intimate friendship with Misia Sert that opened up the cultural world of Cocteau and Diaghilev and Picasso—and Stravinsky (who would become another pearl in Chanel's necklace of romantic conquests)—and that gave further impact and nuance to her work. Of course, these myriad influences would have meant nothing without Chanel's natural alchemical talents—and the instincts that led her in 1921 to choose formula number 5 from the selection presented to her by the perfumer Ernest Beaux.

At the outbreak of World War II, Chanel showed a patriotic collection of red, white, and blue clothes—and then promptly closed up shop. After the war, she watched in horror as a new generation of the homosexual designers she reviled—Dior and Fath now among them—inflicted what she saw as a torturing vision on fashionable womankind.

By 1954 she could take it no more, and at the age of 70 she reopened her house, taking up exactly where she had left off and showing dusty replicas of the sort of clothes she had championed in the thirties. The European press savaged her; Chanel's famed instinct for timing seemed to have failed her. However, American *Vogue's* influential fashion editor Bettina Ballard noted, "I had missed comfortable, reliably young clothes like this, and was sure that other women would want them, too, if they saw them." Ballard promoted Chanel to the all-important American store buyers, and by her next collection, *Life* declared that "Chanel is bringing in more than style—a revolution."

Chanel's influence was soon pervasive—her clothes offered a relaxed, real-life alternative to the exaggerations of the contemporary couture. "Always dress to make yourself feel young," Chanel told Ballard. "This means being free and easy and unpretentious in your clothes." Chanel's stable of adoring and long-suffering acolytes now included Suzy Parker and actresses Anouk Aimée, Romy Schneider, and Jeanne Moreau. The role came at a price. Moreau remembered her as "a tyrannical woman but a real craftsman; I still bear the traces of the pins she stabbed me with!"

Chanel's approach was thoroughly hands-on; unable to sketch, she modeled her clothes on living mannequins—often for hours on end. She constantly destroyed to achieve perfection. "She falls to her knees in front of her work and grasps it firmly," said Colette of Chanel's process, "not to worship it, but to punish it a little more." Evening dresses had to end above the floor (any longer she considered slovenly), but armholes were her particular bête noire. "It's a subtle thing," says Jackie Rogers, "but those high, tight armholes were cut to grab and show a woman's bosom." Suzy Parker recalled how Chanel tore a prized Givenchy velvet jacket from her back and ripped the arm off in front of the designer himself, railing about its inadequacies of construction. Cecil Beaton noted that Chanel's "large-boned, eloquently articulated hands are so accustomed to plying material that even when she is talking at lunch she is pleating the table napkin."

Chanel died in 1971 in the middle of preparations for her spring collection.

For more than a decade after Chanel's death, the house languished, with a reverent design team producing couture clothes—and introducing ready-to-wear for the first time—in Mademoiselle's dowdiest image. This all changed in 1982, when owner Alain Wertheimer (whose grandfather and great-uncle acquired the rights to Parfums Chanel in 1924, and, later, the world of Chanel in 1954) finally persuaded Karl Lagerfeld to assume the mantle. Lagerfeld had trained chez Balmain in the glory years of the haute couture and was later the designer at the house that bore the name of Chanel's hated rival Jean Patou (and whose workrooms still guarded the secrets of antebellum dressmaking). But it was his work for the ready-to-wear house of Chloé that sealed his reputation; with a Chanel-ish instinct for timing, Lagerfeld realized that fashion news in the sixties and seventies lay in the ready-to-wear and not the increasingly moribund couture. "Karl's vigorous, ironic, and knowing modernity," wrote Kennedy Fraser for a 2004 *Vogue* profile, "made him just right to colonize the legend of Mademoiselle." Where Chanel's clothes are subtle, Lagerfeld's are emphatic; where hers are forgiving, Lagerfeld's are demanding. Chanel reviled fashion; Lagerfeld rejoices in it, creates it—and often leads it. "There is a kind of hyperbolic quality to Karl's pieces," says Koda, "but in her day, Chanel was probably just as shocking, taking the materials of service clothing and using it for clothing for a woman of privilege. But times have changed, so it has to be a more vivid transgression—you have to push the boundaries more."

Soon after his appointment, Lagerfeld ransacked his considerable library of fashion magazines and literature to create inspirational scrapbook albums filled with myriad images of Chanel and her work, arranged in approximately chronological order. From these, and from Chanel's own archives, now housed in subterranean depths beneath the Place Vendôme, he constantly derives inspiration. But although Lagerfeld's knowledge of fashion history is encyclopedic, reverence was not his guide in his radical restructuring of Chanel. "If you want to ruin a business," he told Fraser, "be respectful. Fashion is not about respect. It's about fashion."

The timing of Lagerfeld's first collection for Chanel was fortuitous. As Jane Kramer noted for a 1991 *Vogue* article, 1983 represented the beginning of postmodernism, "the year modernism in art and architecture and design and even literature began to give way to 'citation' and 'quotation.' "

But if Lagerfeld trades in postmodernism at Chanel, he can do so because La Grande Mademoiselle defined modernism. "I created the most well-known style in the world," she said bluntly, "because fashion is ephemeral, but style is eternal."

—HAMISH BOWLES, *VOGUE*, MAY 2005

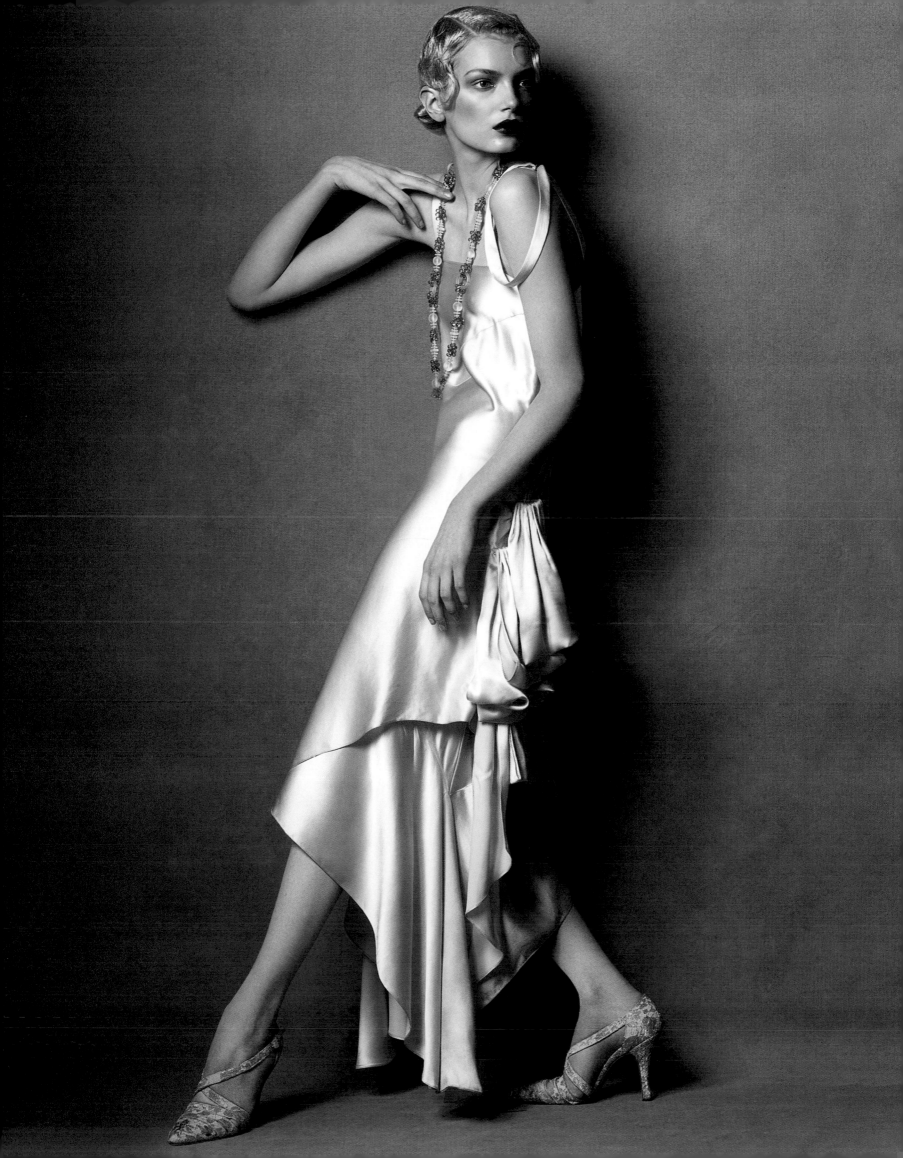

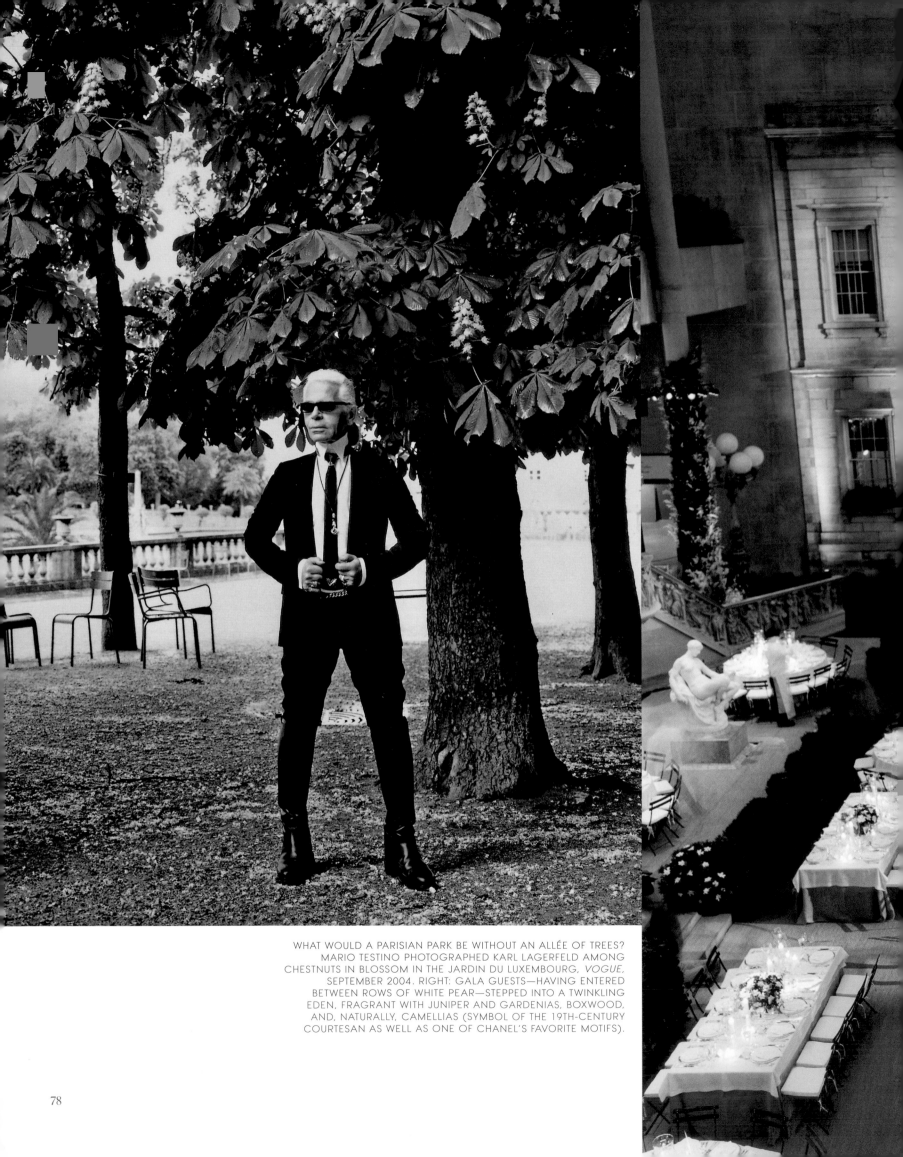

WHAT WOULD A PARISIAN PARK BE WITHOUT AN ALLÉE OF TREES?
MARIO TESTINO PHOTOGRAPHED KARL LAGERFELD AMONG
CHESTNUTS IN BLOSSOM IN THE JARDIN DU LUXEMBOURG, *VOGUE*,
SEPTEMBER 2004. RIGHT: GALA GUESTS—HAVING ENTERED
BETWEEN ROWS OF WHITE PEAR—STEPPED INTO A TWINKLING
EDEN, FRAGRANT WITH JUNIPER AND GARDENIAS, BOXWOOD,
AND, NATURALLY, CAMELLIAS (SYMBOL OF THE 19TH-CENTURY
COURTESAN AS WELL AS ONE OF CHANEL'S FAVORITE MOTIFS).

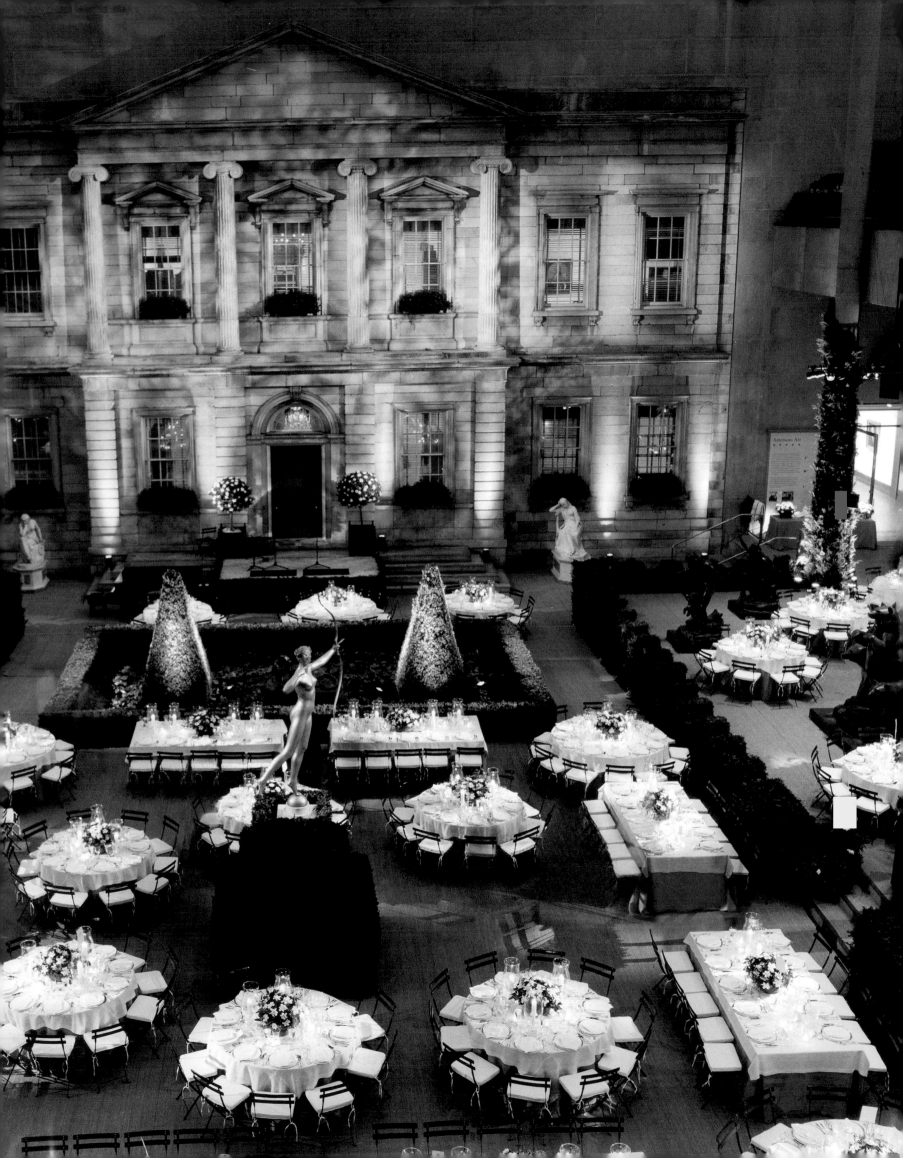

KARL LAGERFELD'S
POP-HUED, "SCUBA" TAKE
ON THE SUITING, 1991.

COCO CHANEL'S SOFT-TAILORED
MINIMALIST BLACK SUIT, C. 1927.

THE MASCULINE PRACTICALITY
OF THIS C. 1954 DRESS
WAS A REVELATION.

LAGERFELD'S RHINESTONE-
ENCRUSTED NEHRU PANTSUIT, 1996.

PATRIOTIC "TRICOLOR" DRESS FROM
1939, ON THE EVE OF WARTIME.

LAGERFELD'S HISTORICISM
IS EVIDENT IN THIS
ORIENTALIST DRESS, 1989.

NEO–EGYPTIAN REVIVAL DRESS
WITH SUNBURST PAILLETTES, 1927.

SILK-CREPE KIMONO EVENING COAT
WITH PADDED CUFFS, C. 1927.

BOWS (A SIGNATURE) ENLIVEN A
TUBULAR SILHOUETTE, C. 1928.

FRINGED FLAPPER DANCE DRESS
IN "CHANEL BLUE," 1926.

STARS—AS ON THIS 1937 GOWN—
ALSO BECAME A MOTIF.

ENSEMBLE FROM COCO'S
COMEBACK COLLECTION, 1954.

FAUX-FRAYED EDGES DISTINGUISH
THIS BOUCLÉ SUIT, 2003.

LITTLE BLACK DRESS OF SILK CHIFFON,
WITH CUMMERBUND, 1959.

SLIGHTLY RACY SHORT DRESS WITH
MATCHING LACE SLIP, C. 1928.

"GYPSY" SHEER DRESS, REVEALING
UNDERGARMENT, 1939.

THE QUILTED CHANEL BAG—
AS A SEQUINED SUIT, 1986.

FUR-LINED RAINCOAT
(EXEMPLAR OF "POVERTY
DE LUXE"), C. 1972.

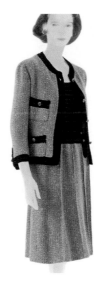

FOUR POCKETS, GOLD CHAIN,
AND BRAIDING, C. 1960.

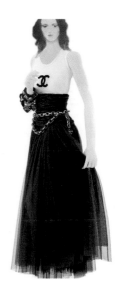

LAGERFELD STAMPED
THE GLOBE WITH DOUBLE
Cs. TANK TOP, 1992.

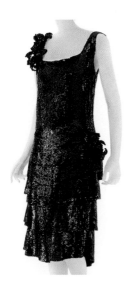

LITTLE BLACK SEQUINED DRESS
WITH TIERS AND CORSAGES, 1925.

SPECTATOR SLINGBACK IN A TYPICAL COCO COLOR SCHEME, C. 1957.

UNUSUALLY ROMANTIC
LACE DRESS, 1930.

ANGLOMANIA TRADITION & TRANSGRESSION IN BRITISH FASHION
2006

IN THE EXHIBITION, ALEXANDER McQUEEN'S UNION JACK BLAZER (MADE FOR DAVID BOWIE, 1996) STOOD IN FOR JOHN BULL. SHARP-DRESSED MODS—NOTABLY, MEMBERS OF THE WHO—HAD WORN SIMILAR JACKETS IN THE MID-SIXTIES (AN INTERESTING PARALLEL TO THE MONDRIAN LOOK ADVANCED BY YVES SAINT LAURENT AT THAT TIME). HOWEVER, IT WAS THE SEX PISTOLS, ET AL, WHO IN THE SEVENTIES TURNED THE WEARING OF THE U.K. FLAG INTO AN AESTHETIC UP-YOURS . . . AND AN ENDURING EMBLEM OF BRITISH FASHION IRREVERENCE.

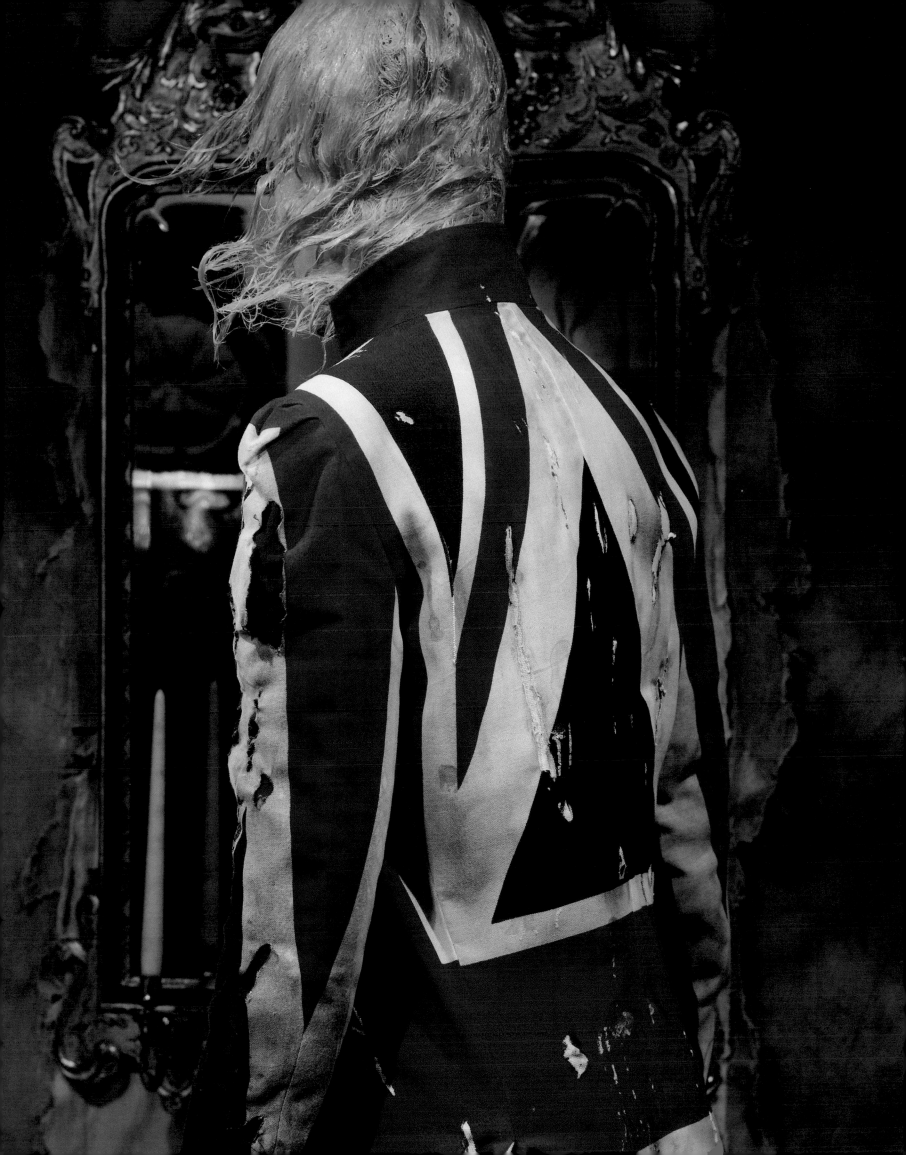

JOHN GALLIANO, A NATIVE OF GIBRALTAR
WHO FOUND FAME IN LONDON, CREATED
THIS EPIC DRESS, FEATURED IN THE EXHIBITION,
FOR DIOR HAUTE COUTURE. DIOR MAY
BE A FRENCH HOUSE, BUT THE LOOK WAS
100 PERCENT VICTORIANA, EVOKING THE
MID–19TH CENTURY'S HOOPSKIRTS AND
THE BLACK WIDOW'S WEEDS WORN BY THE
GREAT ENGLISH QUEEN WHEN SHE WAS
IN MOURNING FOR HER ADORED ALBERT.
OVERLEAF: FOR THE HUNT-BALL TABLEAU,
IN ONE OF THE MUSEUM'S ENGLISH PERIOD
ROOMS, MANNEQUINS IN SCARLET FOX-
HUNTING JACKETS WALTZED WITH LADIES IN
ENORMOUS HOOPSKIRTED GALLIANO AND
VIVIENNE WESTWOOD GOWNS. EVOCATIONS
OF THE PAST (FROM QUIRKY SPINS ON
HARRIS TWEEDS OR THE MACKINTOSH TO
THE THACKERAY HEROINE–ESQUE TAFFETAS
AND SATINS SEEN HERE) HAVE LONG BEEN
AT THE HEART OF BRITISH FASHION.

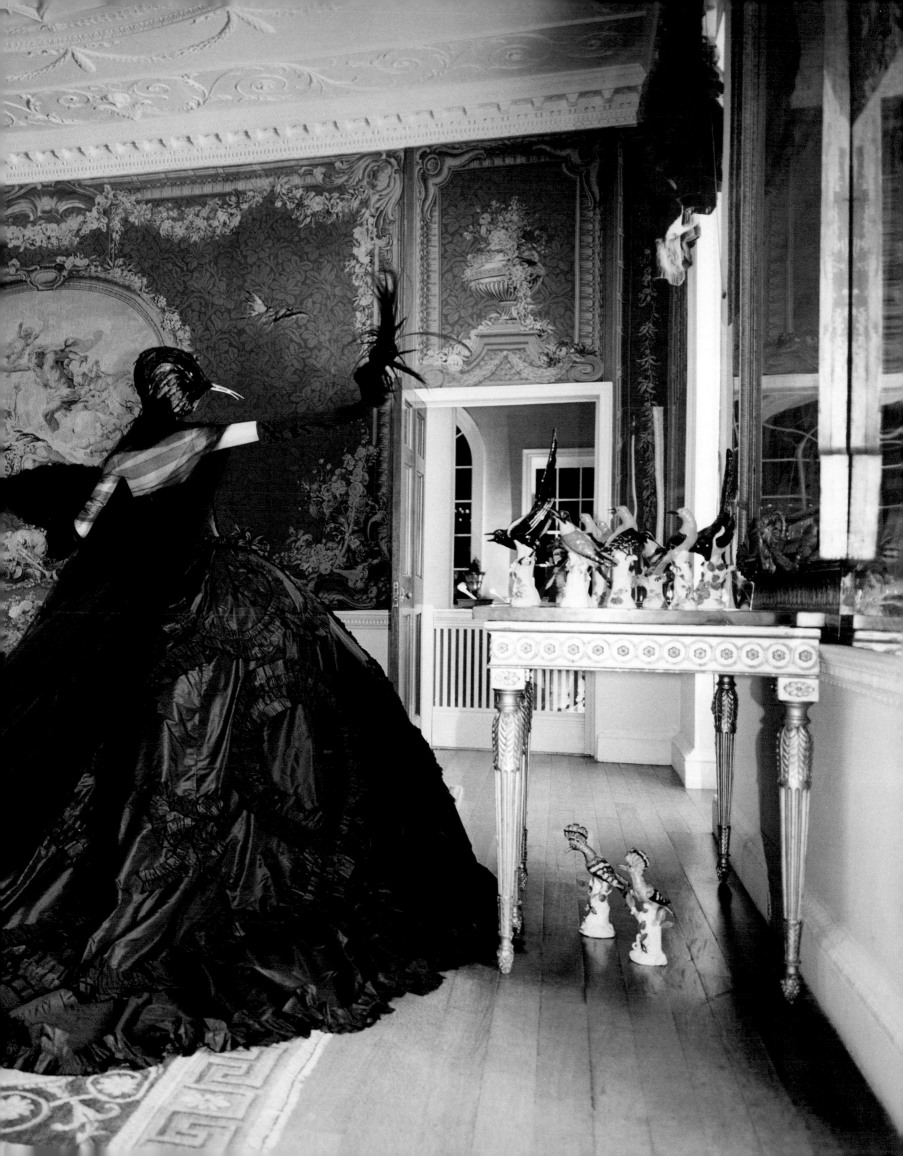

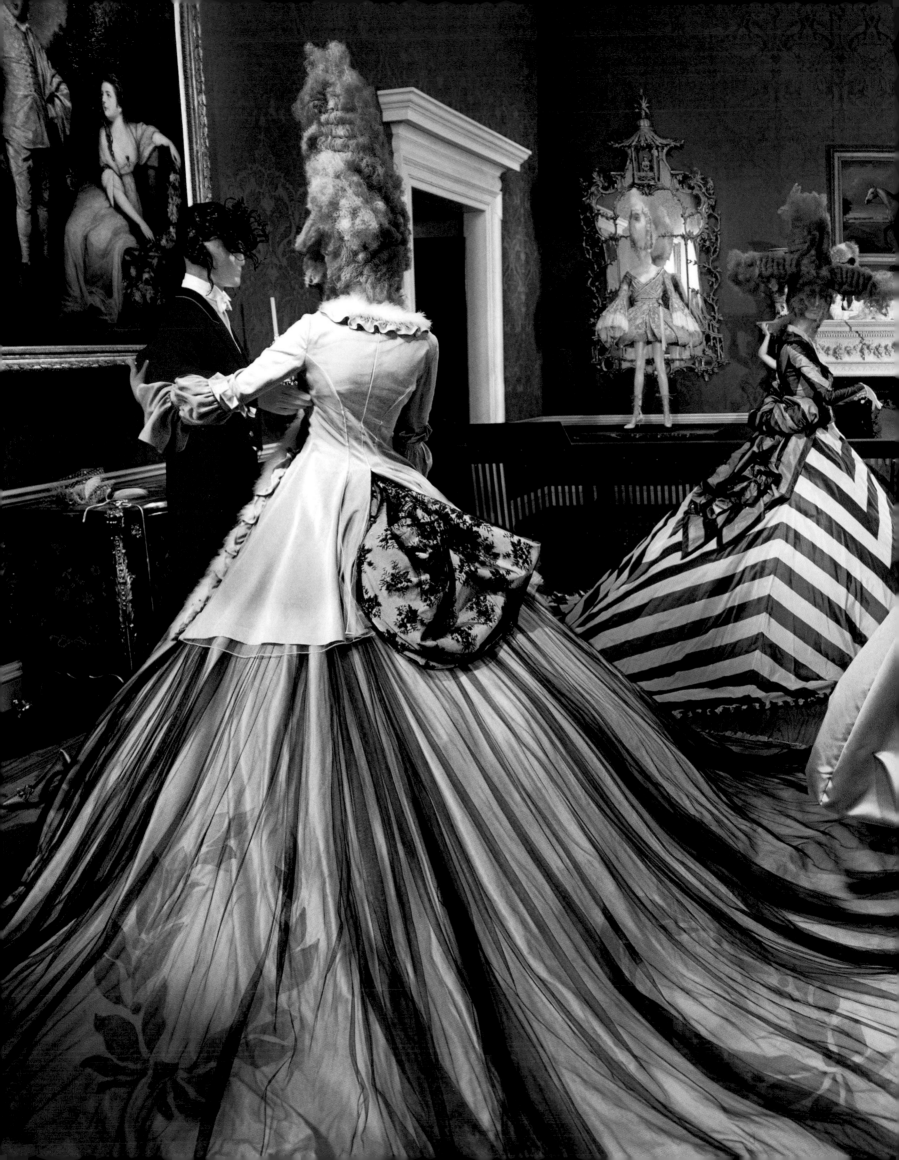

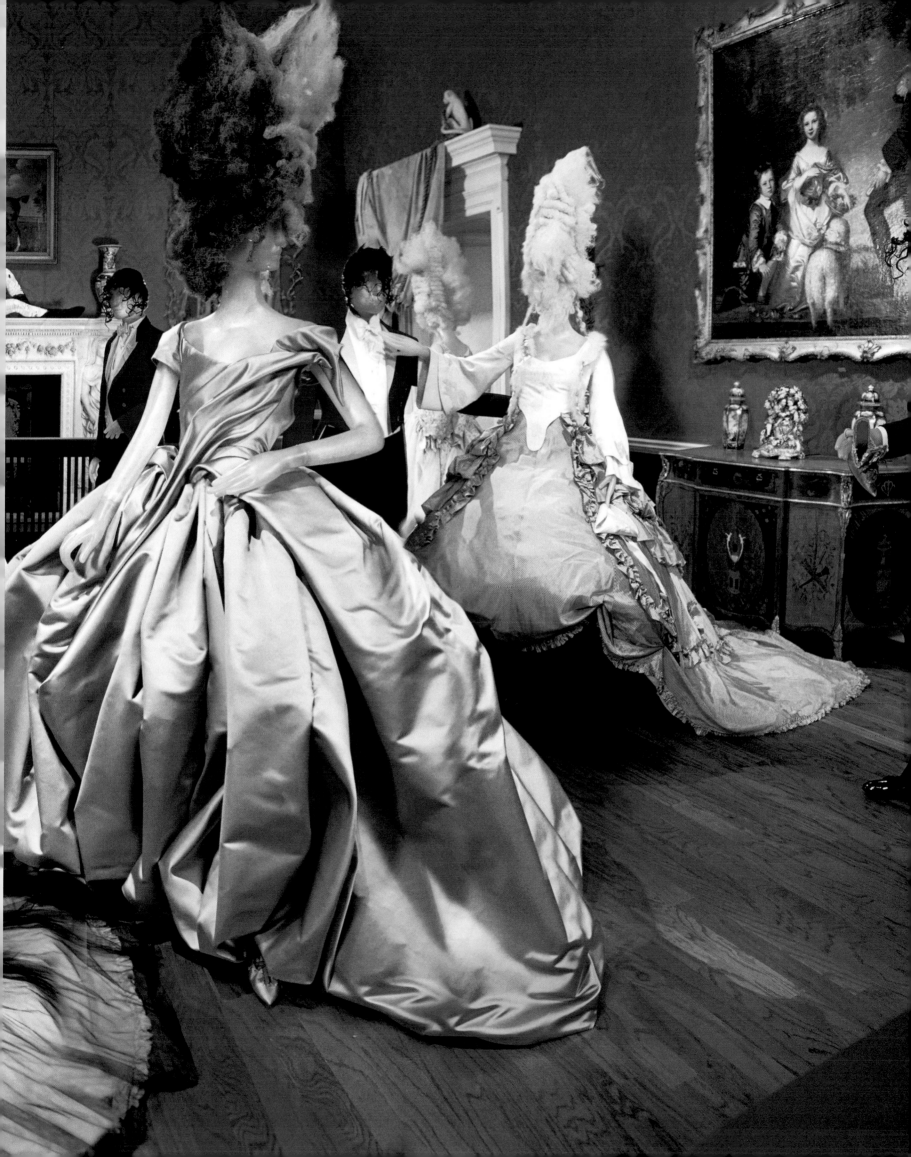

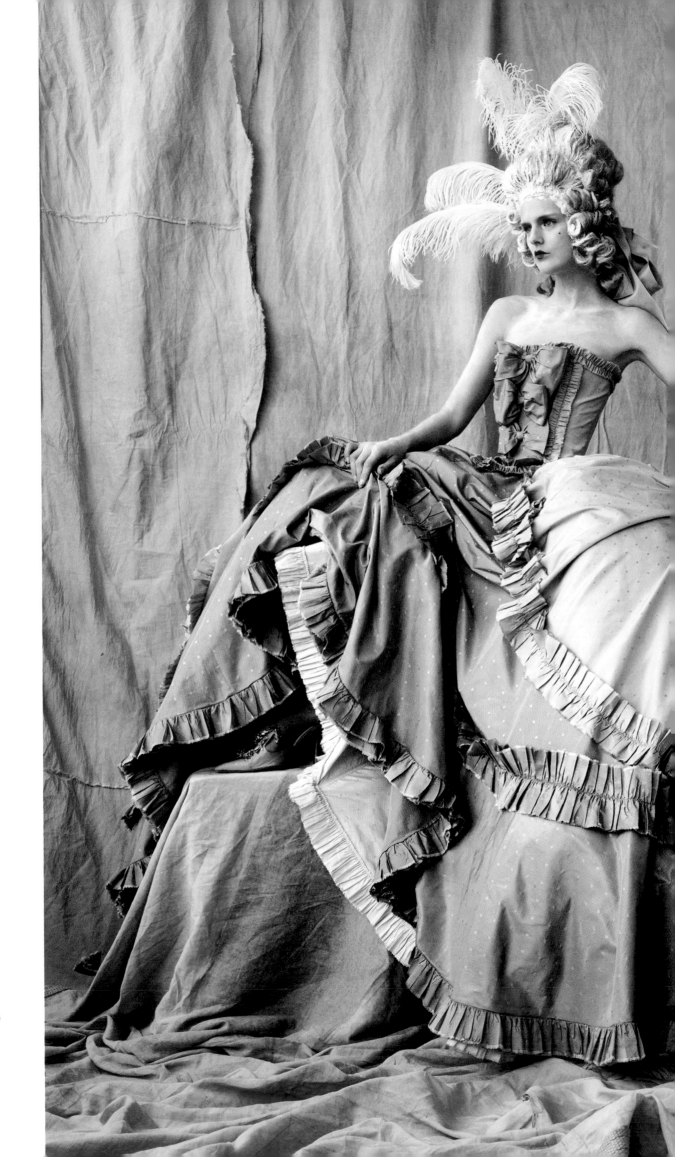

IN THE MAY 2006 ISSUE, STELLA
TENNANT—HIGHBORN AND
A PERENNIAL *VOGUE* FAVORITE—
LOOKED LIKE THE SUBJECT OF
A GAINSBOROUGH PORTRAIT IN
HER CELADON PANNIER GOWN
OF FIGURED TAFFETA FROM DIOR
HAUTE COUTURE'S SPRING 1998
COLLECTION. THE HIGH POWDERED
WIG AND BROAD SILHOUETTE
RECALLED THE INDULGENCES OF
THE 18TH-CENTURY BRITISH
ARISTOCRACY, WHICH BORROWED
MANY OF ITS MODES FROM THE
CONTINENT. PHOTOGRAPHED
BY MARIO TESTINO.

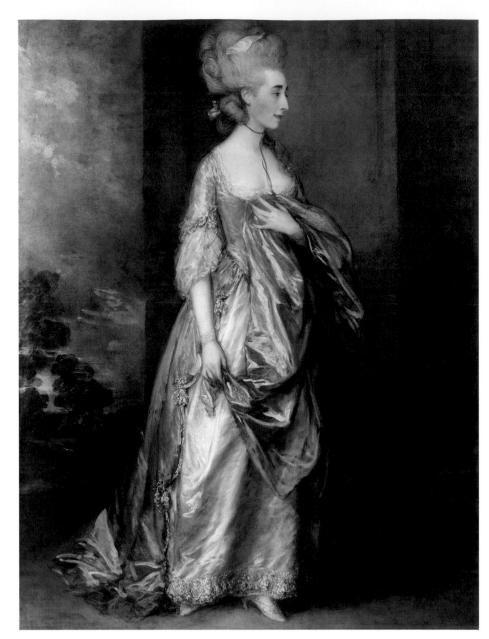

RIGHT: *MRS. GRACE DALRYMPLE ELLIOTT*, BY THOMAS GAINSBOROUGH, 1778 (COMMISSIONED BY THE MARQUESS OF CHOLMONDELEY, HER REPUTED LOVER). FULL-LENGTH PORTRAITS OF THE BRITISH ARISTOCRACY FOCUSED ON DRESS, VISUALLY DEFINING SUBJECTS' CLASS AND WEALTH. FAR RIGHT: FROM THE EXHIBITION, ANOTHER GARMENT ENGINEERED TO MAKE AN IMPRESSION: THE GRAND BUSTLE DRESS WORN BY THE GREAT-GREAT-GRANDDAUGHTER OF GEORGE WASHINGTON TO MEET QUEEN VICTORIA IN THE 1880s.

were being cut away." Some of Chalayan's earliest fashion school experiments involved burying garments for periods of time in his back garden "to create a future archaeology, playing with time and how we perceive clothes."

As Anglomania swept through France in the 1770s and 1780s, England itself was in the grip of Francomania. French was spoken in polite society, where a passion for the fashions, decorative arts, music, etiquette, and cuisine of the country held sway. George William, the sixth Earl of Coventry, was a passionate eighteenth-century Francophile and connoisseur of beauty (his wife, the celebrated fashion plate Maria Gunning, died of blood poisoning at the age of 27, partly as a result of her use of lead-based cosmetics). When the Treaty of Paris ended the Seven Years War between England and France in 1763, Coventry was finally able to indulge his passion, and he hurried to France to commission a series of Boucher-designed tapestries from the royal Gobelins manufactory to decorate a room at Croome Court, his Worcestershire seat. Now installed at The Metropolitan, the room will play host to a vast-skirted haute couture ball gown that Galliano created for Dior's Marchesa Casati show of spring 1998. Galliano's trajectory—from modest London beginnings to the height of the Paris haute couture as designer chez Christian Dior—parallels that of Charles Frederick Worth. As a young man, Worth was appalled by the modest and dreary fashions of early Victorian London and sought inspiration in the sumptuous garments depicted in the old-master paintings at the capital's National Gallery. By the 1860s, installed in Paris, he was dressing the Empress Eugénie and her court, and for half a century he was the undisputed king of fashion, his opulent, idiosyncratic designs evoking the splendors of the seventeenth and eighteenth centuries—using his uniquely English sensibility to define French style.

The final gallery pays tribute to the English eccentric. "The English customer has a wholly unique perception of chic—completely different from any other culture's," says Philip Treacy, whose clients run the gamut of quirky style from Isabella Blow to the Duchess of Cornwall. "It's inbuilt; they are not trying to be eccentric. I deal on a daily basis with very polite, well-bred English women who are quite crazy! Individuality is wholly acceptable here. It's what makes the English tick." The notion of eccentricity was first coined in the eighteenth century, when the satirists and caricaturists of the day—Hogarth, Gillray, Rowlandson—delighted in lampooning exaggerated fashions, but it is just these pieces—bum rolls and crinolines and extravagant headdresses and hats—that have appealed to today's designers. As Treacy says, "There's nothing more English than a hat!"—HAMISH BOWLES, *VOGUE,* MAY 2006

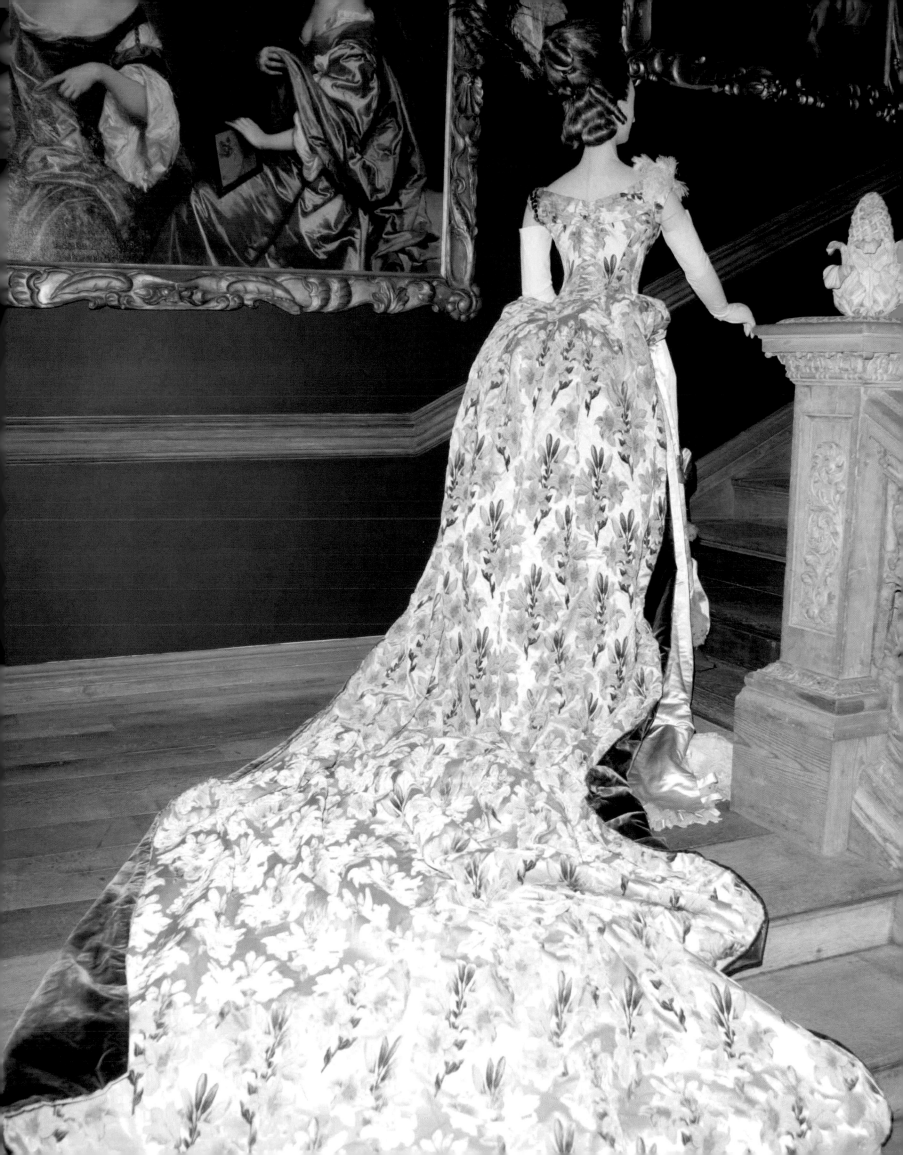

ATTENDANTS DRESSED AS
QUEEN'S GUARDS GREETED
GALA GUESTS IN THE MET'S
GREAT HALL, WHICH WAS
DECORATED BY DAVID E.
MONN. AT REAR, A PROSPECT
OF THE PARK OF A GRAND
COUNTRY HOUSE, IN THE STYLE
OF CAPABILITY BROWN. INSIDE,
DINNER WAS SERVED IN
ENGLISH GARDENS CREATED
WITH 47,000 FLOWERS
(PRINCIPALLY DAFFODILS AND
HYACINTHS) AND 400 FEET
OF ESPALIERED APPLE TREES.

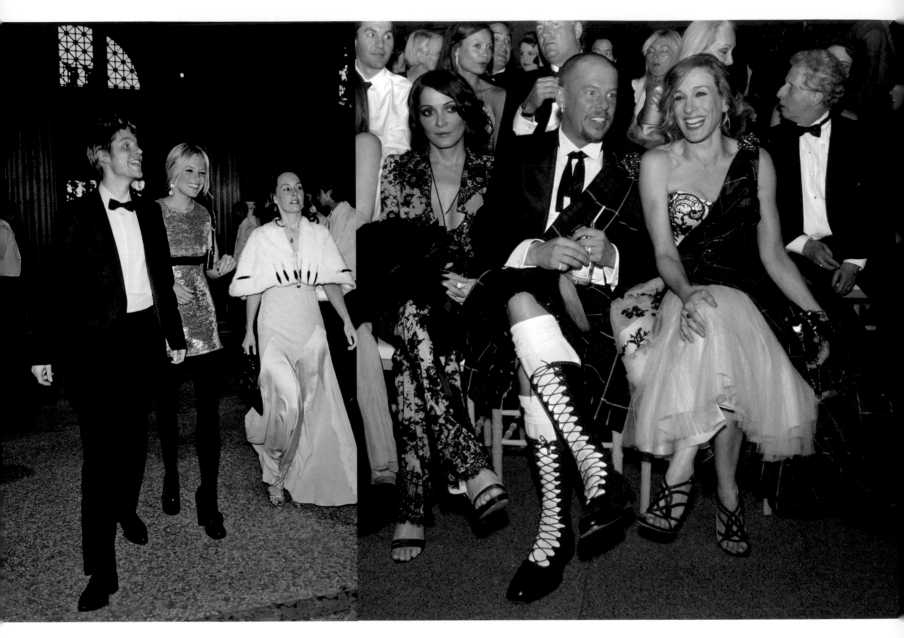

ABOVE RIGHT: TARTAN IS ANOTHER TRADITION SUBVERTED BY BRITISH RABBLE-ROUSERS, FROM ADAM ANT TO ALEXANDER McQUEEN. THE LONDON DESIGNER'S WORK FEATURED HEAVILY IN THE SHOW. HE OUTFITTED HIMSELF—AND ACTRESS FRIEND SARAH JESSICA PARKER—IN McQUEEN TARTAN WOVEN BY LOCHCARRON OF SCOTLAND. ABOVE LEFT: SIENNA MILLER ARRIVED ON THE ARM OF HER COCHAIR CHRISTOPHER BAILEY OF BURBERRY, WHO DESIGNED HER GOLD MINI. OPPOSITE PAGE: JUICY COUTURE'S GELA NASH-TAYLOR (LEFT) IN A COUTURE COUTURE BUSTLE; VIVIENNE WESTWOOD IN HER OWN FLAG GOWN.

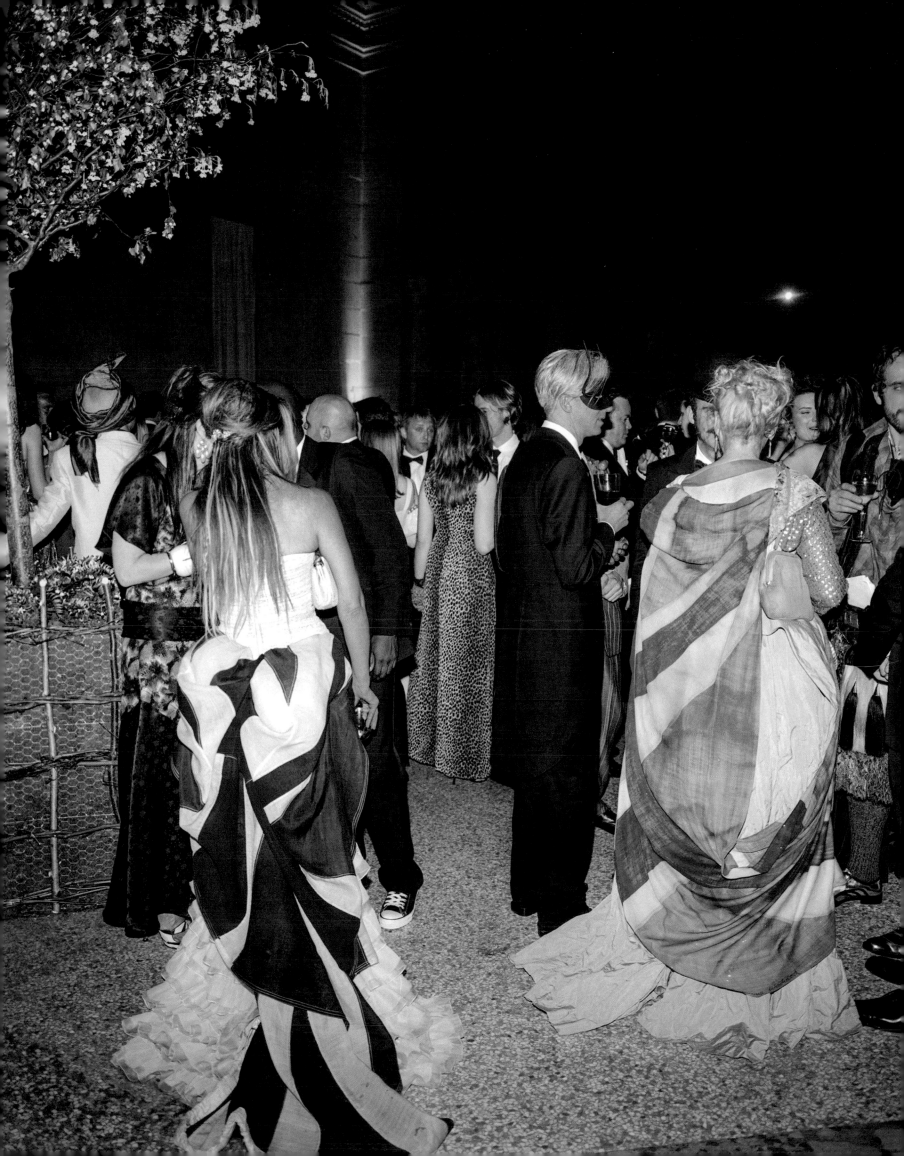

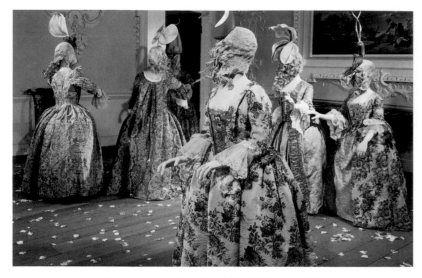

POSY-STREWN SILKS FROM THE 1730s, WORN
WITH PHILIP TREACY'S ORCHID HATS.

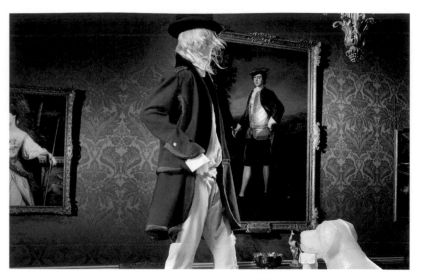

GALLIANO SCARLET RIDING JACKET, WITH A
NONTRADITIONAL, OVERSIZE CUT, 2005.

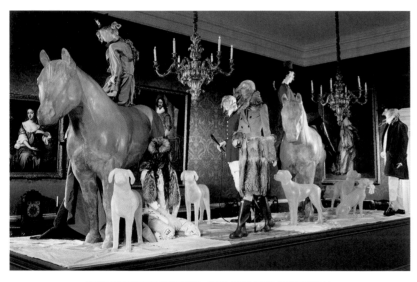

FOX-HUNTING OUTFITS—THE ULTIMATE SARTORIAL
EXPRESSION OF THE CLASS DIVIDE.

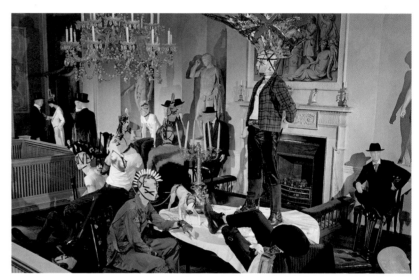

THE GENTLEMEN'S CLUB FEATURED DEBAUCHED
DANDIES AND REGENCY BUCKS.

McQUEEN EVENING SUITS,
BELTED (LEFT) AND
WITH TULLE CAPE, 2006.

A MAID AT HER TOIL WEARS
"RUSTED" COTTON BY
HUSSEIN CHALAYAN, 2002.

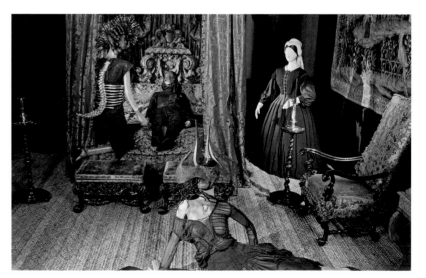

GWYNETH PALTROW'S 2002 OSCAR OUTFIT BY
McQUEEN, IN DEATHBED SCENE.

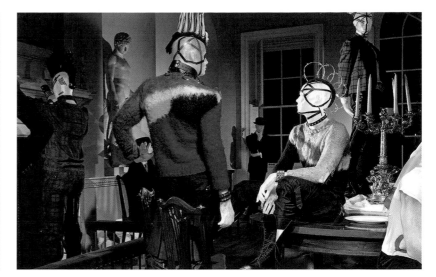

VIVIENNE WESTWOOD'S CHEEKY TAKE ON CORONATION REGALIA, 1987.

THREE-PIECE SUIT WITH PINK BOUCLÉ STRIPE, TIMOTHY EVEREST, 2006.

BONDAGE PANTS AND PUNK MOHAIR, McLAREN AND WESTWOOD, C. 1977–78.

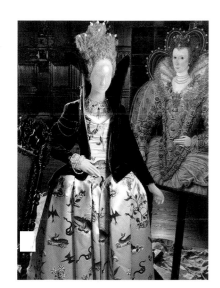

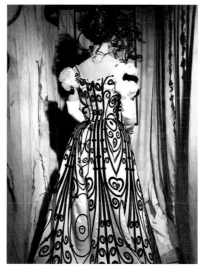

FIT FOR A QUEEN, WESTWOOD'S DUCHESSE-SATIN AQUATIC PRINT, 1997.

SCROLLWORK GOWN, HOUSE OF WORTH, 1898–1900.

GALLIANO NEWSPRINT LONG JOHNS AND STEPHEN JONES HEADDRESS, 2004.

BONDAGE GEAR FROM WESTWOOD AND McLAREN'S KING'S ROAD BOUTIQUE, C. 1980.

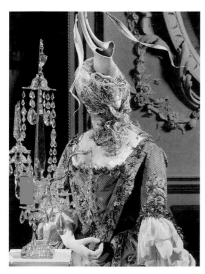

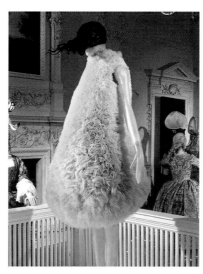

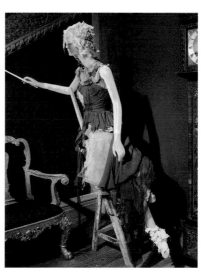

IN THE ENGLISH GARDEN: SPITALFIELDS-SILK ROBE À LA FRANÇAISE, C. 1750s.

HUSSEIN CHALAYAN PINK NYLON-TULLE TOPIARY DRESS, 2000.

DUSTING IN CHALAYAN LACE-AND-TAFFETA RAGS AND TATTERS, 2002.

CANTILEVERED TIPTOE SHOE, MANOLO BLAHNIK, 2006.

POIRET
KING OF FASHION
2007

POIRET COLLABORATED WITH SEVERAL OF THE GREAT CREATIVE TALENTS OF HIS DAY, OFFERING STRUGGLING ARTISTS WELL-PAYING JOBS THAT ENABLED THEM TO CONTINUE PURSUING THEIR LOFTIER AIMS. THE VELVET TEXTILE USED ON THIS RABBIT-TRIMMED COAT IN THE EXHIBITION WAS DESIGNED BY RAOUL DUFY IN 1911 AT POIRET'S "LITTLE FACTORY"; THE RENOWNED FAUVIST PAINTER DEVELOPED A NEW WOODBLOCK-PRINTING TECHNIQUE THERE, UNDER HIS PATRON'S WING.

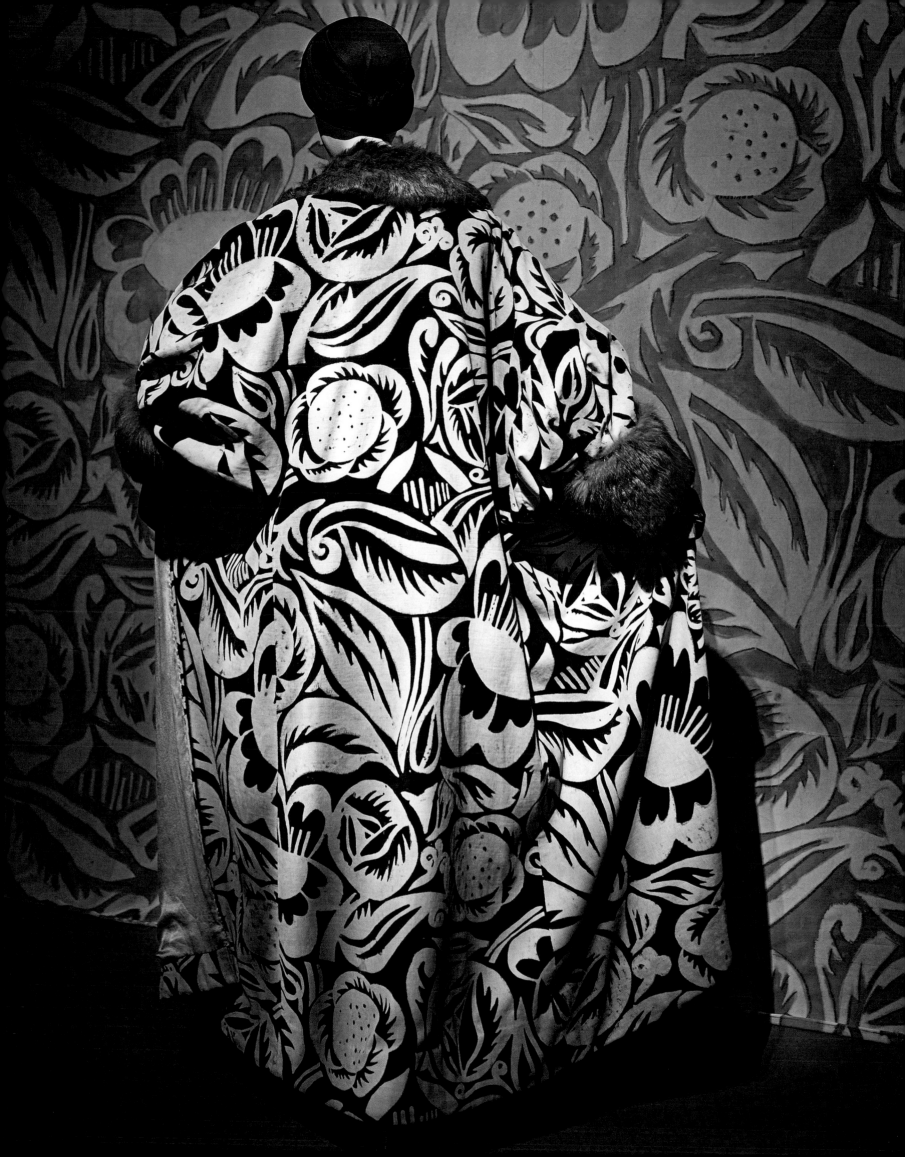

I n the years before World War I, Paul Poiret's star rose like a comet—as his contemporaries Picasso and Stravinsky were reimagining art and music with their iconoclastic brilliance, so he redesigned the twentieth-century woman and became the first fashion designer to create a seductive lifestyle world to reinforce his exceptional vision. But hubris and financial incompetence were to prove his downfall, and his star fizzled ignobly.

Poiret was born to a humble cloth merchant in Paris's hardscrabble quartier of Les Halles. As a boy he was apprenticed to an umbrella manufacturer in an attempt (woefully unsuccessful) to break him of his natural pride. His only solace was in gathering the scraps of silk left over after the umbrella patterns had been cut, which he used to dress a little wooden doll that his sisters (one of whom, Nicole Groult, would become a couturiere herself) had given him and on which he "imagined sumptuous toilettes, faery panoplies"—harbingers of the fantasias that would later scintillate the Belle Époque. As an emboldened teenager, he took his sketches to Mme Chéruit, a dressmaker of considerable personal elegance, who, to his great delight, bought a dozen. Poiret continued to sell his sketches to the grandest Parisian couture houses until 1896, when, at age seventeen, he was hired by one of the most distinguished of them all: Jacques Doucet.

It was an illustrious debut; Doucet was a couturier of immense refinement, a collector and connoisseur of brilliance. His work was characterized by an extreme sense of romance and femininity and a nostalgia for eighteenth-century France, and in private life he amassed a superb collection of that period's art and objets. He sold it all in a series of auctions in 1912, at which point he embraced the cause of modern art—it was Doucet who acquired Picasso's 1907 *Les Demoiselles d'Avignon,* the defining work of early–twentieth century modernism. Poiret's maiden design chez Doucet was a red cloth cape; 400 were sold. With his first paycheck he bought a set of opal cuff links, a portent of his profligacy. He subsequently designed for the storied House of Worth, which was caught up in supplying the opulent court vestments for the coronation of Edward VII. Poiret was responsible for creating what Gaston Worth called "simple and practical dresses . . . fried potatoes" to his brother designer Jean Worth's "truffles." Worth's conservative clientele, however, proved unready for the brazen modernity of his designs, such as a Confucius coat innovatively cut like a kimono. "What a horror," Poiret recalled the formidable Russian Princess Bariatinsky exclaiming when he presented her with it. "When there are low fellows who run after our sledges and annoy us, we have their heads cut off, and we put them in sacks just like that."

Poiret soon broke free, establishing his own house, in 1903, where he initially made his name with variations on the controversial coat. From the beginning, Poiret possessed a preternatural instinct for self-publicity, marketing, and branding as no other designer—not even the great Charles Frederick Worth (father of Jean and Gaston)—had before him. He swiftly gravitated from designing flamboyant window displays in his first shop to throwing legendary parties in his exquisite houses and later in his nightclub, L'Oasis, with themes that promoted his current collection. Inspired by a visit to Josef Hoffmann's design workshop, Wiener Werkstätte, in 1910, Poiret began to create a world that would embrace not only fashion but also furniture, decor, and fragrance. With a nod to his admired master Doucet, Poiret also patronized the arts. He counted Francis Picabia, Maurice de Vlaminck, and André Derain among his intimates, collected Brancusi, Matisse, Modigliani, and Picasso, among others, and commissioned artists Georges Lepape and Paul Iribe to produce the exquisite *pochoir* illustrations for the coveted limited-edition albums sent to favored clients. By 1909, Poiret's fame was such that Margot Asquith, the bold wife of Britain's prime minister (who proved her affinity with the designer's work by flashing him her violet culottes, which Poiret popularized), invited the designer to show his creations at 10 Downing Street, scandalizing the

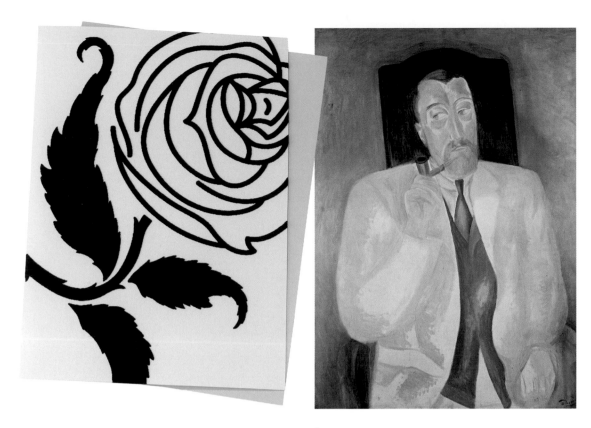

ABOVE RIGHT: ANDRÉ DERAIN'S 1914 PORTRAIT OF POIRET (WHO WAS A VORACIOUS COLLECTOR OF MODERN PAINTING). EONS BEFORE WARHOL AND HIS FACTORY, POIRET EXPLORED CONCEPTS OF ORIGINALITY IN AN AGE OF REPRODUCTION, HIGH VERSUS POPULAR ART. ABOVE LEFT: ON THE GALA INVITATION, THE HOUSE-SIGNATURE ROSE, FROM A DRAWING BY PAUL IRIBE.

national press. They dubbed the prime minister's residence "Gowning Street" and reported that the cheapest garment on offer was 30 guineas, twice the annual salary of a scullery maid.

In 1905, Poiret, a notorious womanizer, astonished his friends by marrying a provincial girl, Denise Boulet, who would become the mother of his five children (Rosine, Martine, Colin, Perrine, and Gaspard), the embodiment of his ideal, and, in her way, as potent a fashion force as any Directoire saloniste. "All those who have admired her since I made her my wife would certainly not have chosen her in the state in which I found her," Poiret wrote spitefully in *King of Fashion,* his vainglorious (and post-divorce) memoir. "But I had a designer's eye, and I saw her hidden graces. . . . She was to become one of the queens of Paris."

With the audacious Denise as his muse, Poiret set out to revolutionize contemporary fashion. "All that was soft, washed-out, and insipid was held in honor," wrote Poiret of style at the time of his debut. "I threw into this sheepcote a few rough wolves; reds, greens, violets, royal blues that made all the rest sing aloud." Poiret also reduced the structured elaboration of contemporary dressmaking to techniques that drew instead on the liquid drapery and simplicity of Greco-Roman and Near and Far Eastern models; abolished the era's encumbering petticoats; and reduced the armorial hourglass corsets of the day to a vestigial band of ivory grosgrain, reinforced with short whalebone strips and sewn into the garment itself. But while he released women from corsets, he perversely hobbled them with narrow skirts or sarouel draped harem pants.

He looked not only to the seraglios of the East for inspiration but, in 1906, to the Directoire, a society dominated by elegant, liberated, and cultivated women such as Mmes Tallien, Récamier, and de Beauharnais (later the Empress Joséphine), who sought a freedom in dress derived from Greco-Roman documents.

Poiret also established two companies in his daughters' names in 1911. For Rosine he created the Parfums de Rosine. Although Poiret's own name was never directly associated with the product, this was effectively the first designer perfume brand, one that prefigured Chanel's No 5 by a decade. The perfumes were such a success that François Coty attempted, unsuccessfully, to buy him out. Although the exquisitely presented fragrances have not survived, Poiret's partners included such eminent names as Henri Almeras, who later went on to create Joy for Jean Patou. For his daughter Martine he created the École Martine, essentially a decorative-arts school for underprivileged but artistically gifted girls who were exposed to the work of Poiret's great artistic collaborators. The brilliantly colored, naïf designs that the students produced for l'Atelier Martine—drawn from the natural world—were used for such Poiret projects as textiles, furniture, decorative schemes, and perfume bottles. Their work also inspired Raoul Dufy, discovered by Poiret at the moment he had turned his back on Fauvism and lost his clients in the process. Poiret installed Dufy in a printing workshop, where he developed textiles and hangings using a homespun woodblock-printing technique. This patronage brought Dufy to the attention of the luxury-fabric manufacturers Bianchini-Ferrier, a relationship that would provide him with the financial independence to pursue his art.

Poiret's autobiography may have downplayed his wife's role in his success, but her impact on his life and work was extraordinary. She was the artistic director of his house, and her free-spirited approach to dress predated and, in some ways, eclipsed that of Gabrielle "Coco" Chanel, the courtesan couturier and Poiret nemesis. (In the twilight of his career, Poiret was alleged to have encountered Chanel, dressed in one of her celebrated impoverished little black dresses so anathema to his exuberant spirit, and to have asked her, "For whom, Mademoiselle, do you mourn?" She acidly responded, "For you, Monsieur.")

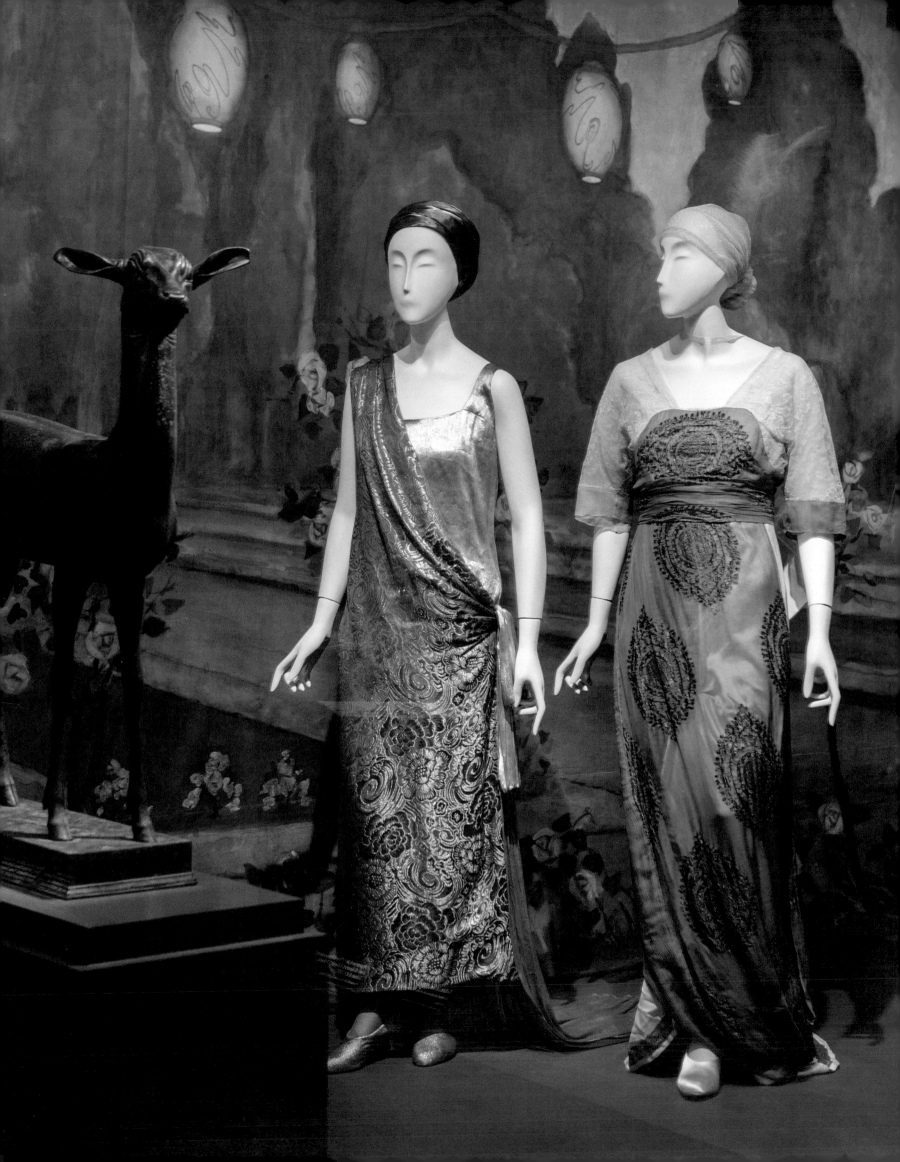

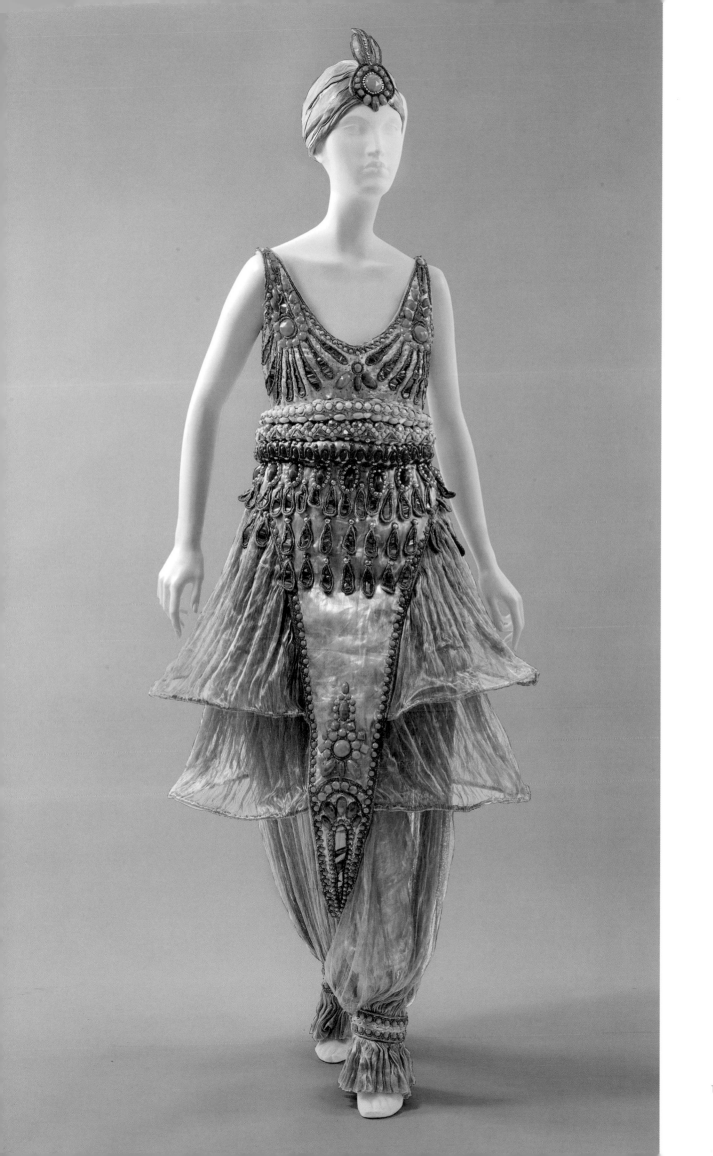

OPPOSITE PAGE, FAR LEFT: A C.
1923 ORANGE DAMASK-AND-
LAMÉ EVENING LOOK AND A C.
1913 ORIENTALIST SILK-CHIFFON
DRESS FROM THE EXHIBITION.
NEAR LEFT: A HAREM COSTUME
LIKELY WORN TO POIRET'S
THOUSAND AND SECOND NIGHT
FANCY-DRESS BALL IN 1911.

"She had a kind of audacity," says Harold Koda, curator, with Andrew Bolton, of The Met's "Poiret: King of Fashion," of Denise Poiret, "a very independent, almost exhibitionist spirit." Unfashionably lithe and sprightly (*The New York Times* dubbed her "a lance in repose"), Mme Poiret wore wigs of kingfisher-blue and viridian-green, stockings in purple silk or golden mesh, and one-shouldered mini-length nightgowns in pale silks sashed with brilliant-colored satin. For Poiret's fabled Thousand and Second Night ball in 1911, Denise was dressed as the sultan's favorite in a golden lampshade tunic and harem pants. As the Queen of Sheba for another costume gala, she wore a gown slashed to the hip to reveal the entirety of her leg, a shocking gesture in 1914, even in the world of the Parisian haute bohème.

But as much as Mme Poiret embodied the wildest flights of her husband's fantasy, her wardrobe included prototypes and pieces created especially for her that prompt a drastic reassessment of his talent. Denise Poiret's clothes included humble cotton and linen dresses of startling modernity for the country; Surrealist pieces (a tunic printed with a child's spelling lesson, complete with ink splashes); deconstructivist items (clothes finished with the fabric's selvage or even raw edges); and recycled period or ethnic garments—all evidence of his extraordinary vision.

Despite the acrimony of their divorce, in 1928 (*Time* reported, "M. Poiret charged that his wife's attitude was injurious; Mme Poiret countercharged that her husband was cruel"), Denise Poiret continued to treasure and esteem her ex-husband's work with a curatorial eye. Her daughter Perrine would share her memories with author Palmer White for his 1973 monograph on the designer, and her son Colin gave some of his mother's spectacular clothes to the Musée de la Mode in Paris. Poignantly, she often sewed muslin patches to the linings of these costumes, noting the date of creation, the title of the piece, and sometimes the event for which it had been made, treating Poiret's work according to his assertion that "I am an artist, not a dressmaker." There is Champs-Élysées, for instance, an airy drapery of ivory brocade and silk-tulle lampshade skirt, worn to the inauguration of the Théâtre des Champs-Élysées, in 1913, and the scandalous premiere of Stravinsky's ballet *The Rite of Spring.*

Denise Poiret's clothes (as well as those of Poiret and their children) were stored in vast trunks until consigned to an unprecedented auction in 2005 at Piasa Paris, from which The Metropolitan Museum acquired 28 masterworks. The auction specialist and fashion historian Françoise Auguet spent two years producing the superbly authoritative two-volume catalog for the sale, relying on copious contemporary photographs (many of them evocatively pastel-toned Vérascopes) and documents to reunite elements from complete looks that had been separated over the years. "It was archaeology!" says Auguet, who was transfixed by the modernity of the designer's work. During her research, she saw some tantalizing, flickering moments of film taken at the christening of Colin Poiret, in 1912. "All the other women are very nineteenth-century," she notes, "but you see how truly different Denise is. You spot her instantly in the crowd—this slender figure in a simple white dress."

In 1911, *Vogue* published a photograph of her husband's scandalous culotte, and in 1913 the magazine dispatched a photographer to New York's Plaza hotel to capture the couturier's wife in some of the radical ensembles she had brought for their American trip. "Denise Poiret has never worn corsets . . ." wrote *Vogue*. "She has never worn a high collar. . . . There is no appearance of the gown being fitted to her figure, and there is no useless ornament. . . . She is notable in any gathering by reason of this startling primitiveness of line and color." Mme Poiret was photographed in a velvet skirt, slit to reveal the Russian coachman's boots she always wore for day, and lounging on some Bakstian cushions in a Sac dress of absolute simplicity, cut like a silk T-shirt to the ankles.

During World War I, Private Poiret served his country by streamlining the tailoring process of uniform production, while his abandoned fashion house teetered on the brink of bankruptcy and he suffered the deaths of his infant son Gaspard from the Spanish-influenza epidemic and of his daughter Rosine from otitis, an ear infection. Discharged in 1919, he returned to re-create his house, but his prewar supremacy was slowly eroding in the face of competition from a slew of young pretenders. "I refuse to make a model which will sell in quantity," Poiret told the British press in the early twenties. "I do not want all women to look and dress exactly alike. I want them to be as different in their dress as they are in their personalities." French *Vogue* pronounced in 1924, "A Poiret creation is never banal," but the sleek homogeneity proposed by designers such as Chanel and Patou was the new order of the day. "Sterile and mutton-ish," railed Poiret of the new garçonne look, but his own styles were soon to become victims of the most ignominious fashion fate of all: Alongside Chanel's beige suits and little black dresses and Patou's sportif ensembles, Poiret's elaborate or folkloric creations seemed suddenly dowdy. The new simplicity relied on exquisite workmanship; as groundbreaking as Poiret's designs were, the clothes were often surprisingly crudely manufactured. "There is a spontaneity," says Koda. "It was really the idea of the dress to read beautifully from afar."

Out of step with the times and beleaguered by unsympathetic business partners as well as the insurmountable debts incurred by his last grand gesture—three magnificently appointed barges created for the Arts Décoratifs exhibition in 1925—Poiret eventually left the house that bore his name. In 1929 it was shut down, the magical clothes sold by weight to ragpickers.

After a hiatus, he returned briefly to fashion, producing ready-to-wear collections for the London shop Liberty and the Parisian department store Printemps. "I have found here, in this House, one of the greatest joys of my life," Poiret effused in the latter's in-house magazine, *Printania*. "We have democratized the haute couture." The concept was prophetic, but the clothes were uninspired and the experiment short-lived. Poiret was reduced to penury. In 1921, Britain's *The Daily Sketch* had pronounced him "the greatest dress designer Paris has produced," but in 1934, the newspaper's front page bore a photograph of the designer brandishing a frying pan in his kitchen, crowned with the headline FASHION LEADER SAVED FROM DOLE. Later, he worked as a bartender to make ends meet and chopped up tea towels to make his own suits. He died in 1944, in German-occupied Paris, fashion's forgotten genius.
—HAMISH BOWLES, *VOGUE*, MAY 2007

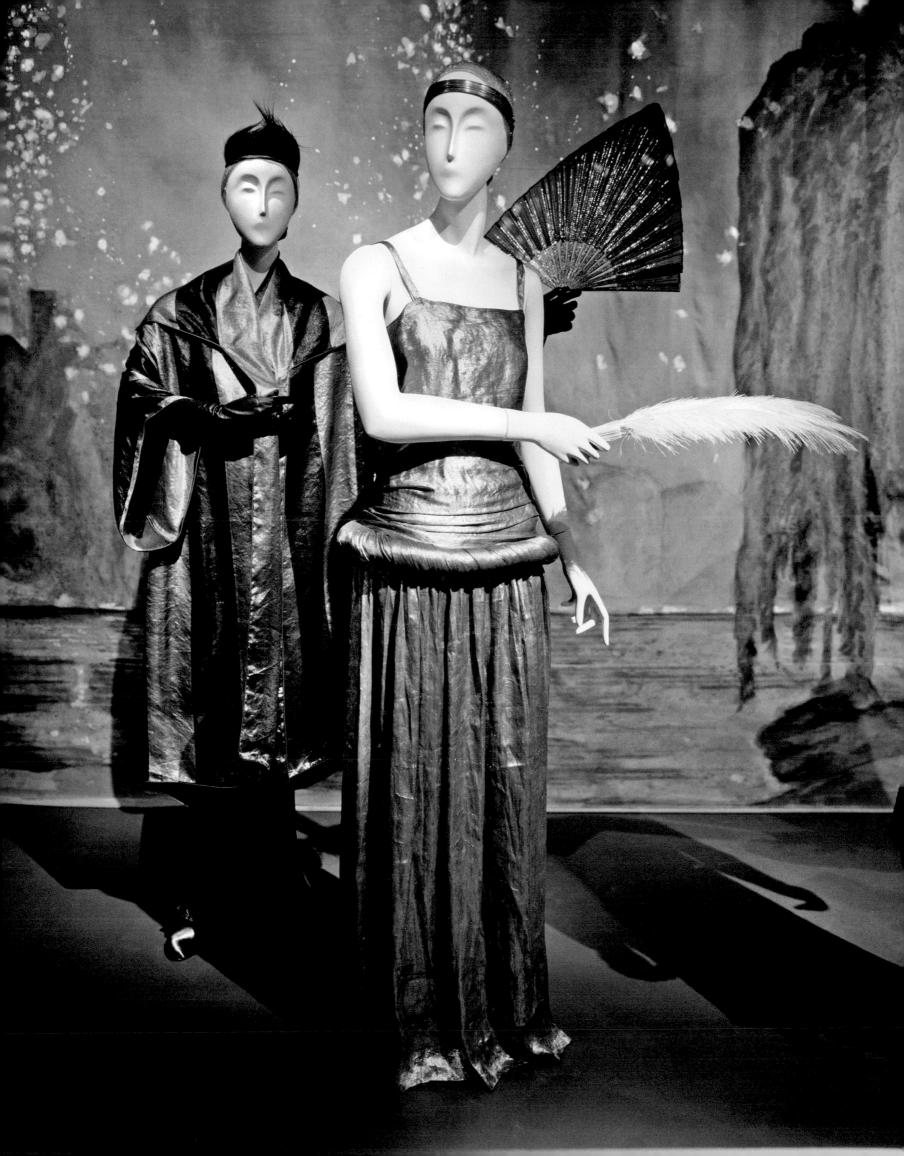

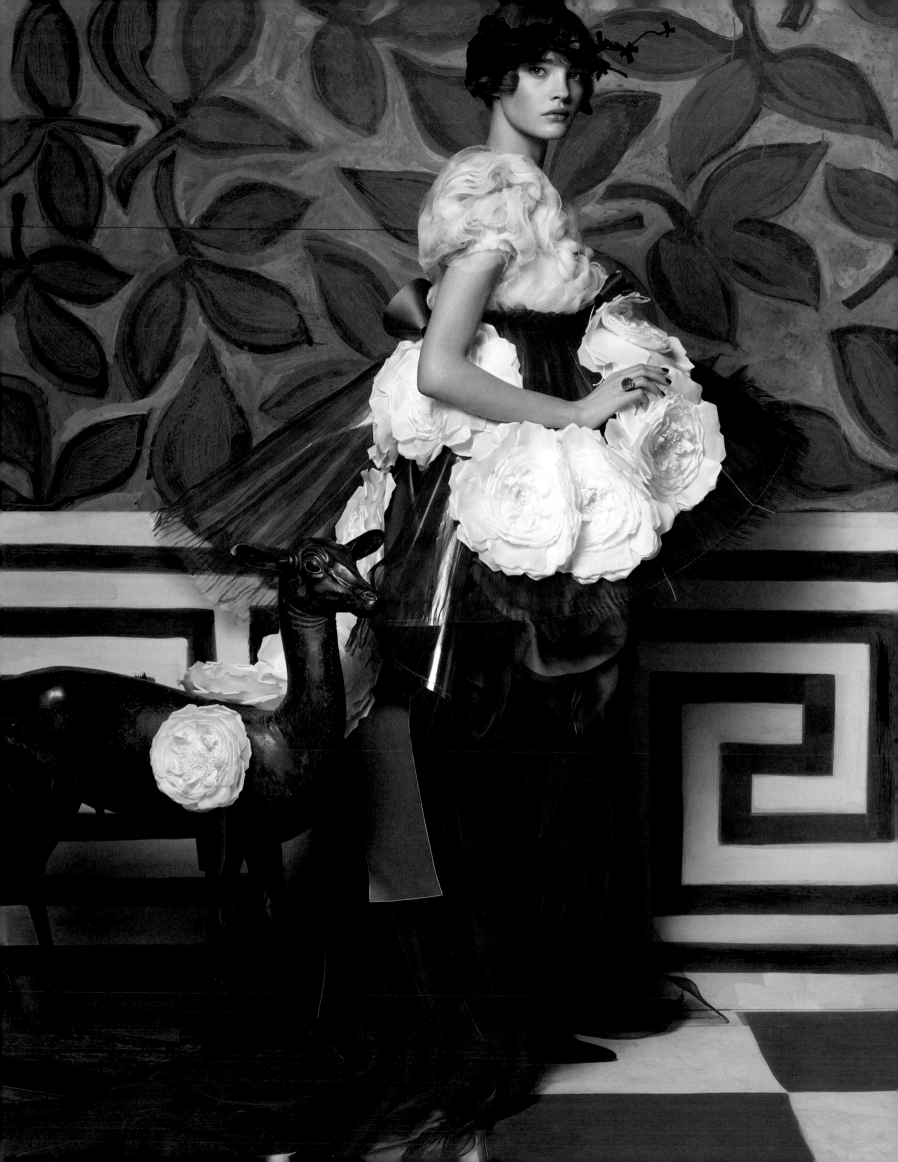

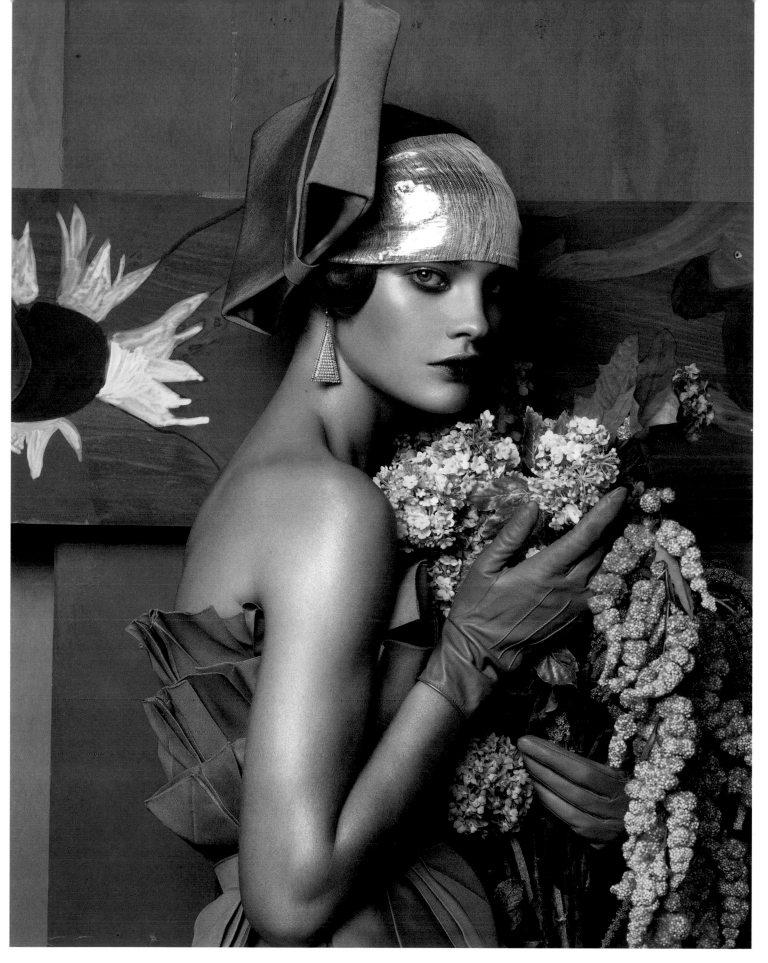

INSPIRED BY POIRET'S LEGENDARY THOUSAND AND SECOND NIGHT BALL IN 1911, THE MAY 2007 ISSUE OF *VOGUE* FEATURED A PORTFOLIO OF CONTEMPORARY INTERPRETATIONS OF HIS FANTASTICAL DESIGNS, PHOTOGRAPHED BY STEVEN MEISEL. ABOVE: MODEL NATALIA VODIANOVA WORE A DIOR HAUTE COUTURE SILK-GAZAR COCKTAIL FROCK WITH FRED LEIGHTON EARRINGS, AND (OPPOSITE PAGE) CHRISTIAN LACROIX'S HAND-PAINTED CREPELINE-AND-ORGANZA CYCLAMEN DRESS WITH AN ORGANDY BLOSSOM BELT. ("NOBODY BETTER EPITOMIZED POIRET'S WORK THAN GEORGES LEPAPE, WHOSE DRAWINGS INSPIRED THIS DRESS," LACROIX SAID.)

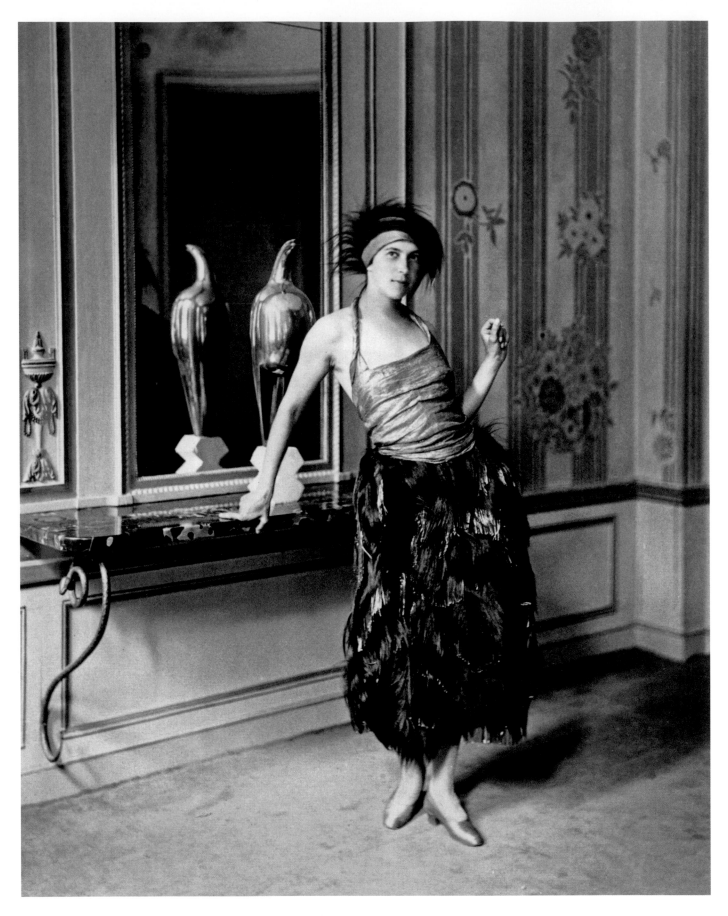

DENISE POIRET (ABOVE) WAS HER HUSBAND'S BEST MANNEQUIN—
A WALKING ADVERTISEMENT WHO, PAUL SAID, CAUSED A
SENSATION WHENEVER SHE STEPPED OUT. IN 1919, SHE WORE AN
EXOTIC (AND REVEALING) LAMÉ–AND–MONKEY FUR COSTUME
TO A PARTY AT HIS CHIC GARDEN NIGHTCLUB, L'OASIS. OPPOSITE
PAGE: NINA RICCI SILVER-FOX CAPE WITH OSTRICH FEATHERS,
DÉGRADÉ BIAS-CUT SILK DRESS, AND SHOES, *VOGUE,* MAY 2007.

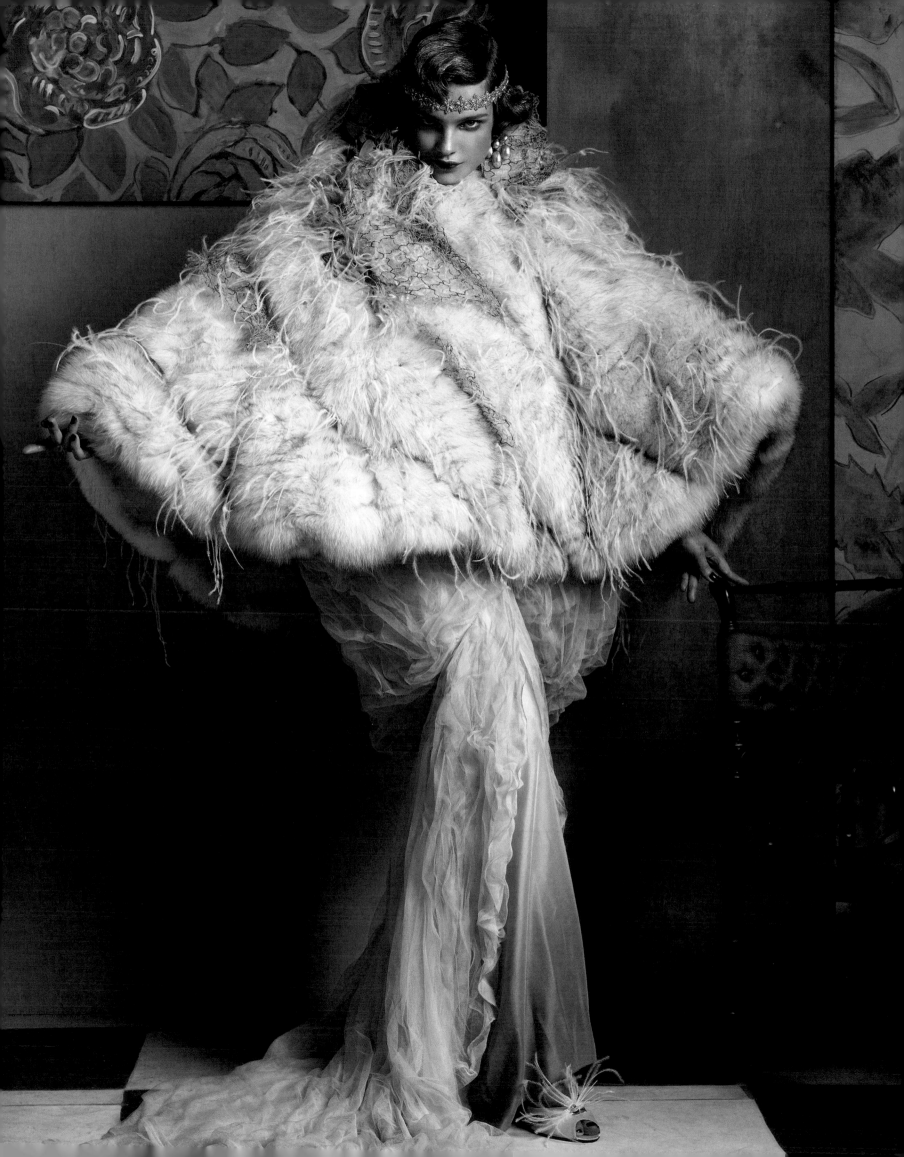

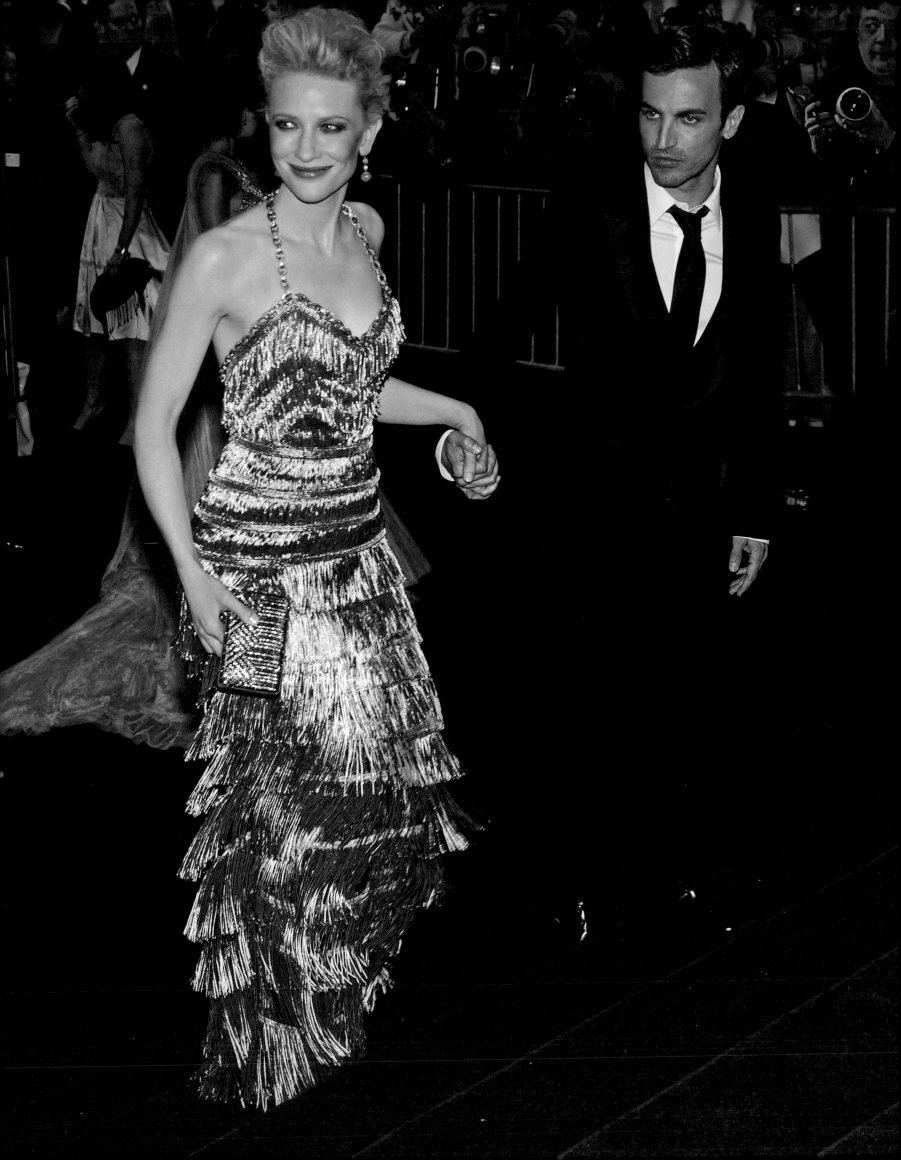

IN THE PUBLIC IMAGINATION, POIRET IS PROBABLY BEST REMEMBERED AS THE ORIGINATOR OF THE LAMPSHADE SILHOUETTE. ACTRESS JENNIFER GARNER (RIGHT) ARRIVED AT THE GALA IN A VINTAGE VALENTINO HAUTE COUTURE EVENING DRESS THAT EVOKED POIRET'S EXTRAVAGANT TASTES. **PREVIOUS PAGES:** THE MUSEUM WAS DONE UP LIKE A PLEASURE PALACE FROM THE TALES OF SCHEHERAZADE. SWINGING LANTERNS AND COLORFUL CUSHIONS, IN PRINTS À LA POIRET, FILLED THE CHARLES ENGELHARD COURT. ACTRESS CATE BLANCHETT (LEFT) AND NICOLAS GHESQUIÈRE OF BALENCIAGA WERE COCHAIRS.

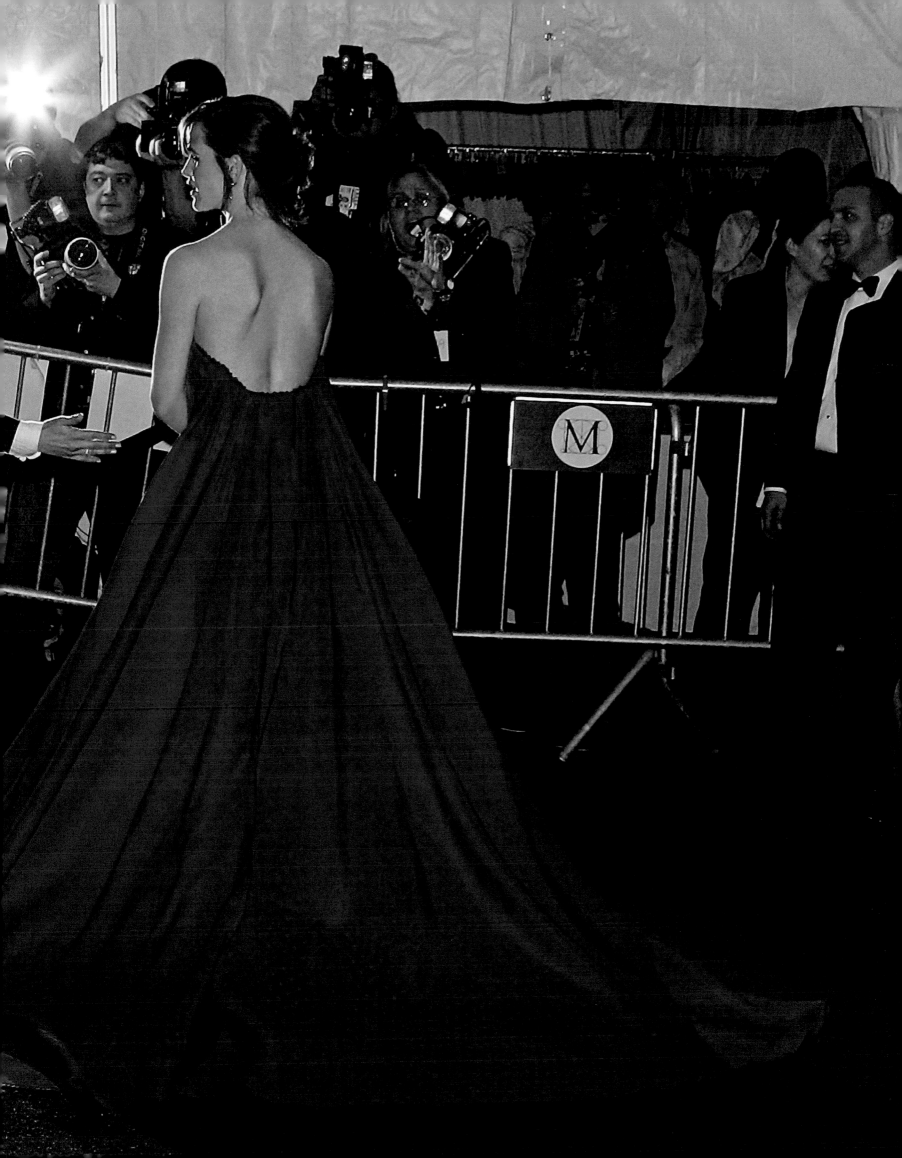

RAINBOW-STRIPED LEATHER-AND-
SILK JAZZ AGE SHIFT, C. 1925.

NAVY WOOL DRESS WITH TROMPE
L'OEIL BUTTON PLACKET, 1925.

POET-SLEEVED SILK, EMBROIDERED
WITH METALLIC THREAD, 1922.

"FLONFLON" OSTRICH HEADDRESS
WORN BY DENISE POIRET, C. 1920.

"PRÉ CATELAN" EVENING WRAP
OF SILK AND GOLD LAMÉ, 1918.

IVORY-AND-BROWN WOOL COAT
WITH BROWN ROSE MOTIFS, 1923.

EVENING LOOK WITH FUR PEPLUM,
GOLD EMBROIDERY, 1924.

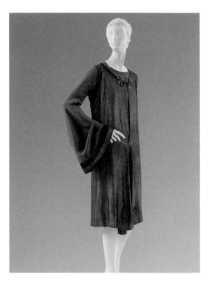

ORANGE SILK BLOUSE UNDER
GOLD LAMÉ JUMPER, C. 1922.

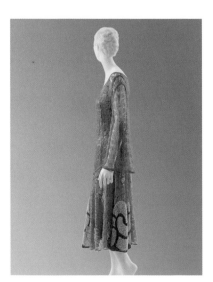

GOLD LAMÉ AND LACE, BEADED
AND FAUX-PEARLED, C. 1925.

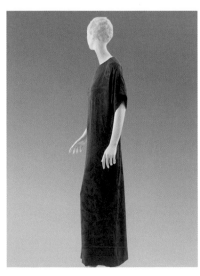

RADICALLY UNSTRUCTURED,
SIMPLE AZURE SILK DRESS, 1912.

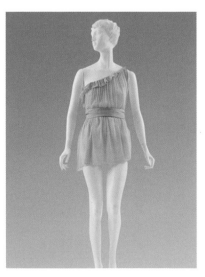

SHOCKINGLY MODERN PALE-
APRICOT COTTON TUNIC, C. 1920.

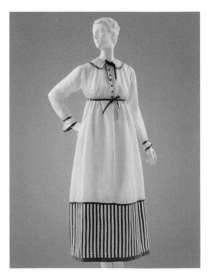

DENISE POIRET'S CORAL-TRIMMED
LINEN DAY DRESS, 1912.

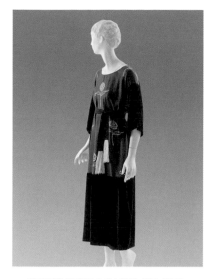

DUFY'S TEXTILE BASED ON PAUL
IRIBE'S ROSE EMBLEM, 1913.

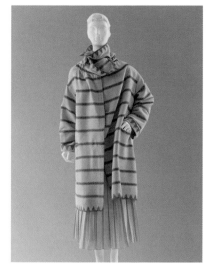

MME POIRET'S MOTORING COAT
OF LINEN AND BLUE SILK, 1912.

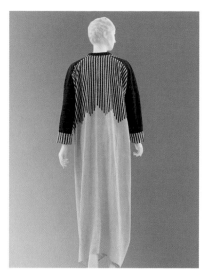

WOOL-JACQUARD DAY COAT
WITH BUNDLING COLLAR, 1918.

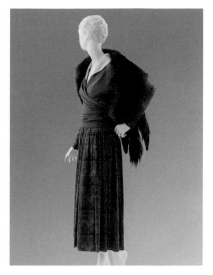

ANKLE-EXPOSING "AUTUMN
LEAVES" ENSEMBLE, 1916.

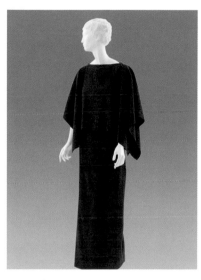

BLOCK-PRINTED SILK DRESS WITH
KIMONO SLEEVES, C. 1922–23.

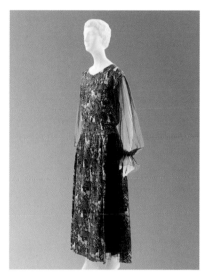

EARTHY-HUED "BOIS DE
BOULOGNE" DRESS, 1919.

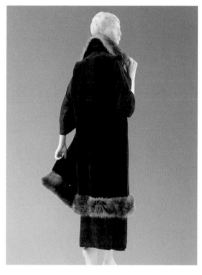

BADGER-TRIMMED
SLEEVELESS COAT, 1912.

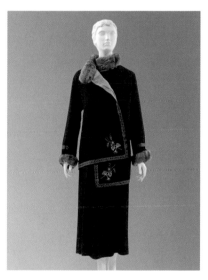

"STEPPE" ENSEMBLE SHOWING
SILK ROAD INFLUENCES, 1912.

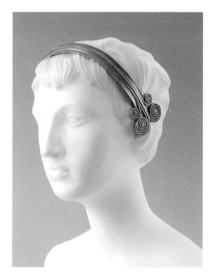

HEADBAND, C. 1910 (A STYLE
MUCH COPIED IN THE TWENTIES).

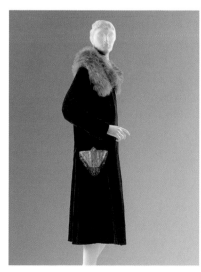

COAT WITH OVERSIZE ROARING
TWENTIES FUR COLLAR, C. 1925.

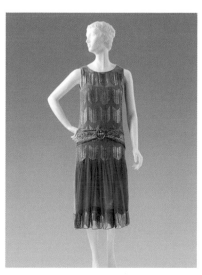

EMERALD CHIFFON WITH GOLDEN-
ARROW FILÉ EMBROIDERY, 1925.

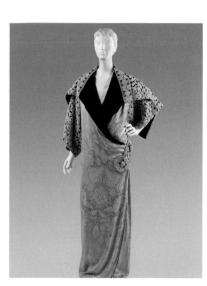

OPERA COAT WITH LOOSE, ASIAN-
INFLUENCED FASTENING, 1911.

SUPERHEROES FASHION AND FANTASY 2008

ACCORDING TO CURATOR ANDREW BOLTON, THE ICONOGRAPHY
OF THE COMIC-BOOK SUPERHERO—CAPE, UNITARD, BELT,
BOOTS—DERIVED FROM THE LATE-19TH CENTURY COSTUMES
SPORTED BY CIRCUS STRONGMEN AND ACROBATS.
OPPOSITE: BERNHARD WILLHELM'S 2006 ROYAL-BLUE DRESS
EMBLAZONED WITH SUPERMAN'S S SHIELD AND MELTED-S
CAPE WITH SHREDDED LEGGINGS, FROM THE EXHIBITION.

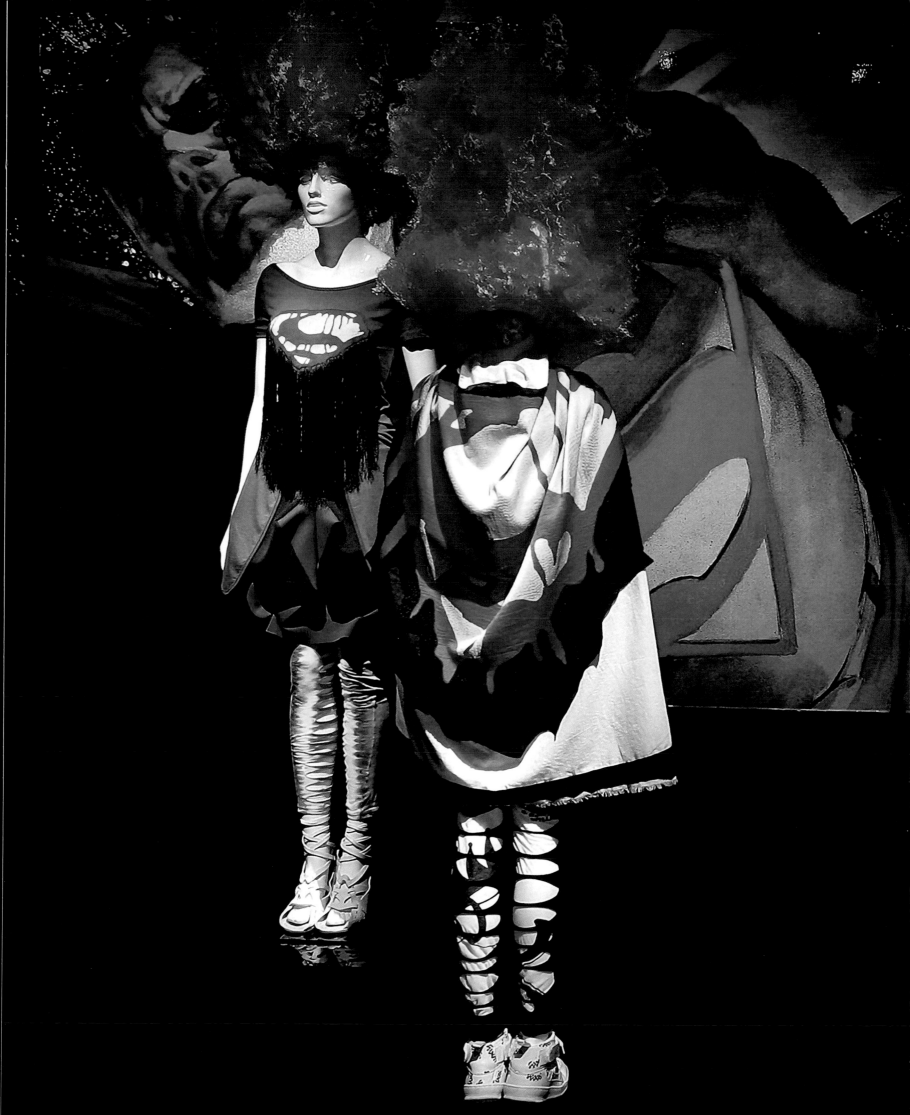

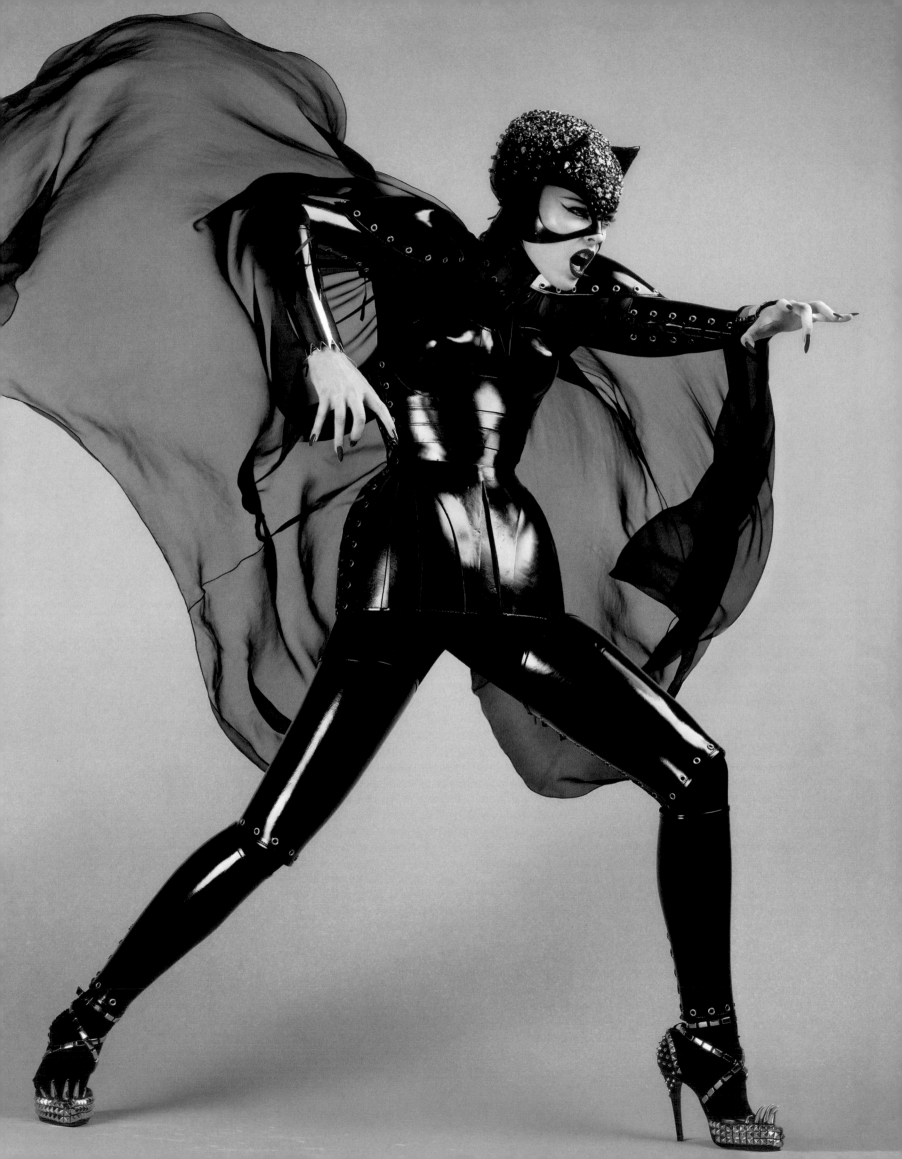

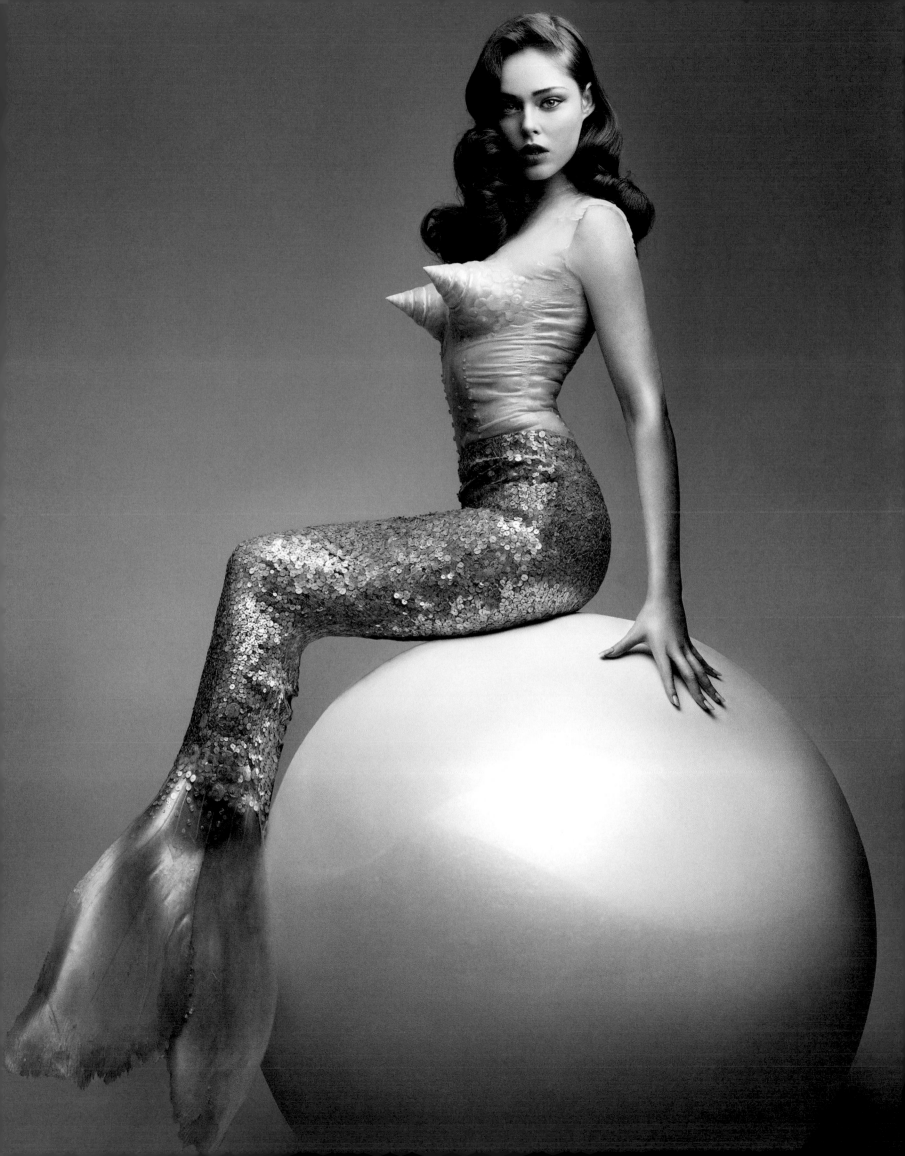

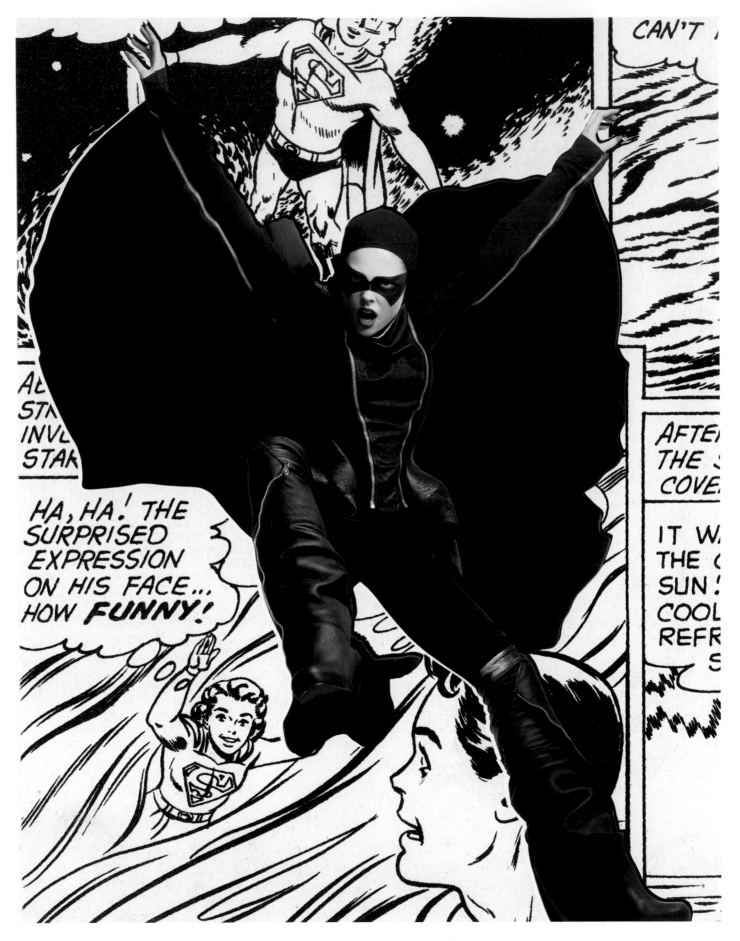

ABOVE: RICK OWENS MADE A ZIPPERED LEATHER-AND-CASHMERE BATMAN
BODYSUIT FOR *VOGUE*'S EXHIBITION-RELATED PORTFOLIO, PHOTOGRAPHED BY
CRAIG McDEAN. RIGHT: THE SHINY SATIN OF THIS ARMANI PRIVÉ SILK DRESS
(FEATURED IN THE MET EXHIBITION) RECALLED THE SILVER SURFER'S METALLIC SKIN.
OVERLEAF: NINA RICCI'S OLIVIER THEYSKENS GAVE THE CAPED CRUSADER'S
ENEMY, THE SUPERVILLAINESS POISON IVY, A LETHAL GREEN ORGANZA BUSTIER
DRESS WITH FEATHER LEAVES AND DROPS OF SWAROVSKI-CRYSTAL VENOM.

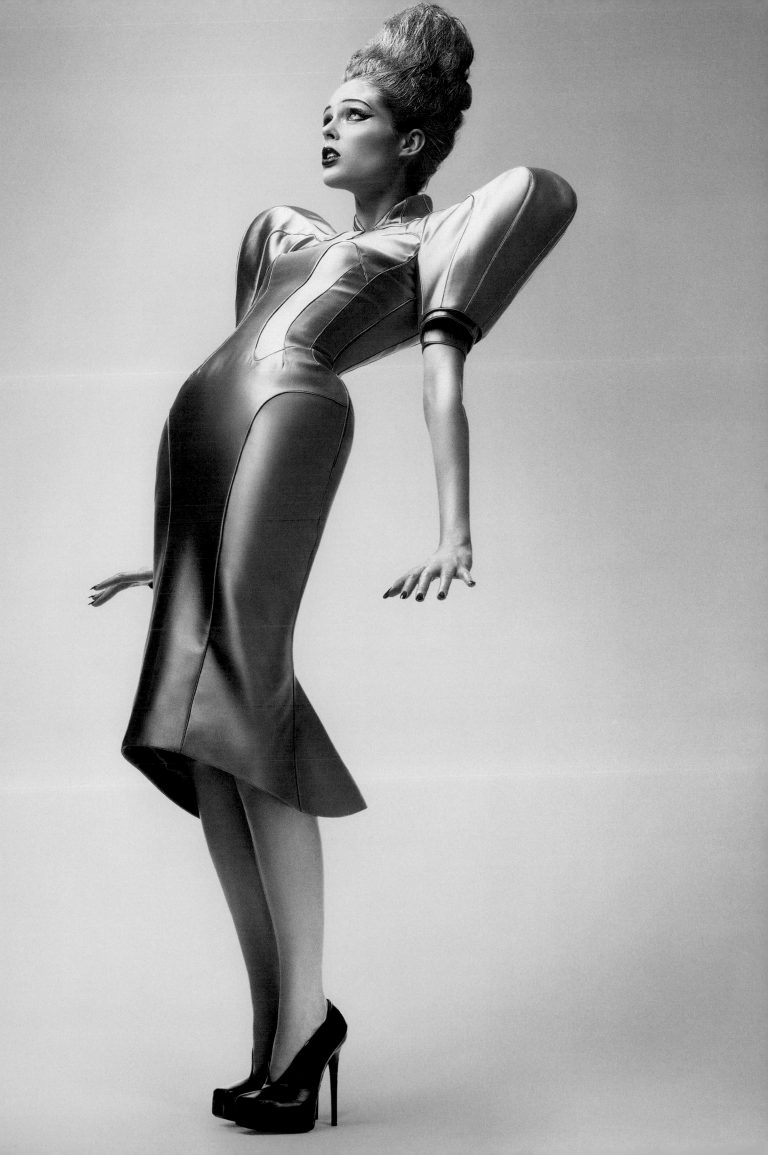

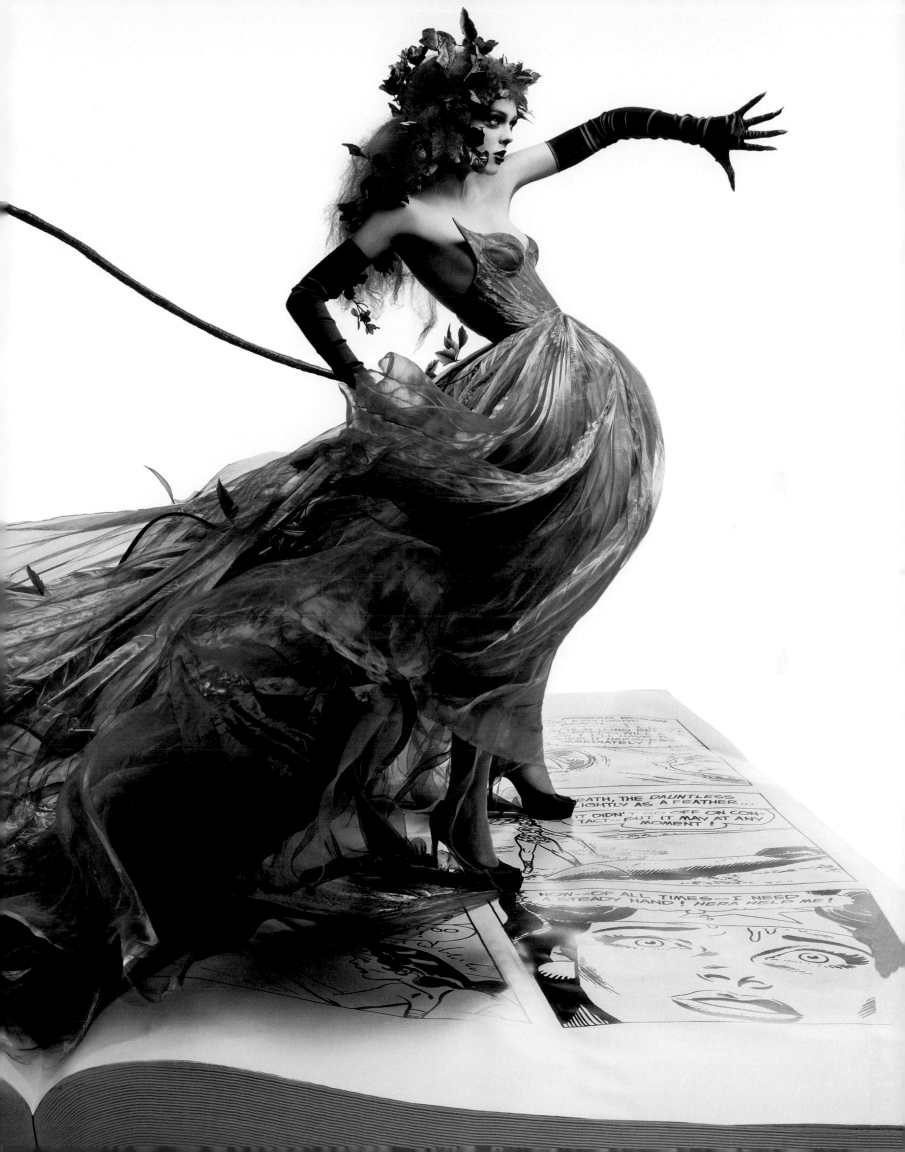

into sky-flying, complete with motors. A fashion parallel is Hussein Chalayan's fall 1999–winter 2000 Airplane dress, a seemingly prim, sleeveless A-line creation mechanized with panels that retract and extend to suggest an airplane landing or taking off. There is also a mock-up of the latest BioSuit for space travel, an innovation that the original creators of superheroes could only have fantasized about.

"The Postmodern Body," personified by the Punisher (1974) and Ghost Rider (1972), is a contemporary take on the idea of graphic signifiers, an eclectic mix of gang fashion and street style. In the apocalyptic world these characters inhabit, their symbols become skulls—as in Alexander McQueen's disintegrating sweaterdress—and flames, like those licking Mugler's 1992 motorbike corset ensemble, complete with built-in handlebars, that represent a collision of "metal and flesh and chromium"—a "Hell's Angel embodiment" suggesting the Ghost Rider's alter ego, stunt rider Johnny Blaze.

Of all fashion designers, perhaps Mugler most literally engaged with the iconography of superheroes through his career, and his oeuvre is represented in sensational pieces from his own comprehensive archive. These include the articulated metal-and-clear-plastic bodysuit (memorably modeled by a robotic Honor Fraser for his fall 1995 show) that reflects "The Armored Body" of Iron Man (1963), and his breathtaking pièce de résistance: his fall 1997 Chimera, lavishly embroidered by Mr. Pearl and bristling with exotic feathers and fur fronds. In its "evolutionary association between reptiles and birds," it parallels "The Mutant Body," represented by Rebecca Romijn's extraordinary reptilian Mystique costume—hundreds of latex scales individually applied to her body, which Bolton describes as "sci-fi couture"—from 2006's *X-Men: The Last Stand*.

Mugler's influence has proved enduring. Nicolas Ghesquière's armored leggings and breastplates from his Here Come the Robots spring-summer 2007 collection for Balenciaga explored futuristic fashion ("The idea of empowering women is a recurring theme in my work," he says. "I liked the idea of a mix between a robot and an Amazon!"), and Dolce & Gabbana seemed to pay homage to Mugler's eighties work in their fall 2007 show. Rick Owens recalls, "When I first got turned on to fashion, it was the time of all of those wonderful Thierry Mugler advertisements photographed by the designer himself. Like his fashions, these drew heavily on arch forties and fifties superhero imagery—wonderful things on tops of buildings, the girls looking like they were about to fall off. That aesthetic has been rumbling under my stuff lately." Owens created a Caped Crusader ensemble for *Vogue* that in true superhero fashion transforms its silhouette through the deft use of zippers. "Fashion is aspirational," he says. "And fashion is about making a more powerful, more sensational you."

As Bolton points out, while most male superhero costumes have mutated through the decades only in the subtlest of ways, the look of the female superheroes evolves with changing fashion ideals. Bolton cites Catwoman, "who has gone through at least nine changes already!" As a forties jewel thief, she is originally depicted in contemporary evening dress, but later in the story line she is a major factor in breaking up Batman's engagement to a socialite, and a sexual dynamic creeps into their relationship. This is paralleled by eroticized accoutrements of black dress, boots, and mask. The dress eventually segued into the high-gloss catsuit with the sprayed-on look, memorably filled by Julie Newmar in the sixties *Batman* television series. Drawing on that imagery and on Mugler's all-powerful eighties Amazons, Domenico Dolce and Stefano Gabbana created a leather Catwoman for *Vogue*. "We love Catwoman!" declare Dolce and Gabbana (who have also referenced Superman and Batman and Robin in their work, though Dolce claims not to have read superhero comics as a child, and Gabbana frankly admits to a preference for Donald Duck). "Catwoman is sexy, feminine. We love the way she moves; it exudes so much strength and personality." Their costume explored the same silhouette as their 2007 collections, with its "many references to the future and to technofabrics." John Galliano in turn looked to Michelle Pfeiffer's own sutured second skin, created for 1992's *Batman Returns* by costume designers Bob Ringwood and Mary Vogt (who described it as "a beautiful sort of dark sculpture"). He mimicked its crude hand stitching (which in plot terms was a device used to indicate that Catwoman Selina Kyle had fashioned it herself) for a dress in his innovative 2001 Dior Haute Couture collection, a deconstructed piece that blended elements of that costume with the attire of a dowdy mid-century librarian and the expensively achieved illusion of thrifty recycling. A Gianni Versace brassiere-and-hotpants ensemble, lashed with buckled straps, plays more explicitly with the fetishistic elements of Catwoman's wardrobe. Bolton calls this section "The Paradoxical Body"; Koda explains, "The cat is sweet, cuddly, and warm but also has this other wild side. Like sadomasochistic play, it's about control and release; a confrontation of instinct."

In Olivier Theyskens's poetic hands, Poison Ivy (née Pamela Lillian Isley, she first appeared in a Batman adventure in 1966) is another female character who has been given a thoroughly-of-the-moment makeover for *Vogue*'s portfolio. "For my summer collection I had been thinking about a girl at a rave party but surrounded by nature, so I love Poison Ivy, who is coming from nature herself. I wanted to use supertechnological fabrics, but I still wanted her to be superfashionable, like a poison-ivy plant but in a very glamorous gown. I cut feathers like leaves and put Swarovski crystals at the end of those leaves, symbolizing the poison drops." Theyskens is excited by the exhibition as an opportunity to study an aspect of American culture he is not familiar with. When he was a child growing up in Belgium, the nearest Theyskens came to the concept was Legume Man—"a supertomato with carrots for hands!" Ghesquière, on the other hand, was fascinated with the Fantastic Four, Silver Surfer, and Iron Man in his youth. "I love that The Met is celebrating the influence this aesthetic has had in fashion," he says. "On a more subliminal level, the fact that fashion is supposed to always be looking forward makes the idea of superheroes and sci-fi very relevant."—HAMISH BOWLES, *VOGUE*, MAY 2008

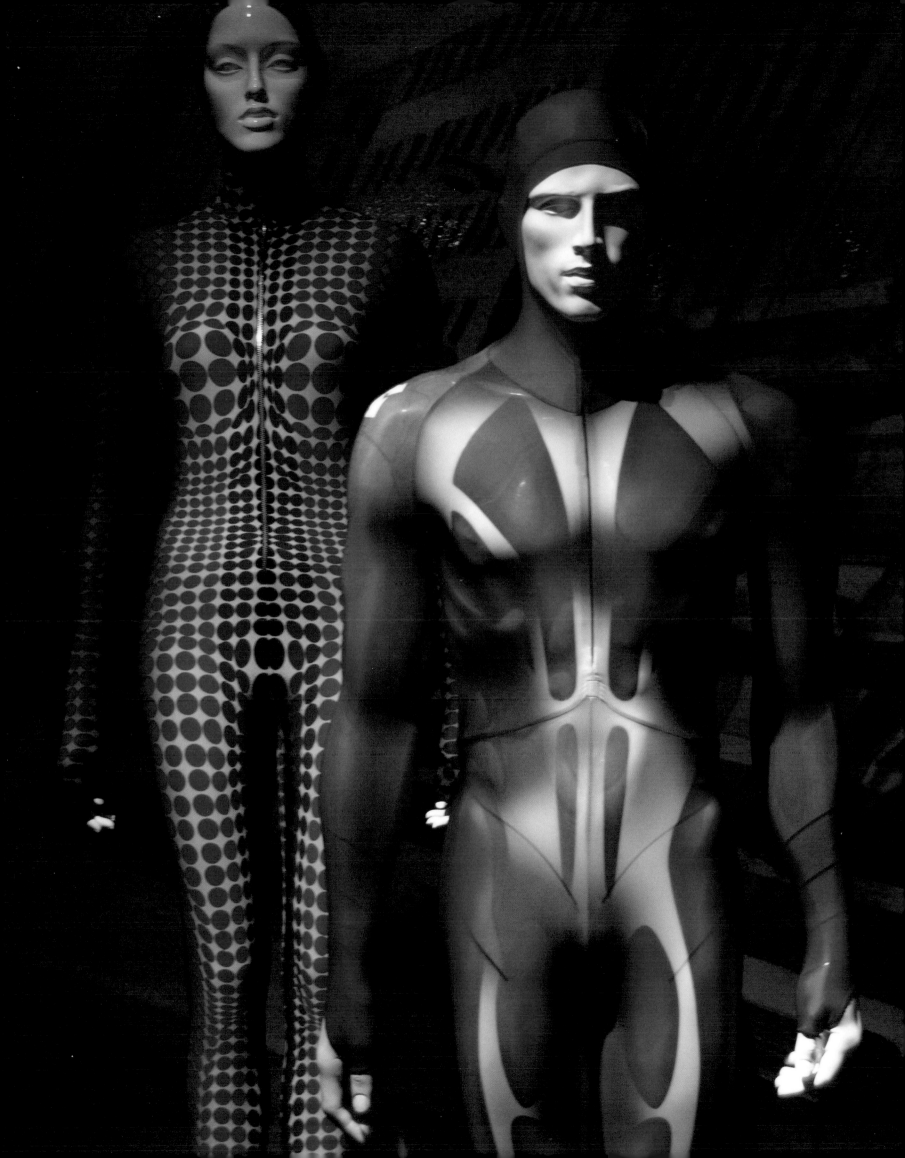

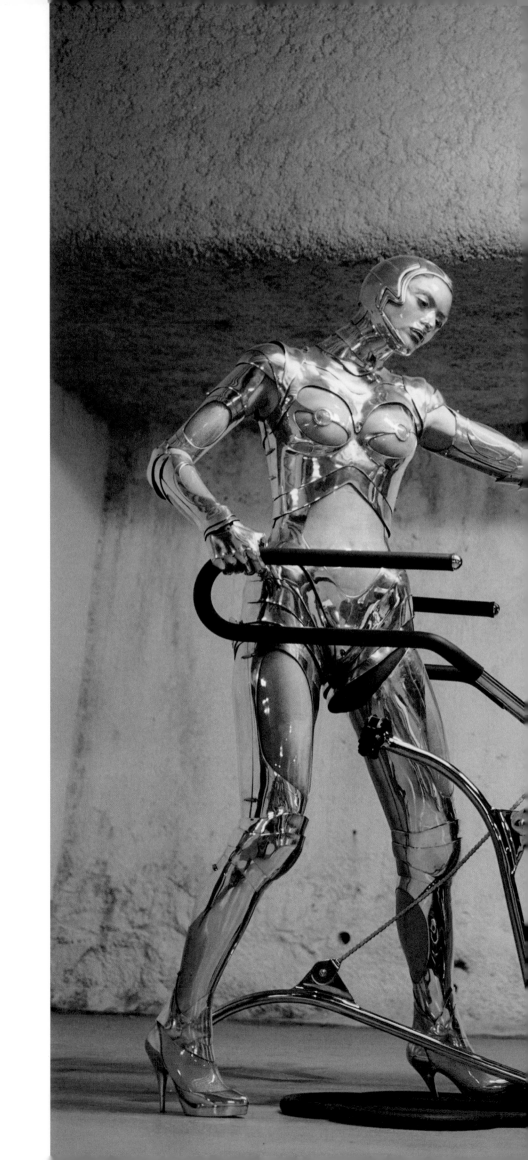

THE ARMORED BODY DISPLAY EXAMINED EXOSKELETONS,
LIKE BATMAN'S OR IRON MAN'S, THAT PROTECT WITH
PADDING OR A HARD SHELL. THIERRY MUGLER'S METAL-
AND-PLASTIC VISION (FAR LEFT, IN A NOVEMBER 1995
VOGUE PHOTOGRAPH BY HELMUT NEWTON) WAS ONE
OF SEVERAL AVANT-GARDE RUNWAY LOOKS IN WHICH,
AS THE CURATORS SAID, "MUSCLE AND METAL, SKIN AND
CHROMIUM COALESCE." **OVERLEAF:** PARTY COCHAIRS
JULIA ROBERTS (IN ARMANI), GEORGE CLOONEY, AND
GIORGIO ARMANI, PHOTOGRAPHED BY MARIO TESTINO.

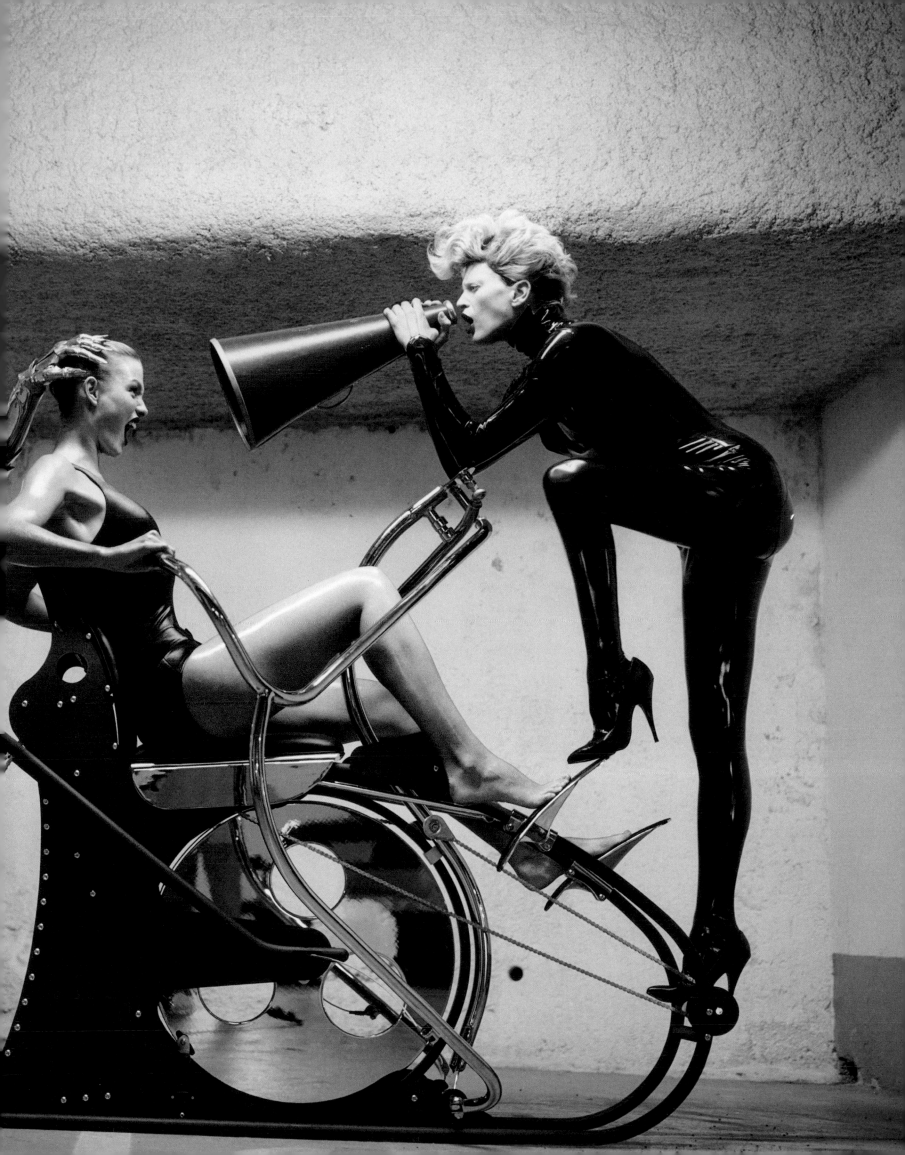

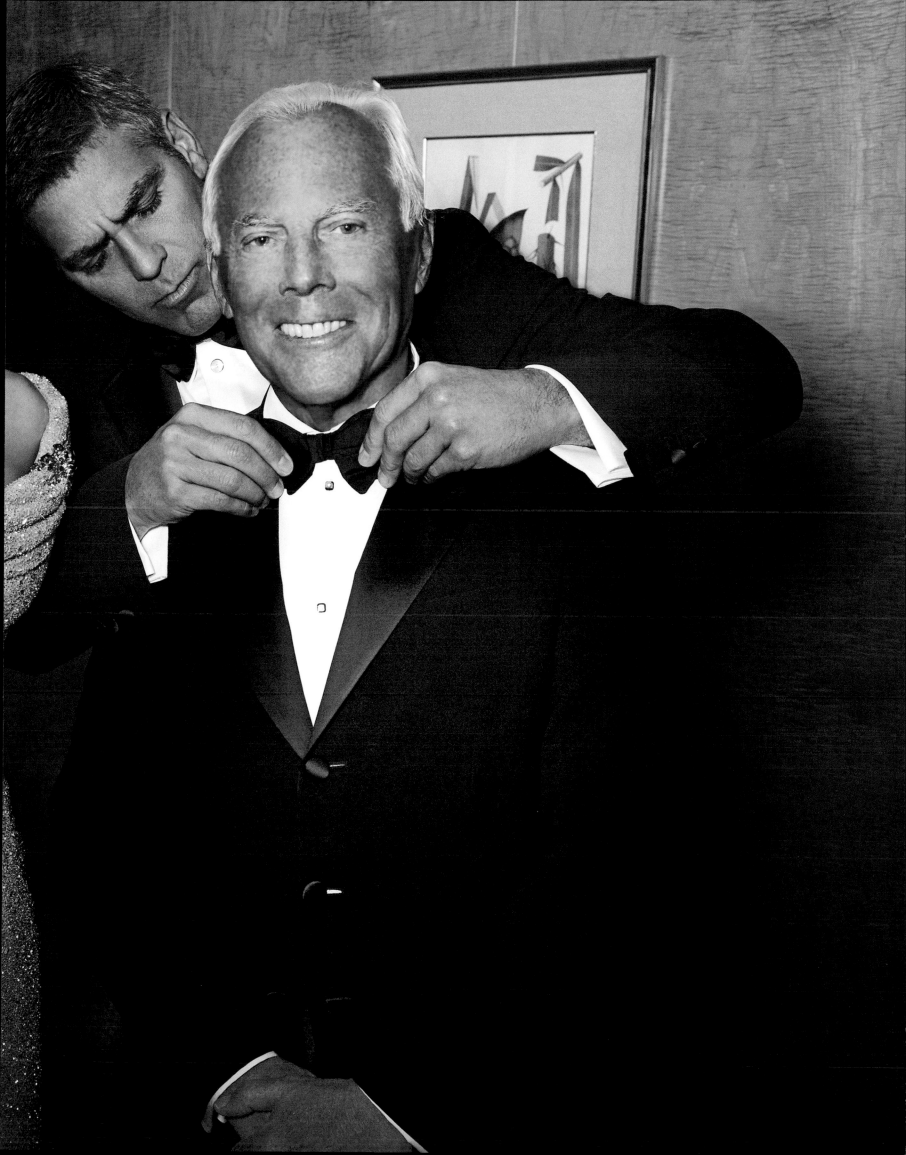

CAPES, CATSUITS, AND COBWEBS

UNITARD WITH BACKPACK
PROTUBERANCE, AS FOUR, 2003.

WILD & LETHAL TRASH BY WALTER
VAN BEIRENDONCK, 1997.

THE PATRIOTIC BODY:
BERNHARD WILLHELM, 2008.

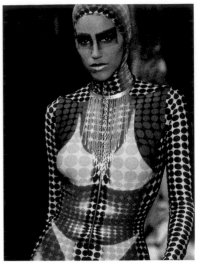

JEAN PAUL GAULTIER PIXELATED
BODYSUIT, 1995.

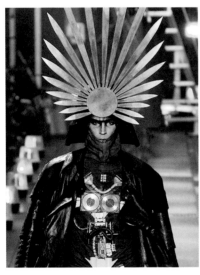

JOHN GALLIANO'S ARMORED
ANTIHERO, 2007.

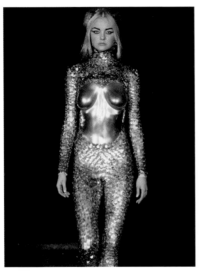

HALF HUMAN, HALF FISH,
ALEXANDER McQUEEN, 2007.

BERNHARD WILLHELM'S
EXAGGERATED MUSCLES, 2004.

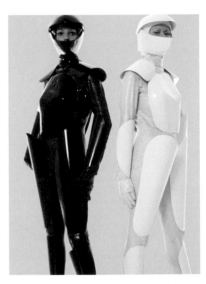

SPACE-AGE WARRIORS, RUDI
GERNREICH, 1973.

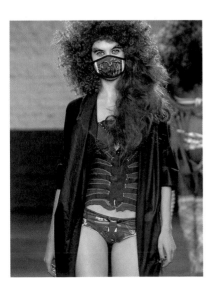

SPIDER-MAN SURGICAL
MASK, NOKI, 2008.

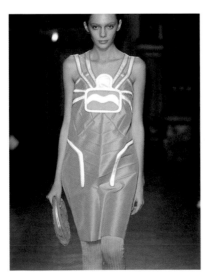

SPIDER LEGS AS STRAPS,
UNDERCOVER, 2008.

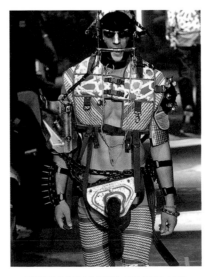

POSTAPOCALYPTIC ARMOR AND
CODPIECE, JOHN GALLIANO, 2008.

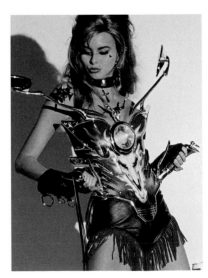

THIERRY MUGLER MOTORCYCLE
BUSTIER WITH HANDLEBARS, 1992.

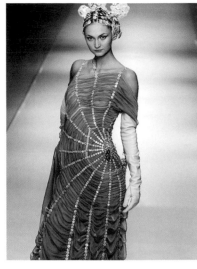

WEB AS GRAPHIC ELEMENT,
GAULTIER, 2003.

CAPITALIST ANTIHERO, VAN
BEIRENDONCK, 2006.

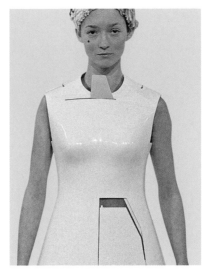

MECHANICAL-LEVER SHIFT,
HUSSEIN CHALAYAN, 1999.

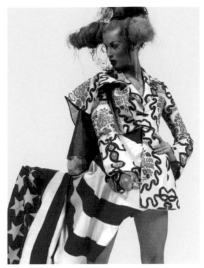

ALL-AMERICAN HEROINE,
JOHN GALLIANO, 1993.

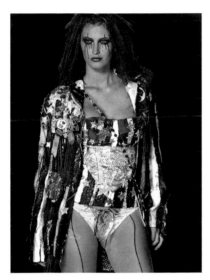

PATRIOTIC HERO, DIOR
HAUTE COUTURE, 2001.

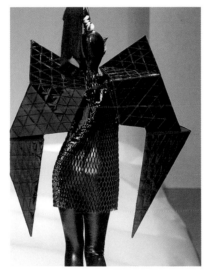

TRANSFORMER DRESS,
GARETH PUGH, 2007.

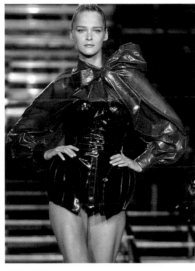

DOLCE & GABBANA
PEPLUM BUSTIER, 2007.

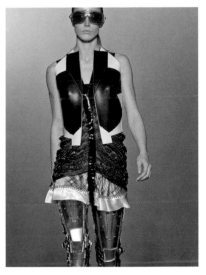

ARTICULATED LEG COVERINGS,
BALENCIAGA, 2007.

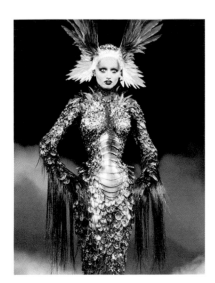

MUTANT LOOK, THIERRY MUGLER
HAUTE COUTURE, 1997.

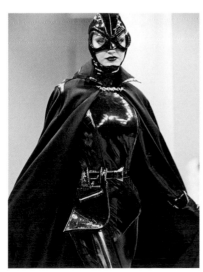

MUGLER'S CAPED-CRUSADER
CATSUIT, 1996.

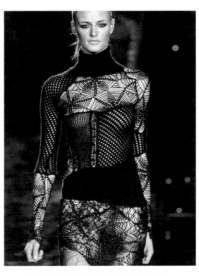

SPIDER-WOMAN COBWEBS,
JULIEN MACDONALD, 2003.

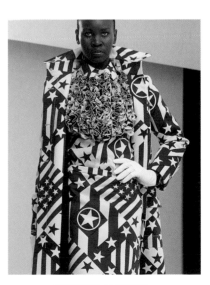

CAPTAIN AMERICA,
VIKTOR & ROLF, 2000.

THE MODEL AS MUSE
EMBODYING FASHION
2009

KNOCKING MOVIEGOERS OUT OF THEIR SEATS WITH HER RED-HOT CAMEO IN *BLOW-UP*, VERUSCHKA SCHOOLED AMERICANS IN THE POWER OF A MERE MANNEQUIN. BORN A PRUSSIAN COUNTESS—VERA GOTTLIEBE ANNA, GRÄFIN VON LEHNDORFF-STEINORT—SHE CREATED A NEW PERSONA ON ARRIVAL IN MANHATTAN AND CAME TO EMBODY THE LIBERATED, "SPACE ODDITY" SEXUALITY OF THE MID-SIXTIES. STYLED TO LOOK LIKE SHE'D BEEN TO THE MOON, WITH DYNEL LASHES, SHE WAS PHOTOGRAPHED BY IRVING PENN FOR *VOGUE*, JUNE 1, 1966.

ARTHUR ELGORT CAPTURED
LISA TAYLOR AS SHE DROVE
A MERCEDES ACROSS THE
GEORGE WASHINGTON
BRIDGE FOR AN OCTOBER
1976 *VOGUE* BEAUTY
PORTFOLIO. HE AND
SITTINGS EDITOR POLLY
MELLEN HUNG OUT THE
WINDOW OF A SECOND
CAR, YELLING INSTRUCTIONS
AND CLICKING AWAY. LATER,
CONDÉ NAST'S EDITORIAL
DIRECTOR, ALEXANDER
LIBERMAN, CALLED THE
IMAGE REVOLUTIONARY FOR
THE WAY IT CAPTURED THAT
SPECIAL 1970s REALNESS:
"IT HAD SOMETHING I
ALWAYS HOPED TO FIND
IN THE PHOTOGRAPHY OF
WOMEN—A MODERNITY."

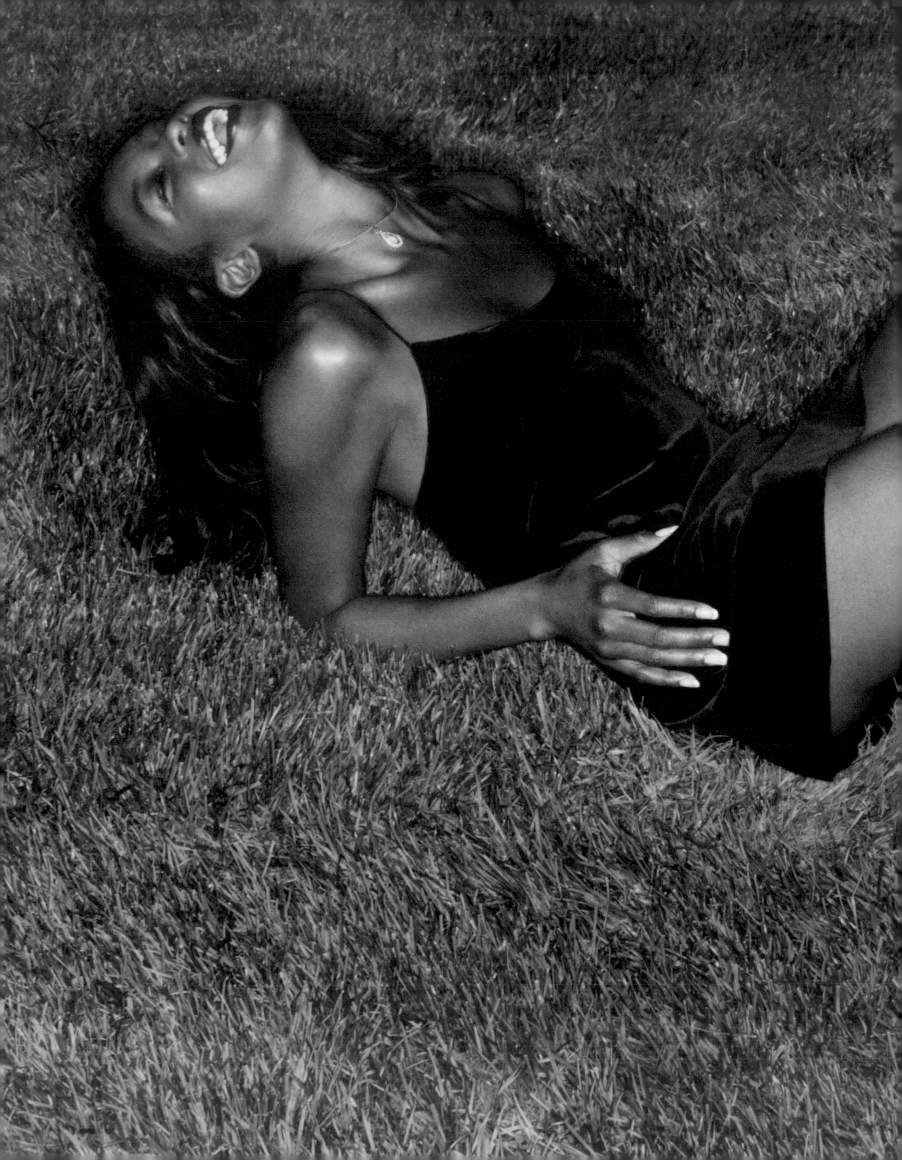

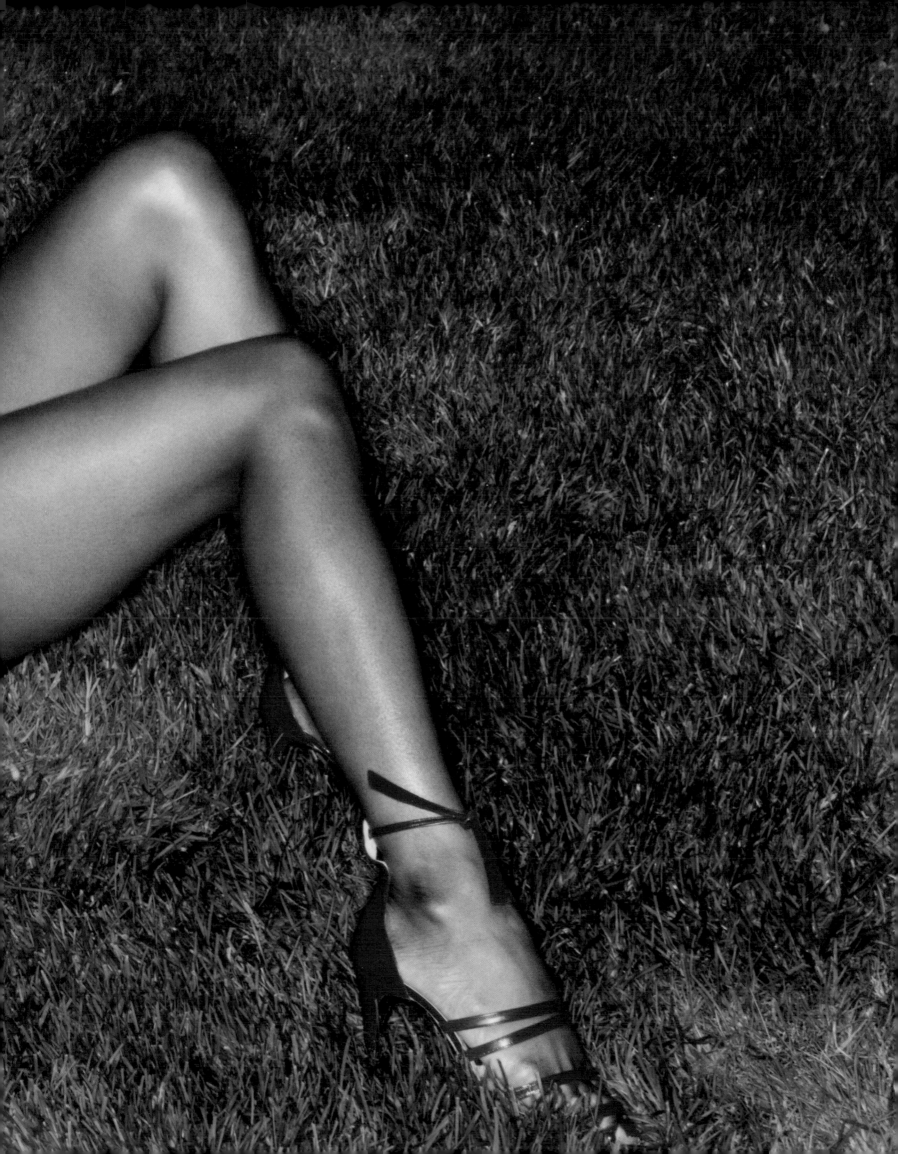

The Model as Muse: Embodying Fashion" explores 50 years of iconic fashions—from Christian Dior's blossoming New Look of 1947 to the reductive simplicity current in the late nineties—through the women whose faces, figures, and attitudes shaped and personified them. Curated by Harold Koda and Kohle Yohannan, the exhibition, designed by John Myhre (whose art-direction credits include the films *Dreamgirls* and *Chicago*), is sponsored by Marc Jacobs, who is as acutely sensitive as any designer working today to the potent impact of models and muses—be they historical, fictional, or completely real and of the moment.

The Costume Institute's exhibition opens with the *Funny Face* era of flawlessly poised models like Lisa Fonssagrives, Dorian Leigh, Suzy Parker, Dovima, and Sunny Harnett, who projected moneyed maturity in the corseted constructions of designers such as Dior and Charles James. Visitors to the exhibition are greeted by a re-creation of Avedon's iconic 1955 photograph of Dovima striking a pose between rearing elephants. Before it is a variant of the dress that she wears in the image—the first design that the young Yves Saint Laurent created for Christian Dior, the stem-slim sheath of black velvet sashed under the bust with a flourish of pearly satin, that established him as the great designer's dauphin. A gaggle of James ball gowns, meanwhile, evokes Cecil Beaton's famed 1948 tableau of the designer's masterworks, worn by sophisticated models dripping with mid-century hauteur. For Koda, it is Jean Shrimpton who bridged the gap between this worldly sophistication and the Youthquake energy of the sixties. The stiff, space-age clothes of Pierre Cardin, Paco Rabanne, André Courrèges, and Rudi Gernreich—and some of the original sculptural costumes from William Klein's 1966 art-movie spoof of the fashion world, *Qui Êtes-Vous, Polly Maggoo?*—reflect the age of Peggy Moffitt, Veruschka, Twiggy, and Donyale Luna, the first black supermodel.

The paradigm shifted once more in the seventies, when "body-grazing clothing provided a disclosure of the body that was unprecedented and required a different type of woman to carry it," as Koda explains. A new era of athletic, all-American beauties—Lisa Taylor, Patti Hansen, Jerry Hall—"frequently seen in dark and sexual scenarios" by photographers like Helmut Newton and Guy Bourdin, is represented in a "face-off between the simplicity and minimalism of the clothes of the Halstonettes and the fantasy of the Saint Laurent girls, with their transparent blouses and Gypsy skirts."

The eighties represented the apotheosis of the supermodel, with design houses like Chanel and Versace introducing a new breed of girls whose first names were identifier enough—Linda, Christy, Naomi, Cindy, Claudia.

Koda will showcase Jacobs's infamous grunge-inspired collection designed for Perry Ellis in 1992 (Jacobs was fired soon after, and the collection itself was never produced), and Kate Moss's embodiment of it, to illustrate a movement away from the Amazonian glamour of the first generation of eighties supermodels. "While her face could clearly be a part of that supermodel world," Koda explains, "her gamine-like proportions were a repudiation of the supermodel."

Ironically, of course, Moss was to become perhaps the most iconic supermodel of them all. "Her incredible personal style is what put Kate Moss up there on the Olympus of supermodeldom," wrote *Vogue* in September 2004, "inhabiting that special peak of fame reserved for the few who have crossed over to become pop-cultural goddesses."

Although Moss has transcended fashion to become a global brand herself and a muse to artists, including Lucian Freud and Marc Quinn, she continues to resonate in the fashion world. For his William Rast clothing line—a tribute to America as "a melting pot of

THE GALA INVITATION FEATURED AN AUGUST 1, 1967, *VOGUE* PHOTOGRAPH OF TWIGGY, BY RICHARD AVEDON. WITH HER DOELIKE FEATURES AND RAKE OF A BODY, SHE WAS BORN TO WEAR THE ANDROGYNOUS DESIGNS OF SWINGING LONDON. **PREVIOUS PAGES:** NAOMI CAMPBELL, 1994. WITH HER CLIQUE OF SUPERDIVA 1990s MODELS— KICKING UP THEIR HEELS IN GEORGE MICHAEL VIDEOS AND MISBEHAVING IN THE PAGES OF THE *ENQUIRER*— CAMPBELL, HERE PHOTOGRAPHED BY JUERGEN TELLER (*VOGUE*, SEPTEMBER 1994), PROVED THAT IT WASN'T JUST ON-FILM PERFORMANCE THAT COULD CAPTURE THE ZEITGEIST.

cultures, the blending of Europe and Britain and everywhere"—Justin Timberlake cites Moss's style as a primary influence. Jacobs echoes this refrain. "It could be looking at an old forties *Vogue*," he says of the sparks that kindle his ideas. "Or it could be having just seen an art show, or it could be what Kate Moss wore last night at a fabulous party. There's been so much written about her personal style. But it isn't her personal style that interests me, it's her person; it's the life and the spirit."

The impact of such muses—some enduring, others ephemeral—on Jacobs's creative process as he put together his fall-winter 2009 collections for both Marc Jacobs and Louis Vuitton seemed absolute. "A collection is just that—a collection of thoughts, ideas, and experiences, trials and errors, editing and adding," Jacobs told me. "It's something that unfolds." But at some point in this process, for every collection, a muse emerges.

This fictional character may be *The Great Gatsby*'s Daisy Buchanan, Violet Incredible from *The Incredibles,* or a Tim Burton heroine. "All of those characters remind me very much of the spirits and personalities of girls that I've loved, and who have become friends and muses—these fallen angels," he said. "So whether it is Kate Moss or Winona Ryder, it's the imperfection that I find so beautiful. The flaw, their Achilles heel, is as interesting as the perfection.

"What really informs our choice is a personal connection," adds Jacobs. "Besides having a look or a style, these women have a lifestyle. If Naomi [Campbell] were very well behaved and always on time, and didn't have her little tantrums, I don't know that she'd still be around and traveling like Elizabeth Taylor with an entourage."

In January, when Jacobs was in the midst of thinking about his latest collections, he threw a party to celebrate the late Stephen Sprouse, with whom he collaborated on artwork for Vuitton accessories. Icons of Sprouse's era—Debbie Harry and Maripol among them—came to celebrate. "There was just a kind of force and power and energy. I guess I miss that sort of dynamic," Jacobs told me soon after, and his mind turned to the women who defined the joie de vivre of the eighties, the downtown divas who ruled the nightclub scene when he first experienced it himself, as a fifteen-year-old stock boy at the achingly cool fashion boutique Charivari.

"What I'd like to do," he said a month before the collections, when his fabrics were in development and his design teams in Paris and Manhattan were working to interpret his briefs, "is, through rose-colored glasses, to look at New York in the way I remembered it, not the way it really feels right now, because to me it's not the most happy place in the world at the moment. But I know that there's a vitality here, there's an energy, and anybody can be whatever they want to be. The idea of fearless risk-taking, creative, energetic youth and beauty is what the high times of New York are about. We have this gift in fashion—we can kind of pretend it is that way!"

On his New York inspiration board for the collection, Jacobs had pinned these images: Vivienne Westwood's 1987 mini-crinis; early Gianni Versace wrappings and Comme des Garçons draping; Thierry Mugler's Flash Gordon goddess dresses; and, everywhere, Amy Arbus's photographs of club kids and Maripol's Polaroids of the women who ruled the Manhattan night, including Teri Toye, Stephen Sprouse's transgendered, Warholian muse with the bangs and curtain of ironed peroxide hair, and Madonna when she first hit town in her oversize man's coats and leggings.

But there are other influences at play, too. Jacobs has just returned from a rare holiday in St. Barth's, which made quite an impression. "To see girls almost nude, with just a little dress on, and going to a party that finishes at midnight, but as if it had gone all night long, I thought, Why would anyone bother with anything else?" he says. "The ease of being on vacation—how does one translate that?"

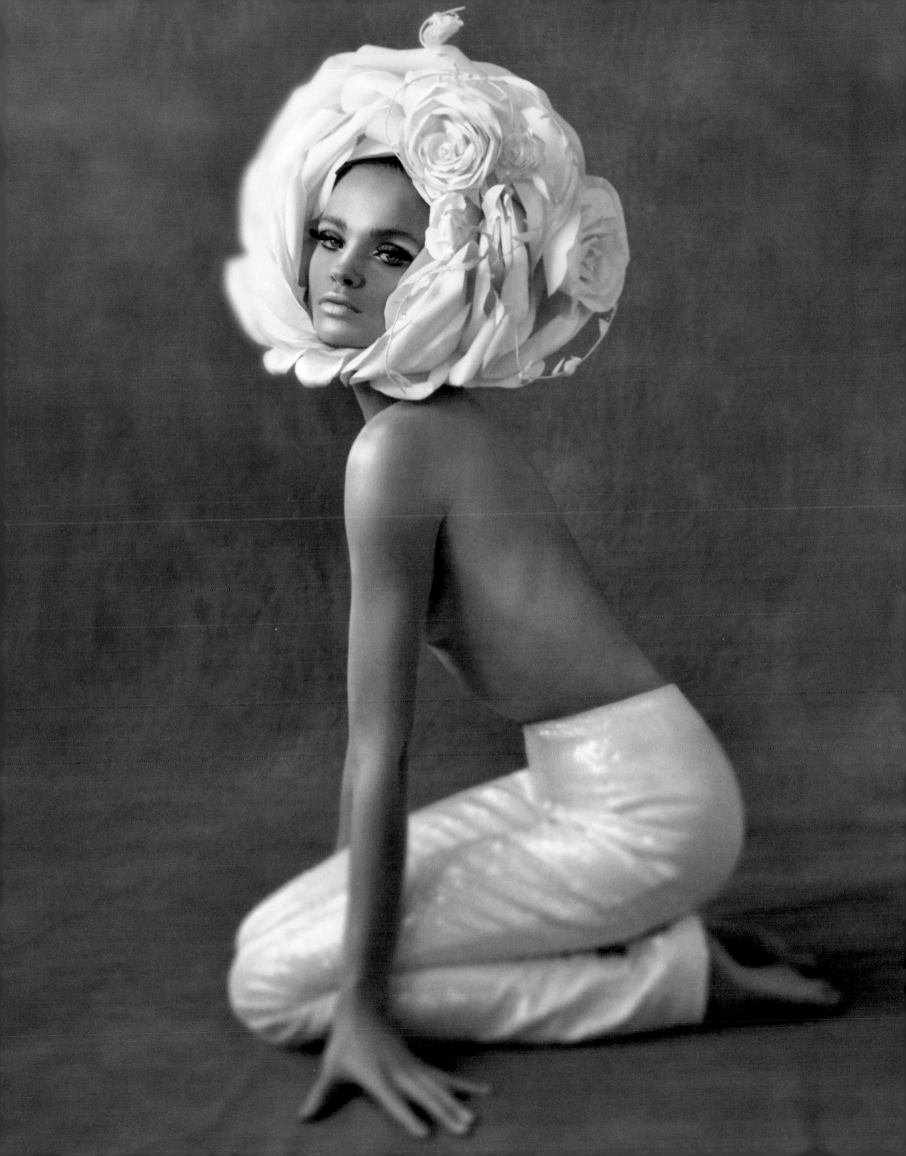

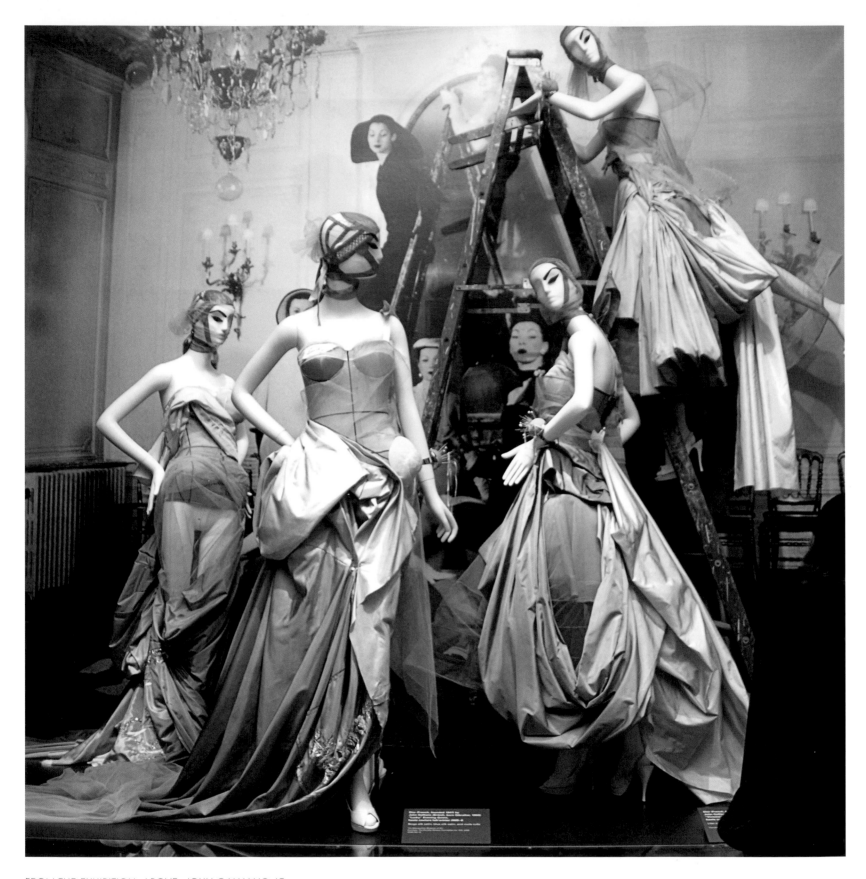

FROM THE EXHIBITION, ABOVE: JOHN GALLIANO AT
DIOR, 2005, CONJURED THE *MANNEQUINS CABINES* OF
THE GREAT COUTURE HOUSES A HALF-CENTURY EARLIER.
OPPOSITE: GIORGIO DI SANT'ANGELO STRETCH MESH
DRESSES, 1988–91. **PREVIOUS PAGES:** NATALIA VODIANOVA
CHANNELED HER FOREBEARS IN STEVEN MEISEL'S MAY 2009
VOGUE PORTFOLIO, PLAYING TWIGGY AND VERUSCHKA.

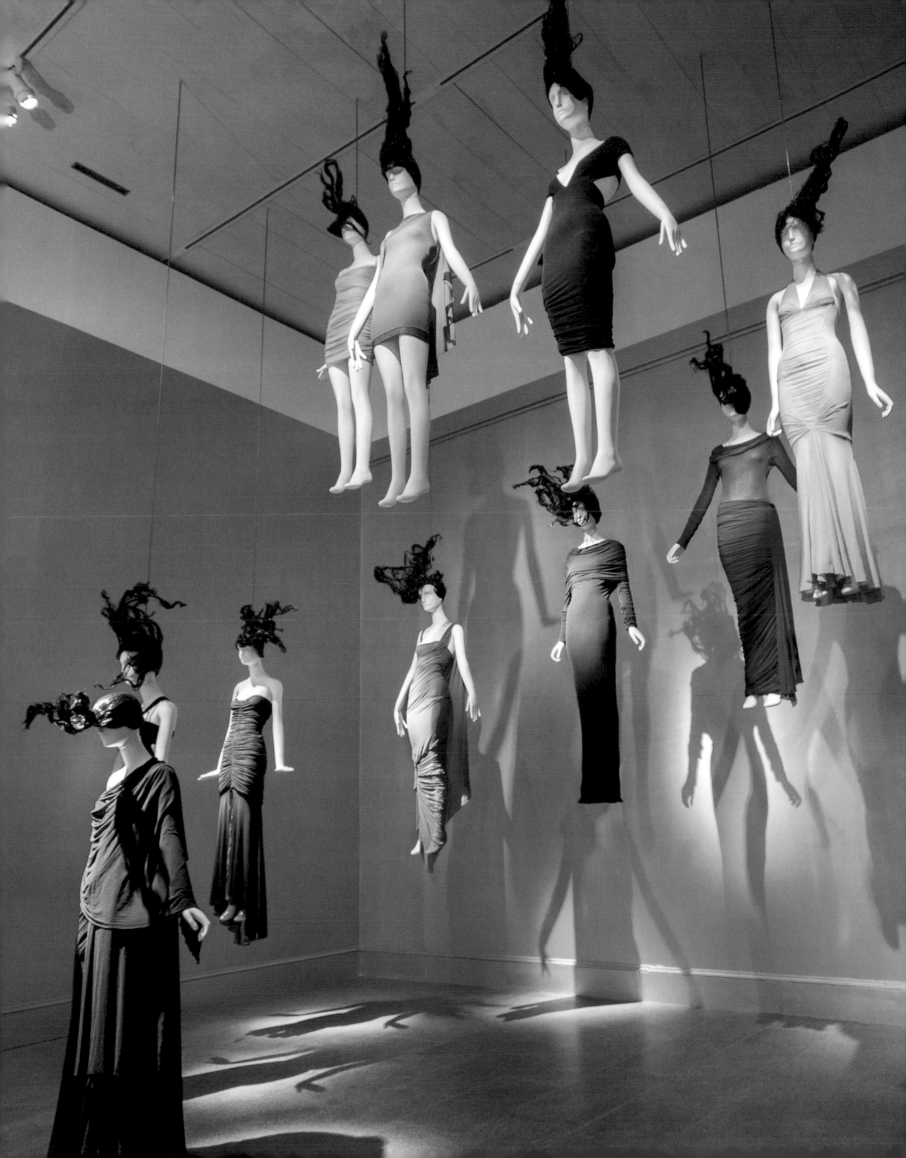

Because of his involvement with the Costume Institute gala, Jacobs initially discussed including long dresses in his show. "Since watching the Golden Globes, I thought, There's absolutely nothing more tedious than a long, strapless dress to the floor in a mermaid shape. I can't bear it. It doesn't look young, it doesn't look glamorous—it's just old. It's become a generic experience." Instead, Jacobs experienced something of an epiphany when he saw the 1967 *Vogue* Avedon image of Twiggy, wearing a simple metallic minidress (it will be used in The Costume Institute's exhibition). "I thought, There's something about that little dress. . . ."

The weekend before his show (at 8:00 P.M. on Monday) is a period when, in a frenzy of activity and endless decision making, the runway collection really comes together, with 40 tailors and dressmakers working often literally through the night, and the soft-spoken English stylist Venetia Scott and head designer Joseph Carter working with Jacobs and the team to execute his vision. Jacobs is extraordinarily focused but as droll as ever. He raises an eyebrow as the girls are fitted in their clothes that evoke the glory days of Sprouse and Lacroix. "I don't know," he says playfully. "Feels terribly *aujourd'hui* to me!"

Even when Jacobs's references have their roots in the past, as with this season, it is the models who animate his creative process and bring his looks firmly into the twenty-first century. "Each girl walks in, and you kind of color them," Jacobs explains. "You put clothes on them that seem attractive or interesting for their coloring, and also for their character. You couldn't put together 50 looks without 50 different girls: one look on each girl. And you have no time to think about it, so they're very immediate and spontaneous things. That does give it a freshness, and it doesn't feel too studied or too contrived, even if the looks are perfect in the end."

This season, hairstylist Guido Palau and veteran visagiste François Nars have been asked to create an individual look for each of the 61 girls in the show, and inevitably they play up their resemblances to some of the icons Jacobs has been thinking about in his design process. Georgie Badiel looks uncannily like Mounia, the Martinique-born beauty who was the Yves Saint Laurent runway star in the seventies and eighties. Tao Okamoto suggests Tina Chow, and with her bangs and ironed hair, Alana Zimmer evokes the gangly Teri Toye. Meghan Collison looks uncannily like Debi Mazar in an early Madonna video, Karolin Wolter is channeling Michelle Pfeiffer in *Married to the Mob,* and Colette Pechekhonova looks like Scarlett, the terrifying door girl at the London Cha Cha Club, who was famous for brandishing a hand mirror to reflect the hapless and inaptly dressed and asking them, "Would you let yourself in?" Musician Jamie Bochert, who inspired Jacobs's acclaimed spring-summer 2009 collection, was initially given an elaborate forties wave and victory roll during her fitting, but Jacobs wasn't feeling it any more than she. "More rock, less rinky-tinky," he commanded during the hair test, and her signature grungy Patti Smith look was back for the runway.

"I'm so happy," says Jacobs the night before his show. "I think it's going to be horribly vulgar in a charming sort of way!"

"It's exciting that each girl has her own touch," said Raquel Zimmermann backstage at the show, "so we don't look like clones!"

A little more than three weeks after his dynamic Marc Jacobs show, the designer unveils his Vuitton collection. Here, Jacobs is also thinking about the girls who just wanted to have fun in the seventies and the eighties, dancing on the lip of the volcano as the economy imploded. This time, however, Jacobs's inspiration boards are pinned with images of the women who ignited not the Manhattan but the Parisian nightclub scene, who danced on tables at Club Le Sept and who posed on the Garouste & Bonetti chairs at Le Palace, the models and socialites whose beauty and presence and style influenced the designers who defined those decades. "Giddy, Parisian, fun" is Jacobs's mantra for the show.

On his inspiration boards are Loulou de la Falaise as a waifish vamp in a drapey camouflage jersey dress and fox boa from Yves Saint Laurent's notorious forties-coquette collection of 1971. A steely Wallis Franken channeling Chanel in Mademoiselle's apartment at the Ritz. A dramatic Paloma Picasso in Saint Laurent's lipstick-red fichu, with her iconic blunt haircut and gash of scarlet lips. A wistful Tina Chow in Lagerfeld's couture dress for Chanel, its neckline garlanded with trompe l'oeil necklaces. A sultry Bianca Jagger as a thirties silver-screen siren in arctic fox and pearls with a jeweled veil. Christian Lacroix's muse Marie Seznec, with powdered face and prematurely gray hair swept up into an elaborate French pleat. A piquant Victoire de Castellane, with her ironed Penelope Tree hair, and Lagerfeld's faintly S&M Chanel leathers. Hieratic Farida Khelfa, with her Egyptian-hieroglyph profile, shot by Jean-Paul Goude for an old *Tatler* cover. Here are the models and fashions that most of Jacobs's young team will not remember, like the luscious Mounia and the androgynous Jeny Howorth, and the ruffles and flounces and drapes and print cocktails of Emanuel Ungaro's eighties couture confections.

"I clearly don't give a rat's ass this year!" Jacobs says, laughing, as he tucks a lemon-yellow organza pom-pom into the cowled back of a swathed houndstooth pouf dress, but his optimistic, devil-may-care vision seems a seductive proposition in the face of grim economic realities.

At 2:00 A.M. the day of the show, there are just three fittings to go (two girls will come in the morning). "I'd thought we'd be working all night, so I drank so much green tea today!" says Katie Grand, the stylist who collaborates with Jacobs here, as she purposefully arranges the final-fitting Polaroids to establish the running order of the show. "We're opening with the really fancy eveningwear," she says.

For the show, the clear-plastic-sided marquee, with views of the courtyard of the Louvre, has been arranged to evoke a couture salon with ebonized ballroom chairs upholstered in bright candy-pink, and Offenbach playing. For Jacobs and his team, this is the first time he has seen his entire collection, and after nights in the chaos of the studio, fitting the exhausted girls, it is dazzling to have this fresh perspective, to see them in this bright-white light, their hair (Palau's Marie Seznec meets French *Playboy*) and makeup (Pat McGrath's subtle turquoise eye flick and glossed blush-pink lip) immaculate, their clothes buoyant and lovingly molded by Vuitton's couture-quality workrooms. "Little courtesans," says Jacobs, beaming affectionately at the girls who so perfectly incarnate his vision of joyous optimism, "so sweet."—HAMISH BOWLES, *VOGUE*, MAY 2009

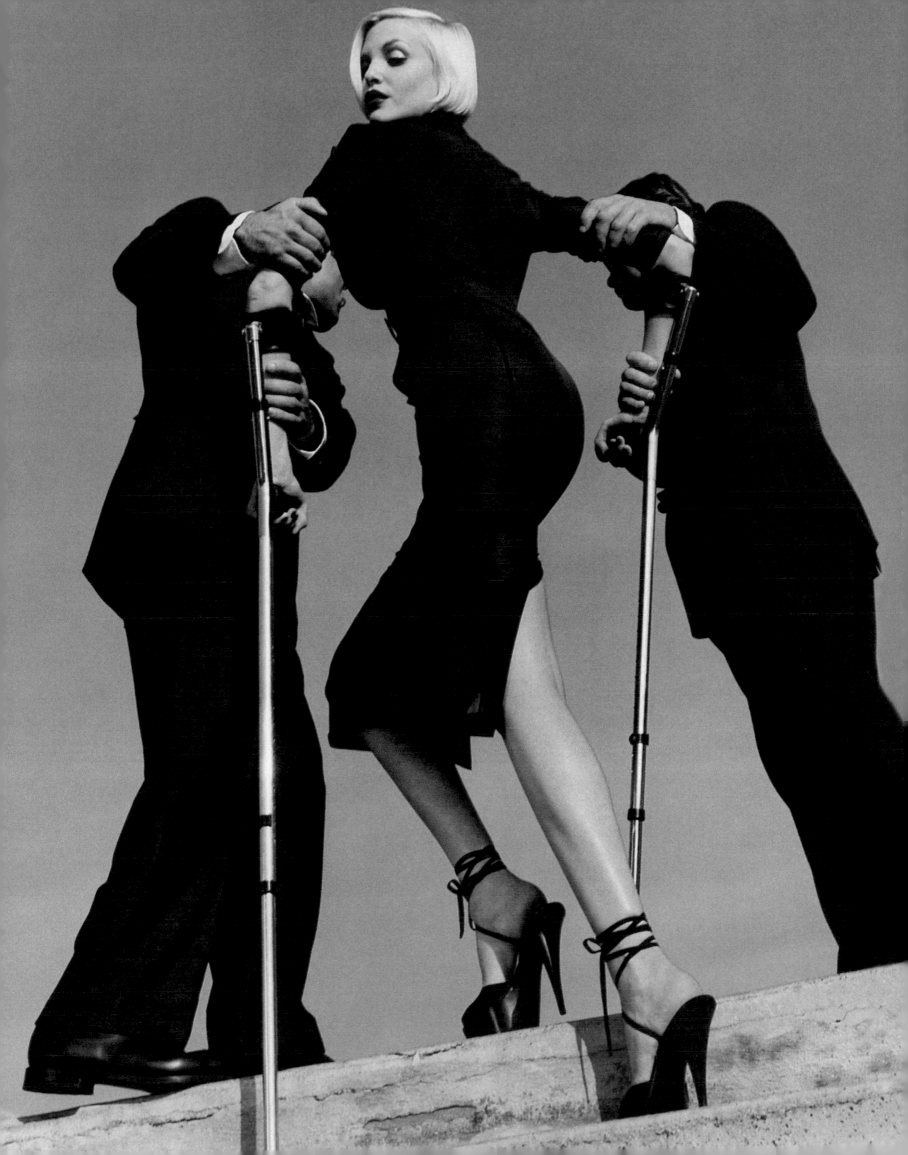

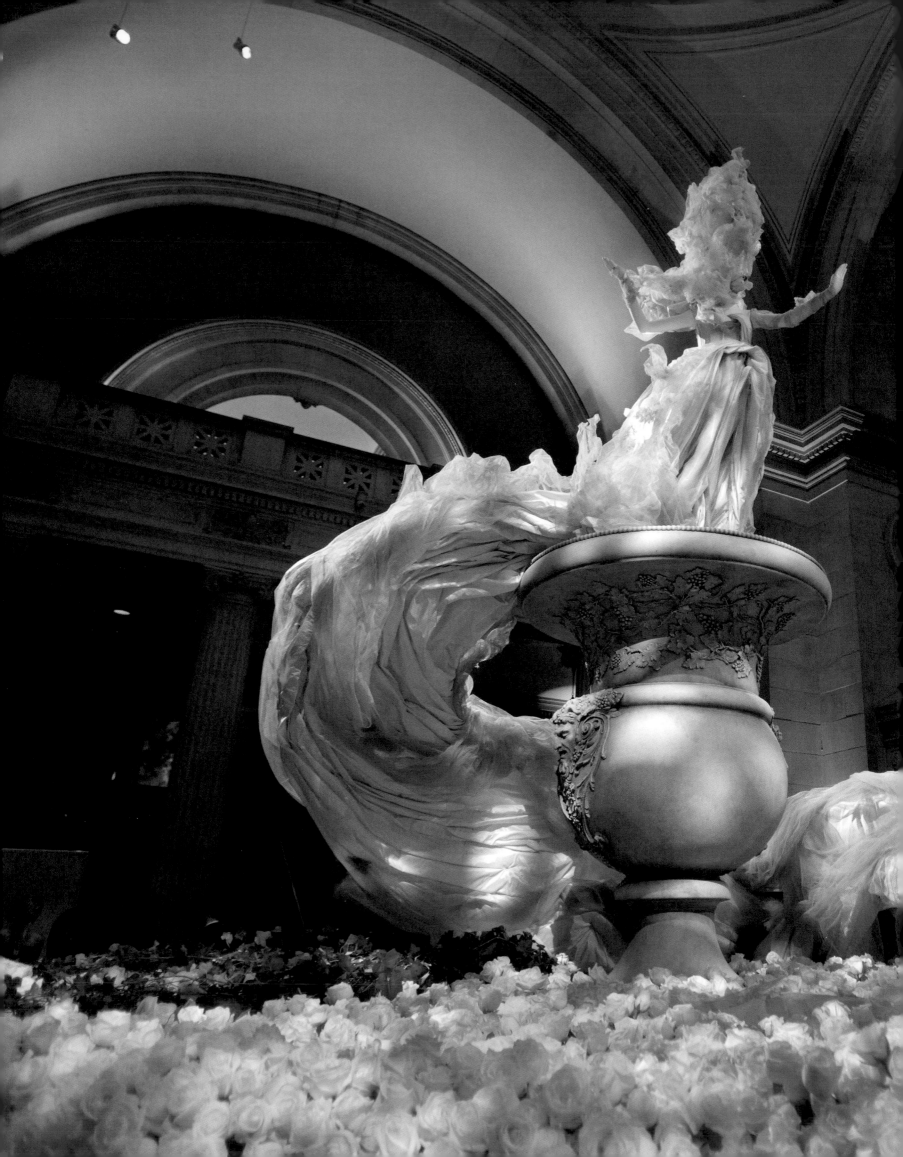

MARC JACOBS CREATED
THE WHORLING DRESS
WORN BY A MANNEQUIN
GREETING PARTYGOERS
IN THE GREAT HALL.

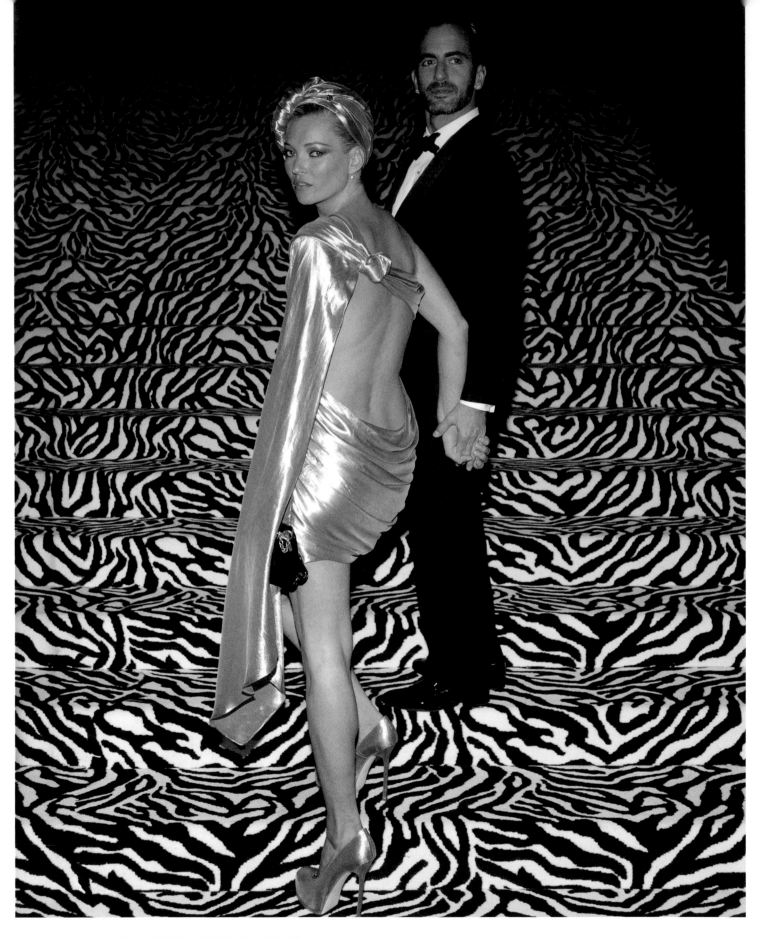

KATE MOSS AND MARC JACOBS CLIMBED THE MUSEUM'S
FAMOUS STEPS—A CASUAL GATHERING PLACE FOR NEW
YORKERS MOST DAYS BUT, DURING "THE PARTY OF THE YEAR,"
THE GANTLET THROUGH WHICH AMERICA'S BEST DRESSED MUST
GATHER THEIR SKIRTS AND PASS. OPPOSITE: JULIE MACKLOWE
(IN FLOOR-SWEEPING OSCAR DE LA RENTA) MADE THE WALK.

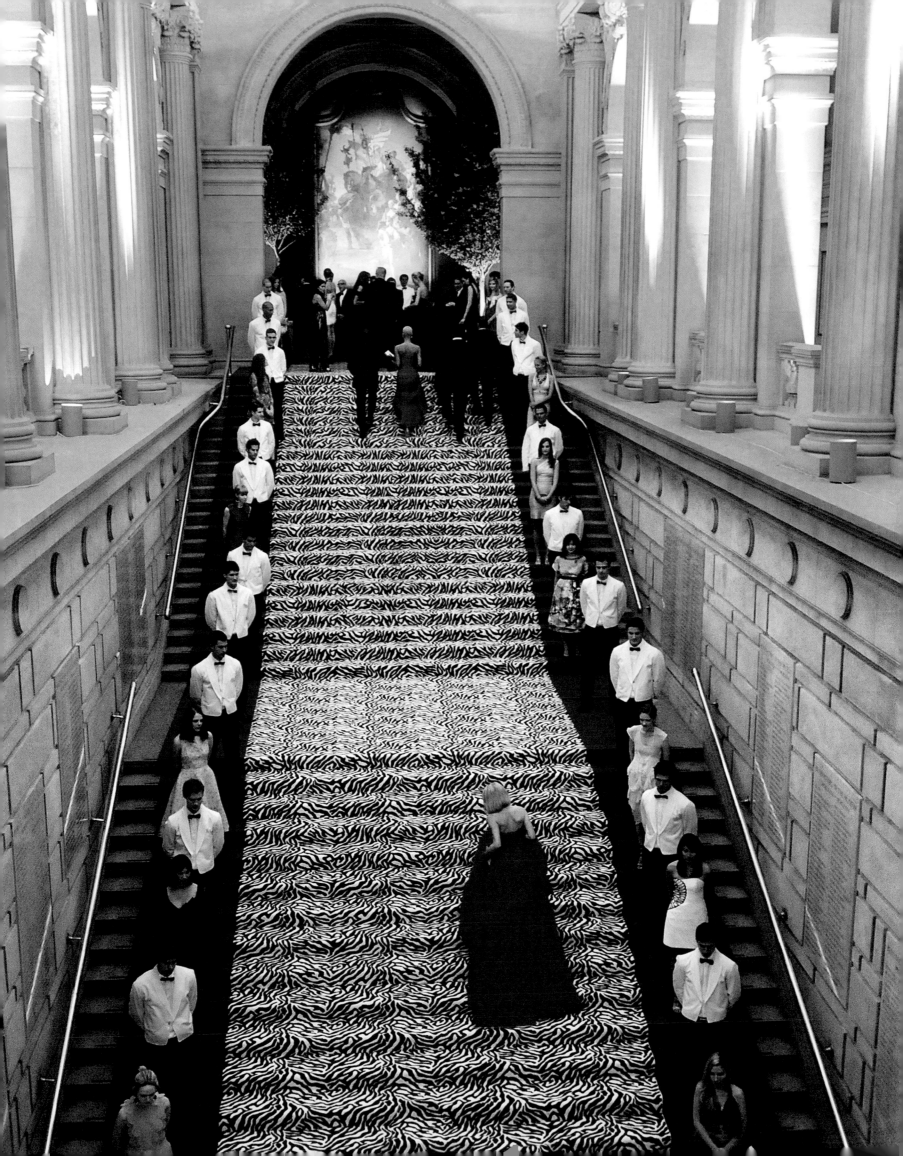

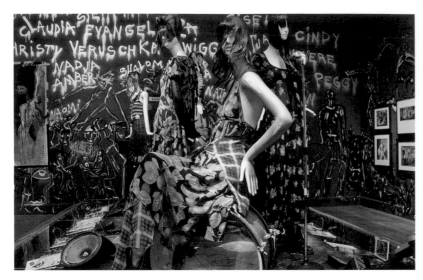

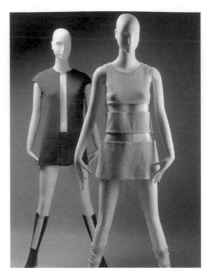

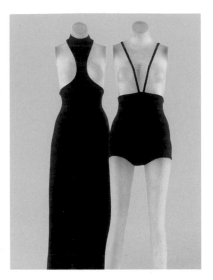

THE GRUNGE MOMENT, ANNA SUI
AND MARC JACOBS FOR PERRY ELLIS, 1993.

FUTURISTIC RUDI GERNREICH
MINIS, WORN (AND INSPIRED)
BY PEGGY MOFFITT, 1967.

MOFFITT WAS A SENSATION
IN GERNREICH'S "TOPLESS"
SWIMSUIT, 1964.

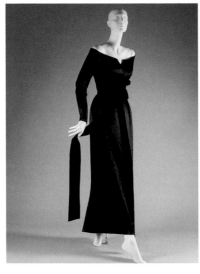

BLACK SATIN DIOR, FROM AVEDON'S
DOVIMA WITH ELEPHANTS, 1955.

AVEDON SHOT DONYALE LUNA IN
A SIMILAR 1960s PACO RABANNE.

STEPHANIE SEYMOUR HIT THE RUNWAY
AS A VUITTON NURSE, 2008.

ELEANOR LAMBERT'S RED-
VELVET CHARLES JAMES, 1949.

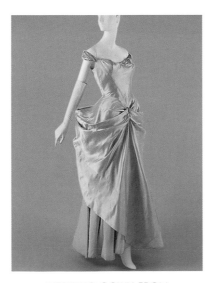

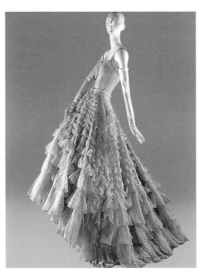

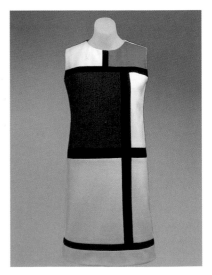

BOHEMIAN SKIRTS FROM
SAINT LAURENT'S RUSSIAN
COLLECTION, 1976.

WEDDING GOWN FROM
THE JAMES GROUPING
(À LA BEATON), 1948–49.

DIOR GOWN NAMED FOR IN-HOUSE
MODEL EUGÉNIE POMPON, 1948.

VERUSCHKA WAS AMONG
THE FIRST TO WEAR YSL'S
MONDRIAN SHIFT, 1965.

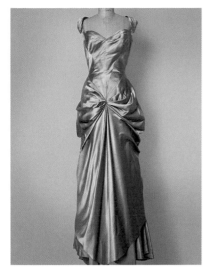

SATIN CHARLES JAMES
(LIKE THE ONE DORIAN
LEIGH WORE), 1950–52.

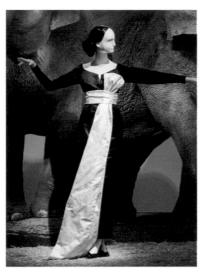

THE 1955 *ELEPHANTS* DRESS
WITH A WHITE SASH.

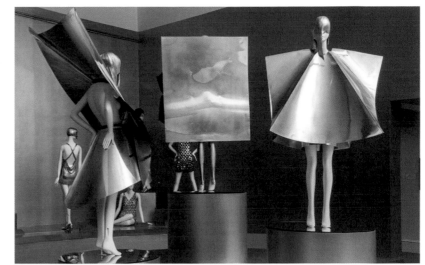

BASCHET COSTUMES FROM *QUI ÊTES-VOUS, POLLY MAGGOO?*, 1966.

HIROKO MATSUMOTO WAS A STAR
IN CARDIN MINIS, 1966–67.

BALENCIAGA SACK—FOR A
COUTURE SLOUCH, 1955–56.

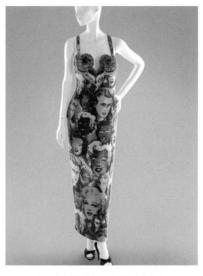

LINDA EVANGELISTA WAS
THE POSTER GIRL FOR VERSACE'S
POP COLLECTION, 1991.

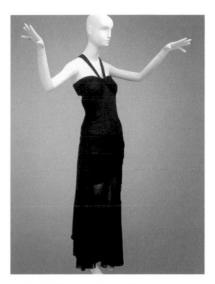

ANOTHER CLINGY SANT'ANGELO
FOR HARD BODIES, 1991.

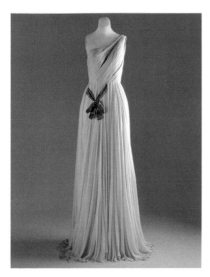

SUNNY HARNETT POSED IN
THIS MADAME GRÈS, 1954.

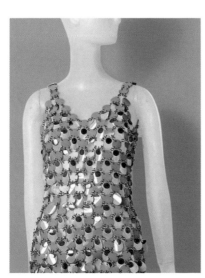

SPACE-AGE PACO RABANNE CALLED
FOR A TWIGGY FIGURE, 1965.

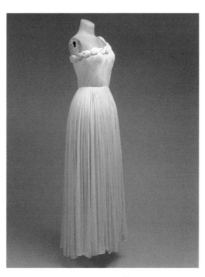

A 1958 MADAME GRÈS WITH THE
HOURGLASS WAIST OF THE ERA.

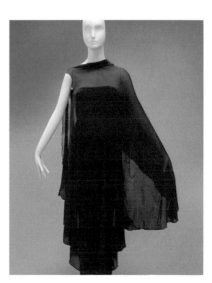

SANT'ANGELO STRETCH MESH,
AS WORN BY THE ORIGINAL
SUPERMODELS, 1991.

AMERICAN WOMAN FASHIONING A NATIONAL IDENTITY 2010

THE STORY OF WOMEN'S FASHION IN THE U.S. HAS ESSENTIALLY BEEN ONE LONG TALE OF LIBERATION: A GRADUAL LOOSENING OF THE CORSET LACES THAT BIND, A SLOW FREEING OF THE BODY. THE BICYCLE WAS FADDISH IN THE 1890s, GIVING JOYOUS ACCESS TO A MEASURE OF INDEPENDENCE MANY HAD NEVER FELT BEFORE. THESE WOOL CYCLING OUTFITS FROM 1896–1898, SHOWN IN THE EXHIBITION, FEATURED BIFURCATED ANKLE SKIRTS AND STYLISH PUFF SLEEVES.

WHEN F. SCOTT FITZGERALD'S BERNICE
BOBBED HER HAIR, THE WHOLE WORLD
SHOOK. YOUNG GIRLS' FLOUTING OF
CONVENTION WAS A YOUTHQUAKE IN
THE 1920s THAT HAD ENORMOUS SOCIAL
SIGNIFICANCE. THE FLAPPER WORE—AS
SEEN HERE IN THE SHOW—LIMB-EXPOSING
FROCKS THAT LAY FLAT OVER THE BODY
(THE ANTITHESIS OF THE VICTORIAN
HOURGLASS). THE RICHNESS ON THESE
SPARE LINES CAME VIA OSTRICH PLUMES,
BEADING, FABRICS OF DIVINE DELICACY.

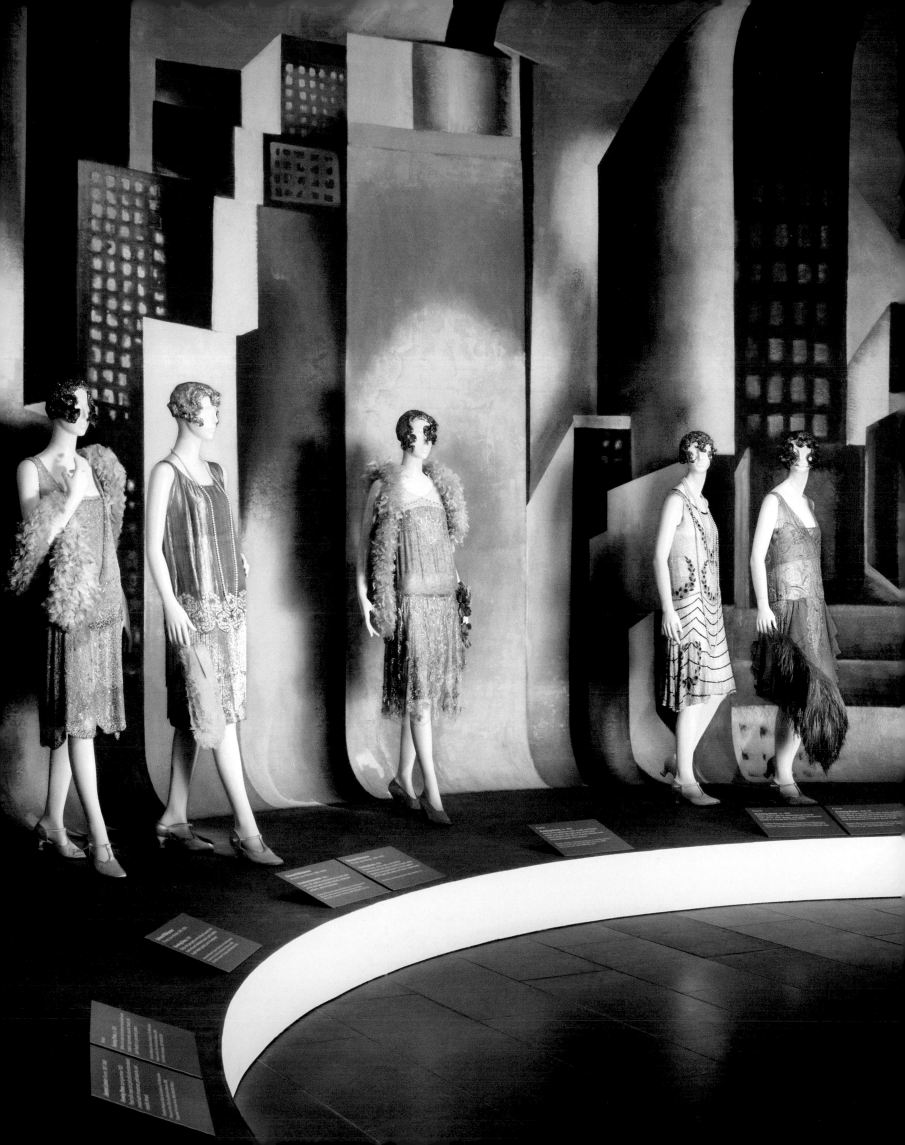

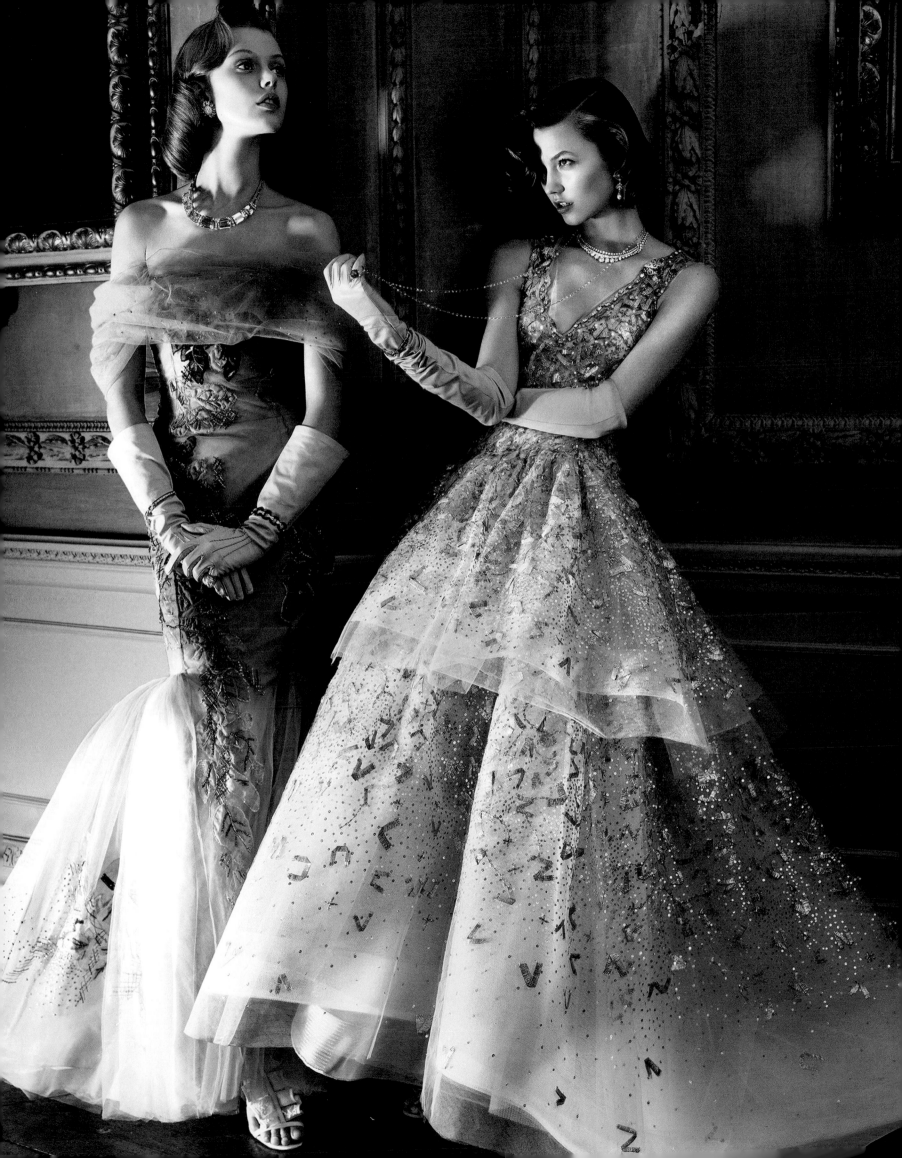

merican Woman: Fashioning a National Identity," at The Costume Institute, is an exultant celebration of The Metropolitan Museum of Art's collaboration with the Brooklyn Museum, drawing from some 25,000 objects in the Brooklyn collection's holdings. Curator Andrew Bolton has conceived the exhibition, underwritten by Gap, with designer Nathan Crowley as a series of panorama rooms of the sort that transfixed visitors at turn-of-the-century world's fairs. These settings reveal American female archetypes from the 1890s through the 1940s, such as the Heiress, the Gibson Girl, the Patriot, the Flapper, and the Screen Siren. "Together," Bolton says, "they constitute what we now see as American style."

The show will be complemented by "American High Style: Fashioning a National Collection" at the Brooklyn Museum, curated by Jan Glier Reeder, which will focus on American and French masterworks from Brooklyn's collection. Established in 1902 (The Costume Institute, now headed by Harold Koda, was founded in 1946), Brooklyn's holdings feature superb early-twentieth century creations ordered by New York's preeminent socialites and fashion leaders from the great Parisian houses, among them Worth, Doucet, Paquin, and Pingat, as well as comprehensive examples of American designers, both lauded and unsung, notably the largest assemblage of Charles James pieces from many of his most emblematic clients, including Millicent Rogers and Austine Hearst. The collection also houses fascinating garments from the wardrobes of such remarkable women as the fey Belle Époque beauty and writer Rita Lydig and the chalcedony-eyed Kentucky belle Mona Bismarck.

There is much happy rapport between the two collections, now so excitingly united. The Costume Institute, for instance, already had Rita Lydig's extraordinary shoes, preserved in the Russian leather trunks she had made for them in St. Petersburg. These shoes were fashioned from Renaissance velvets and precious Venetian lace by the mysterious Yantorny, the Italian curator of the Cluny Museum. Cecil Beaton noted that Lydig collected violins "expressly so that Mr. Yantorny could use their thin, light wood for his shoe trees." Now these wonders are shown alongside Lydig's haute bohème tabard-and-pantaloon ensembles, made for her in collaboration with the Callot Soeurs, the great Parisian dressmakers whose business she helped to support. Although these women and others whose clothes are included in the Met show had, as Bolton notes, "individual identities that came through clearly in their clothing," he felt that the Brooklyn collection told a compelling story of the evolving collective identities of these decades.

Bolton's exhibition begins in 1890, a time, he believes, when the identity of the American woman in literature and art—in the writings of Henry James and Edith Wharton, and the bravura portraits of John Singer Sargent and the hourglass idealizations of Charles Dana Gibson—first came into sharp focus. "The most potent American archetype that emerged during the late nineteenth century was the heiress," Bolton says. During that period, he points out, moneyed young American women and their striving mothers looked to Europe not only for titled husbands but for fashion and style leadership and an ideal of beauty. Couturier Charles Frederick Worth, who dressed the royal courts of Russia and Europe and the greatest courtesans of the day, valued his American clients above all others because, in his words, "they had faith, figures, and francs." For someone like the preeminent leader of fashion and staunch defender of society's portals, the redoubtable Mrs. William Backhouse Astor, Jr., née Caroline Schermerhorn (whose ballroom capacity of 400 effectively defined the limits of contemporary high society), Francophile tastes were an exercise in flag flying. "Her patronage of French products—fashions or furniture—was to her a symbol of patriotism, elevating the cultural image of America by investing it with nobility," Bolton explains.

AMERICAN WOMAN

FASHIONING A NATIONAL IDENTITY

THE GALA INVITATION IMAGE BY MARTIN MUNKÁCSI (1933) CAPTURED THE ATHLETICISM AT THE HEART OF AMERICA'S SELF-CONCEPTION AS WELL AS ITS SPORTSWEAR TRADITION. **PREVIOUS PAGES:** IN MAY 2010, *VOGUE* PUBLISHED A PORTFOLIO BY DAVID SIMS OF CURRENT RUNWAY STYLE THAT COINCIDED WITH THE EXHIBIT'S THEME. LEFT: ALEXANDER WANG RE-CREATED A GIBSON GIRL LOOK—SELF-POSSESSED, HEALTHY, AND (IN SPIRIT AND IN BODY) YOUNG—WITH A CORSET SWEATSHIRT. RIGHT: DEB DRESSES À LA BRENDA FRAZIER, FROM CAROLINA HERRERA (LEFT) AND OSCAR DE LA RENTA.

But by the 1940s, he adds, because of the influence of Hollywood style and the emergence of homegrown designers, "all of Europe began to look toward America for their ideal of beauty. The American woman gradually found a confidence in her own voice from the 1890s to become this apex of glamour by the 1940s. I wanted to tell that story, too, about the gradual sartorial emancipation of the American woman. These women initially became recognized by the public through painting, illustration, and photography, but by the 1920s and 1930s film was the most powerful tool in the dissemination of the American identity." The notion of the film siren is embodied in one of Paramount designer Travis Banton's spectacular costumes for Anna May Wong (in 1934's *Limehouse Blues*). Later, MGM's Adrian and Irene and Paramount's Howard Greer all emerged from the studio system to establish themselves as fashion designers; Adrian would prove especially influential. At the same time, New York fashion designers, including the now relatively unknown Elizabeth Hawes and Jessie Franklin Turner, were proving that Paris did not have a monopoly on high style, as their striking clothes in the exhibition prove.

Nathan Crowley (the visual mastermind of The Costume Institute's dynamic 2008 "Superheroes: Fashion and Fantasy") has designed the series of connecting rooms as an exercise in time travel "to immerse the audience," he says. "To make each room represent that period and to express the period through the artistic style of the time—the Astor ballroom is hand-painted; for the Suffragist and Patriot we use photography for a realist edge; and by the time we get to the 1930s, we use film."

An evocation of Stanford White's Washington Arch leads visitors in. This triumphal symbol was dedicated in 1895 in Washington Square—at that time, as Bolton notes, the "nexus of social activity." Society soon began to move uptown, at which point Washington Square became associated with the bohemia of Greenwich Village. The first room suggests the ballroom of a storied seaside "cottage" in Newport, Rhode Island, appointed in the height of ersatz turn-of-the-century Louis Seize prettiness, furnished with pieces from the collections of Mrs. Astor and her nemeses, the Vanderbilts (whom she considered parvenus).

Here, a bevy of fin de siècle swans is gathered for a ball, dressed by Worth in gowns of exquisite opulence. From the ballroom the scene shifts to the Gibson Girl, created by the well-connected artist Charles Dana Gibson (whose sisters-in-law included Nancy Astor and whose niece was Nancy Lancaster) and for Bolton "the first American standard of beauty that became recognized globally. She is still relatively patrician in her sensibility, but there is a tomboy side to her—the outdoorsy, athletic sensibility, which is still relevant to how we see American style today." That athleticism is reflected in clothes specially developed for the newly popular sport of cycling, and the more traditional ones of horseback riding, ice-skating, croquet, and swimming.

Rita Lydig's Callot Soeurs creations are the highlight of the Bohemian gallery, set in a room evoking Louis Comfort Tiffany's famous studio, ripe with the promise of Eastern decadence. Here, too, clothes by Poiret and Paquin reveal the lean, uncorseted silhouette that they introduced on the cusp of the First World War. The Orientalism of kimonos, the exoticism of Egyptian motifs, and historicist elements suggest the fertile imaginations of clients like Lydig and Gertrude Vanderbilt Whitney, whose artistic tastes have enriched Manhattan's cultural landscape. And from there we go into the Patriot and Suffragist section, with clothes worn by female cadets or set against a backdrop of images of suffrage marches. These women broke the conventional mold and enabled the liberated Flapper of the 1920s to emerge. She is set against a Cubist backdrop suggestive of the settings in which the artist Tamara de Lempicka placed her sitters. The Career Woman is represented by the new streamlined, no-nonsense day clothes of the period,

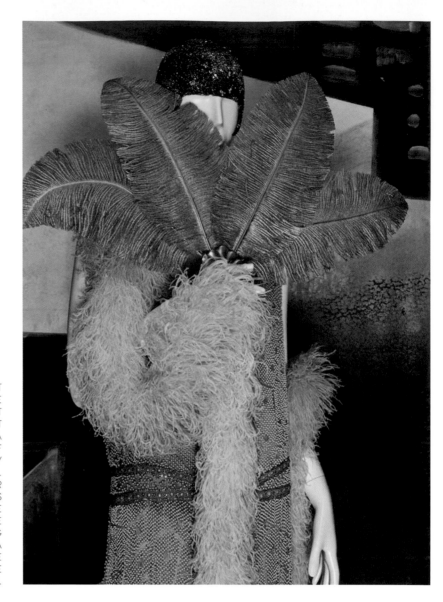

and the Jazz Baby by the era's short, coruscating, and unstructured evening clothes, here in a ravishing palette of face-powder pinks and soft mauves by designers including Lanvin and Molyneux. American clients had a direct impact on the Paris couture during this decade. In 1924 the couturier Jean Patou, a designer of sleek, sportif day clothes and of glamorously modern evening dresses and a serious rival to Gabrielle Chanel, held a competition (judged by *Vogue*'s editor, Edna Woolman Chase, among others) to find lithe American models he could bring to Paris to showcase his clothes so that the all-important American clients could better relate to them.

The Screen Siren is set in a glamorous 1930s movie house, complete with three screens. Although Samuel Goldwyn summoned Chanel to Hollywood in 1931 on an unprecedented million-dollar contract to design for his film goddesses, including Gloria Swanson and Ina Claire, the much-publicized experiment was not a success. Chanel's clothes were judged too subtle, and she had little patience for the studio's demanding stars. Homegrown talents instead prevailed.

In addition to Banton's magnificent femme-fatale creation for Anna May Wong, there are clothes conceived for fashionable offscreen life by the great contemporary American designers. Charles James is represented by a quartet of his jersey mermaid dresses, including one worn by the famed ecdysiast Gypsy Rose Lee, renowned, perhaps ironically, for her superb taste in clothes. Far less celebrated was Madame Eta Hentz, a Hungarian-born American designer working between the wars whose superb draped evening clothes, based closely on the Greco-Roman statues that she had seen and admired in The Metropolitan Museum's 1943 show "The Greek Revival in the United States," are a revelation of sophistication and classical beauty.

The final room brings these abstract archetypes to life by associating them with real-world examples through the decades. The traditional elegance of the Grande Dame, for instance, is embodied by women from Alva Vanderbilt to Annette de la Renta and Jayne Wrightsman, the refined simplicity of the Heiress from Alva's daughter, Consuelo, to Aerin Lauder and Ivanka Trump. The unconventional artistic flair of the Bohemian, once expressed by Isadora Duncan and Gertrude Vanderbilt Whitney, is now channeled by Rachel Feinstein and Lady Gaga. The pragmatism of the Patriot by Eleanor Roosevelt and Michelle Obama. The confidence of the Gibson Girl by tennis stars from Helen Wills to the Williams sisters, by Lauren Hutton and Halle Berry. The glamour of the Screen Siren by Marilyn Monroe and Angelina Jolie. The carefree rebellion of the Flapper by Josephine Baker and Kirsten Dunst. Taken together, in a sensory-overload presentation of moving and still pictures designed by Trey Laird, they will provide an "overarching definition of American style."

Bolton's paradigms also reveal the bounding changes in women's lives during these decades of immense societal upheaval, illustrated by the timelines in the passages linking the various rooms. "Just seeing the Nineteenth Amendment [ratified in 1920, giving women the right to vote] being passed," says Bolton, "I still get goose bumps when I read that."—HAMISH BOWLES, *VOGUE*, MAY 2010

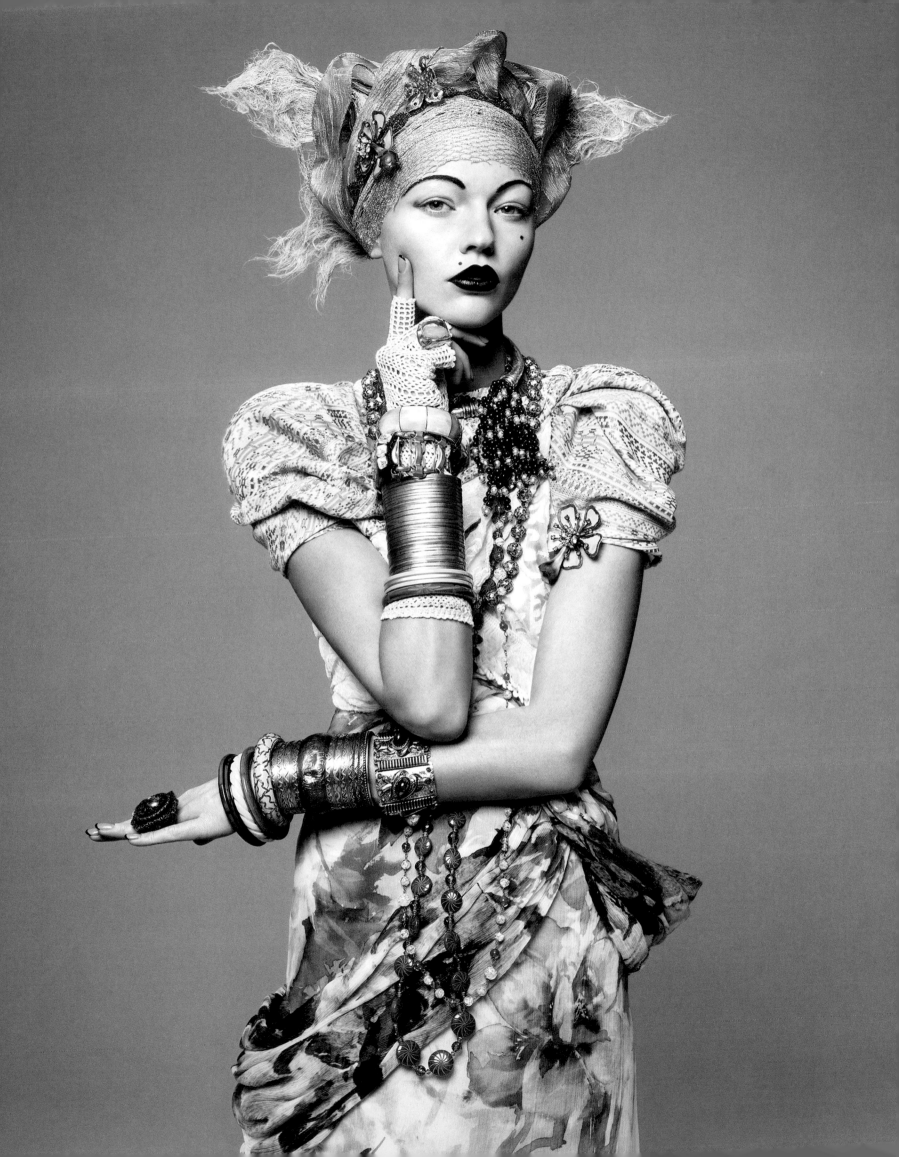

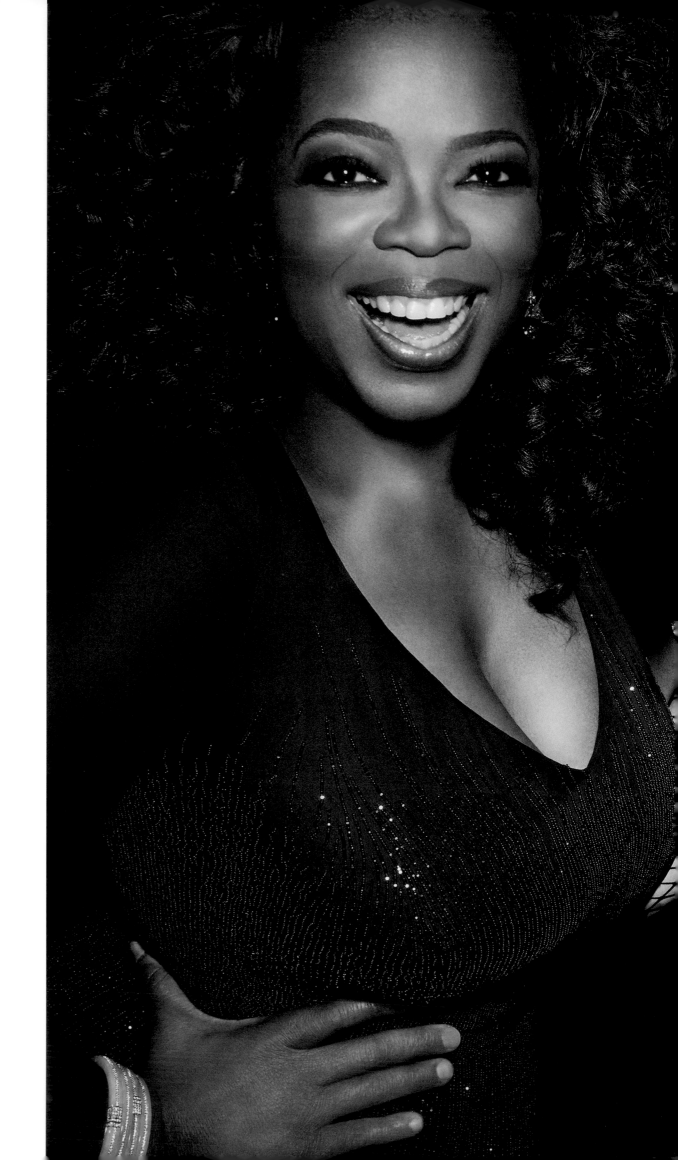

THE LAND OF THE FREE
NURTURES NONCONFORMISTS.
WITNESS LADY GAGA, WHO—IN
THE FOOTSTEPS OF MANHATTAN
SCENEMAKERS FROM ULTRA
VIOLET TO LADY MISS KIER—HAS
USED OUTLANDISH COSTUME
AS A PROVOCATION. WORLDS
COLLIDED WHEN GAGA
(IN CUSTOM PRADA) MET
OPRAH WINFREY (IN OSCAR
DE LA RENTA) AT THE GALA.
PHOTOGRAPHED BY MARIO
TESTINO FOR *VOGUE,* JULY 2010.
OVERLEAF: NATHAN CROWLEY
AND RAÚL ÀVILA, WHO DID THE
DECOR, INFLATED A HOT-AIR
BALLOON TO GREET GUESTS.

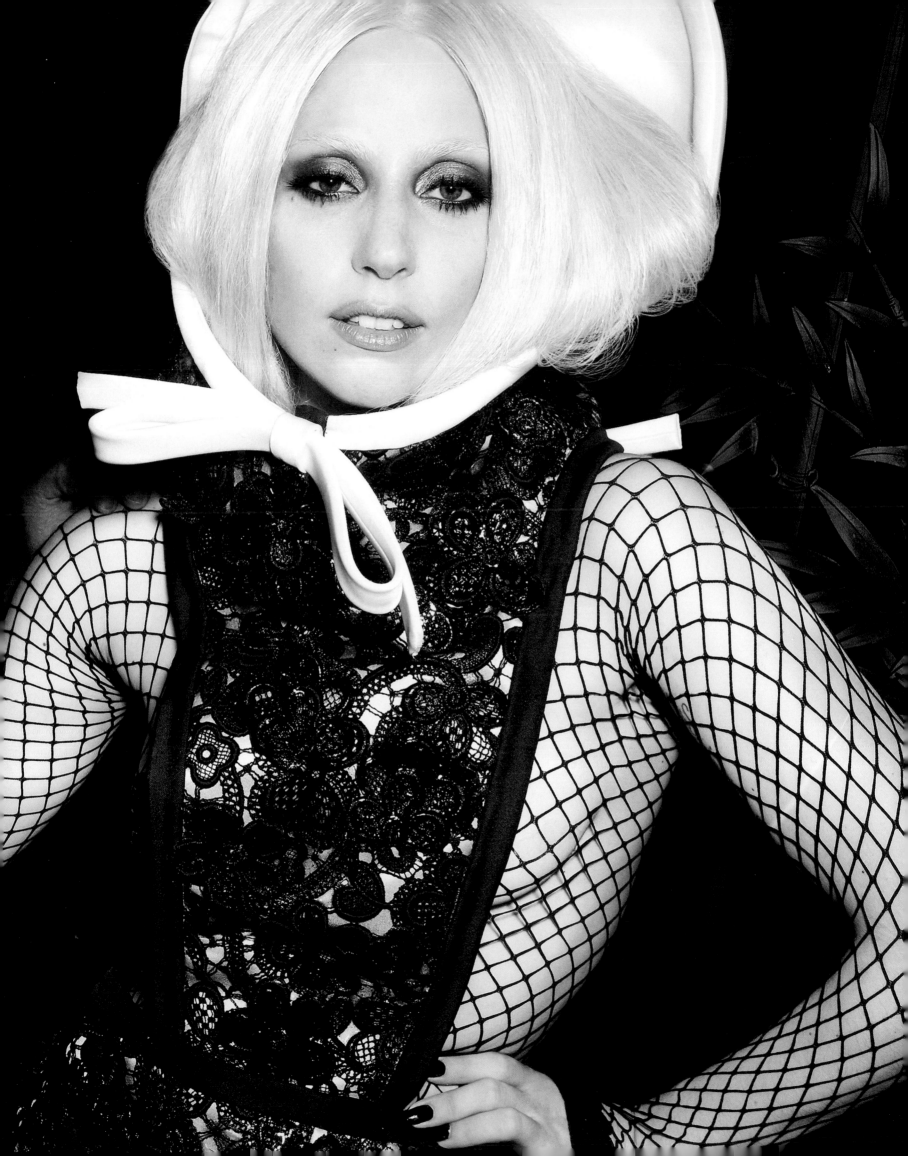

RIDING HABIT BELONGING TO
MISS ELEANOR HEWITT, C. 1896.

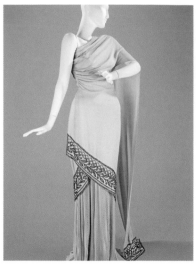

GRECIAN DRAPED GOWN BY
MADAME ETA HENTZ, 1944.

UNIFORM FOR WOMEN'S MOTOR
CORPS DRIVER, 1916–18.

EVENING DRESS
SHOWING TUBULAR JAZZ
AGE SHAPE, 1924.

LACE VEST BY CALLOT SOEURS FOR
RITA DE ACOSTA LYDIG, 1913.

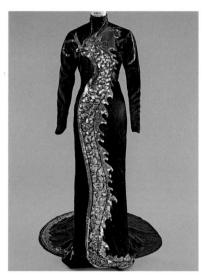

TRAVIS BANTON FOR ANNA
MAY WONG IN PARAMOUNT'S
LIMEHOUSE BLUES, 1934.

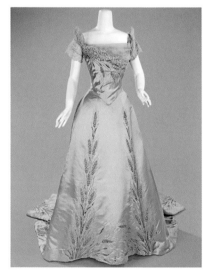

AN HEIRESS'S DRESS FROM
HOUSE OF WORTH, PARIS, 1900.

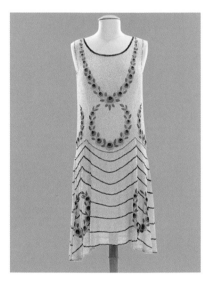

BOYISHLY FLAT SILHOUETTE WITH
GIRLISH ROSES, COTTON, C. 1925.

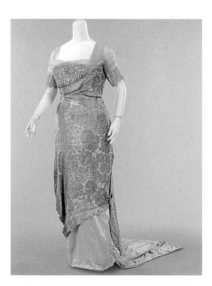

CALLOT SOEURS SILK DRESS WITH
METALLIC THREAD, 1911–14.

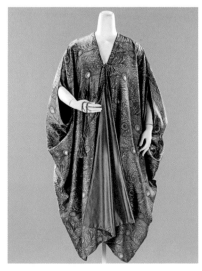

ASIAN-INFLUENCED PEACOCK
TEXTILE, LIBERTY & CO., 1910–15.

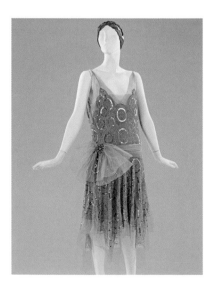

GOLD DRESS EMBROIDERED
WITH LANVIN'S SIGNATURE
SWIRL, 1923.

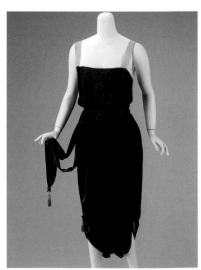

LITTLE BLACK DRESS
(ACTUALLY, A DHOTI-STYLE
SKIRT), CALLOT SOEURS, 1910.

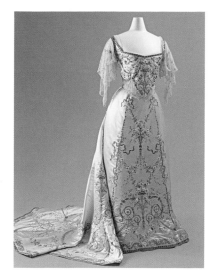

BALL GOWN FROM THE
END OF THE CORSET ERA,
WORTH, 1900–05.

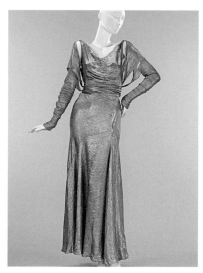

LINGERIE LOOK GOLD LAMÉ, JESSIE
FRANKLIN TURNER, C. 1933.

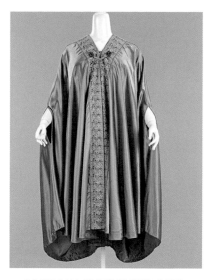

BOHEMIAN SILK EVENING CAPE,
LIBERTY & CO., 1910–15.

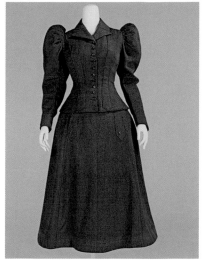

CYCLING SUIT WITH SPLIT
UNDERSKIRT FOR RIDING
ASTRIDE, 1896.

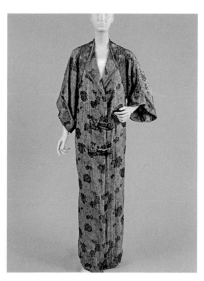

THE CORSET-FREE SILHOUETTE:
KIMONO COAT FROM
POIRET, C. 1912.

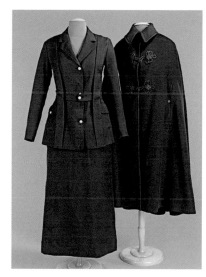

YEOMANETTE UNIFORM, U.S.
NAVY RESERVES, 1918.

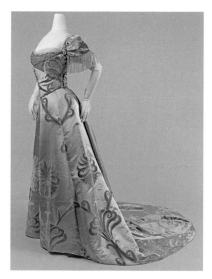

BELLE ÉPOQUE EVENING
DRESS, WORTH, 1898–1900.

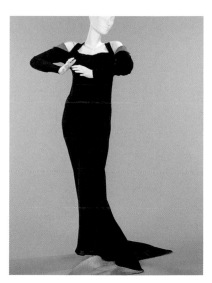

FISHTAIL LANVIN PHÈDRE
GOWN, 1933.

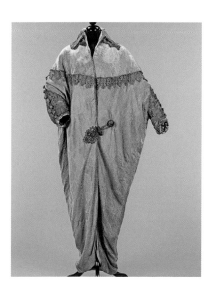

ORIENTALIST COCOON COAT,
WEEKS OF PARIS, 1911–14.

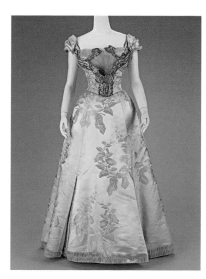

SILK BALL GOWN, CUSTOM-MADE
IN PARIS BY WORTH, 1895–1900.

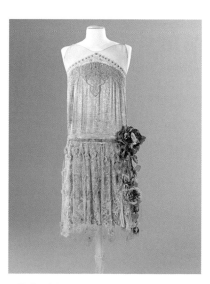

EXQUISITE BEADING AND TRACERY
OF BLOSSOMS, FRENCH, 1925.

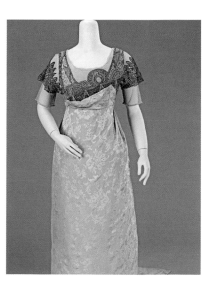

EGYPTIAN REVIVAL, WITH SCARAB
BEADING, SIMCOX, 1912.

ALEXANDER McQUEEN
SAVAGE BEAUTY
2011

"LIFE TO ME IS A BIT OF A (BROTHERS) GRIMM FAIRY TALE,"
McQUEEN ONCE SAID. RIGHT: THE BILLOWING PARACHUTE-SILK
COAT AND SYNTHETIC TROUSERS IN THE EXHIBITION, FROM FALL
2002'S "SUPERCALIFRAGILISTICEXPIALIDOCIOUS" COLLECTION,
WERE INSPIRED BY THE MACABRE FILMS OF TIM BURTON.

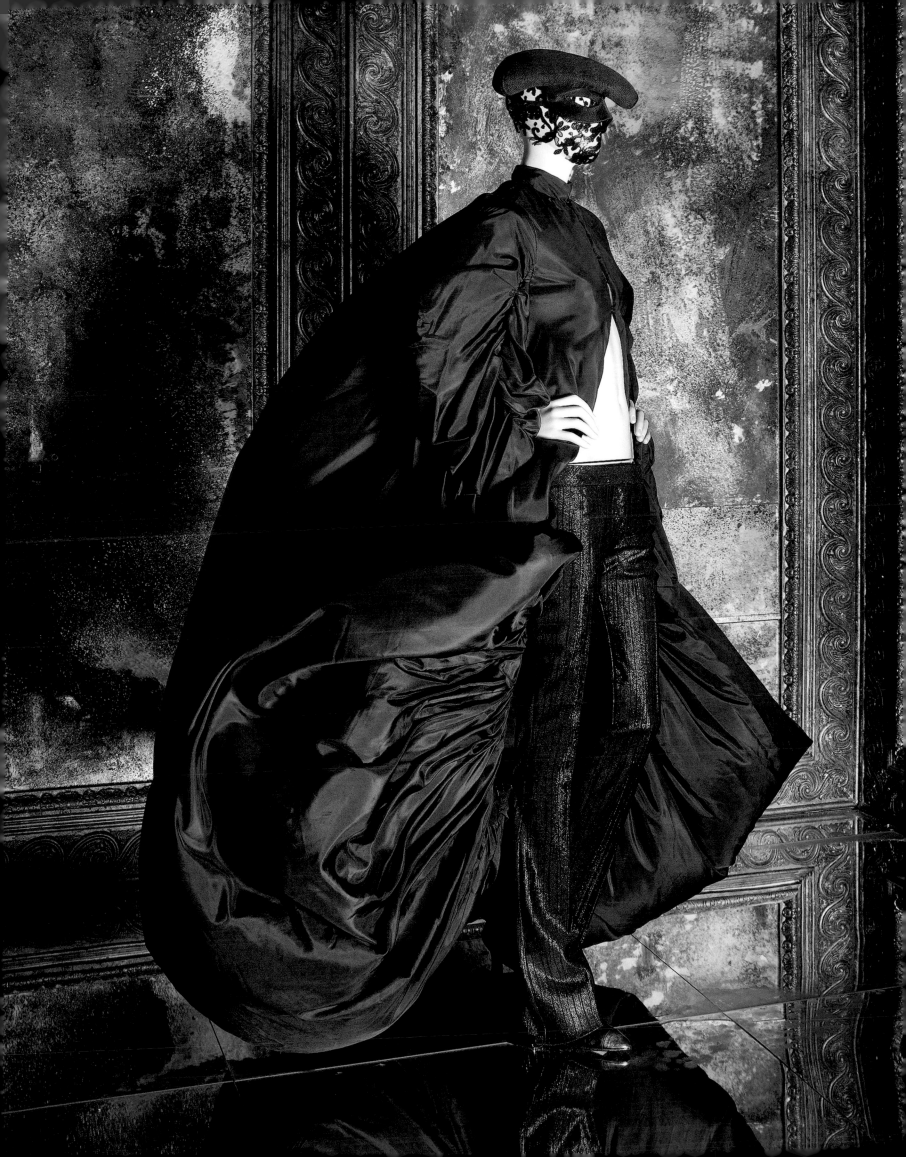

In advance of *"Alexander McQueen: Savage Beauty"* Vogue's Sarah Mower sat down with Sarah Burton—named creative director of the house after McQueen's death—to reflect on the late designer's most iconic collections.

WIDOWS OF CULLODEN, FALL 2006

"The collection was about the 1745 massacre of the Scottish Jacobites by the English, which Lee felt so passionately about because of his Scottish family heritage, which his mother had researched. The women were the widows of the slaughtered army. This dress (page 179) was actually based on my wedding dress—I got married two years earlier. We had to figure out how to make lace work in the round with those ruffles because Lee hated gathering. So we cut out all of the flowers from the lace and reappliquéd it on tulle to make our own fabric. This is the collection most people remember as the one with Kate Moss in a hologram. Oh, my God, it was so beautiful. He loved that show."

VOSS, SPRING 2001

"So much of this show was about the collective madness of the world. It was presented in a two-way mirrored glass box in London, and the girls had bandaged heads, acting like inmates of a mental asylum. Lee wanted the top of this dress (page 183) to be made from surgical slides used for hospital specimens, which we found in a medical-supply shop on Wigmore Street. Then we hand-painted them red, drilled holes in each one, and sewed them on so they looked like paillettes. We hand-painted white ostrich feathers and dip-dyed each one to layer in the skirt."

NUMBER 13, SPRING 1999

"This was from the amazing show in London where Shalom Harlow stood on a turntable and was spray-painted by robots. This particular look (page 182) was made from wood to form the shape of a fan: It was all about the craftsmanship. The wooden wings were in this show, too, and the prosthetic legs he had carved for Aimee Mullins, who walked in the show. That was so moving. There were so many ideas in there. Each of his shows was like ten of anyone else's."

SARABANDE, SPRING 2007

"The collection was based on Handel's 'Sarabande' in the film *Barry Lyndon*. It was held in the round at the Cirque d'Hiver Bouglione in Paris, with classical musicians playing onstage under a giant chandelier. This dress (page 181) had fresh flowers on it. We put them on just before she went out, and they started to fall off one by one as she walked. I remember people saying Lee timed it. We had a laugh about that. It was an accident!"

IT'S ONLY A GAME, SPRING 2005

"All the girls were dressed as chess pieces, and the show was choreographed as a chess game. It was about the chessboard of fashion. Lee did have foresight and a sense of humor! This is one of the two horse pieces (page 178). He made it by commissioning Steve Powell, a hospital prosthetics expert, to make the body. And the horsetails were from the same suppliers who make the plumes for the queen's Royal Horse Guards."

VOSS, SPRING 2001

"This [piece] (page 180) is a straitjacket, a kimono with the sleeves strapped around the back, embroidered with raised birds and flowers, and the flowers on the hat were real. I saved all the showpieces from every collection because I'm an obsessive, obsessive hoarder. Sometimes Lee would look at them again, just to remember what he'd done with something. It was his dictionary he was building, really."

—SARAH BURTON AS TOLD TO SARAH MOWER, *VOGUE*, MAY 2011

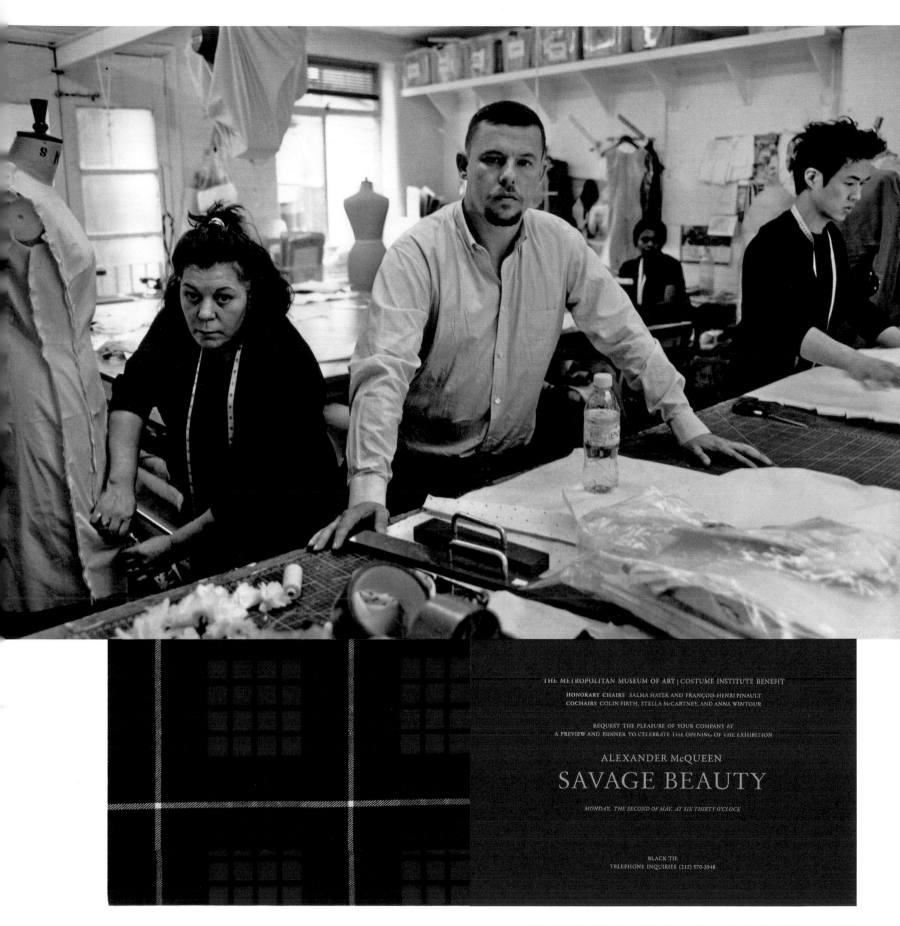

THE METROPOLITAN MUSEUM OF ART | COSTUME INSTITUTE BENEFIT

HONORARY CHAIRS SALMA HAYEK AND FRANÇOIS-HENRI PINAULT
COCHAIRS COLIN FIRTH, STELLA McCARTNEY, AND ANNA WINTOUR

REQUEST THE PLEASURE OF YOUR COMPANY AT
A PREVIEW AND DINNER TO CELEBRATE THE OPENING OF THE EXHIBITION

ALEXANDER McQUEEN

SAVAGE BEAUTY

MONDAY, THE SECOND OF MAY, AT SIX THIRTY O'CLOCK

BLACK TIE
TELEPHONE INQUIRIES (212) 570-3948

TOP: IN THE STUDIO, LONDON 2008. ABOVE: TRADITIONAL CLAN McQUEEN TARTAN ON THE GALA INVITATION. **OVERLEAF:** LEFT, CHESS KNIGHT OF MOLDED LEATHER AND HORSEHAIR FROM "IT'S ONLY A GAME," SPRING 2005. RIGHT: WIDOW'S WEEDS FROM THE FALL 2006 SHOW COMMEMORATING THE 1745 CULLODEN MASSACRE. PHOTOGRAPHED BY STEVEN MEISEL, *VOGUE*, MAY 2011.

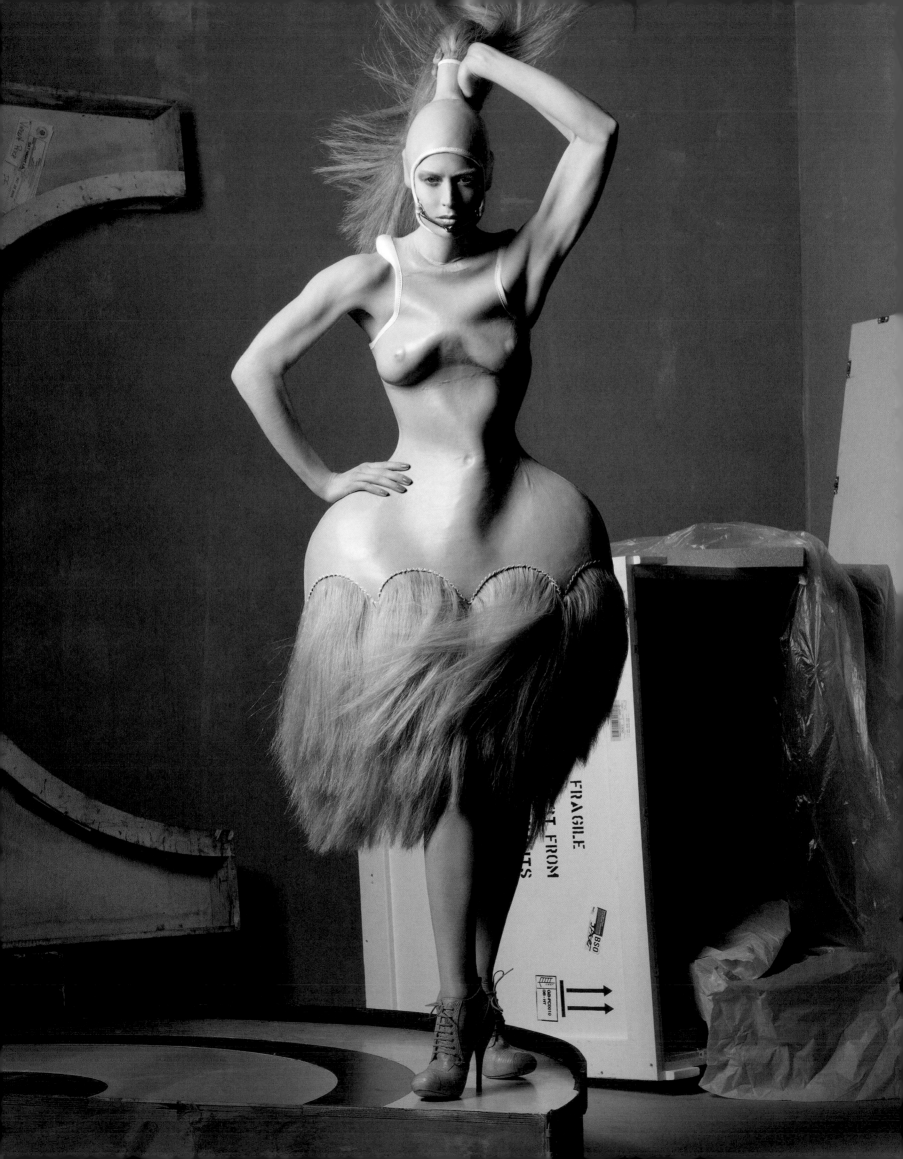

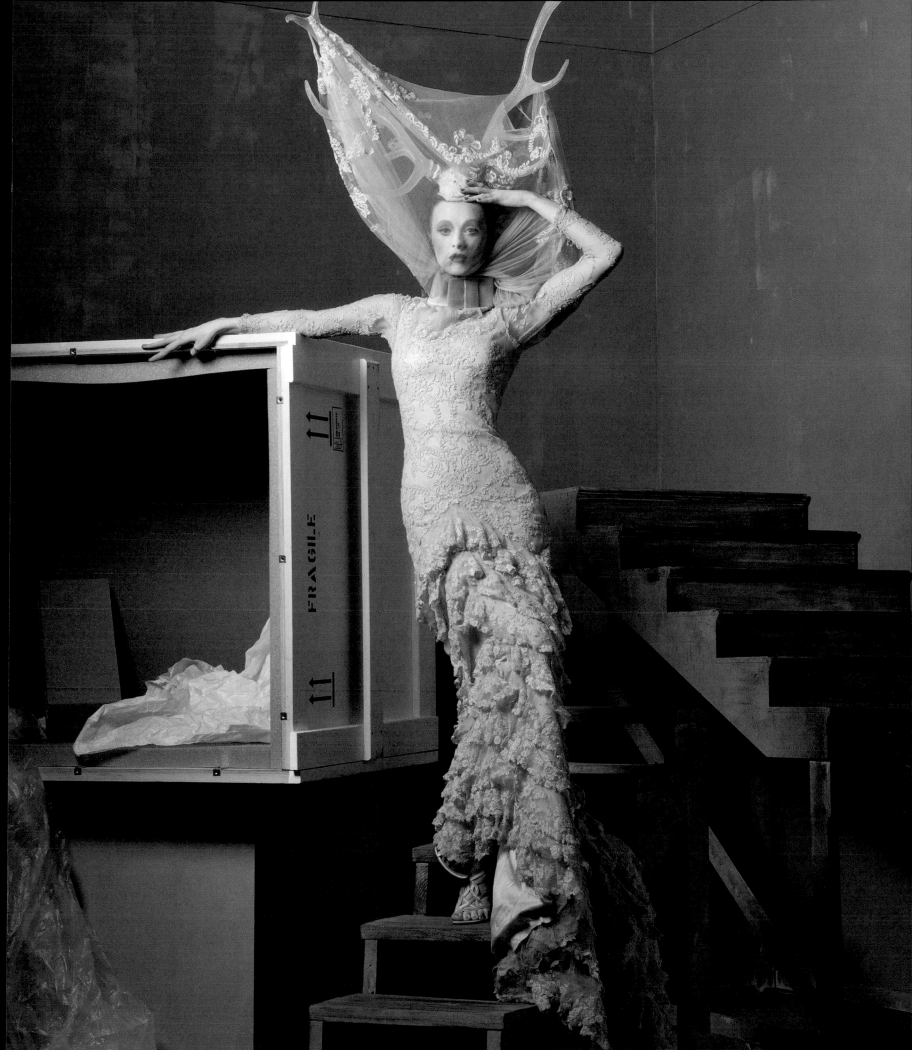

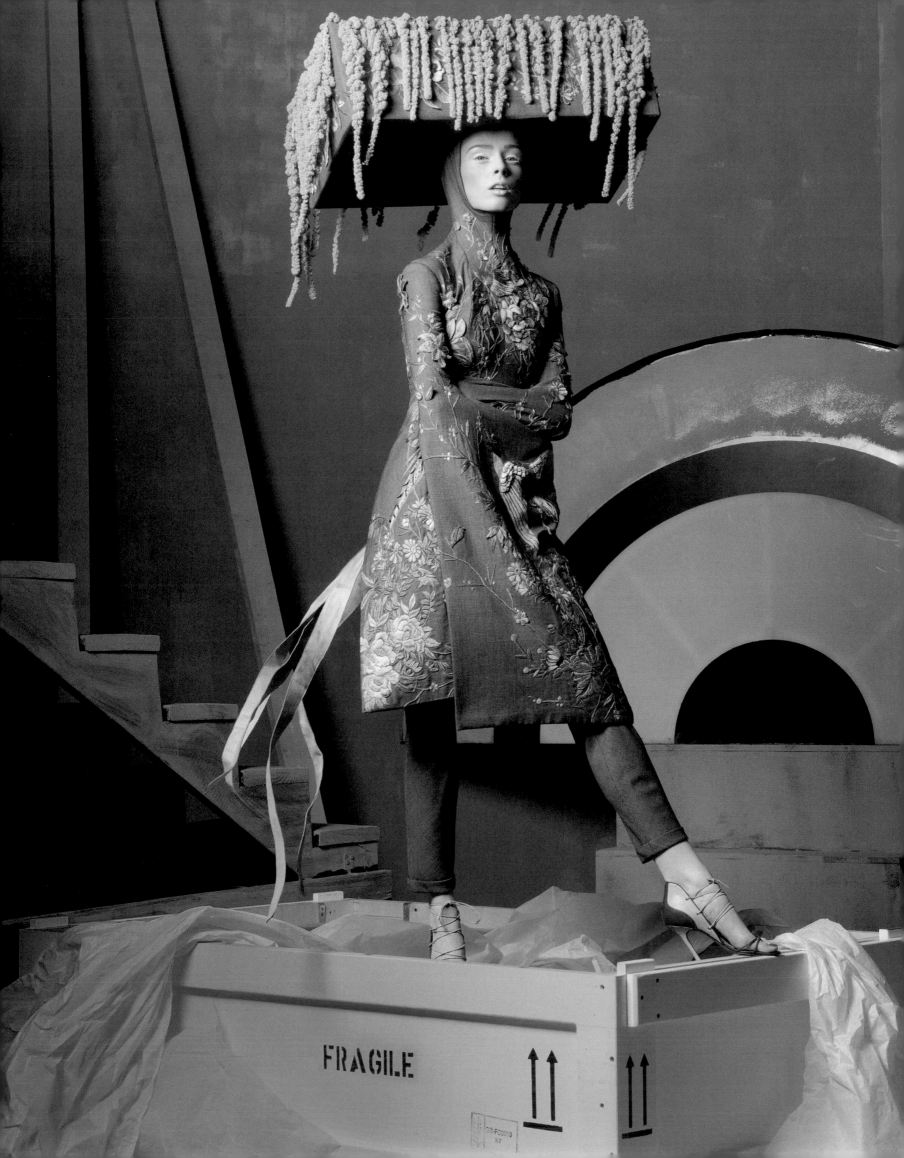

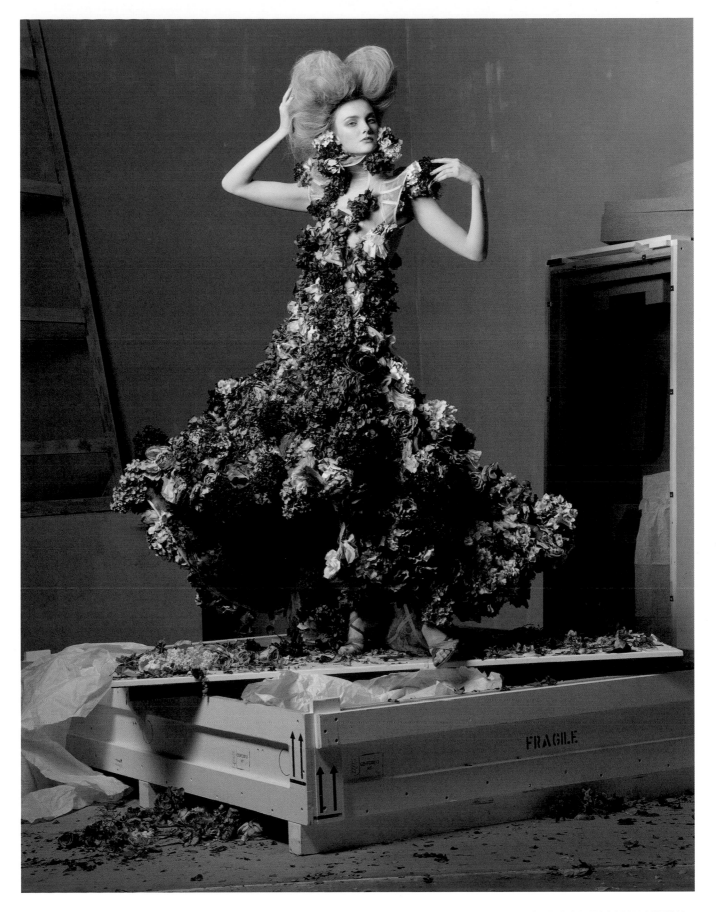

"THIS DRESS HAD FRESH FLOWERS ON IT," SARAH BURTON—
McQUEEN'S RIGHT HAND AND THEN SUCCESSOR—SAID OF A
PIECE FROM 2007'S "SARABANDE" RUNWAY SHOW. "WE PUT
THEM ON JUST BEFORE SHE WENT OUT, AND THEY STARTED
TO FALL OFF ONE BY ONE AS SHE WALKED. I REMEMBER
PEOPLE SAYING LEE TIMED IT. WE HAD A LAUGH ABOUT
THAT." OPPOSITE: KIMONO STRAITJACKET, SPRING 2001.

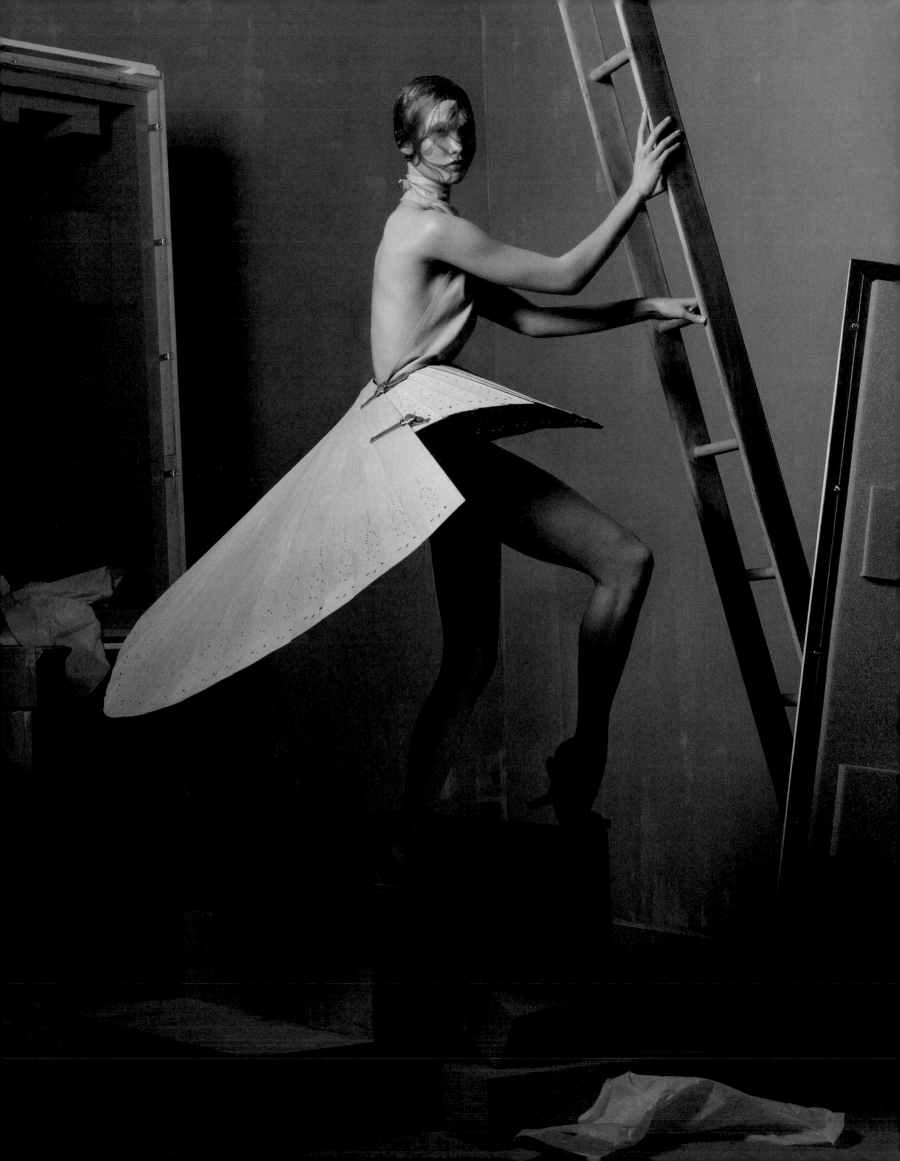

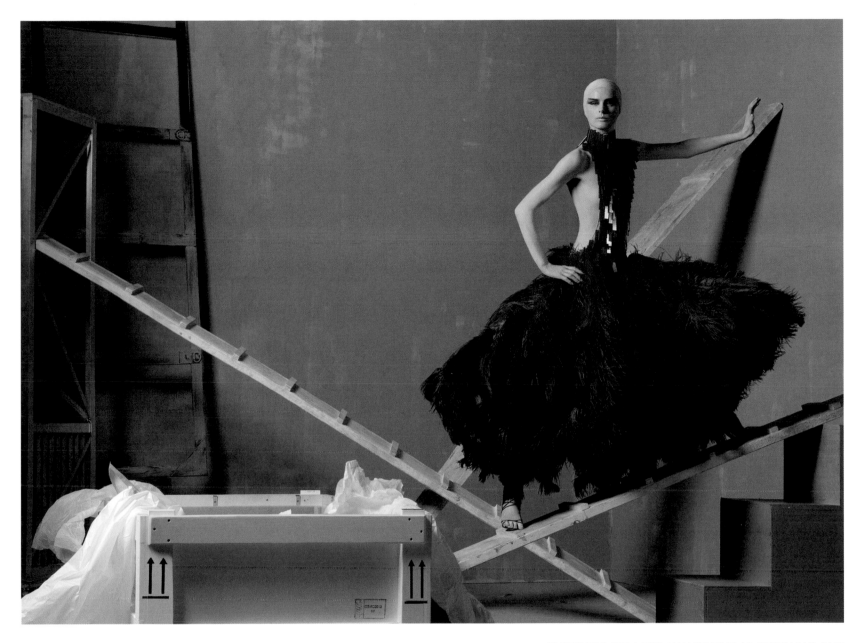

"WHEN YOU SEE A WOMAN WEARING McQUEEN," HE SAID
IN 2005, "THERE'S A CERTAIN HARDNESS TO THE CLOTHES
THAT MAKES HER LOOK POWERFUL. IT KIND OF FENDS
PEOPLE OFF." THAT WAS PATENTLY TRUE OF THE SPRING
1999 BALSA-WOOD SKIRT (OPPOSITE)—AND ALSO TRUE OF
THE SEEMINGLY ROMANTIC SPRING 2001 DRESS ABOVE,
WHICH HAD MICROSCOPE SLIDES WITH FAKE BLOOD AND
A SKIRT OF OSTRICH FEATHERS. **OVERLEAF:** RAVISHING
PIECES FROM McQUEEN'S FINAL COLLECTION, FALL 2010.

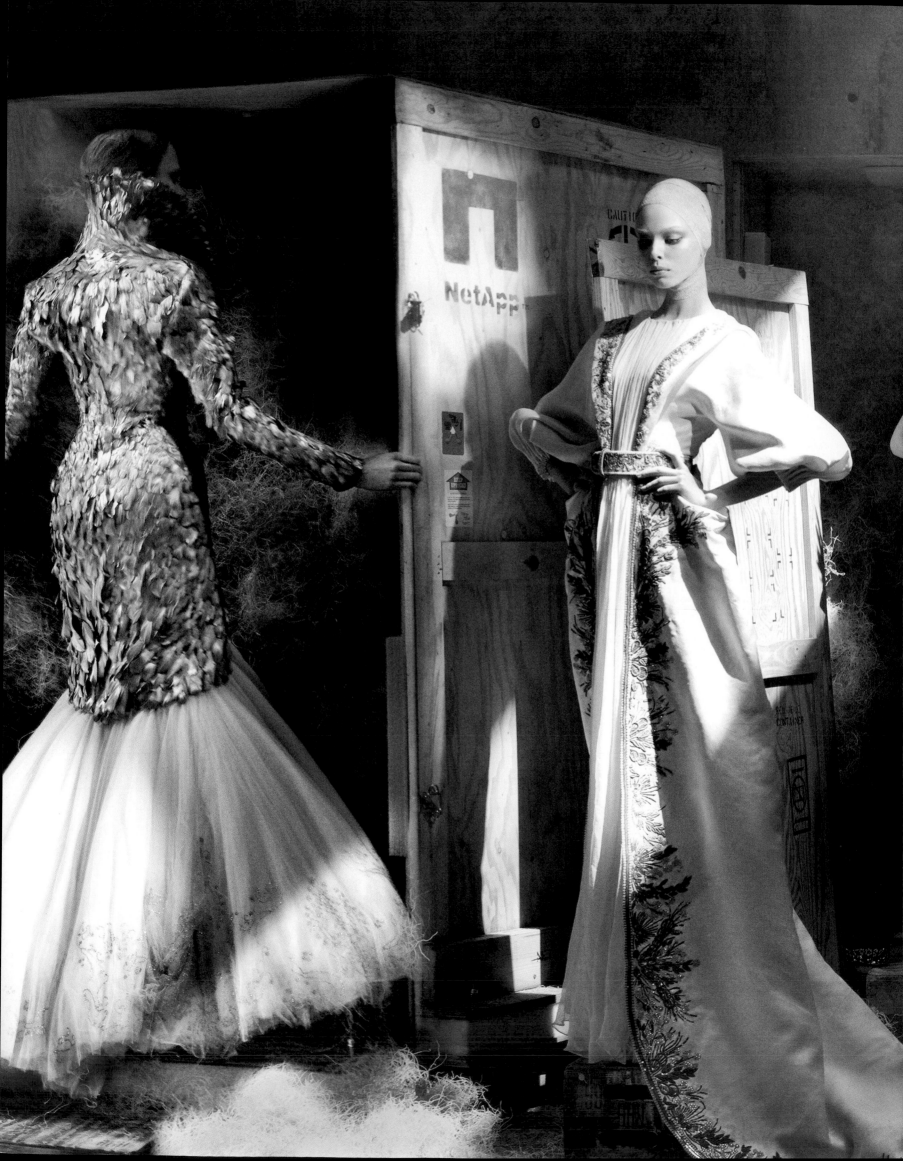

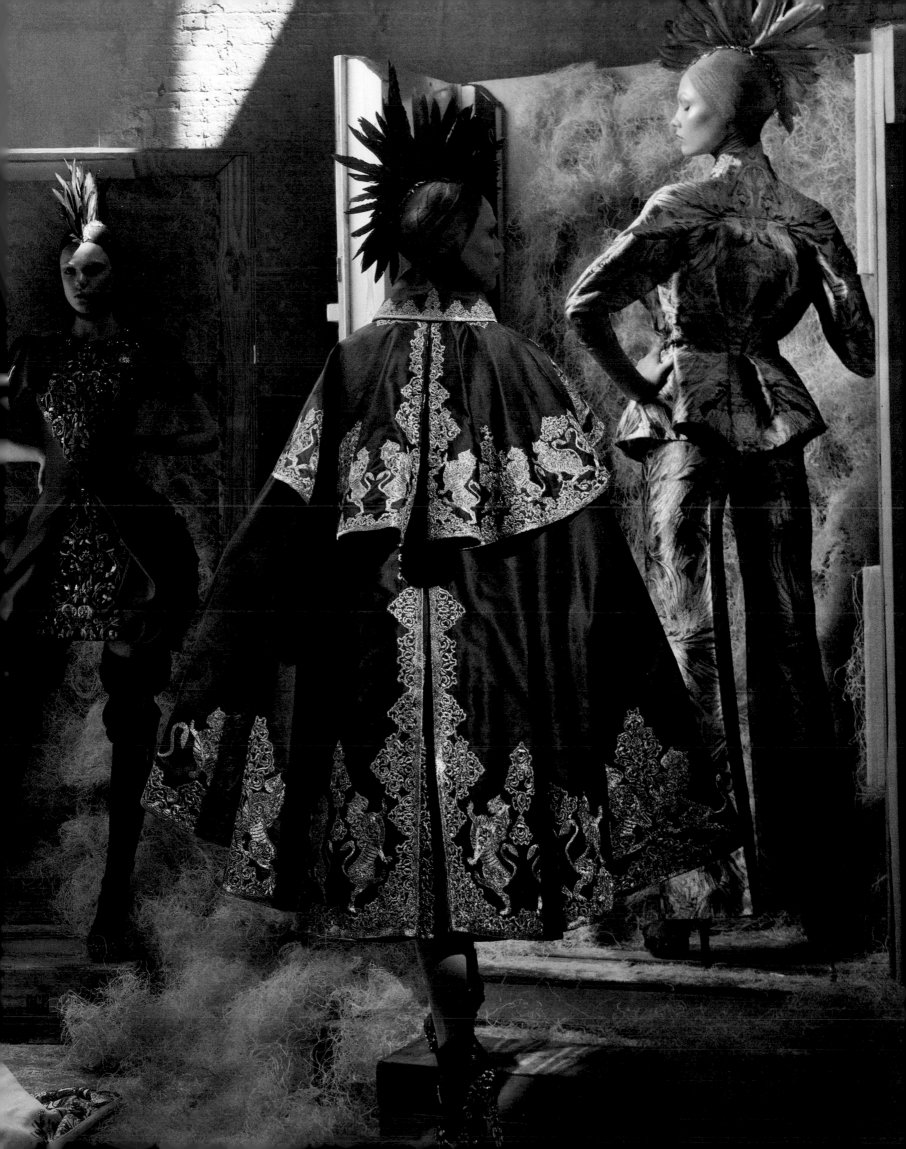

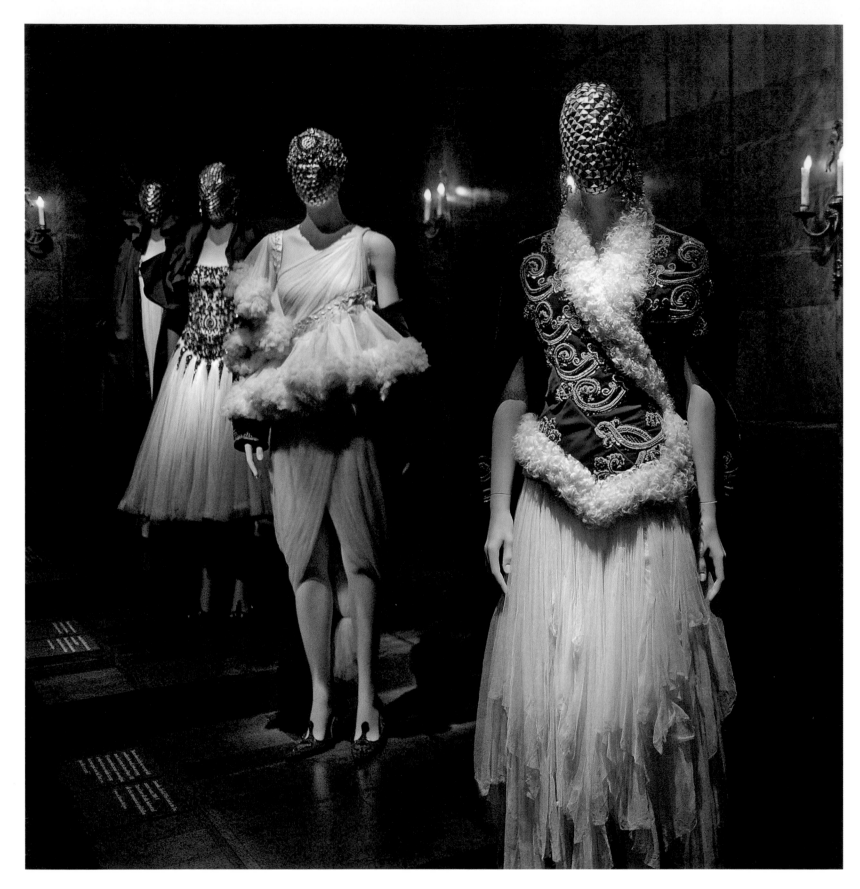

ABOVE, FROM THE EXHIBITION: WITH THE SCARLET AND GOLD OF HIS "THE GIRL WHO LIVED IN THE TREE" COLLECTION FOR FALL 2008, McQUEEN REFERENCED THE REGALIA OF THE BRITISH EMPIRE—ADDING FROTHS OF ERMINE AND FEATHERS. OPPOSITE: DAVID SIMS PHOTOGRAPHED SASHA PIVOVAROVA IN A CRIMSON SATIN OPERA COAT FROM THE SAME SEASON FOR *VOGUE*, SEPTEMBER 2008. **OVERLEAF:** FIVE LOOKS FROM THE SIXTEEN-PIECE COLLECTION THE DESIGNER WAS WORKING ON AT THE TIME OF HIS DEATH IN FEBRUARY 2010. AT CENTER, A MAGNIFICENT COAT OF GILDED FEATHERS AND A SKIRT OF EMBROIDERED TULLE.

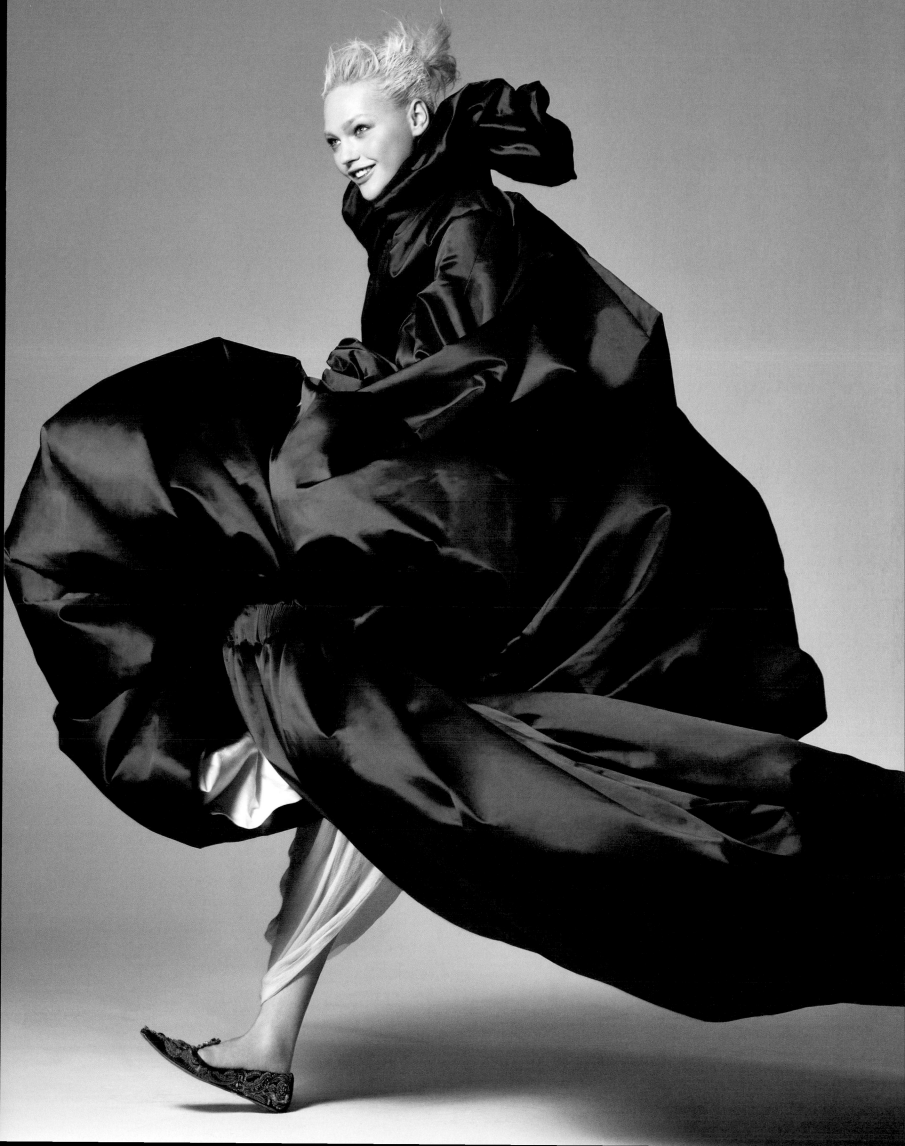

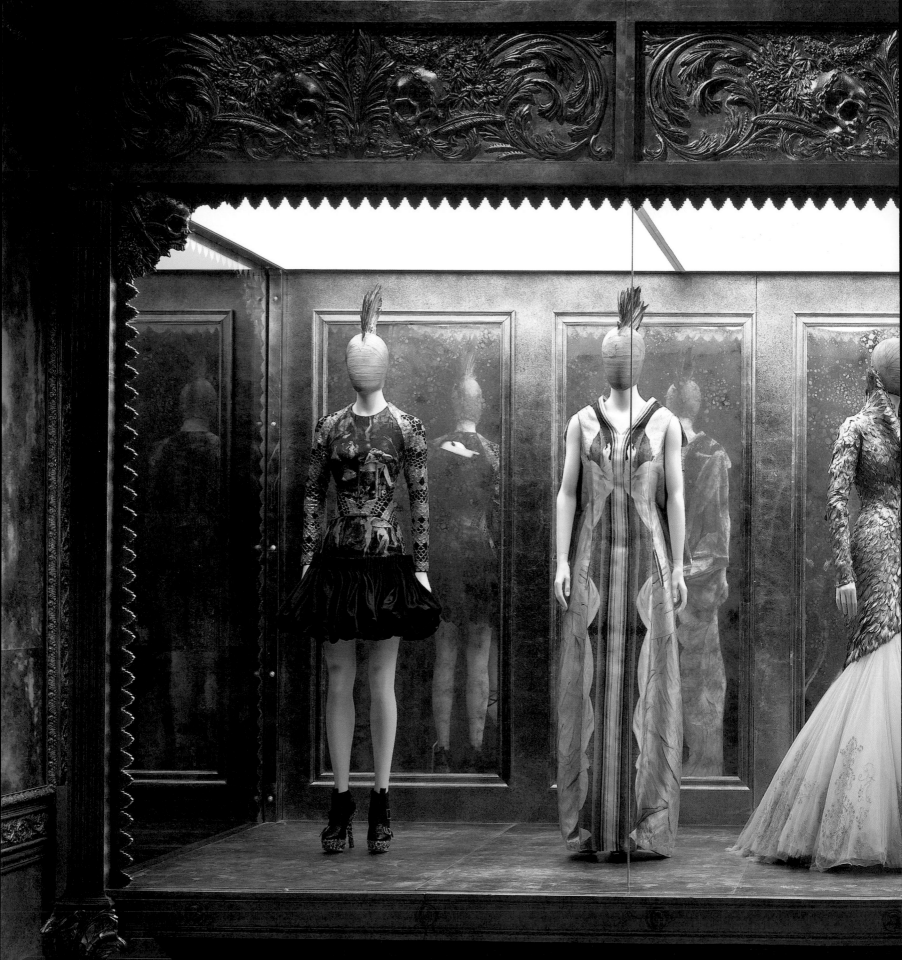

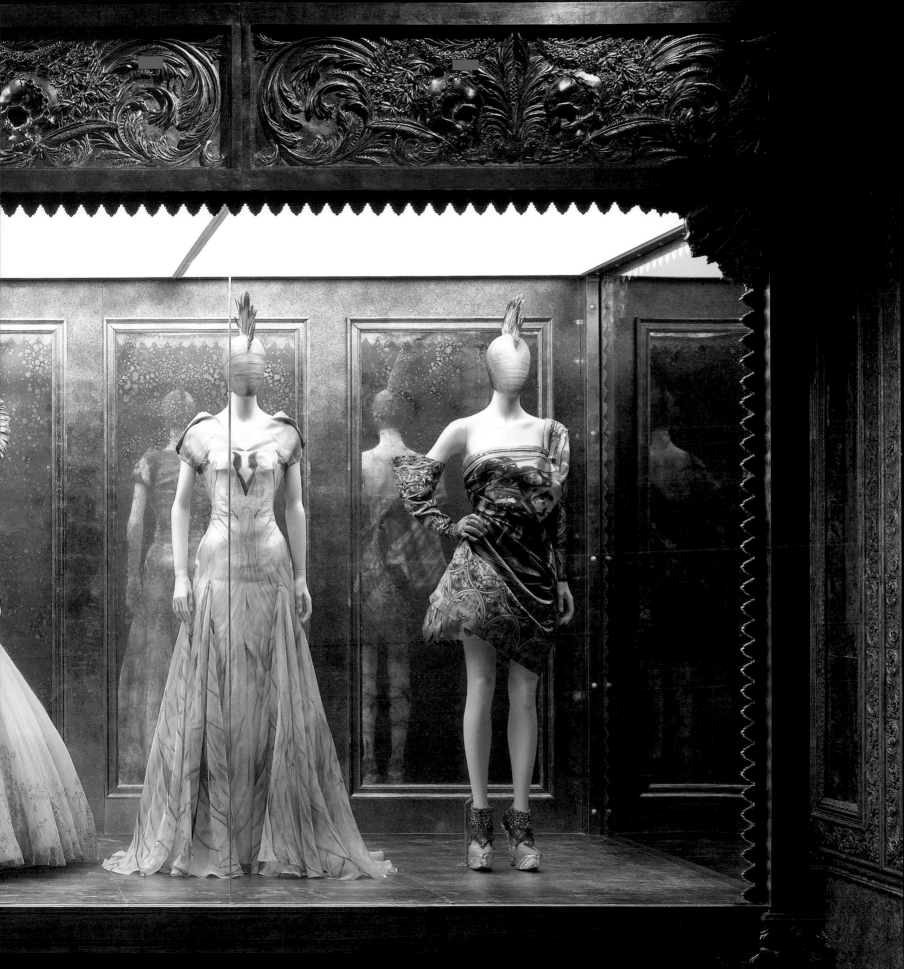

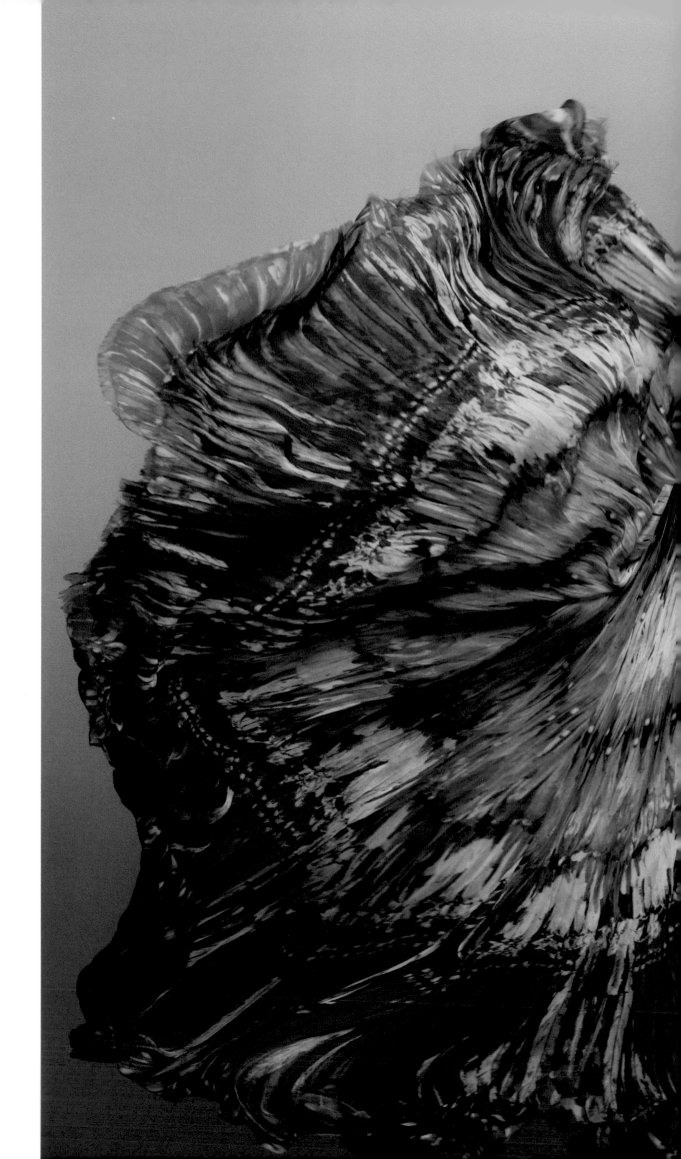

THE BIRD-OF-PARADISE PRINT
ON THIS MUCH-PHOTOGRAPHED
SPRING 2003 DRESS WAS
COMMISSIONED FROM FUTURE
BRIT-DESIGN STAR JONATHAN
SAUNDERS, WHO HAD JUST
GOTTEN HIS MASTERS IN TEXTILES
FROM CENTRAL SAINT MARTINS.
OVERLEAF: GILDED SHOE FROM
THE FINAL COLLECTION (WHICH
WAS COMPLETED BY BURTON AND
THE ATELIER). JELLYFISH ENSEMBLE
AND ARMADILLO BOOTS FROM
"PLATO'S ATLANTIS," SPRING 2010.

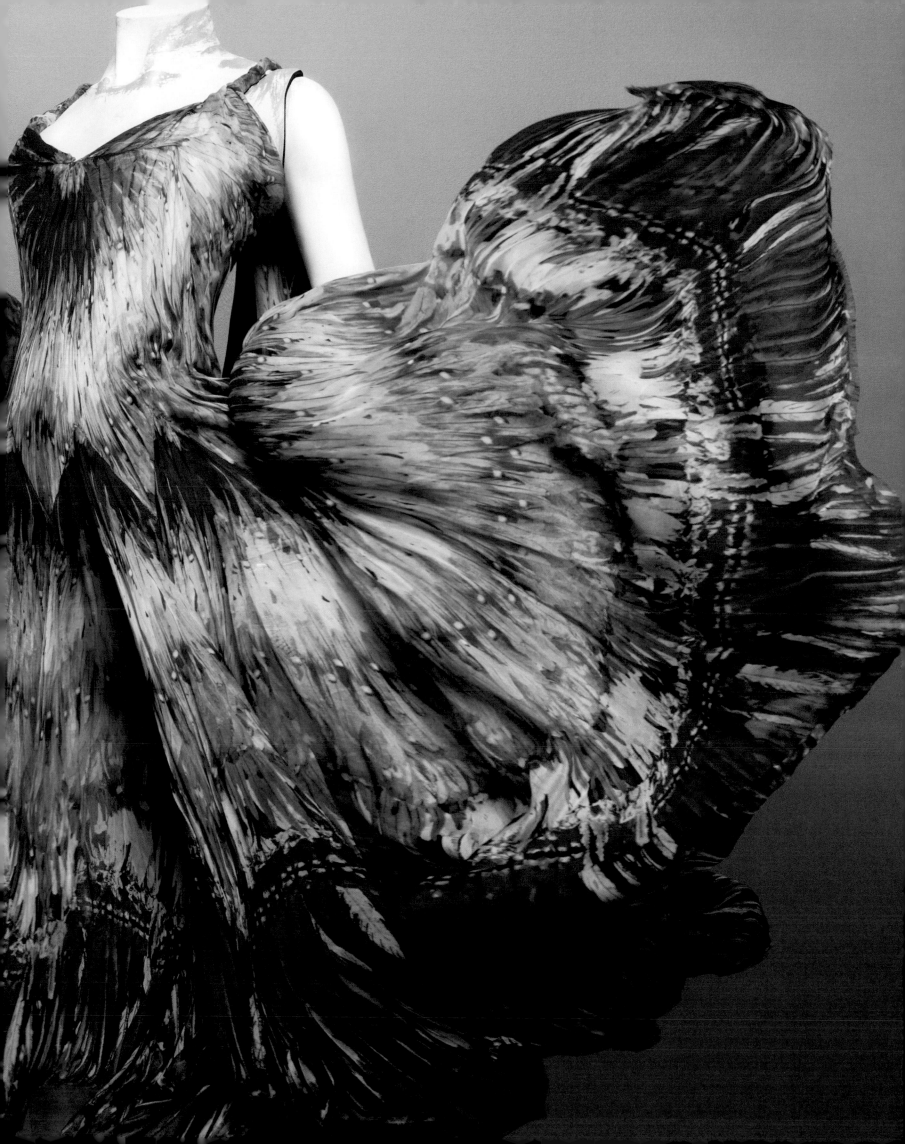

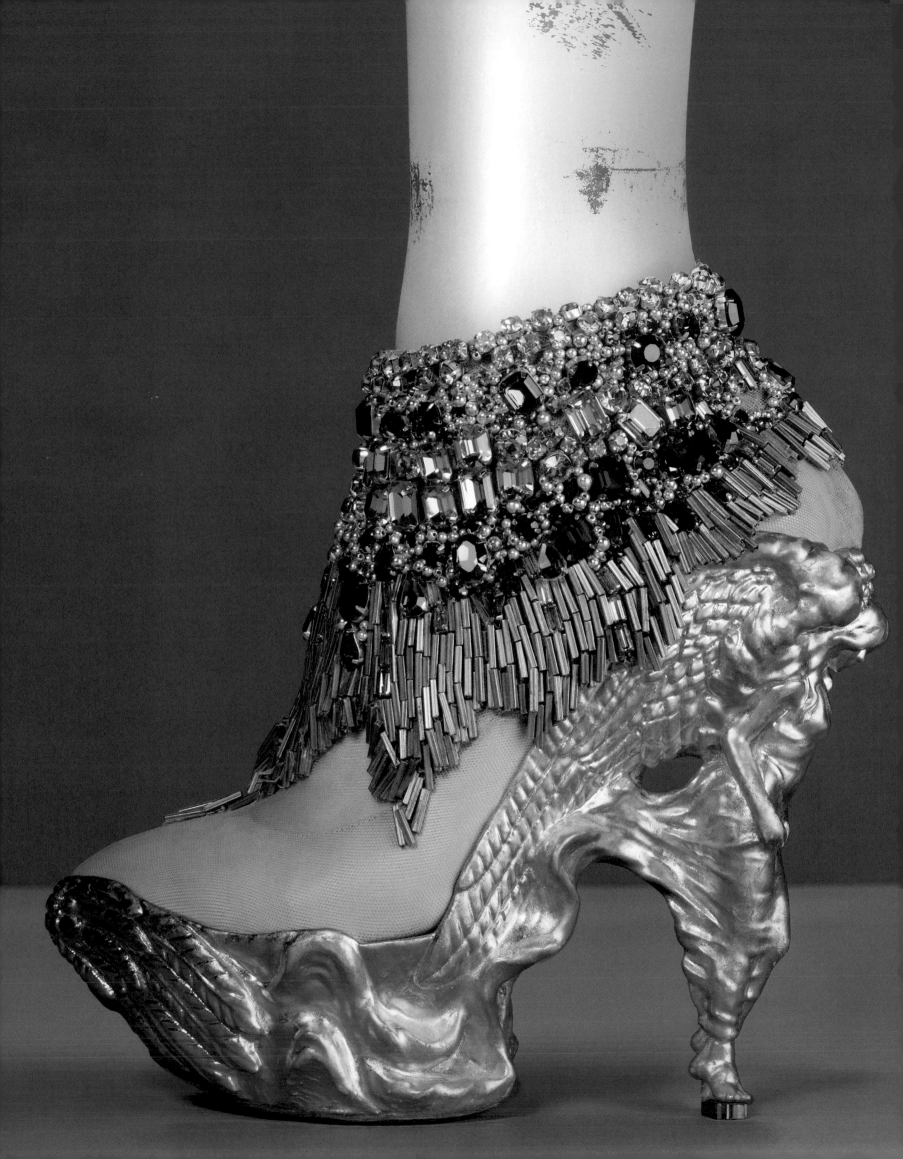

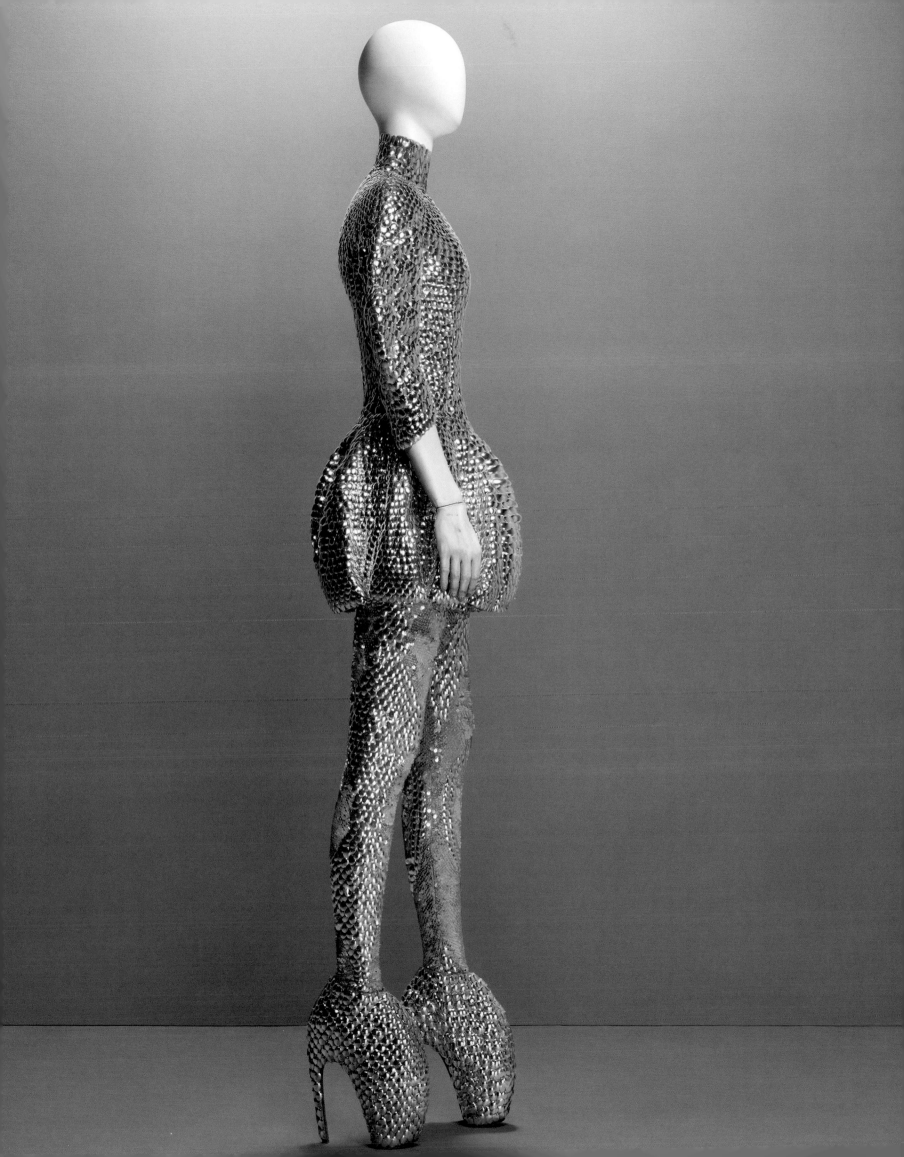

DOUTZEN KROES, IN GIAMBATTISTA
VALLI, CLIMBED THE DOGWOOD-,
MOSS-, AND HEATHER-LINED STAIRCASE.
PREVIOUS PAGE: INDIE ROCKER
FLORENCE WELCH SPREAD HER WINGS
IN McQUEEN AS GALA COCHAIRS
COLIN FIRTH (IN TOM FORD) AND STELLA
McCARTNEY (IN HER OWN DESIGN)
LOOKED ON. PHOTOGRAPHED BY
MARIO TESTINO, *VOGUE*, JULY 2011.

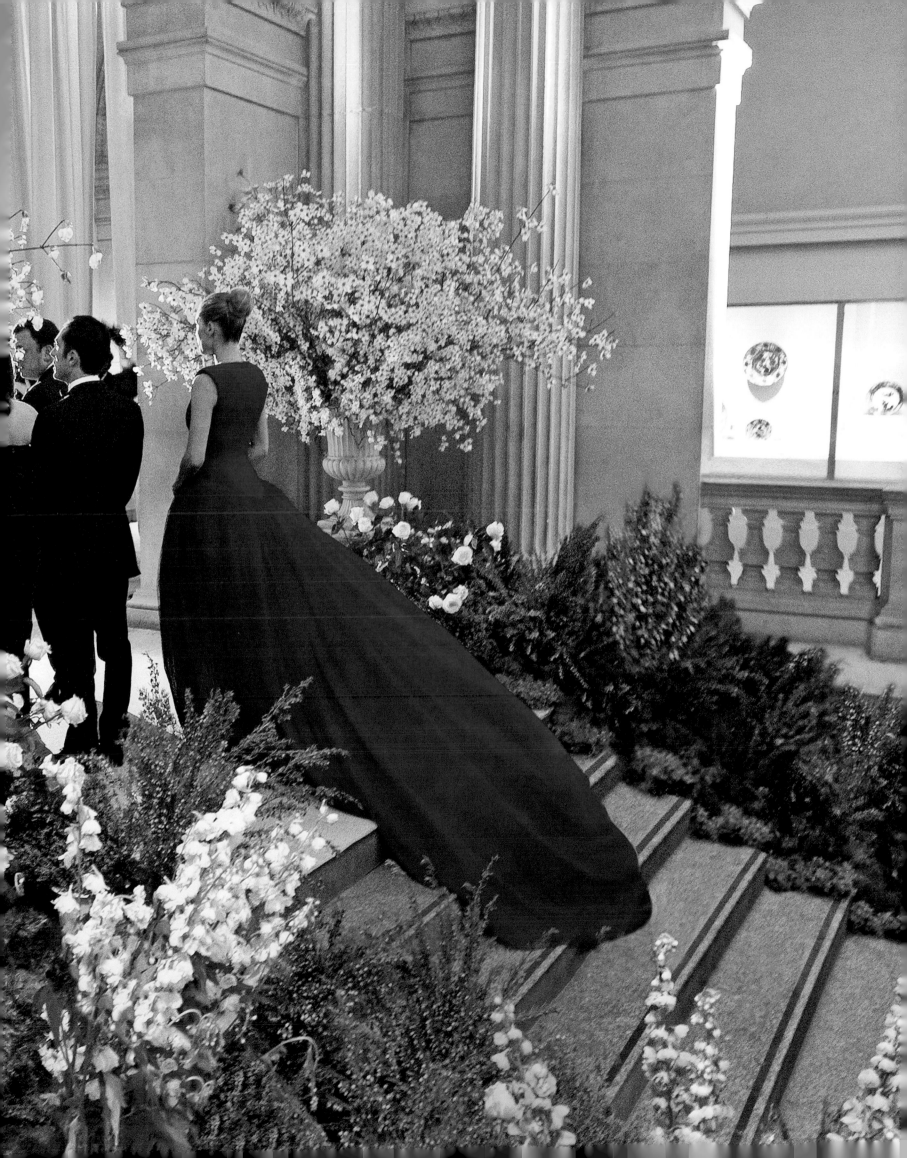

IMPALA-HORN JACKET,
"IT'S A JUNGLE OUT THERE,"
FALL 1997.

ROBOTS SPRAY-PAINTED THIS ON
THE SPRING 1999 RUNWAY.

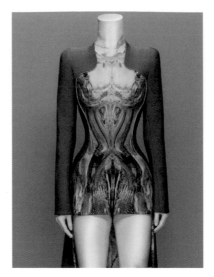

COMPUTER-GENERATED SEA-
REPTILE PRINT FROM McQUEEN'S
PENULTIMATE SEASON.

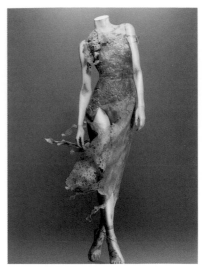

TORN-LACE DRESS,
"HIGHLAND RAPE" SHOW, FALL 1995.

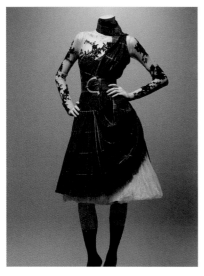

McQUEEN WOOL TARTAN,
"WIDOWS OF CULLODEN," FALL 2006.

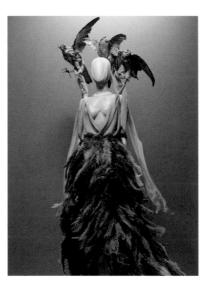

TAXIDERMY HAWKS,
"VOSS," SPRING 2001.

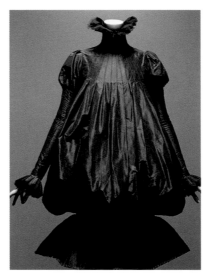

BLACK SILK BALLOON
DRESS, PRE-FALL, 2006.

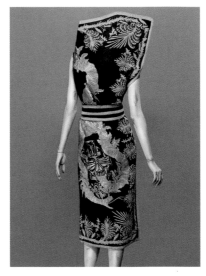

MILITARY BULLION,
"WHAT A MERRY-GO-ROUND,"
FALL 2001.

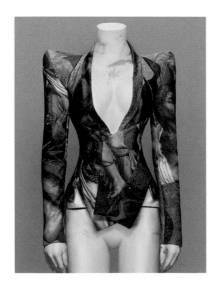

PRINT OF CAMPIN'S
"THE THIEF TO THE LEFT OF CHRIST,"
FALL 1997.

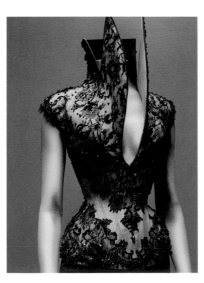

MOURNING COLORS OF LILAC
AND BLACK, "DANTE," FALL 1996.

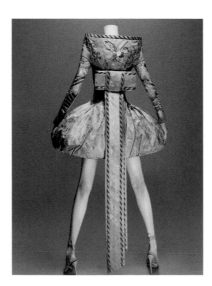

JAPANESE-QUEEN OUTFIT FROM
THE CHESS SHOW, SPRING 2005.

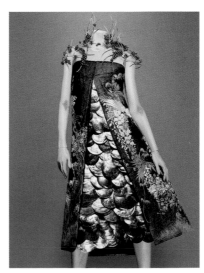

OYSTER SHELLS AND
PEARLS ON 19TH-CENTURY
SILK, SPRING 2001.

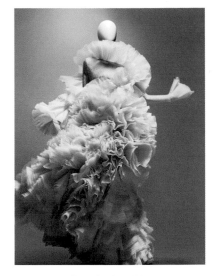

SILK ORGANZA,
"WIDOWS OF CULLODEN,"
FALL 2006.

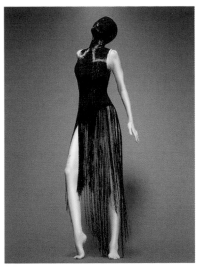

JOAN OF ARC–INSPIRED, WITH
RED BUGLE BEADS, FALL 1998.

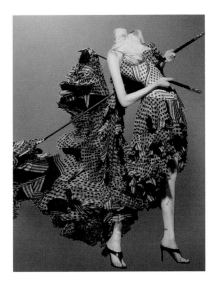

PICADOR LANCES,
"DANCE OF THE TWISTED BULL,"
SPRING 2002.

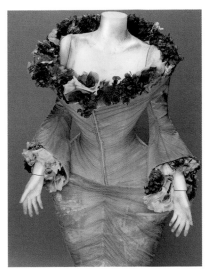

FRESH AND SILK FLOWERS,
"SARABANDE," SPRING 2007.

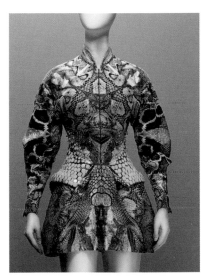

FROM LAST FULL COLLECTION,
"PLATO'S ATLANTIS," SPRING 2010.

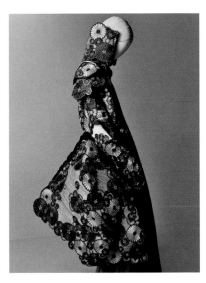

RAFFIA COAT WITH
CHRYSANTHEMUM ROUNDELS,
"VOSS," SPRING 2001.

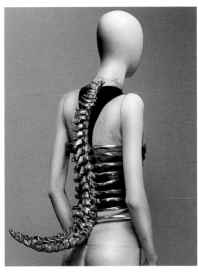

ALUMINUM SPINE CORSET, SHAUN
LEANE FOR McQUEEN, 1998.

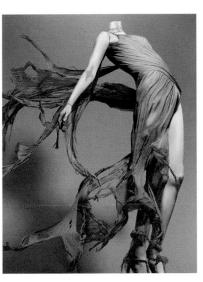

TATTERED BEIGE SILK,
"IRERE," SPRING 2003.

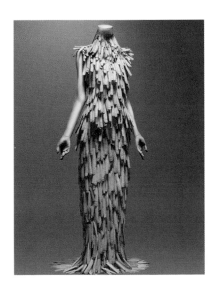

RAZOR-CLAM SHELL DRESS,
"VOSS," SPRING 2001.

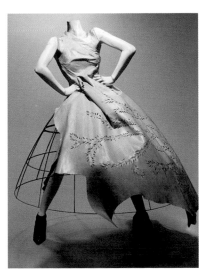

LEATHER OVER CRINOLINE,
YORUBA-INSPIRED, FALL 2000.

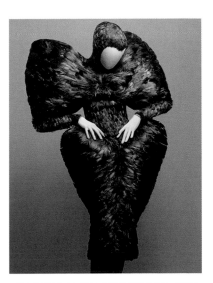

FEATHERS (A FAVORITE THEME), "THE
HORN OF PLENTY," FALL 2009.

NUDE SYNTHETIC WITH
MUD AND WOOD BEADS,
"ESHU," FALL 2000.

SCHIAPARELLI & PRADA IMPOSSIBLE CONVERSATIONS 2012

A HEADPIECE BY GUIDO PALAU IN THE EXHIBITION NODS TO BOTH PRADA'S LADYLIKE 2000 LIP PRINT AND THE MORE AVANT-GARDE SUIT WITH LIP-SHAPED POCKETS THAT SCHIAPARELLI CREATED IN COLLABORATION WITH SALVADOR DALÍ IN 1937. (OTHER PIECES IN WHICH DALÍ HAD A HAND WERE A SUIT WITH DRAWERS FOR POCKETS, HATS RESEMBLING LAMB CHOPS, AND THE ORGANDY FROCK PRINTED WITH A GIANT LOBSTER AND PARSLEY SPRIGS THAT WALLIS SIMPSON ORDERED FOR HER TROUSSEAU.)

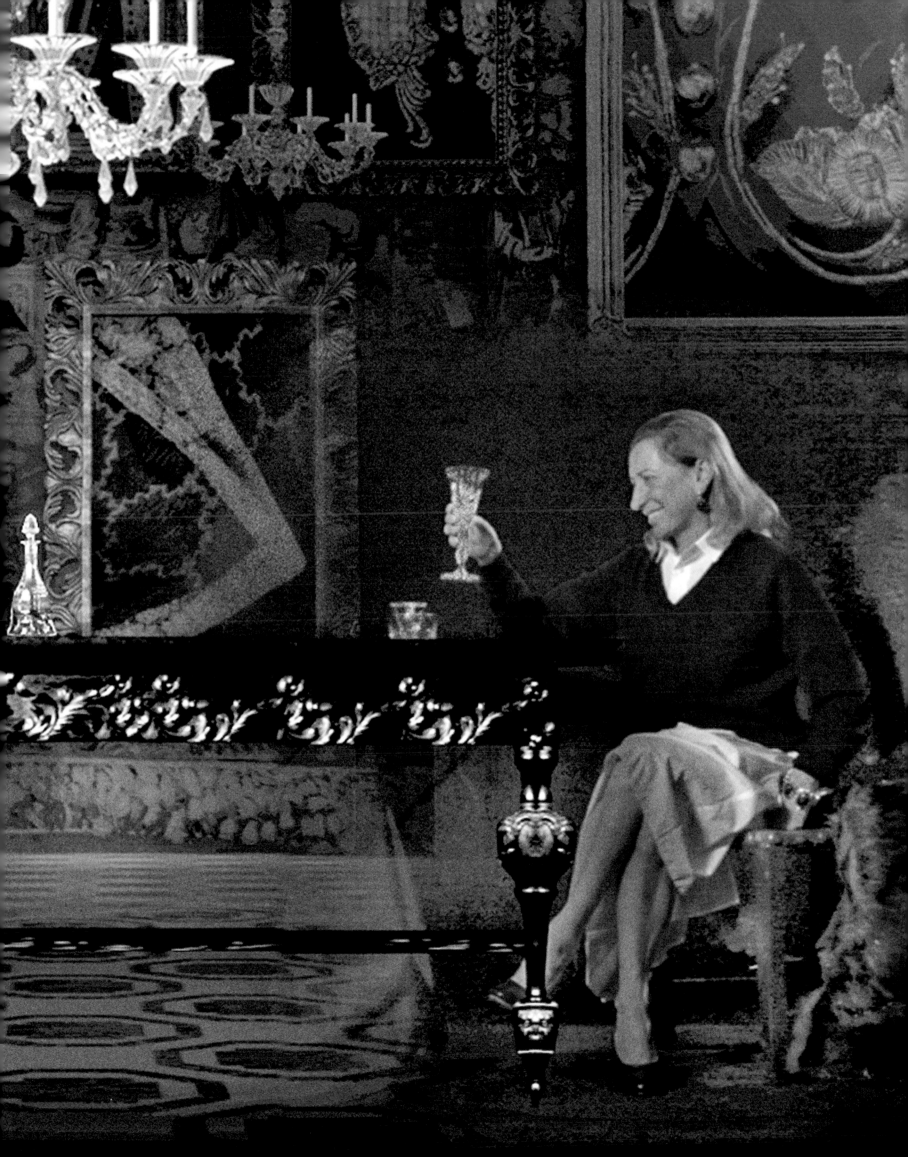

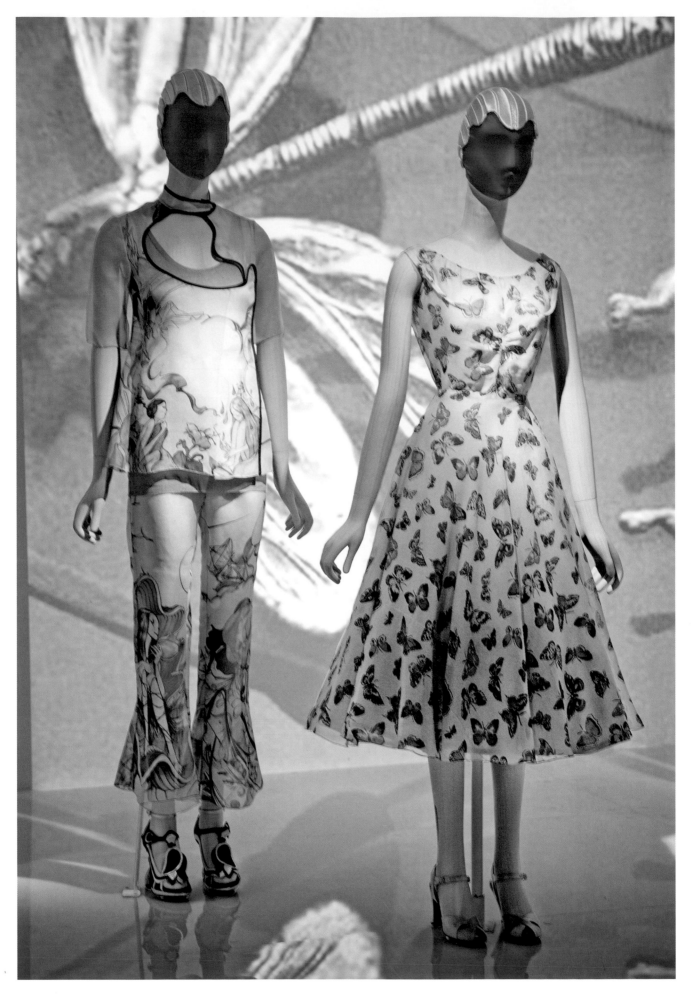

BOTH DESIGNERS HAVE BEEN KNOWN FOR HUMOR AND RADICALISM—AND A
DELIGHT IN FUN FAUNA PRINTS. FROM THE EXHIBITION, ABOVE: PRADA TOP AND PANTS
(2008), SCHIAPARELLI BUTTERFLY DRESS (1937). OPPOSITE: SCHIAP'S COTTON-NET
WEDDING VEIL, 1938. **PREVIOUS PAGES:** DISPLAYS WERE THREADED TOGETHER WITH VIDEOS
BY BAZ LUHRMANN DEPICTING IMAGINARY CONVERSATIONS BETWEEN THE TWO. PRADA
PLAYED HERSELF; ACTRESS JUDY DAVIS STOOD IN FOR SCHIAPARELLI. SNIPPETS OF DIALOGUE
WERE BORROWED FROM THE LATE COUTURIERE'S 1954 MEMOIR, *SHOCKING LIFE.*

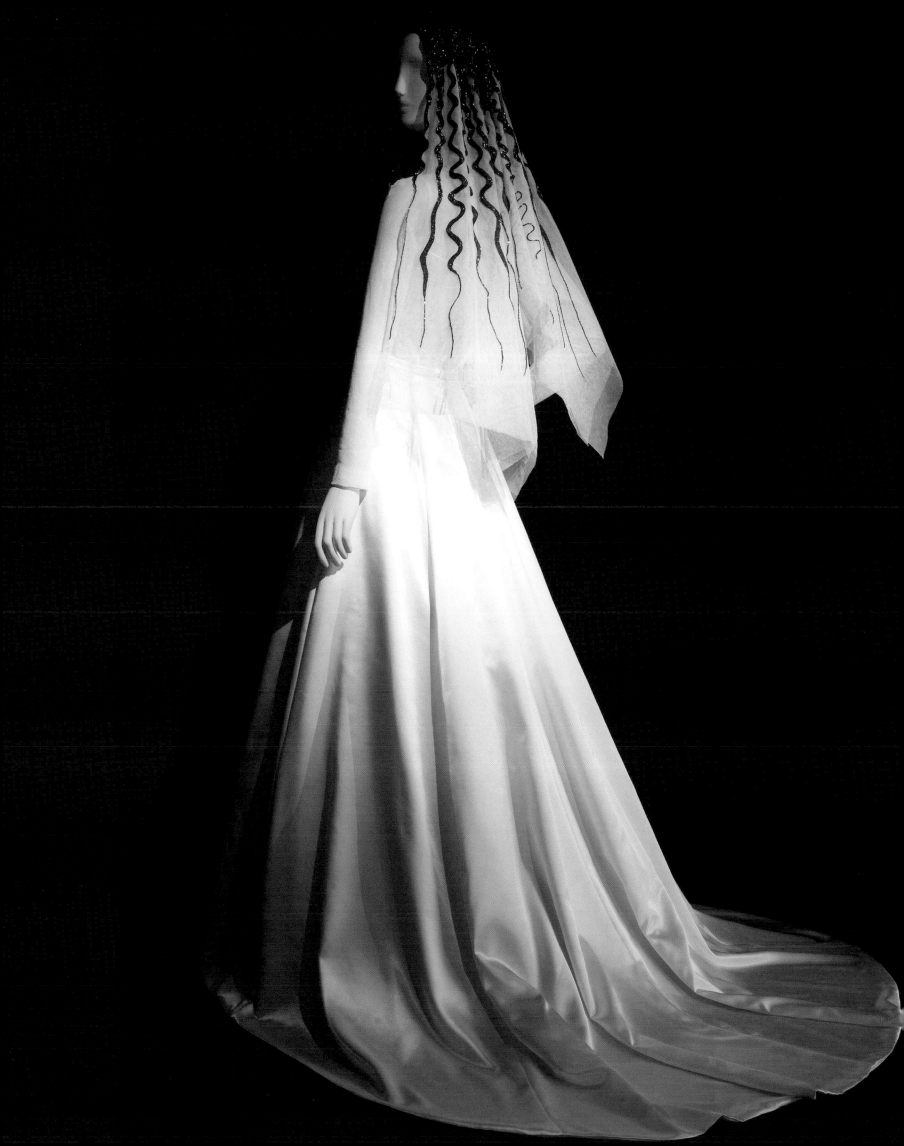

T he bold and brilliant universes, and the compelling, inscrutable personalities, of two formidable Italian designers are celebrated at The Metropolitan Museum of Art this month, when The Costume Institute unveils "Schiaparelli and Prada: Impossible Conversations." A half century separates the birth of Elsa Schiaparelli's Jazz Age fashion house and Miuccia Prada's debut at the storied luggage company started by her grandfather, but these two consistently thoughtful and thought-provoking bluestockings have each, as cocurator Andrew Bolton notes, used "fashion as a vehicle to provoke, to confront normative conventions of taste, beauty, glamour, and femininity."

Bolton and Costume Institute curator-in-charge Harold Koda use such categories as "Hard Chic," "Ugly Chic," "Naïf Chic," and "The Surreal Body," among others, to explore aesthetic similarities in the two designers' oeuvres—resonances that astonished Prada. "I looked at her [work]," she says, "but it was always so precise that I couldn't quote her." The disembodied lips that swirled over Prada's pleated skirts in spring 2000 were a quotation from Yves Saint Laurent, who in turn was paying homage to "Schiap," as Prada later discovered. The Saint Laurent references are autobiographical, after all; Prada has a closetful of originals and famously handed out Communist literature while wearing Rive Gauche. "Every piece of Prada is a Proustian madeleine that Miuccia then processes through her aesthetic," wrote *Vogue* in 1995. The echoes are there, however. Miuccia's Lost in the Woods collection (fall 1999), for instance, featured black, shiny bugs on an orange tweed midi skirt. A prim black Schiap suit from 1938 has a candy-pink Claudine collar that, on closer inspection, is crawling with metal insects, a Surreal subversion. Schiap introduced sari dresses in 1935; Prada fashioned a draped evening dress from sari silk for spring 2004. And Schiap's radical innovations in textiles—fabrics molded like tree bark, cellophane, and spun glass—parallel Prada's own fabric experiments.

"What I think is very important is the difference in times," says Prada. "It's really fundamental. Because we more or less approach all of the things that everybody approaches: embroidery, feather, color, beauty. But eccentricity then was more possible than now. She was in a revolutionary moment of her own. And I lived through the sixties and seventies, a completely different revolution. . . . But probably she wanted to break rules to move forward in her time, and I want to move forward in my time. So that is what is [in] common." Schiap's sari dress, for example, was inspired by the sensational appearance of the orchidaceous fourteen-year-old Princess Karam of Kapurthala in thirties Parisian society; Prada, meanwhile, was toying with the idea of globalization, grafting the sari onto a fifties couture silhouette. And while the rococo whorls of white leather embellishing Schiap's 1937 black evening jacket anticipate the same motifs in a playful print dress from Prada's spring 2011 collection, Schiap may have been thinking of the volutes of the modish neo-Romantic decorations of Serge Roche and his ilk, whereas Prada was playing with notions of fifties Hollywood and Carmen Miranda kitsch.

The installation, designed by Nathan Crawley, is threaded with a series of videos by creative consultant Baz Luhrmann, eavesdropping on a series of "impossible conversations" (the title is inspired by one of the "Impossible Interviews" the artist Miguel Covarrubias created for *Vanity Fair*, depicting an imagined meeting between Stalin and Schiap following the designer's controversial 1935 trip to the Soviet Union for a trade fair). As Bolton proves, the two women's words echo uncannily across the decades.

Schiap: "I enjoy creating for the woman who, no matter what her years, wears my clothes with the poise of youth."

Prada: "I hate the idea that you shouldn't wear something just because you're a certain age."

SCHIAPARELLI & PRADA

IMPOSSIBLE CONVERSATIONS

ON THE GALA INVITATION: *OBSERVATORY TIME—THE LOVERS* (1932–4), ONE OF THE MOST RECOGNIZABLE WORKS BY MAN RAY, REPORTEDLY FEATURES THE LIPS OF MODEL/MUSE/PHOTOGRAPHER LEE MILLER. **OVERLEAF:** PRADA PIECES FROM THE SHOW— SPANNING COLLECTIONS FROM SPRING 1996 TO FALL 2011—WERE PHOTOGRAPHED BY STEVEN MEISEL FOR THE MAY 2012 *VOGUE*.

Schiap: "One [has] to sense the trend of history and precede it."

Prada: "For me, it's important to anticipate where fashion is heading."

If Schiap is remembered today, it is for Surreal eccentricities and her trademark color, the purple-tinged magenta she dubbed "shocking pink," but in fashion terms, "she changed the outline of fashion from soft to hard, from vague to definite," in the words of *Vogue*'s mid-century fashion editor Bettina Ballard. In the uncertain years before World War II, the revolutionary audacity of Schiap's designs deliberately subverted conventional notions of beauty and attraction. Prada's own astonishingly febrile imagination provides complementary inspiration. "If I have done anything, it is to make ugly appealing," Prada told Bolton. "In fact, most of my work is concerned with destroying—or at least deconstructing—conventional ideas of beauty, of the generic appeal of the beautiful, glamorous, bourgeois woman. Fashion fosters clichés of beauty, but I want to tear them apart."

There are common autobiographical threads, too, from their artistic engagements to their unconventional looks. Schiap was born to a patrician family of academics. As a child she was berated by her mother for her plain appearance, and as a result she sowed flower seeds in her ears, nose, and mouth, hoping that they would transform her into a blooming beauty. At home, Prada appraises herself in three slices of mirror, revealing different aspects of her appearance but never its totality.

Schiap's path to design was unconventional. She ran away from her sequestered life in Italy, eventually traveling to America with her husband, a charismatic spiritualist, Count Wilhelm de Wendt de Kerlor. When the caddish de Kerlor abandoned her (apparently for Isadora Duncan) and their infant daughter (Maria Luisa Yvonne Radha, known as Gogo), she took up with the Greenwich Village Dadaists. She eventually moved to Paris, working as a salesclerk and later as a freelance designer for a series of lesser-known fashion houses. In 1927 Schiap opened her boutique on fashionable Rue de la Paix. Her success was meteoric; by 1932, she had a staff of 400 working in eight ateliers to produce up to 8,000 garments a year. Although she originally focused on streamlined sweater-and-skirt combinations, one of her earliest evening dresses was a black crepe sheath with a white chiffon jacket that tied like an elegant strait-jacket. Flamboyant publisher Caresse Crosby accessorized her version with jade earrings and a green-wrapped after-dinner mint to complete the picture. Such were the perfectionist details of the Schiap clients, who included such exigent women as Millicent Rogers and Daisy Fellowes, and movie goddesses including Marlene Dietrich, Greta Garbo, Katharine Hepburn, and Joan Crawford. The turn-of-the-century costumes that Schiap designed for the voluptuous Mae West in *Every Day's a Holiday* (1937) inspired a flurry of late-Victorian fashion details, and the curvaceous torso that West sent in lieu of fittings informed artist Leonor Fini's hourglass-shaped perfume bottle for Shocking, the heady fragrance that wafted through her new Place Vendôme salons. Schiap was also inspired by her mother's wasp-waisted Belle Époque gowns, elements of which resonated in her ironically romanticist late-thirties clothes. For Prada, who never studied fashion history, fashion-historical references are also highly personal. "I'm more interested in the impression of a period," she says. ". . . My learning process is by eye alone; it's not at all scientific. I jump by chance on something because of my life, because of what I see—an exhibition, a movie, a picture. My learning process was through vintage because in the eighties I bought a lot of vintage. They have a deep influence on me because I lived with them, so I know what they mean as a woman."

Both women share a sly and antic sense of humor. Schiap made her name with trompe l'oeil sweaters hand-knitted with sailors' tattoos, imaginary jabots, or a skeleton torso, and in the wake of the Wall Street Crash, she used a dollar sign to fasten a coat. She

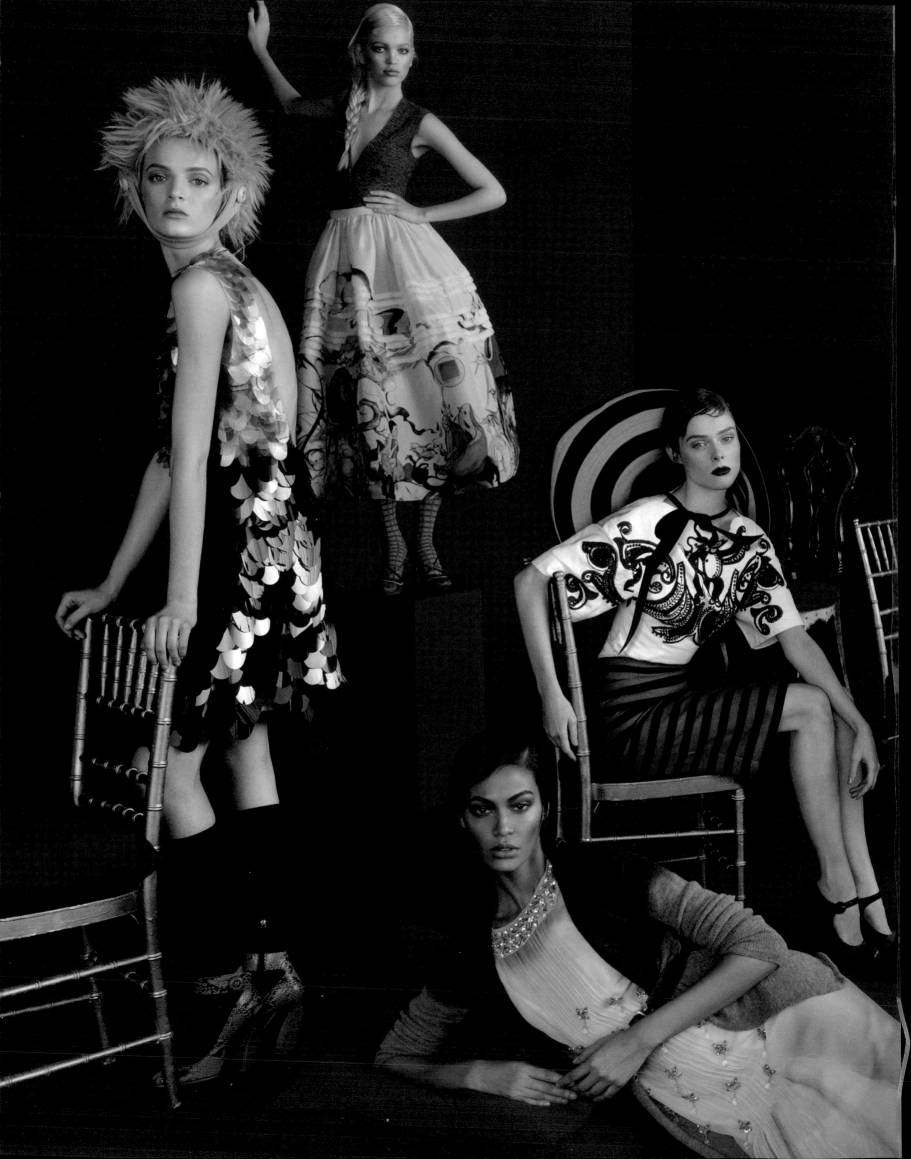

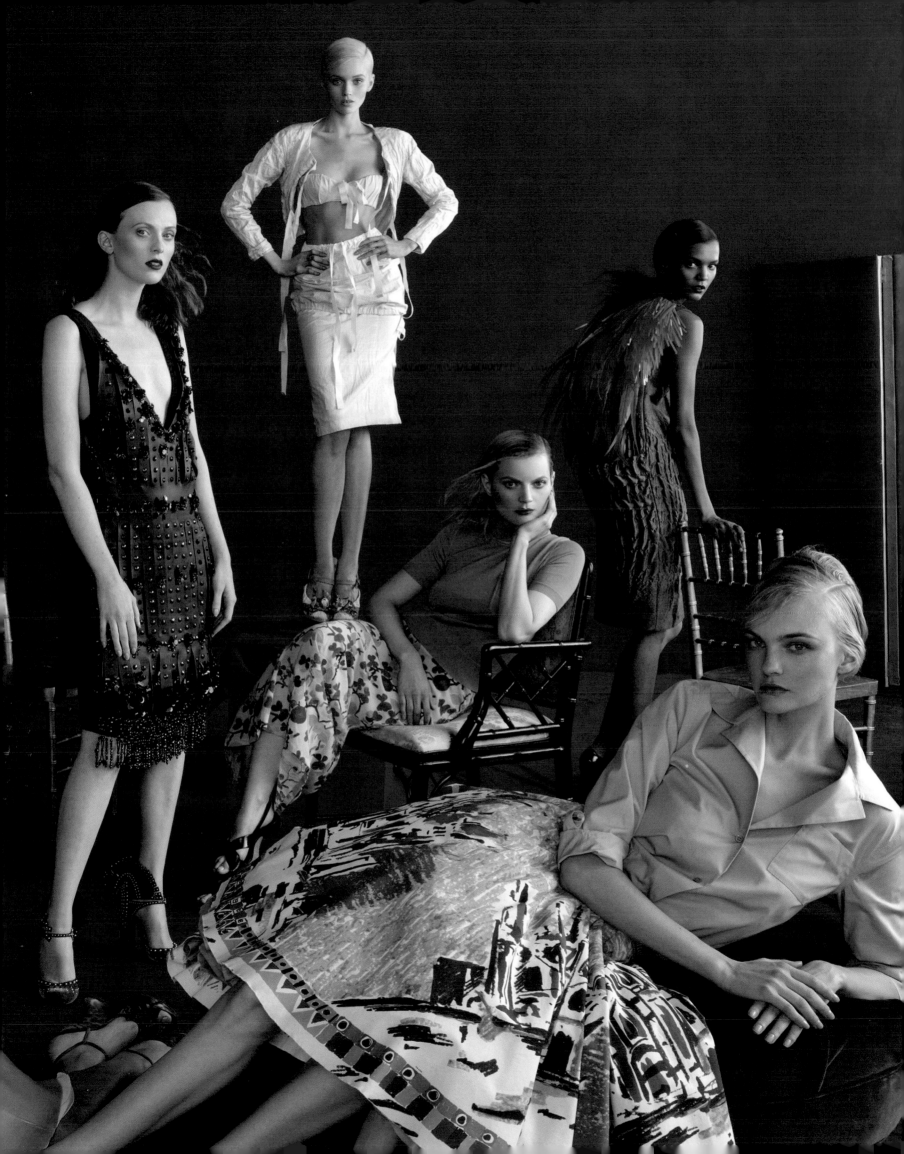

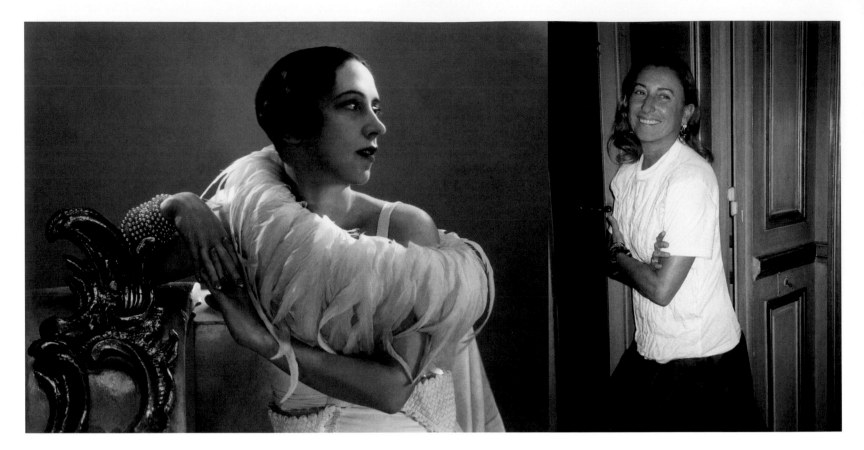

SCHIAPARELLI IN A COQ-FEATHER BOA, BY GEORGE HOYNINGEN-HUENE,
VOGUE, SEPTEMBER 1, 1932. PRADA BEFORE THE MIU MIU SHOW IN PARIS, BY
MANUELA PAVESI, OCTOBER 2008. OPPOSITE: HUBERT DE GIVENCHY ONCE
POINTED OUT SCHIAPARELLI'S MISMATCHED SHOES. "WOULD YOU KNOW CHIC
IF IT HIT YOU IN THE HEAD?" WAS HER IMPERIOUS RESPONSE. DARIA STROKOUS
WORE A 1937 MIRROR-PRINT SUIT AND SILK-VELVET TURBAN IN THE MAY 2012 ISSUE.

also collaborated with Salvador Dalí on a suit with drawers for pockets, an organdy debutante frock printed with a giant lobster and parsley sprigs (Wallis Simpson ordered one for her trousseau), and hats resembling lamb chops or inverted shoes. She went further still with a 1938 evening dress in a print that suggests the flayed skin of an animal. Like Prada, however, she never neglected her less adventurous clients and was equally famed for her impeccable little black day dresses, razor-sharp tailoring, and the evening clothes that Dilys Blum, curator of the Philadelphia Museum of Art's landmark 2003 Schiaparelli exhibition, described as "often deliberately provocative, exhibiting a subtle or sometimes blatant sexuality [that] . . . played with notions of concealment and exposure." For her part, "I try to make women feel more powerful without losing their femininity," Prada has said.

In 1978, Prada, who has a doctorate in political science, took over the Milanese luggage company her grandfather founded in 1913 (she began designing clothes in 1988) and, with husband and business partner Patrizio Bertelli, made the label an international brand name and potent fashion force, initially by crafting handbags from resilient army-tent material. She has embroidered her faux-frumpy frocks with bottle tops, broken cutlery, and mirror shards, and in her austere third-floor office, rearing like the head of the Loch Ness monster, is the entrance to a spiraling slide by the artist Carsten Höller that transports the intrepid to the courtyard below. And like Schiap, she has delighted in subverting the purpose of clothing, transforming uniforms like hospital scrubs and utilitarian pieces such as aprons into high-fashion garments.

But in addition to the parallels, it is the two women's differences that define them. One section of the exhibition is titled "Waist Up/ Waist Down." Schiap, thinking of scintillating dinner parties, theater soirees, and a partner's embrace on the dance floor, generally focused her attention above the waist, introducing whimsically embellished evening jackets and playful hats. Prada, on the other hand, with her uniform of the simplest cardigans and sweaters worn with flamboyant skirts (and, this season, pants), focuses on the waist down. "To me the waist up is more spiritual, more intellectual, while the waist down is more basic, more grounded," she told Bolton. "It's about sex. It's about making love. It's about life. It's about giving birth. Basically, below the waist is more connected to the earth."

In the frivolous thirties, Schiap had dressed modern women on the move—sleek by day, audacious after dark—but because, according to Ballard, she "never wanted to be bored by her business or to bore her customers" and was facing bankruptcy, she shuttered her doors in 1954. Archrival Coco Chanel derisively described Schiap as "that Italian artist who makes clothes," and Schiap would not have been insulted by the designation. "Dress designing . . . is to me not a profession but an art," she wrote. She was photographed by Man Ray, painted by Picasso, and worked not only with Dalí and Jean Cocteau but with Alberto Giacometti (who designed buttons for her), Meret Oppenheim (a fur-covered cuff), and Elsa Triolet (an "aspirin" necklace). Prada, meanwhile, has collaborated with the architects Rem Koolhaas and Jacques Herzog and Pierre de Meuron on innovative retail environments, and the magnificent Fondazione Prada galleries in Milan and Venice bear witness to her profound and informed involvement with the contemporary-art scene—a world, however, that she keeps very separate from her design atelier. Does Prada consider fashion art? "In the end I decided, Who cares what it is?" she says, laughing. "The important thing is if it's good or not."—HAMISH BOWLES, *VOGUE*, MAY 2012

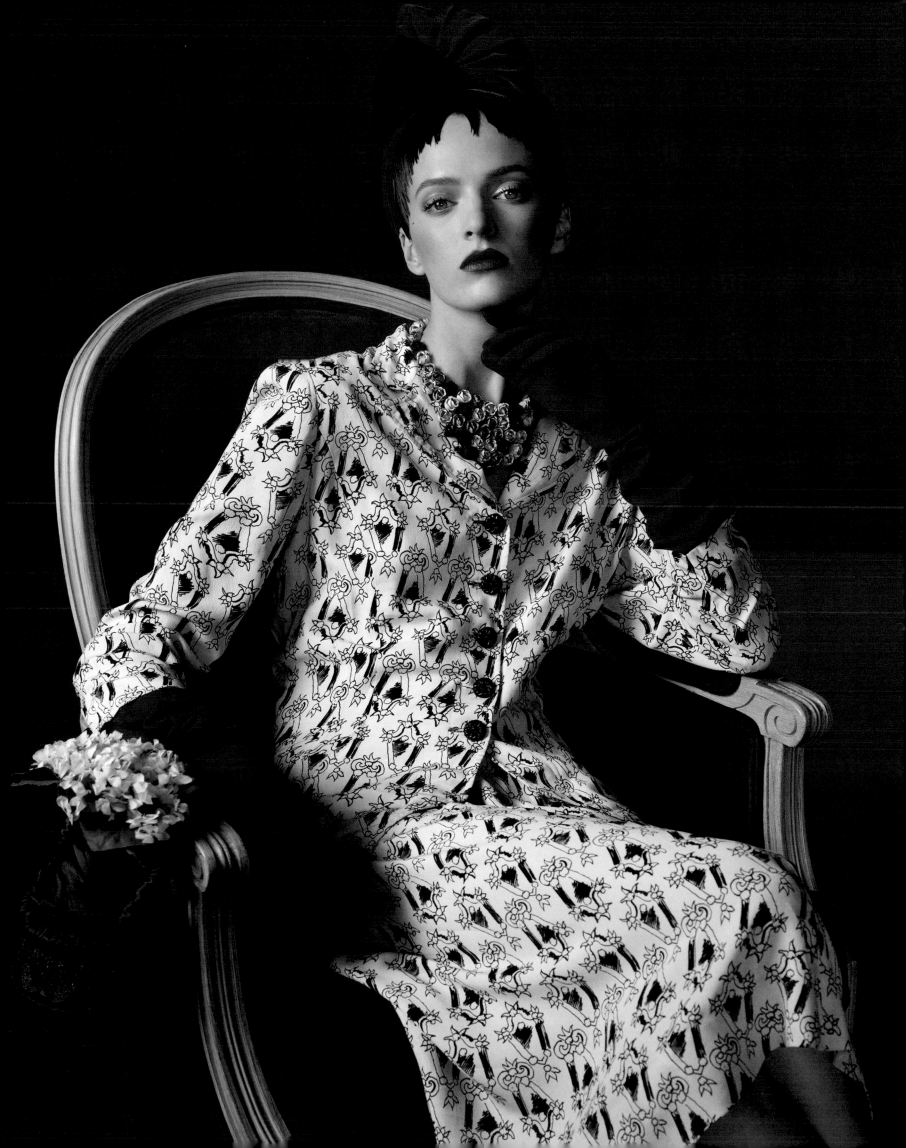

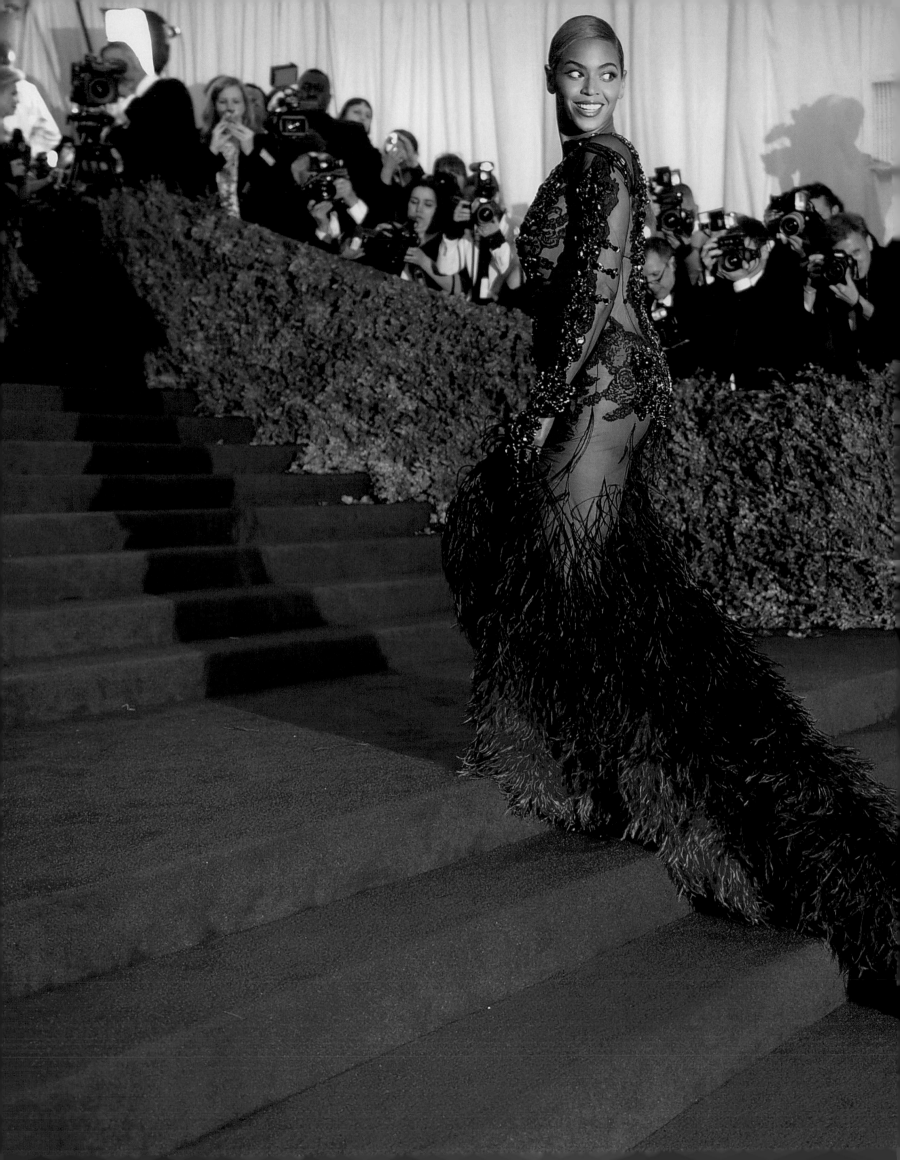

BEYONCÉ ARRIVED IN A SHEER-
FROM-TOP-TO-BOTTOM LACE DRESS
BY GIVENCHY. **OVERLEAF:** A FEW
HOURS BEFORE GUESTS BEGAN TO
STEP OUT OF THEIR TOWN CARS,
MARIO TESTINO CAPTURED PRADA,
COCHAIR CAREY MULLIGAN (IN
PRADA), AND SINGER BRUNO MARS
(FAR RIGHT) RELAXING AT THE
MARK HOTEL WITH BAZ LUHRMANN
(THE EXHIBITION'S CREATIVE
CONSULTANT), *VOGUE,* JULY 2012.

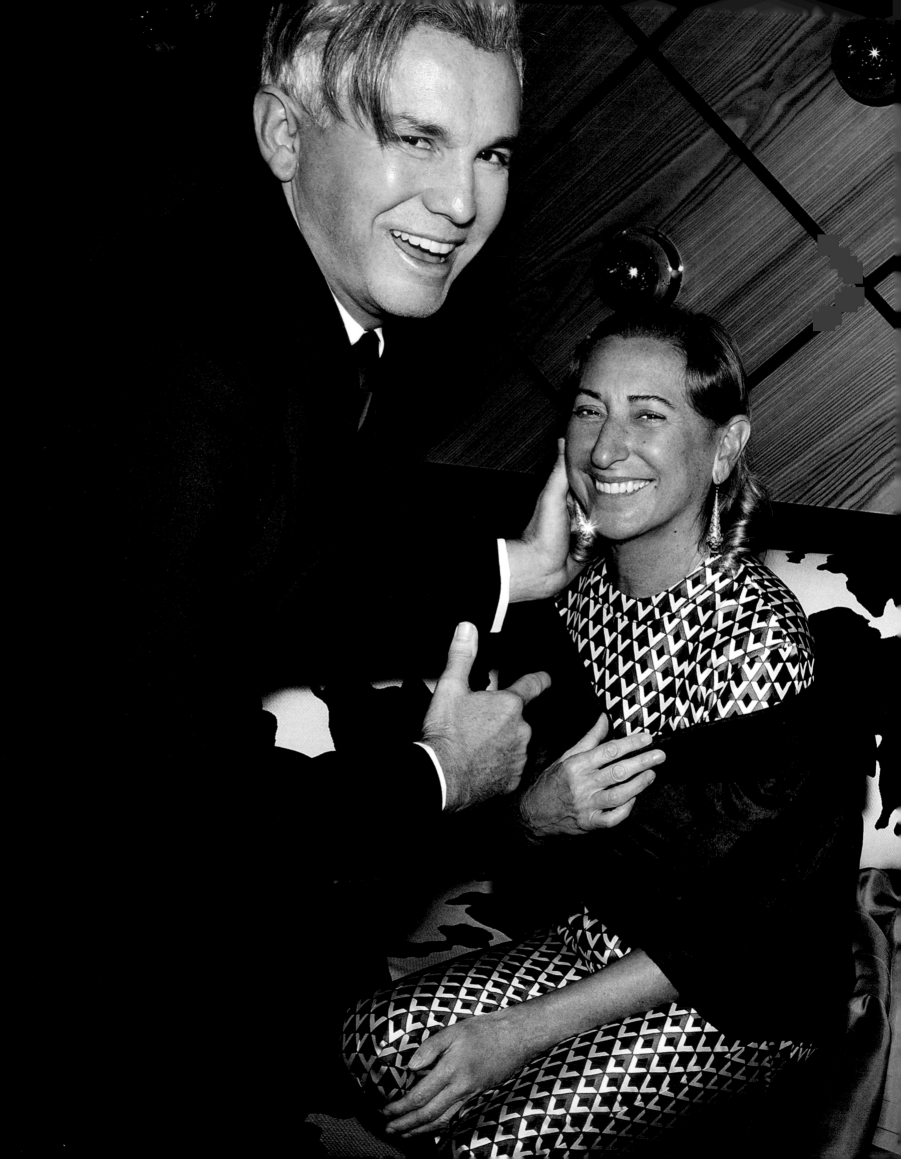

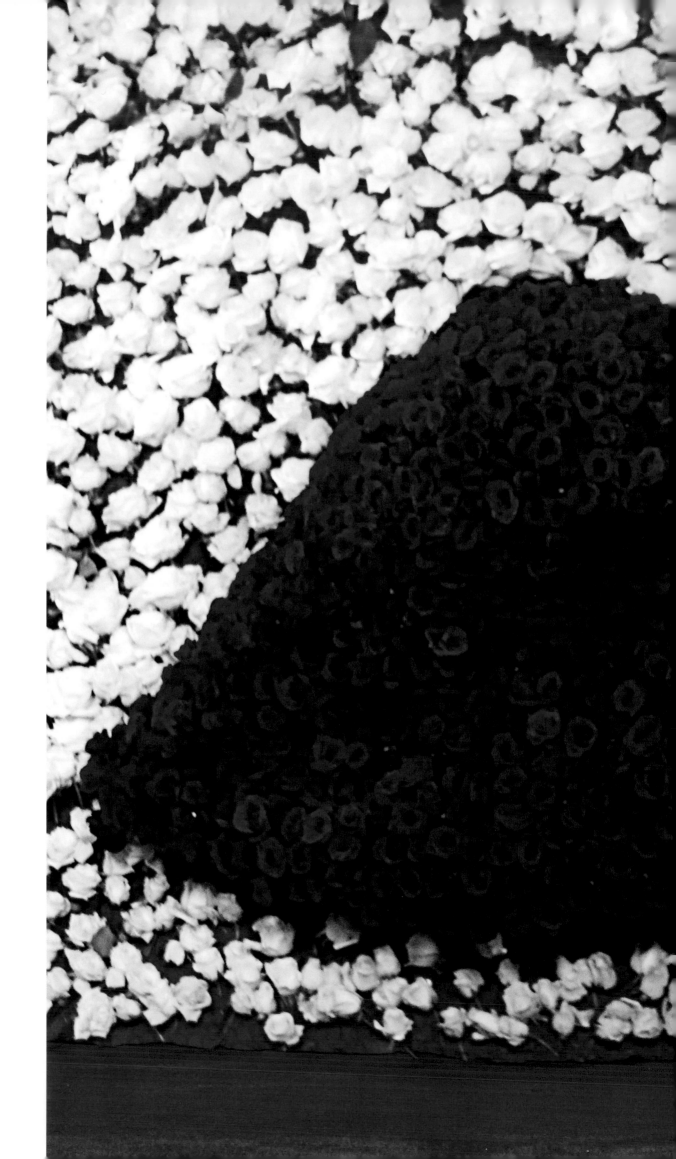

RAÚL ÀVILA OVERSAW A
DECOR STAFF OF 150 AS THEY
WORKED WITH 200,000 RED
AND WHITE ROSES—SHIPPED
IN FROM COLOMBIA AND
ECUADOR—TO CREATE THE
OUTSIZE FLORAL EFFECTS
INSIDE THE HALLS. **OVERLEAF:**
AT DINNER IN THE TEMPLE OF
DENDUR, THE FASHION-OBSESSED
COULD RECOGNIZE MANY OF
PRADA'S MOST POPULAR PRINTS
IN THE CHAIRS' UPHOLSTERY.

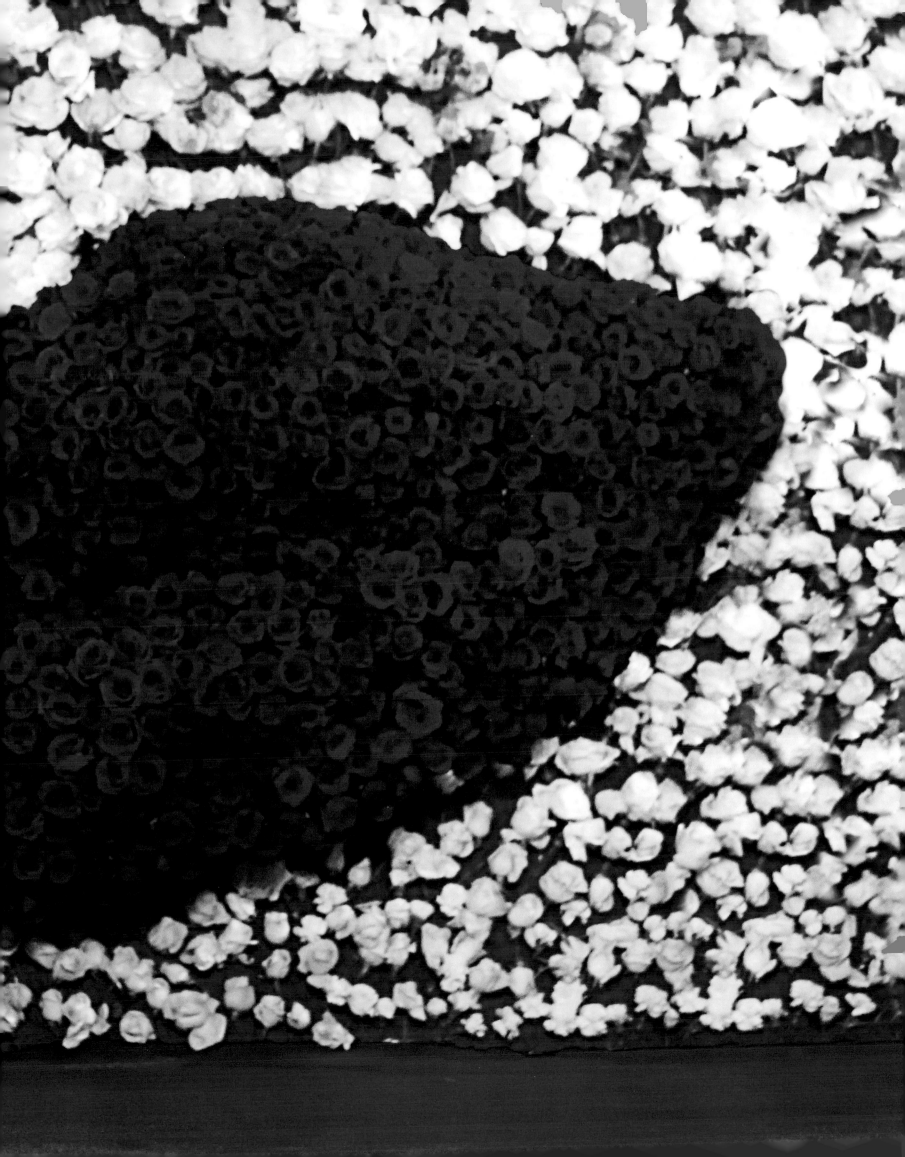

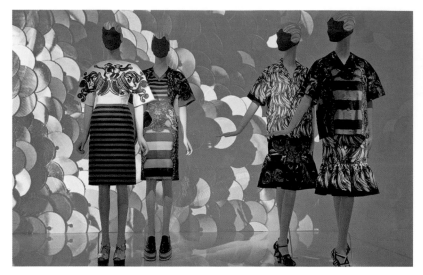

PRADA MONKEY AND BANANA PRINTS, WITH SCHIAP-ESQUE ZANINESS, 2011.

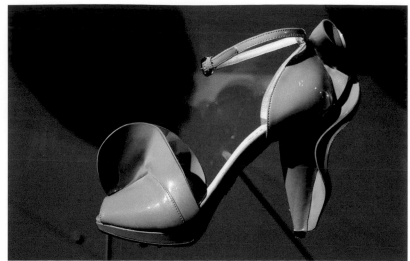

PRADA SANDAL, 2008. (SCHIAPARELLI WAS KEENER ON HATS.)

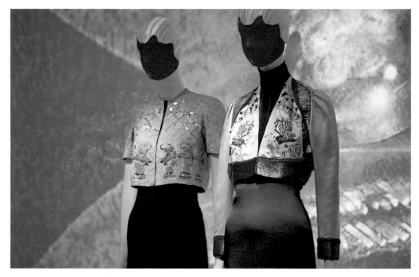

CIRCUS-ELEPHANT JACKET AND TRICK-HORSE BOLERO, SCHIAPARELLI, 1938.

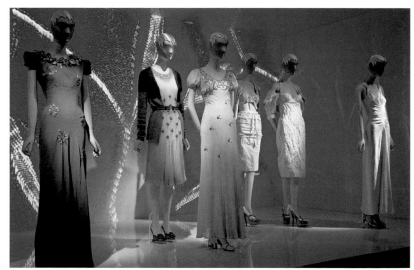

FROM BOTH, A GROUPING OF GODDESS LOOKS, SPANNING SOME 70 YEARS.

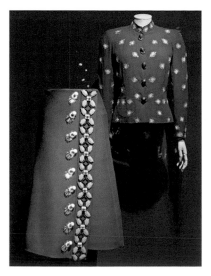

AREAS OF INTEREST: SCHIAPARELLI
JACKET (1938), PRADA SKIRT (2012).

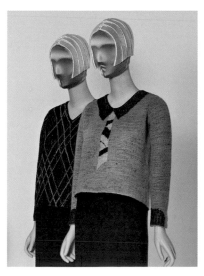

1930s SCHIAPARELLI SWEATERS,
ONE TROMPE L'OEIL.

PRADA ORANGE/BLACK DRESS WITH
NUDE STRETCH COLLAR, 2008.

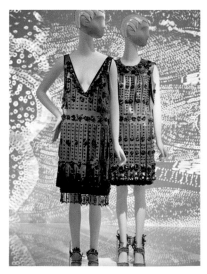

THE CLASSICAL BODY: PRADA RUSTIC
LEATHER GLADIATOR LOOKS, 2009.

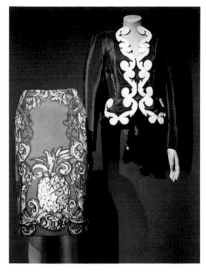

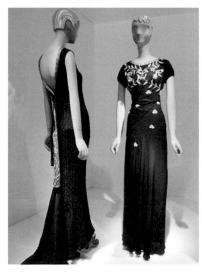

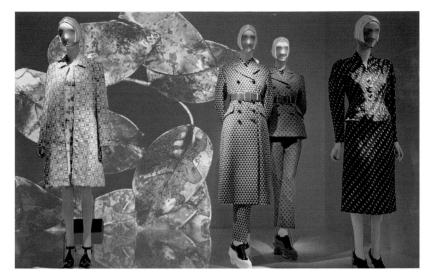

ANOTHER SCHIAPARELLI-JACKET, PRADA-SKIRT PAIRING.

NOTE THE POSITION OF SCHIAP'S ROSEBUDS.

UNPOPULAR COLORS, DIFFICULT SILHOUETTES NEVER SCARED EITHER.

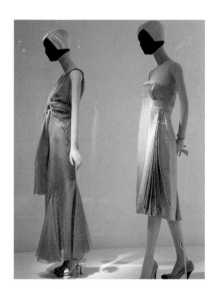

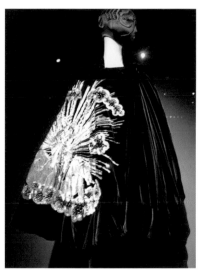

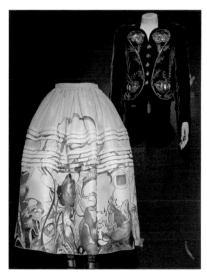

ORANGE SCHIAPARELLI, 1939, AND 2004 PRADA.

SCHIAPARELLI CAPE EMBROIDERED WITH APOLLO OF VERSAILLES, 1938.

GREEN VELVET JACKET, 1937; ILLUSTRATION SKIRT, 2008.

SCHIAP C. 1938 EVENING JACKET; PRADA 2002 DRESSES.

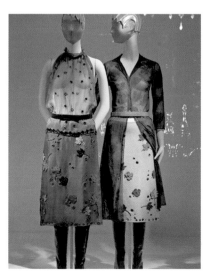

SCHIAP HAD FUN WITH FLOWERS ON HATS; PRADA PLAYED WITH DAISIES, 2012.

PRADA'S LEATHER LEAVES, 1999.

WOOD GRAIN–ILLUSION SUIT BY SCHIAPARELLI, 1938.

PUNK
CHAOS TO
COUTURE
2013

THE MOVEMENT WAS ABOUT ADOLESCENT RAGE, AND CREATING AN IMAGE
AS CONFRONTATIONAL AND OFFENSIVE AS POSSIBLE TO HIPPIES, PARENTS,
AUTHORITIES OF ANY STRIPE. THE MET EXAMINED PUNK AS AN AESTHETIC—NOT
AN ATTITUDE. THE CLASH WORE SPLATTERS BECAUSE THEY WERE BROKE AND
HAD BEEN PAINTING A WAREHOUSE. DOLCE & GABBANA USED SPLATTERS (RIGHT,
2008, FROM THE EXHIBITION) BECAUSE THEY ADMIRED JULIAN SCHNABEL.

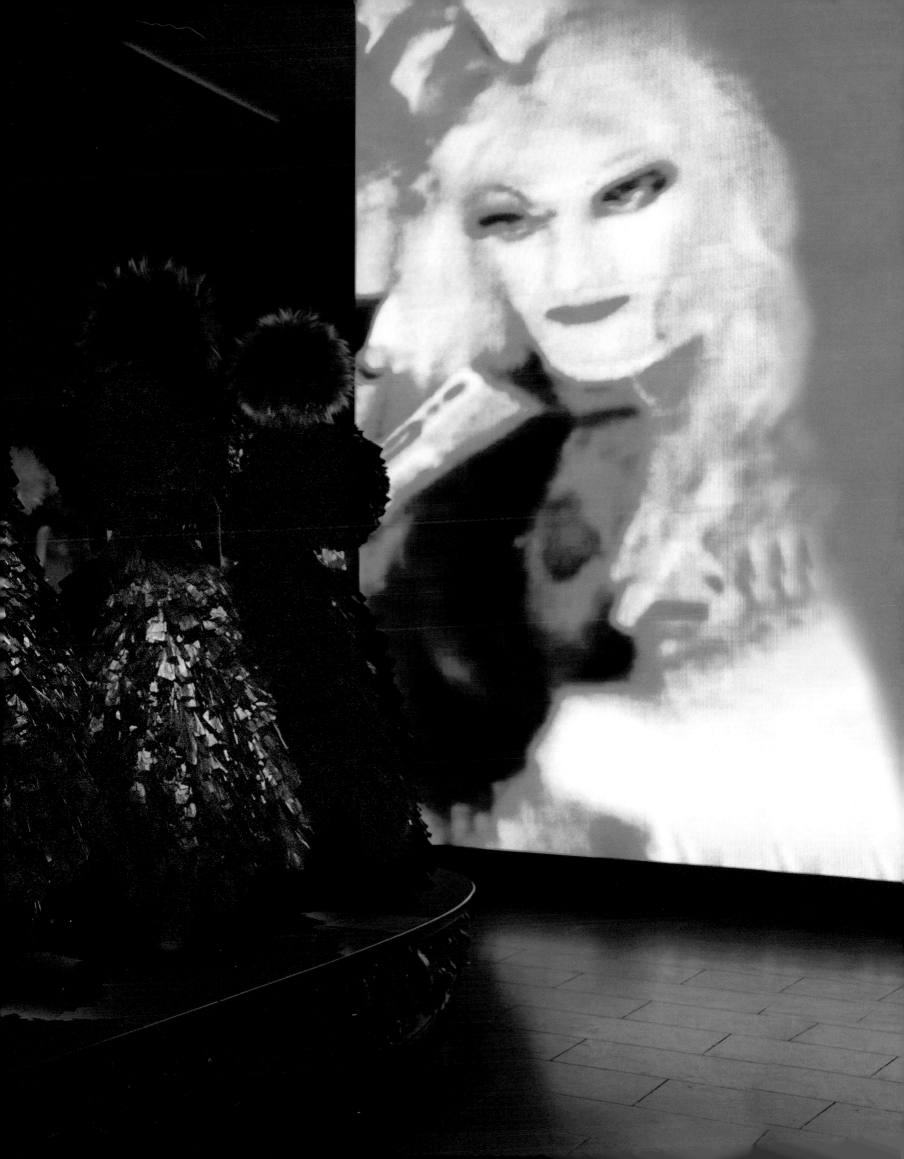

THE BATHROOM OF CBGB
WAS RE-CREATED FOR THE
EXHIBITION—MUCH TO THE
AMUSEMENT OF JADED
NEW YORKERS. **PREVIOUS
PAGES:** TRASH-BAG DRESSES
BY GARETH PUGH, 2013,
IN THE DIY: BRICOLAGE
GALLERY. THE FIRST PUNK
LOOKS WERE HOMEMADE
BECAUSE NO ONE (EXCEPT
MALCOLM McLAREN AND
VIVIENNE WESTWOOD) SOLD
SUITABLY DEVIANT CLOTHES;
THE COUNTERCULTURE WAS
YET TO BE COMMODIFIED.
THE MET TRACED A LINK
BETWEEN THAT ETHOS OF
DIY AND THE HANDMADE
ELEMENT OF HIGH FASHION.

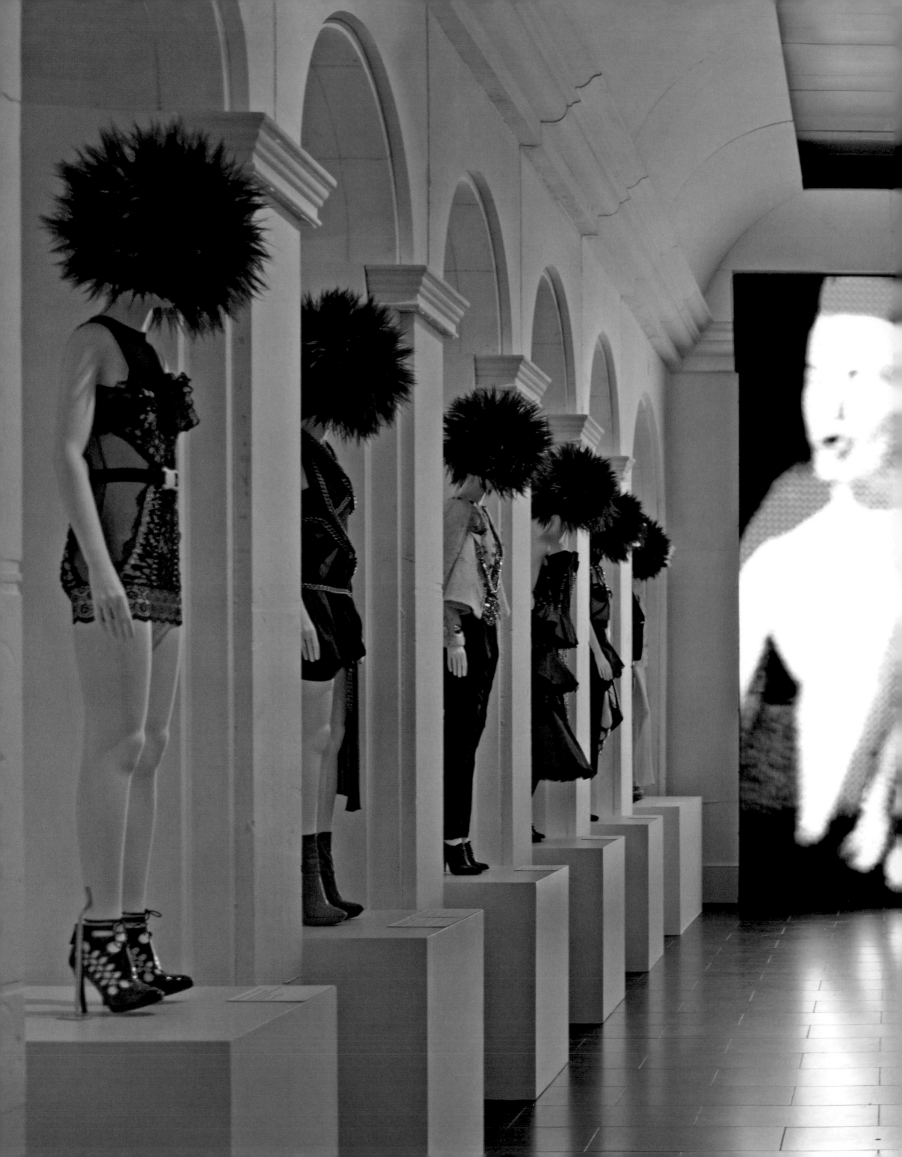

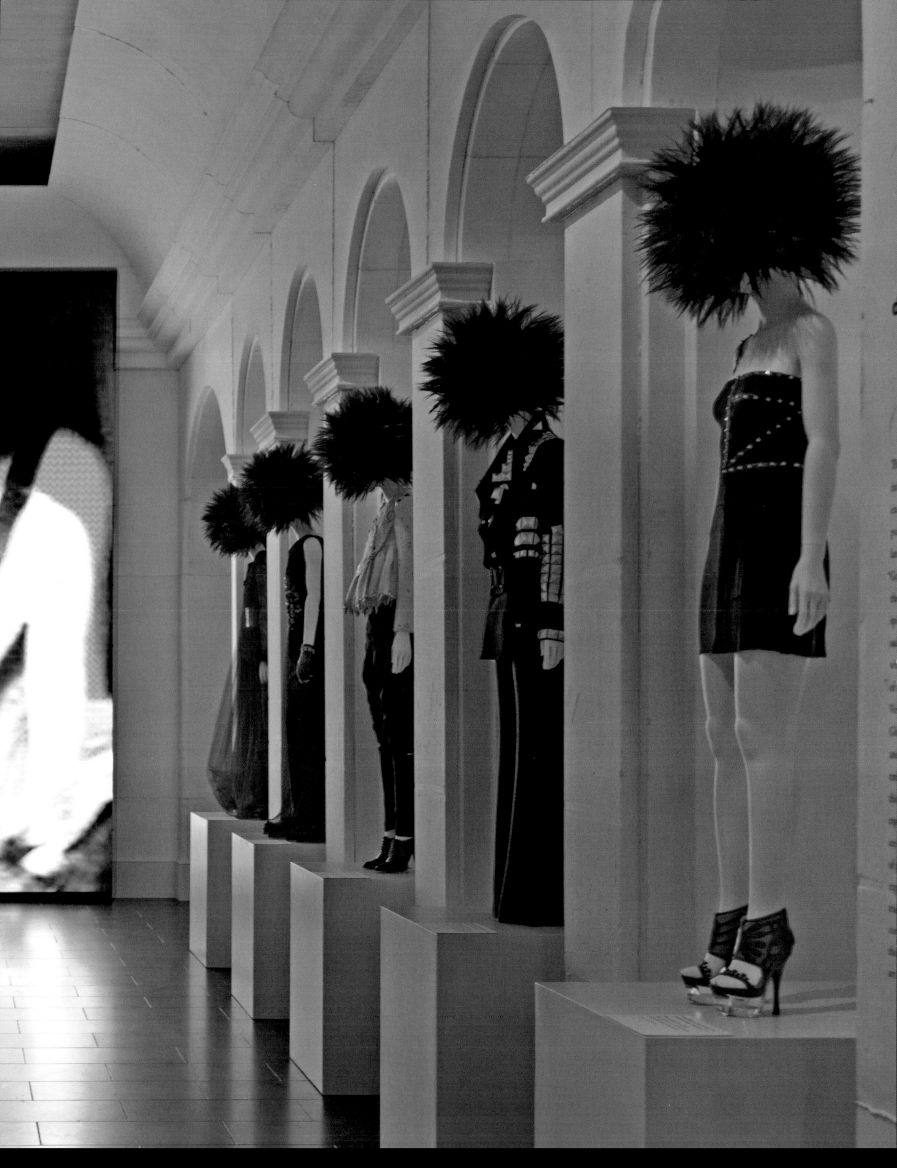

I f punk were just a kind of music or just a look, just a political statement or just a word that
described a time and a moment in just New York or just London—if it didn't mean so much to so many dispa-
rate places around the world—then it wouldn't be so alive and kicking. It would simply be nostalgia. And one measure of punk's
relevancy—one of the reasons that it still feels so true—is that it continues to exert such a gravitational pull on the imaginations of
different generations of fashion designers, from Yohji Yamamoto and Marc Jacobs to Kate and Laura Mulleavy of Rodarte and
Christopher Kane. Back to the well they go, again and again, and for some unknowable reason, it always feels modern.

All of this is made visible in The Metropolitan Museum of Art Costume Institute's exhibition "Punk: Chaos to Couture." As
Andrew Bolton, its curator, says, "No other countercultural movement has had a greater influence on fashion." Indeed, there are
more than 30 designers represented in the show, a testament itself to punk's universal power. "I think there's still a need to own it by
everybody who was involved in one form or another," says Bolton. "I think people have such an emotional response to punk because
it was this complete exorcism of everything that went on before. It was like a brave new world." Microcosms of that brave new world
have been re-created in seven galleries for the exhibition, including the seminal New York City rock club CBGB and Vivienne West-
wood and Malcolm McLaren's King's Road boutique Seditionaries, in London. Through juxtaposition of original, do-it-yourself-style
punk garments from the seventies with haute couture from more recent years, the show lays bare just how literally, how lovingly, punk
has been reinterpreted for the runway again and again.

Punk, like fashion, has always felt a bit like a competitive sport. No matter how outrageous or offensive or grotesque or radical you
or your friends thought you were being, with your torn or splattered whatever, your shaved or spiked something or other, there was
always someone more shocking, more mesmerizingly weird than you. There was always that one person who was more committed.

My stomping ground was early-eighties Philadelphia: the Zipperhead boutique on South Street; the Kennel Club on Walnut; Dead
Kennedys shows at the TLA. The pecking order went something like this: gawking tourists at the very bottom; then the fashion kids,
who were just below all those art students (there are so many art students in Philly); who were followed by the musicians who had
actually started a band. And at the tippy top were the truly dedicated superfreaks. Invariably, they were the ones who couldn't be
bothered with trying to look normal, nine to five, because they were unemployable. There was this one guy named Michael Moffa
who turned up every Saturday night at the Kennel Club, and I couldn't wait to get a load of him: He was so tall and terrifying—
so incomprehensibly crazy-looking with his layers and layers of black tattered clothing covered in tiny safety pins—that he could
clear a room. He had a kind of Edward Scissorhands aspect, minus the gentle demeanor; but his makeup and hair were the work of
a true artist, and you could not *not* stare at this beautiful monster, which, of course, is exactly what he wanted, but which also made
him want to stub a cigarette out on your forehead. And wherever Michael Moffa went, "the Death Dolls" followed. That is what my
friends and I called these three women whose skin was as powdered white as their dresses were lacy and black and who drifted by us
everywhere we went, looking like they had just dug themselves out of a shallow grave. But beautiful! And fabulous!

By sophomore year of college, I began to take on the coloration of the tribe I was spending so much time with on weekends in
Philly. I would drive back to my dorm in the suburbs (with wheat-pasted posters for shows at Love Club that I had carefully peeled
off the walls of abandoned buildings), and see how far I could push things on campus: I shaved the left side of my head and shoved

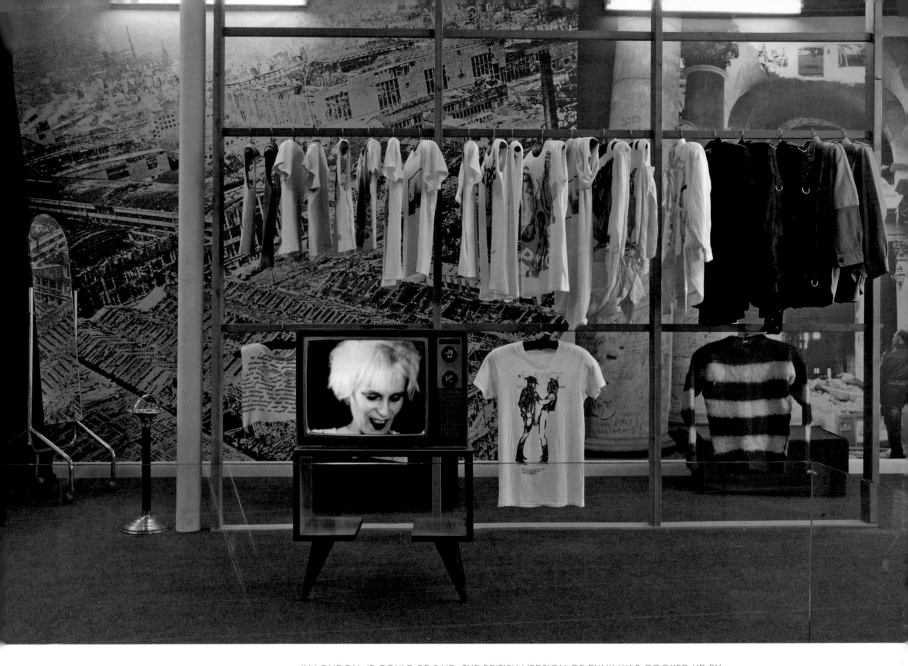

IN LONDON, IT COULD BE SAID, THE BRITISH VERSION OF PUNK WAS COOKED UP BY
McLAREN AND WESTWOOD IN THEIR KING'S ROAD BOUTIQUE—CALLED SEX, THEN
SEDITIONARIES, THEN WORLDS END. IT WAS RECONSTRUCTED FOR THE SHOW (ABOVE).
PREVIOUS PAGES: THE GHOST OF SID VICIOUS (REAR, IN VIDEO) HAUNTED THE DIY
HARDWARE DISPLAY, FLANKED BY RANKS OF WIGGED-OUT MANNEQUINS.

a safety pin through my ear; stole a biker jacket off a bar stool at a local pub and made it my own (still have it); nabbed the perfect pair of tartan pants at the Bring and Buy; ripped my clothing to shreds. The result was bittersweet: The alienation (and bullying) my new look inspired was genuinely painful; the handful of people who recognized me as one of them, however, became the best kind of friends—to this day.

After Philly, I wound up in Atlantic City for a few years. Nothing punk about that place, you say? Untrue! The whole city was punk. The glamorous decrepitude! The urban blight! The horror of it all! There was a shock to the system on every street corner, a daily jolt—paddles, clear!—that made you feel electric and alive. And then I met Mortimer. The phrase *club kid* had not yet been coined to describe a guy like him, but that is what he would have been called had he lived in early-nineties New York. He crossed my path in 1985 in a nightclub on New York Avenue in some cockamamie getup, and I just knew we'd become friends. He did me one better and became my roommate; we lived together for a year in a creaky old brick row house in the Back Bay neighborhood, a place that often looked—on rainy days, from certain angles—like Liverpool.

Mortimer was that unemployable sort. He availed himself of all the DIY tools of the trade: tartan, trash bags, sleeveless mesh, torn thrift-shop sweaters, black leather—all held together with safety pins. With a can of Aqua Net and a blow-dryer, he would blast his long red curls straight up into what looked like an anvil sitting atop his head. He had the palest, most porcelain skin I have ever seen, and he wore combat boots every day. One time, he turned up at some club dressed as a priest, carrying a Bible, just to fuck with everyone. On another occasion, he went out carrying a hand mirror, which he stared into all night—even while talking to his friends. We started throwing the most insane parties at that crappy house on that spooky bay. One was around the holidays. Mortimer wrapped himself in Christmas lights and remained plugged into an outlet in the living room, attached to a very long extension cord, greeting people at the door, offering to take coats, fetching cocktails. It was brilliant.

231

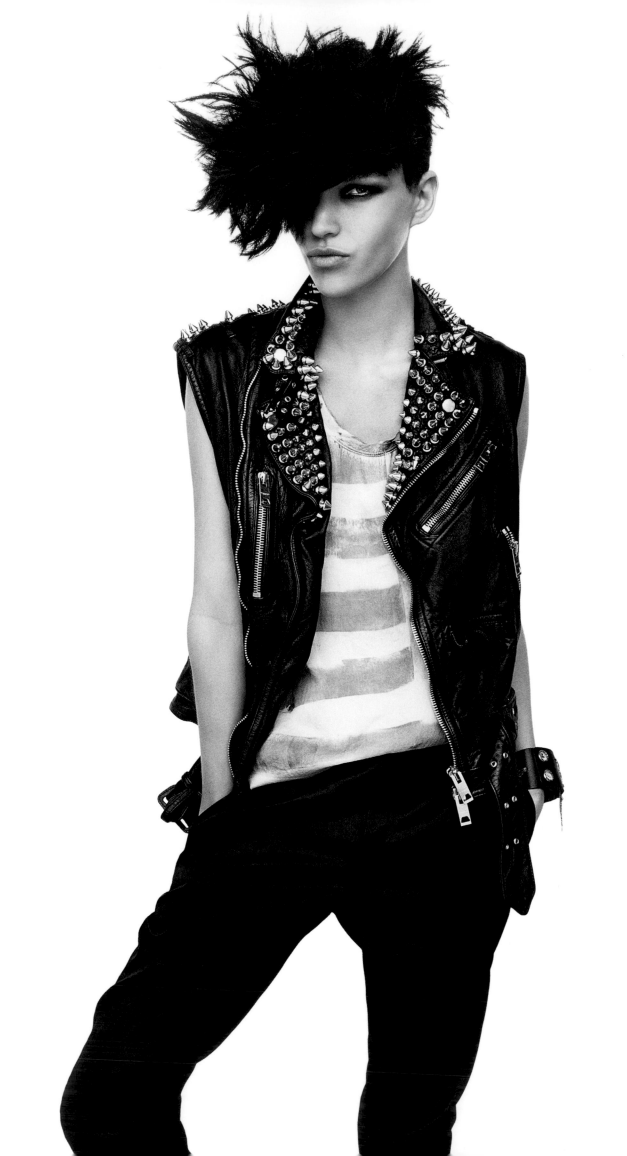

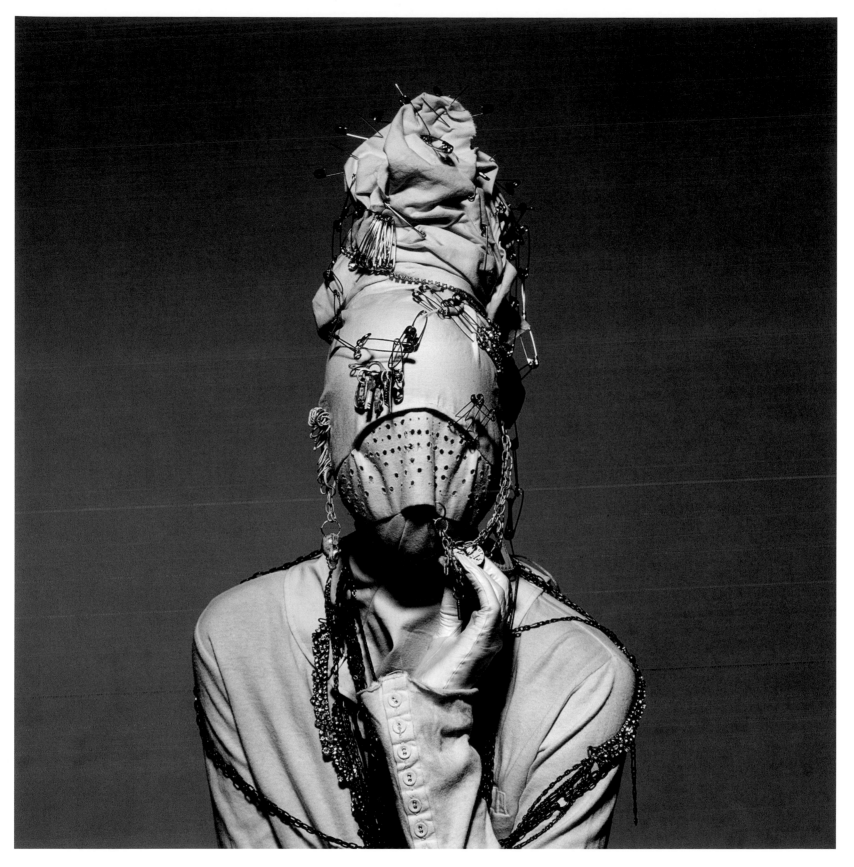

ABOVE: SAFETY PINS (AND RAZORS AND S&M STUDS) WERE THE CALLING CARD OF THE "I WANNA BE SEDATED" GENERATION. IRVING PENN PHOTOGRAPHED A FACE-CONCEALING HEADPIECE BY UNDERCOVER FOR *VOGUE*, SEPTEMBER 2006. LEFT: BURBERRY PRORSUM SLEEVELESS LEATHER WITH A $4,795 PRICE TAG, PHOTOGRAPHED BY DAVID SIMS, *VOGUE*, MARCH 2011. THE BIKER JACKET HAD COME A LONG WAY SINCE THE RAMONES RODE THE M TRAIN IN FROM LEFRAK CITY, QUEENS.

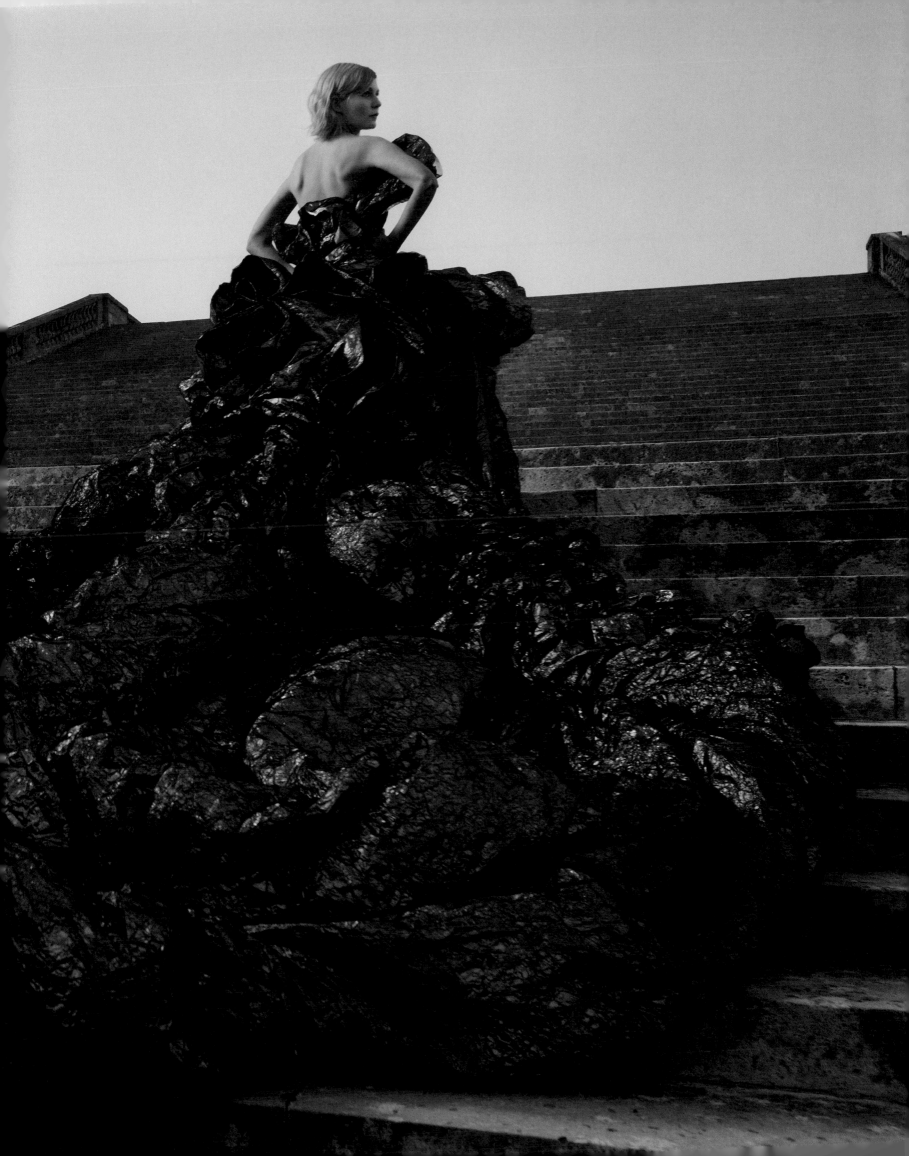

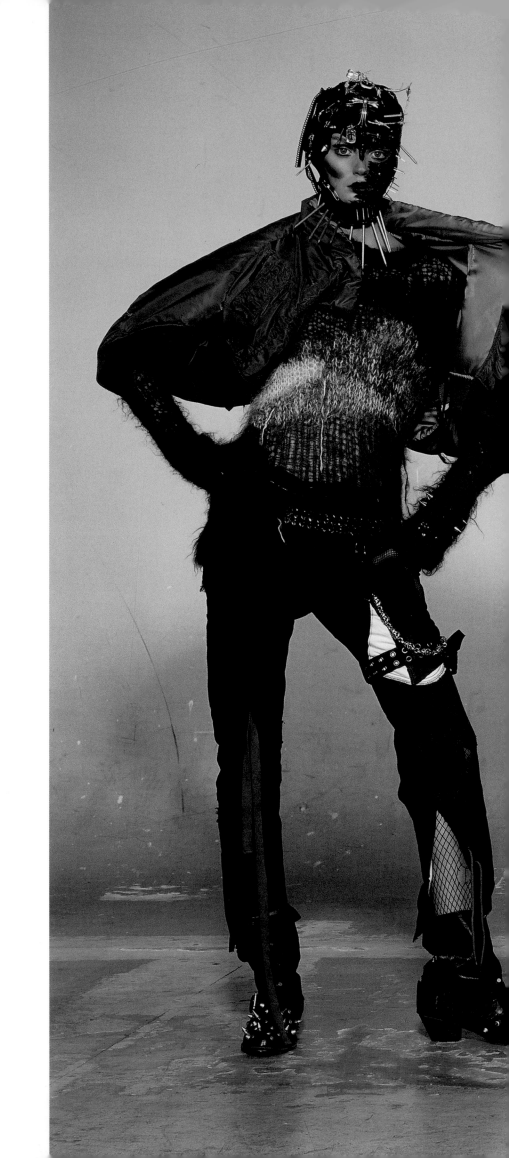

FOR SOME BANDS (SUCH AS THE CLASH OR CRASS),
PUNK WAS POLITICAL PROTEST. ITS VISUAL GESTURES
ARE STILL SOMETIMES USED AS COMMENTARY ON
CIVILIZATION'S SORRY STATE. JUNYA WATANABE'S WAR-
RAVAGED WOMEN WERE PHOTOGRAPHED BY IRVING
PENN FOR *VOGUE*, SEPTEMBER 2006. **PREVIOUS PAGES:**
"THE TRUTH IS ONLY KNOWN BY GUTTERSNIPES," JOE
STRUMMER SANG. BUT PUNK STYLE HAD TRAVELED ALL
THE WAY TO VERSAILLES BY THE TIME ANNIE LEIBOVITZ
SNAPPED THIS DIOR HAUTE COUTURE BALL DRESS
ON KIRSTEN DUNST FOR *VOGUE*, SEPTEMBER 2006.

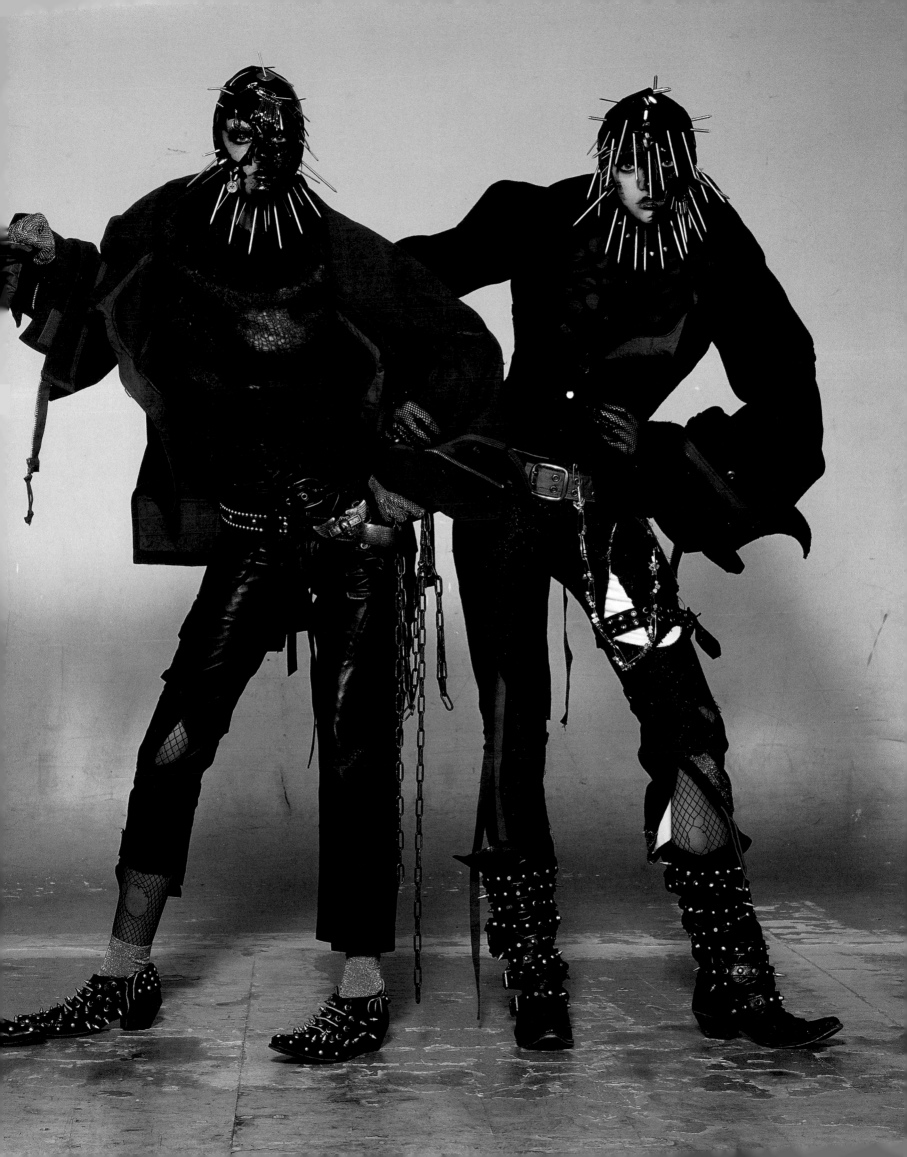

PUNK: CHAOS TO COUTURE

After another long, late party, I woke around noon surrounded by empty beer cans and cigarette butts to find that he had spent hours while I was asleep gluing tiny plastic ants in a long trail that went across the floor of the dining room, into the kitchen, up the side of the cabinets, and across the counter to the drain. There must have been thousands of them. My reaction? Incomprehension, followed by stunned amazement, followed by shrieking delight. That he had spent all night doing this to get precisely the reaction he got goes a long way toward explaining why I admired him. I was always in awe of his total dedication to—his absolute belief in—making a spectacle. There was just something heroic about it.

Punk is like porn: You know it when you see it. Courtney Love appearing high on *Letterman,* pulling up her shirt and heckling people in the audience, for example. At its best (worst?) it wants to offend your bourgeois sensibilities. It wants to rub your face in something unpleasant. It wants to spit on you. It is infantile and bratty and obscene and totally rude and inappropriate. Punk is a dare: Try to look away.

It doesn't matter how far away in years or miles you are from the late-seventies big-bang moment of punk in Vivienne Westwood's London or Patti Smith's New York; all that matters is context. Mortimer read as punk a decade after that because he chose to dress and behave as he did in Atlantic City, a barrier-island dump that may as well have been Cuba: the land that time forgot, living under the repressive regime of Donald Trump. Either you worked in one of those preposterous casinos or you were impoverished and angry. Today, the realest of punk scenes thrive mostly in places where the young people would probably leave—if only they could: Havana, Baghdad, Yangon. Indeed, one of the most genuinely punk-rock things that's happened recently is Pussy Riot, the feminist rock collective that formed in Russia in 2011 as a challenge to the legitimacy of Vladimir Putin. Its members stage protest performances in neon-colored balaclavas. Last winter, three of them were arrested while performing on the altar of a church, and charged with "hooliganism"—just an old-fashioned word for punk, really. Two of them remain in prison camps to this day and have become international heroines whose cause has been taken up by no less than that little punk-disco diva herself, the woman otherwise known as Madonna.

What Madonna admires, obviously, is their bravery. But punk does not require polemics—or politics of any kind—to be meaningful. Sometimes it's just about wearing a dress with a swan on it to the Oscars while pretending to lay an egg on the red carpet. Iconoclasts like Björk, or Marilyn Manson or Leigh Bowery or Lady Gaga, are brave. They are (or were) interested in presenting themselves as animals or monsters to show that there is always another way to look at things. Like punk, they change your eye. And although Gaga's Little Monsters shtick may strike some as a bit too Care Bears to ever be punk, the fact that she worked herself literally to the bone—her obsession with wheelchairs now all too real—proves that she isn't kidding about suffering for her art. Actually hurting yourself onstage, after all, is the ne plus ultra of punk.

Every now and then I hear myself mutter under my breath, "That is so punk rock." And it's not always a compliment. Sometimes it's an acknowledgment of heroism, sometimes nihilism. Sometimes it's just me quietly relishing someone's outlandishly amazing outfit or a reaction to some staggeringly inappropriate public behavior. For example, I have been trying to understand the whole Rihanna/Chris Brown pas de deux these last few years—with no success. But when I looked at them through the lens of punk, their relationship suddenly made perfect sense. They are the Sid and Nancy of our time, intentionally rubbing our faces in something unpleasant, with their tattoos and Twitter feeds. Just to get a rise out of us . . . maybe. Oh, do they offend your bourgeois sensibilities? Well, then, the joke's on you.—**JONATHAN VAN METER,** *VOGUE,* **MAY 2013**

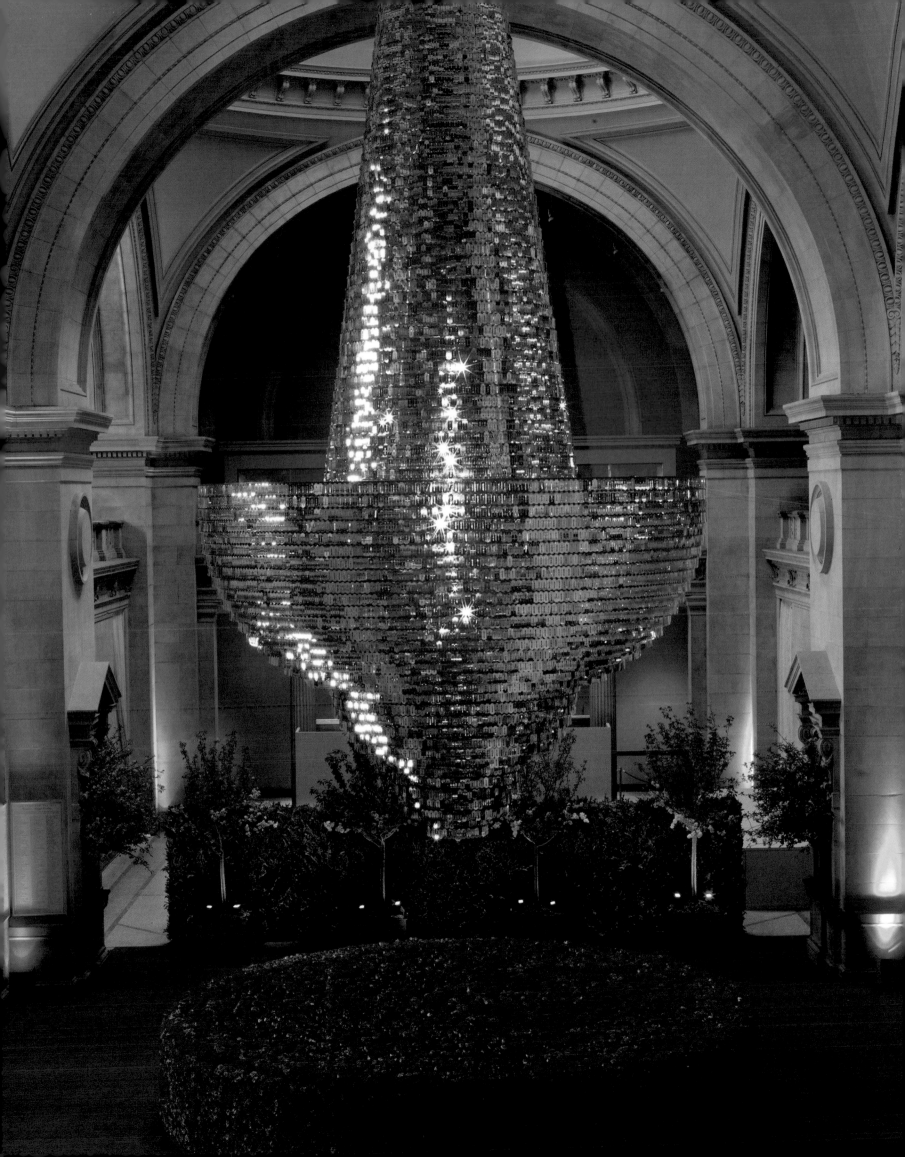

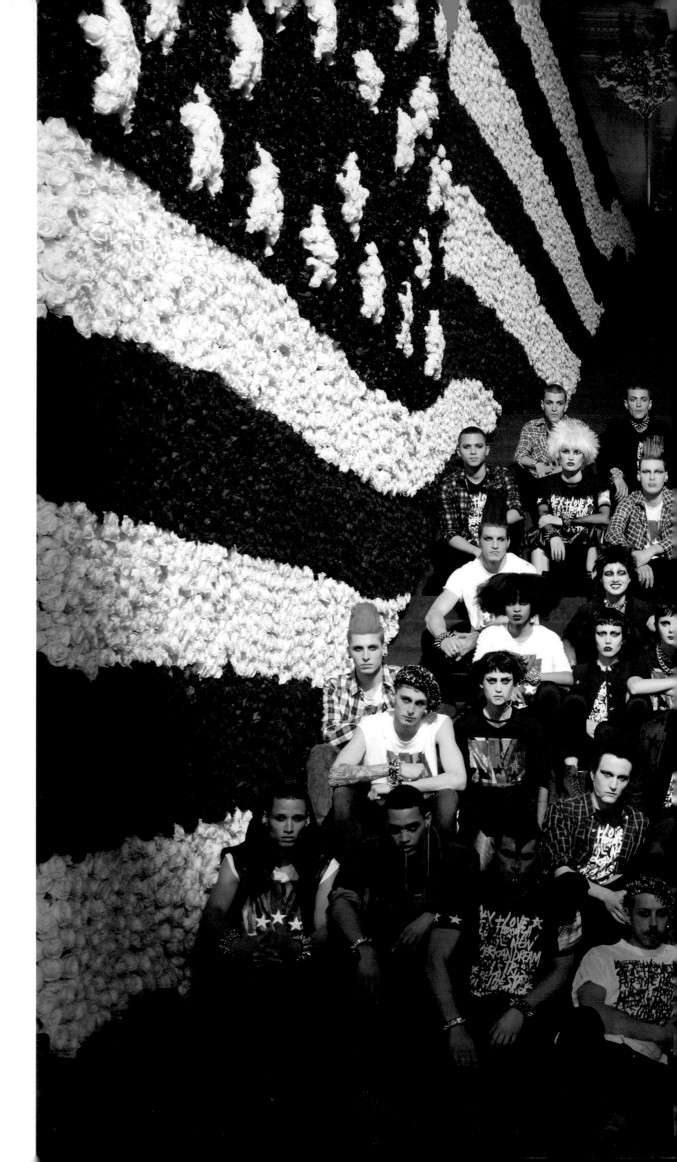

THE STAFF AT THE GALA WAS
KITTED OUT WITH BONDAGE
GEAR, SLOGAN T-SHIRTS, AND
COMBAT BOOTS. **OVERLEAF:**
DARK-AND-BROODING STAR
ROONEY MARA AND GIVENCHY'S
RICCARDO TISCI (PHOTOGRAPHED
BY NORMAN JEAN ROY FOR
VOGUE, SEPTEMBER 2012) WERE
COCHAIRS AND ESCORTED
EACH OTHER TO THE PARTY.

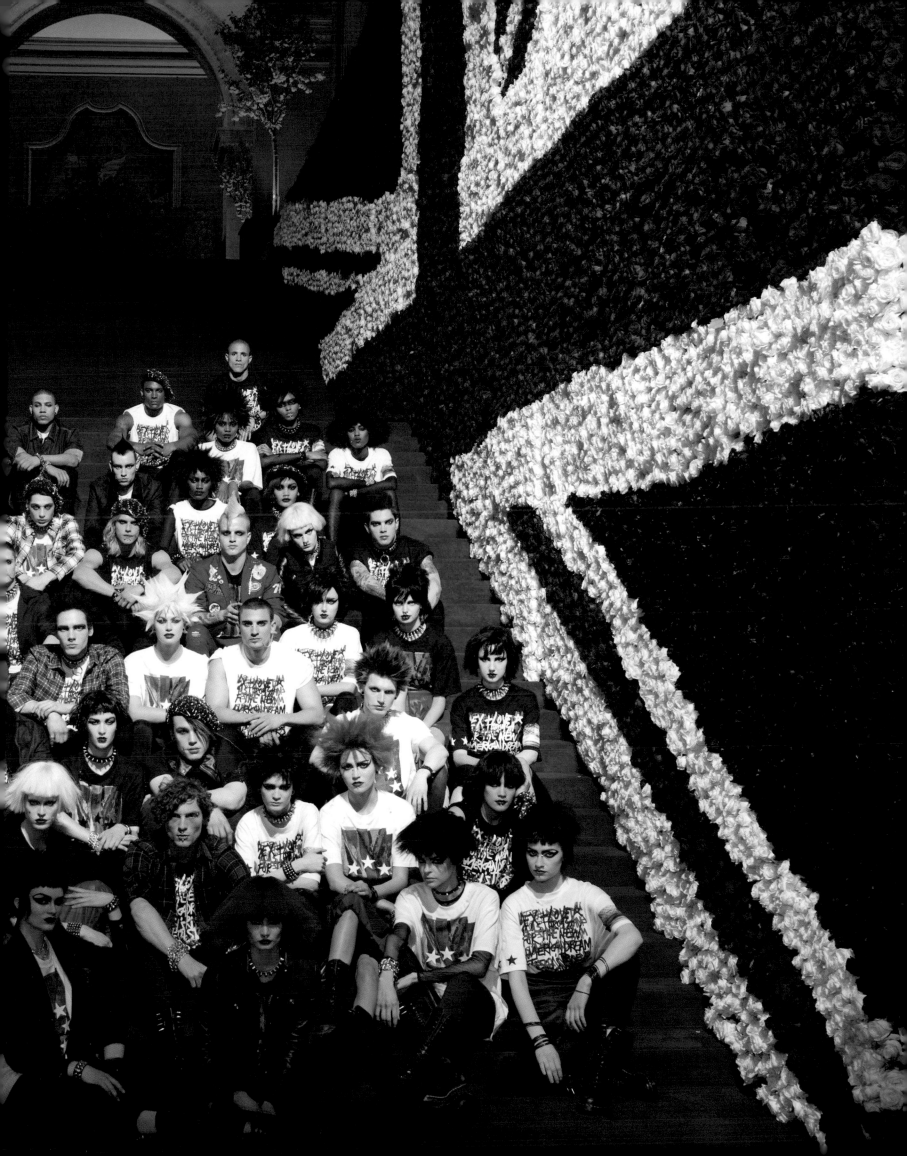

BALMAIN KNIT WITH METAL
MESH AND SEQUINS, 2010.

JOHN GALLIANO USED SCOTCH TAPE
ON A RECYCLING DRESS, 2001.

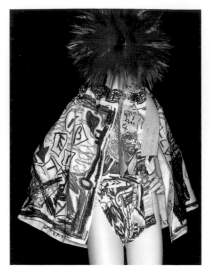

VIVIENNE WESTWOOD GRAFFITI
CAPE AND TOP, 2007.

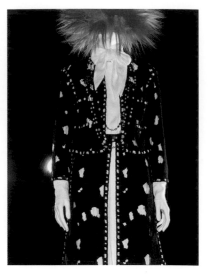

CLASSIC CHANEL TWEED SUIT
RIDDLED WITH HOLES, 2011.

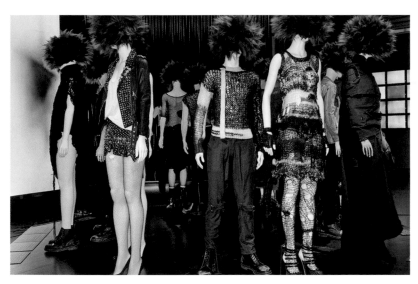

THE MOHAIR LOOK THAT ORIGINATED AT McLAREN
AND WESTWOOD'S COUNTERCULTURAL HUB.

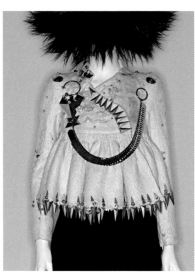

HAUTE GOLD STUDS FROM
GIVENCHY, 2009.

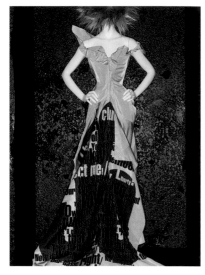

WESTWOOD "LIFE AND THEFT"
SLOGAN DRESS, 2008.

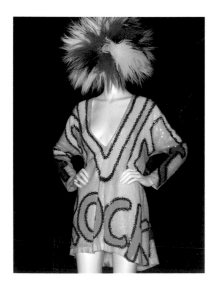

NEON SCRAWL BY
GRAFFITI-MASTER STEPHEN
SPROUSE, 1984.

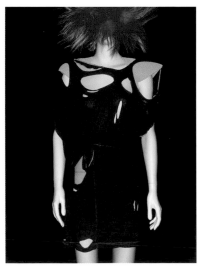

EXPOSED SHOULDER PADS,
MAISON MARTIN MARGIELA, 2009.

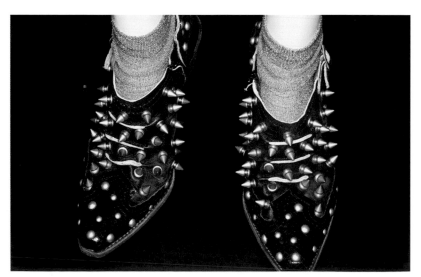

SPIKED BLACK LEATHER WINKLEPICKERS, JUNYA WATANABE, 2006.

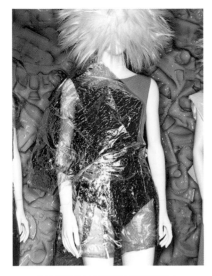

MAISON MARTIN MARGIELA
IRIDESCENT FOIL DRESS, 2011.

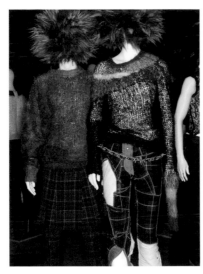

TARTAN FROM SEDITIONARIES
(LEFT, 1976–80) AND JUNYA
WATANABE (2006).

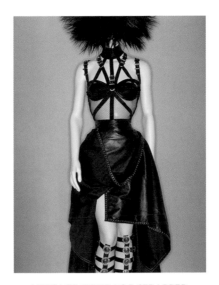

VERSACE BONDAGE-STRAPPED
SATIN AND LEATHER, 1992.

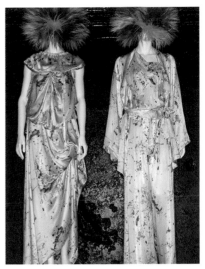

ANN DEMEULEMEESTER SPLATTERED
WHITE SATINS, 2006.

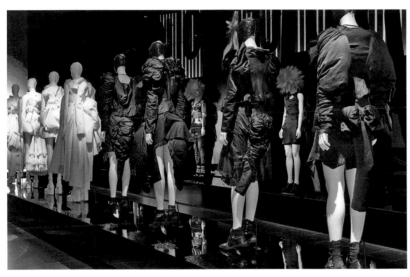

GARBAGE-PICKER CHIC, COMME DES GARÇONS, 2004 AND 2013.

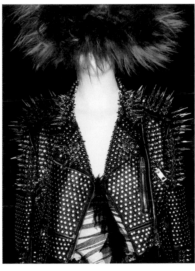

BURBERRY STUDDED BLACK
LEATHER JACKET, 2013.

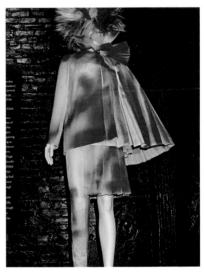

VIKTOR & ROLF SHOCK-PINK,
SPRAY-PAINTED SILK, 1998.

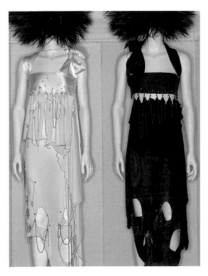

ZANDRA RHODES BALL-
CHAIN TATTERS, 1977.

ELIZABETH HURLEY'S FAMOUS
VERSACE SAFETY PINS, 1994.

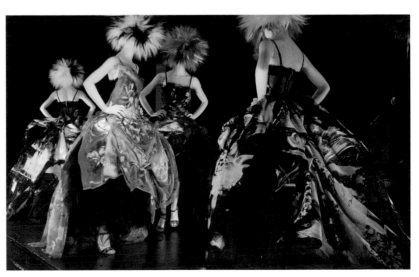

DOLCE & GABBANA COLOR-CLASH BALL DRESSES, 2008.

CHARLES JAMES BEYOND FASHION 2014

CRISTÓBAL BALENCIAGA SAID THAT JAMES, HIS CONTEMPORARY, WAS "THE ONLY ONE IN THE WORLD WHO HAS RAISED DRESSMAKING FROM AN APPLIED ART TO A PURE ART." THIS SILK-VELVET, SILK-SATIN, AND COTTON-ORGANDY GOWN FEATURED IN THE EXHIBITION WAS WORN BY BABE PALEY FOR A 1950 *VOGUE* SITTING. WITH ITS TORQUED AND WRAPPED OVERSKIRT—REVEALING JAMES'S GENIUS FOR COMPLEX AND ORIGINAL DRAPING—IT, LIKE MOST OF THE COUTURIER'S GREATEST PIECES, HARKED BACK TO THE WARDROBE ELABORATIONS OF ANOTHER CENTURY ENTIRELY.

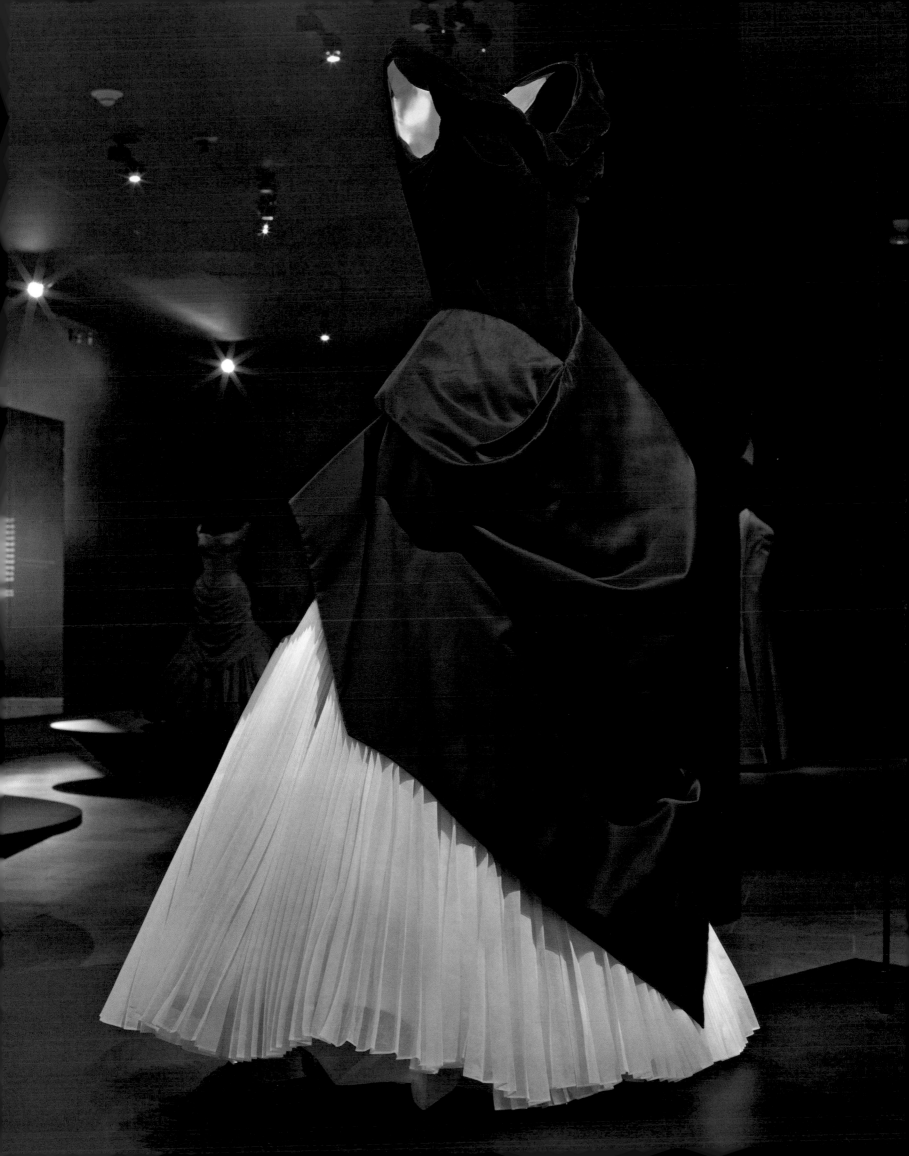

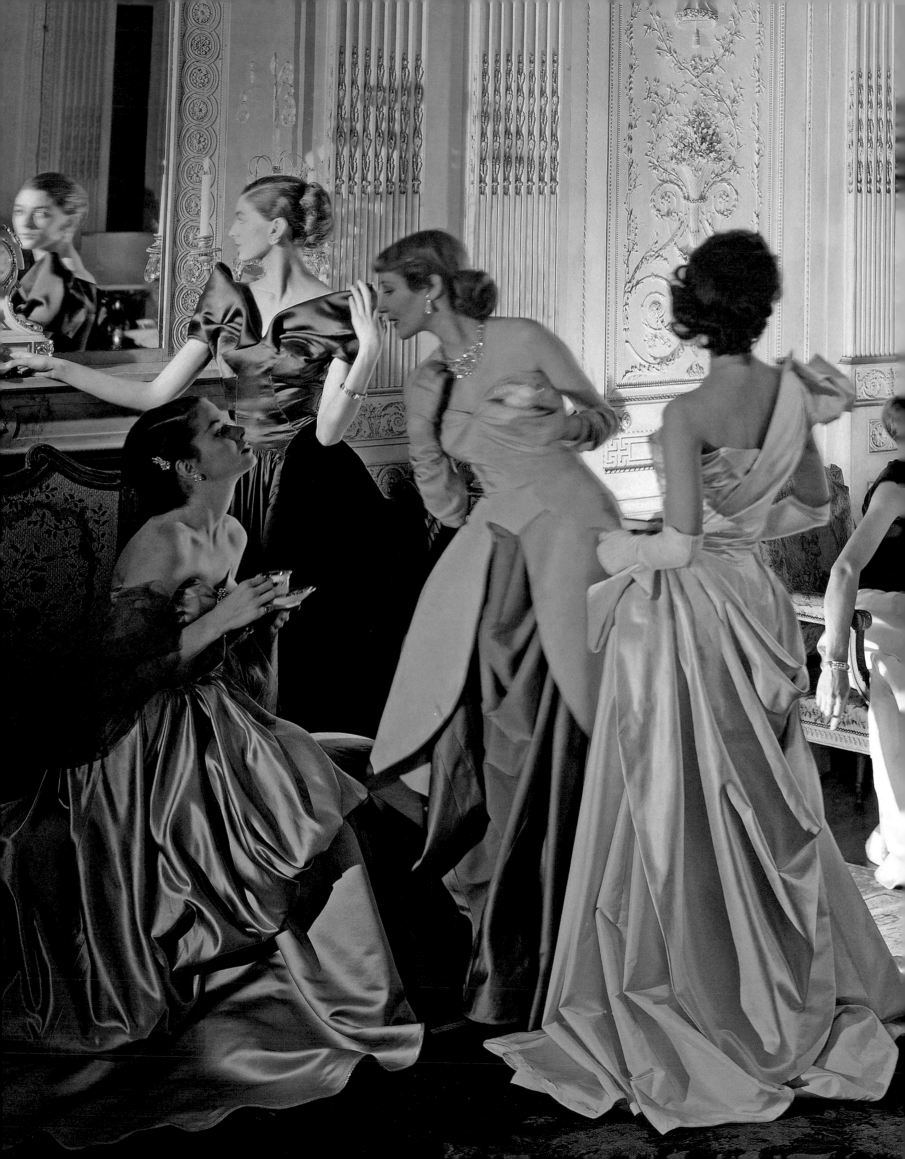

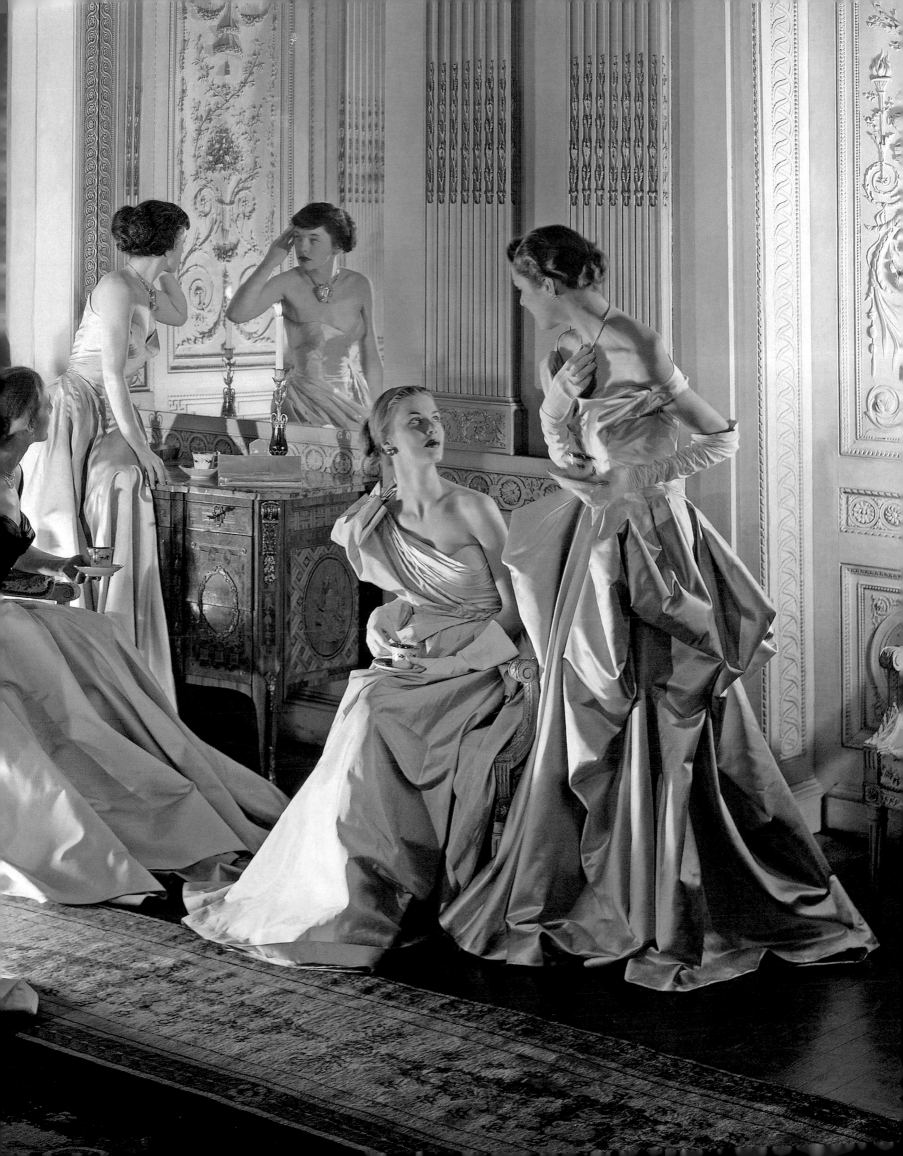

rancusi had his medium; Picasso, Faulkner, Shostakovich theirs," declared the couturier Charles James. "Mine happens to be cloth."

An immodest genius, James was as complex as the magisterial clothes he labored over, their idiosyncratic seams, sly Surrealist detailing, and artfully manipulated swathes of fabric frozen in time like the robes of Sargent's haughty sitters or the angels in Renaissance paintings. Though he influenced a generation of acolytes and apprentices—Halston, Scaasi, Adolfo, Miguel Ferreras, George Halley, and Homer Layne among them—James's creations were unlike anything else seen before or since. In the decades following his death in 1978, creative forces as varied as Gianni Versace, Azzedine Alaïa, Christian Lacroix, Claude Montana, Ralph Rucci, Alexander McQueen, John Galliano, and Zac Posen have all paid overt homage to James.

"He was an artist and a technician," Posen says. "His pieces remind me of Brancusi sculptures. They're so sophisticated, but there is a humor there through his play with sexuality in the lines and the gestures in the cut." Posen equates studying an original James gown with looking at a body on a dissection table; both reveal "the core structure, the muscle structure, the full anatomy of a human body," he says. "The multiple layers of his dresses are like sculpted body casts."

Though James himself occasionally quoted from the past—incorporating the rigor of a nineteenth-century uniform jacket into his virtuosic tailoring, or the cut of an Empire bodice on a Regency dress into his variant on a prototypical sports bra— he was determinedly futuristic, his innovations often prophetic. James's body-caressing Taxi dress of 1932, for example, with its then–newly invented zipper winding around the body of the garment so that (as the designer suggested) the dress could be unzipped in the back of a taxi, prefigured the ease of the wrap dress, while his quilted satin eiderdown jacket of 1938— a piece that Dalí admired as an example of "soft sculpture"—was in turn the direct precursor of the now-ubiquitous sleeping-bag coat and puffer jacket.

James also understood the power of branding and licensing long before such ideas were common currency. "What's in a name? It's the designer's capital," he said, although his querulous personality and inability to work within a conventional Seventh Avenue structure of deadlines and bottom lines ultimately defeated his efforts and drained his finances. The designer was at once brilliant, impossible, and self-destructive—and now all but forgotten to the world at large.

"Charles James: Beyond Fashion," in the Lizzie and Jonathan Tisch Gallery and Special Exhibition Galleries at The Metropolitan Museum of Art, aims to correct that. Organized by Harold Koda and Jan Glier Reeder and drawing on The Costume Institute's unparalleled holdings of the designer's work (inestimably enhanced by the recent assimilation of the Brooklyn Museum's collection), the exhibition brings the work of this singular talent into focus every bit as sharp as his seams.

James was revered by both clients and contemporaries—"a designer's designer," as a *Life* story in 1950 put it. "All my work was inspired by women who were not merely lovely or rich but personalities," James said, and they were the best-dressed women of his age, from Millicent Rogers to Marlene Dietrich and from Babe Paley to Gypsy Rose Lee (who ended her ecdysiast performances *dressed* in James's most elaborate gowns). Chanel and Schiaparelli both ordered James's clothes to wear themselves; Christian Dior anointed him "the greatest talent of my generation" and is said to have claimed him as the source of Dior's own era-defining New

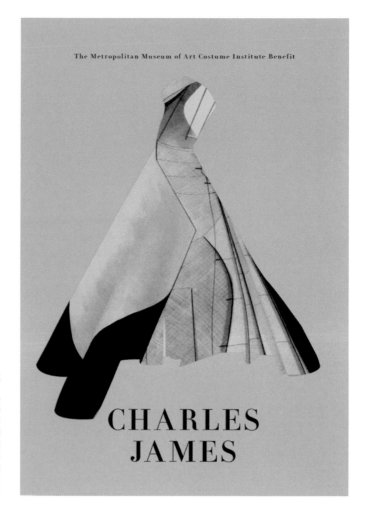

The Metropolitan Museum of Art Costume Institute Benefit

CHARLES JAMES

ON THE GALA INVITATION: THE CLOVER LEAF, CREATED FOR SOCIALITE AUSTINE HEARST TO WEAR TO THE EISENHOWER INAUGURAL BALL IN 1953. JAMES CONSIDERED IT HIS MASTERWORK. **PREVIOUS PAGES:** WHEN CECIL BEATON PHOTOGRAPHED JAMES'S OUTRAGEOUSLY OPULENT POSTWAR LOOKS FOR *VOGUE* IN 1948, HE NODDED TO THEIR HISTORICISM BY SETTING HIS MODELS AS A CLASSICAL FRIEZE IN AN 18TH-CENTURY DRAWING ROOM.

Look; Cristóbal Balenciaga, meanwhile, described him as "not only the greatest American couturier, but the world's best"—the only one, he said, who had elevated dressmaking to "a pure art form."

"I pass you my crown," Paul Poiret told James in the 1930s, having seen a cape the young designer created of radiating panels made from a cache of Belle Époque Colcombet millinery ribbons discovered in a Paris flea market. "Wear it well." In some ways, Poiret's gift was a poison chalice. "It is the destiny of many great artists to read of their influence on a world that has left them for dead," James wrote of Poiret, who died in penurious obscurity, but he may well have been foreshadowing his own woeful trajectory.

James was born in England in 1906 to a world of privilege, the last gasp of the opulent Edwardian era that the First World War was soon to sweep away. (Several of his designs nostalgically echo the silhouettes—the bat-wing coats and peg-top skirts—of his early childhood.) His pretty, doting mother—a Chicago heiress to a shipping and real estate fortune—and dashing English father, an army captain, sent their young son to Harrow, the British public school, where the puckish figure befriended Cecil Beaton, who was to prove instrumental in James's career. A piano prodigy, he later equated musical and design theory and set his fashion shows to music by Bach, Ravel, Debussy, and Satie. (A client from the 1930s recalled having to pick her way across his salon floor, messily strewn with 78 rpm records, "like someone obliged to ford a river" to get to the looking glass.)

Following what is usually described as a "sexual escapade" at Harrow, James's father pulled him from the school and sent him to work in Chicago for his friend Samuel Insull's Commonwealth Edison utility company. When James was discovered brandishing some batik beach wraps of his own design around the office, Insull had the sense to swiftly remove him from his desk job and set him down in the architectural department. Although the opportunity was short-lived, James relished it and absorbed many of the fundamental skills that he would later apply to his structured fashion creations.

Soon he left to focus on making hats. "I attempted the impossible," he wrote, "out of a compulsion to be involved in a business of which my father disapproved." His father, suitably enraged, cut him off, but his indulgent mother—though forbidden to wear her son's creations—surreptitiously supported him, while her coterie of affluent society friends became his backers and clients, and in 1926 James set up shop under the label Boucheron (his father having forbidden the association of the family name with such a trade). As a milliner, James fashioned extraordinary, unforgiving hats shaped like stingrays or winged helmets modeled directly on his clients' heads.

He soon graduated to clothing, flitting between Chicago, New York, London, and Paris's Hotel Lancaster, where clients might discover him wafting around in swimming shorts, brandishing dressmaking shears. In London he created a wardrobe for the aristocratic British aesthete Stephen Tennant and dressed the gratin of fashionable British society. Bloomsbury mavens, fashion-plate actresses, and Bright Young Things all flocked to his salons, though James was exceedingly particular about just whom he would lavish his skills upon. Oliver Messel's enchanting sister Anne Armstrong-Jones (later the Countess of Rosse) was James's beloved client of the period—one indulgent enough to be amused when she arrived for her fittings to find the designer wearing the clothes intended for her. Mindful of his ever-precarious financial situation, Armstrong-Jones once brought a deep-pocketed American acquaintance of hers to his salon. After a quick appraisal of the woman, James told her crisply, "I couldn't possibly make anything for a frump like you—why, you can't even walk properly." (Armstrong-Jones also recalled an episode when James, fleeing the credit bailiffs as usual,

"IT WEIGHS TEN POUNDS," SAID CURATOR
HAROLD KODA OF THE CLOVER LEAF IN
THE EXHIBITION, "BUT THE PHYSICS OF IT IS
SO CAREFULLY DISPOSED OVER THE BODY
THAT YOU COULD LITERALLY DANCE IN
THIS HUGE DRESS!" JAMES CONTINUALLY
REVISITED AND REWORKED HIS OWN
IDEAS, AS WITH THIS EVOLVED—AND
MORE ROMANTIC—VERSION, DONE IN
BLACK LACE AND MARIGOLD SHANTUNG.

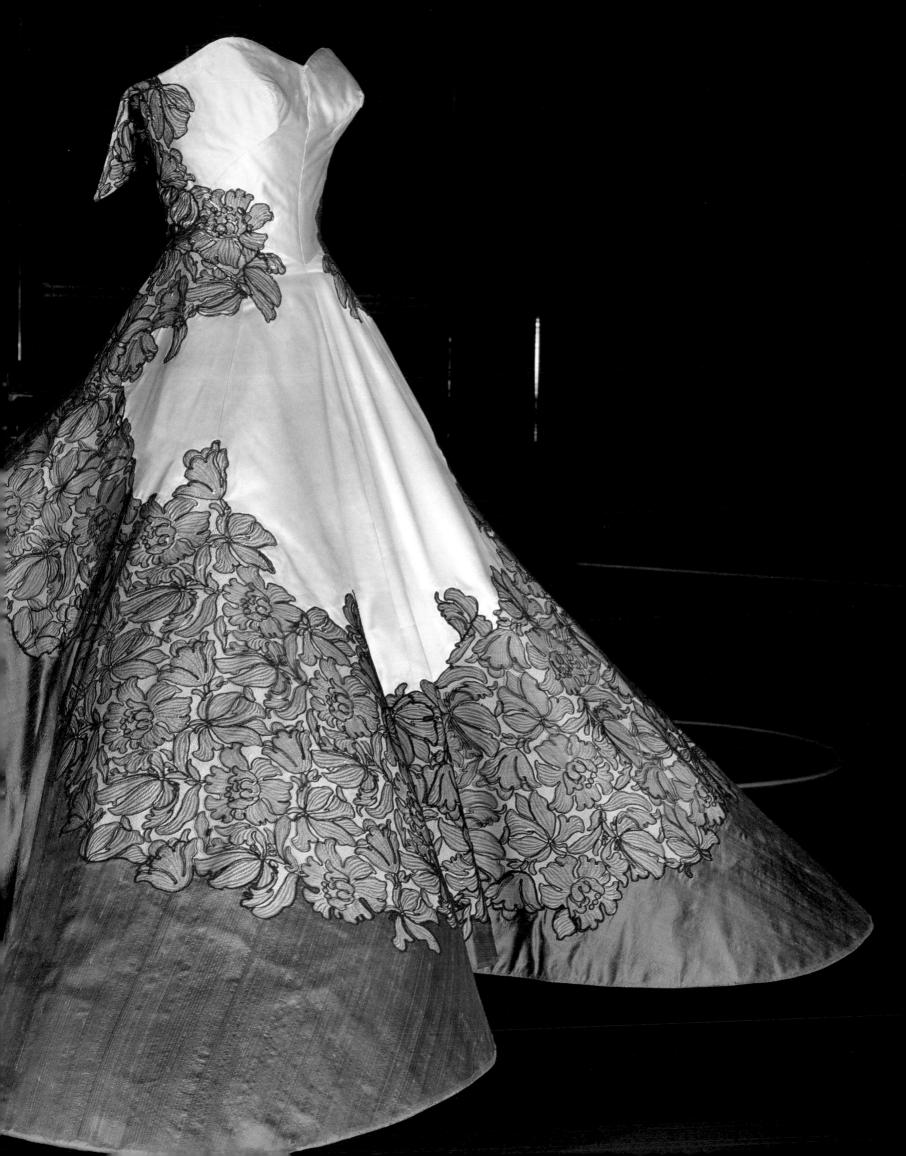

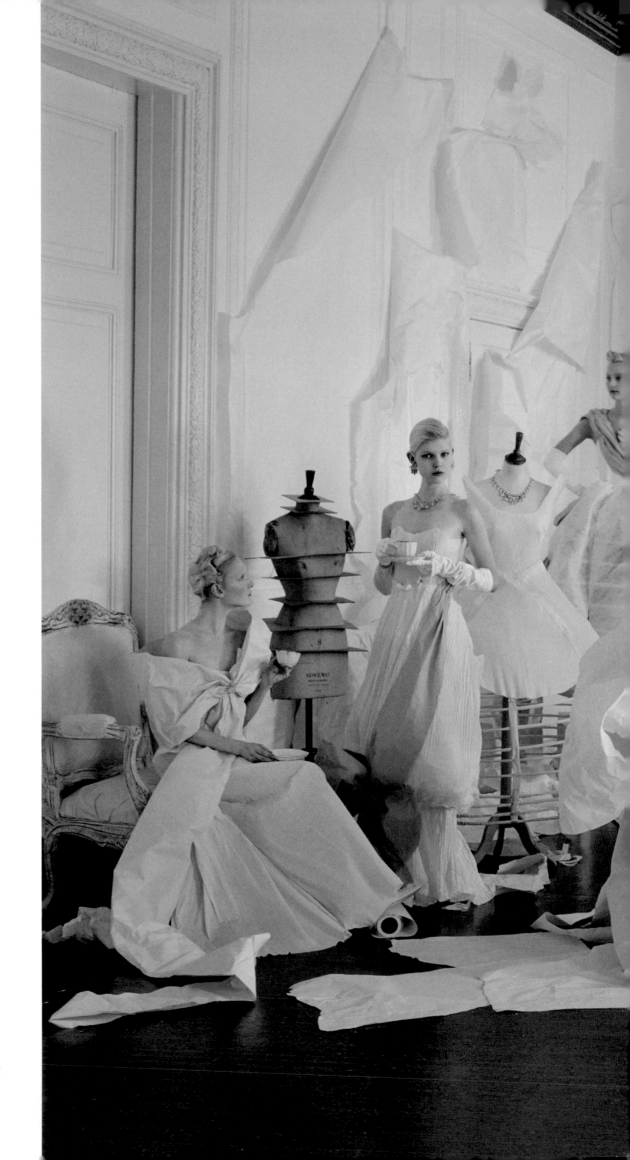

THE 1948 BEATON GATHERING OF
MANNEQUINS (WHICH ALSO APPEARED ON
THE EXHIBITION CATALOG'S COVER) WAS
RE-CREATED WITH DRESSES AND JEWELS OF
PAPER, BY SET DESIGNER AND COSTUMER
RHEA THIERSTEIN, AND PHOTOGRAPHED BY
TIM WALKER, FOR *VOGUE*, MAY 2014. THE
MODELS WERE, FROM LEFT, MAJA SALAMON,
OLA RUDNICKA, CODIE YOUNG, ESMERALDA
SEAY-REYNOLDS, NASTYA STEN, SASHA LUSS,
ALEXANDRA KIVIMAKI, AND ALICE CORNISH.

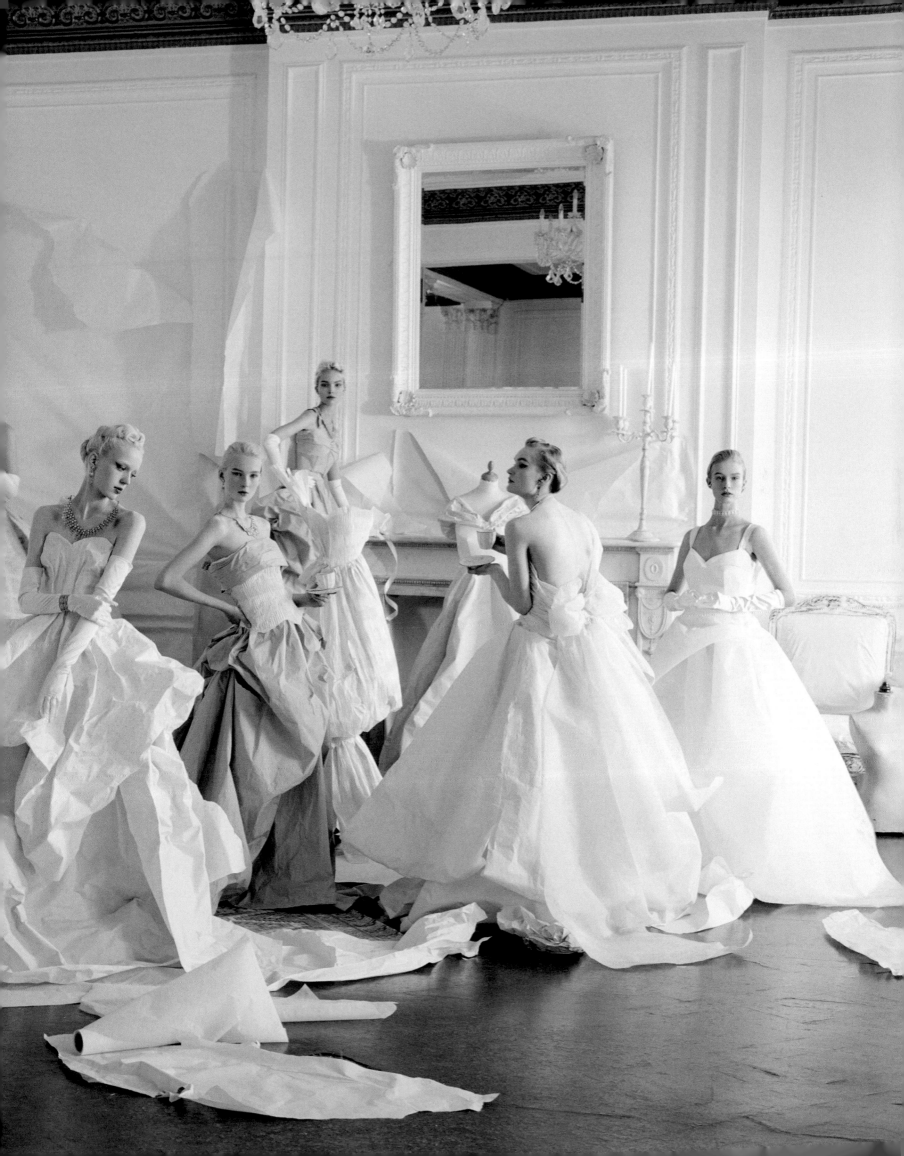

BEATON TOOK THIS PORTRAIT
OF HIS CHILDHOOD FRIEND—
AND CLASSMATE AT HARROW,
THE ENGLISH BOYS' BOARDING
SCHOOL—IN THE LATE 1920s. (CECIL
CALLED HIM SIMPLY "CHARLIE.")
OPPOSITE: JAMES'S FASCINATION
WAS WITH THE TRANSFORMATION
OF TWO-DIMENSIONAL FABRIC
INTO THREE-DIMENSIONAL FORM.
HERE, AN INK SKETCH, C. 1970.

appeared unannounced at her house accompanied by a fleet of taxis stuffed with armfuls of his creations—"specialties for special people; all masterpieces"—which he then scattered across the floor of her dining room just before a lunch party.)

"Charlie escaped from the chores of life by episodes that were like the acts of trapezists in the circus," noted his friend the British Surrealist Sir Francis Rose. The designer romped through a life out of Evelyn Waugh, living generally beyond his means in swank hotels and funding his haute couture fantasies with money extracted from doting family, society friends, clients, and occasionally lovers.

Having settled in New York in the early 1940s to establish his couture salon there, James and his talent soon blossomed. Clients clamored for his grand statement ball gowns, such as those immortalized in the iconic Cecil Beaton tableau shot for *Vogue* in 1948. Dorry Adkins, the statuesque beauty on the far right of the image (which she describes as "Fashion's answer to *The Last Supper*"), recalled that her dress was "so beautifully made it could stand alone, independent of one. The folds of heavy French silk would do a design as you moved; it almost had a mind of its own."

But though he was among the most expensive dressmakers of his day—a James ball gown could set a customer back $1,500 in 1950, a giddying sum—his perfectionism meant that his pieces were exorbitantly expensive to produce. James was always destroying finished garments on the eve of delivery and sending them back to be reworked. (He also spent two years and an alleged $20,000 developing the perfect sleeve.) As Harold Koda notes in the handsome book accompanying the exhibition, "James considered even the most resolved idea to be poised in a penultimate state."

Clients, though, were frequently exasperated by his posturing and his tantrums, his idiosyncratic billing methods (he was known to sell the same dress to more than one person), and his inability ever to deliver a garment on time. Gloria Vanderbilt, who asked James to make her a simple tweed suit, recalls endless fittings in his suite at the Sherry-Netherland hotel. "He did all the fittings himself—nobody ever put hands on the garment except him," Vanderbilt says. "He was such a perfectionist that he never felt he got it right—it literally took hours. [Later] he would call and say, 'I just need you one more time,' and the whole thing would be ripped apart and put back together. It was a simple suit, not an extravaganza. He never finished it."

Austine Hearst, a client of exceptional beauty with a pocketbook as plump as she was slender, ordered James's Four Leaf Clover dress—the piece he considered his masterwork, or thesis—for the Eisenhower inaugural gala in 1953. When it did not arrive in time for the inaugural, she decided to wear it several weeks later to a March of Dimes benefit, for which James also improvised a bolero jacket smothered in fresh gardenias. James then lent Hearst's gown to Gloria Vanderbilt to wear to another benefit. Although it weighed ten pounds, with the skirt's hem seven feet in diameter, "it was not a bit difficult to wear," Vanderbilt remembers. "The dress was so well balanced it became part of the wearer. He really was an absolute genius."

He also pushed both his employees—Bill Cunningham, a friend, has noted that James thought nothing of locking them in the studio overnight to complete an order for the morning—and himself harder than anyone. Patron M. E. Hecht recalled that "excoriation would barely cover the language he used" to staff who had failed his exacting standards. John de Menil and his wife, Dominique, asked James to decorate the modernist house in Houston they had commissioned from Philip Johnson. "Charlie was impossible," noted Dominique. "But all that mattered was that he was a genius." She cherished her James wardrobe just as she did her Dalí, Magrittes, and Mirós (a jewel-box exhibition of her James-designed clothing and furniture—"A Thin Wall of Air: Charles James"—will run at the Menil Collection in Houston as a complement to The Met's extravaganza).

James's romantic life was as shambolic as his working conditions—he attempted suicide on more than one occasion, apparently as a result of amorous disappointments. (Jean Cocteau, staying in a Paris hotel room opposite James, once discovered him trying to hang himself, and cut him down.)

"All my designing represented a vicarious love affair with women whose beauty I took delight in enhancing," James said toward the end of his life. In 1954, though, he surprised his intimates by marrying Nancy Lee Gregory, the former wife of one of his lovers and an heiress who helped finance and organize a roster of new business ventures. James insisted that he married for love, and the couple had a son, Charles, and a daughter, Louise, which soon led to their father designing children's clothes—Princess Grace included some in her daughter Caroline's layette.

But Nancy left him in 1961, and his ambitious schemes soon floundered. In 1964 he moved into Manhattan's Chelsea Hotel, where he survived on the generosity of the manager, Stanley Bard; handouts from friends and erstwhile patrons; and the occasional paying student. Surrounded by the detritus of his life's designs in an atmosphere of *Grey Gardens* squalor, he would regale those who came to pay homage (including William Ivey Long, who moved to the Chelsea to be near him, and the occasional client, such as Elsa Peretti) with his fashion philosophies.

Meanwhile, the brilliant fashion artist Antonio Lopez began both to document his work and to introduce the young Warholian circle to it; soon, James was lending his precious originals for madcap nights on the town. Karl Lagerfeld remembered the potent impact of seeing Pat Cleveland in James's 1938 down jacket (though he was less impressed with James himself: "He was a tiny little midget with dyed hair—the most unpleasant man I ever met. I think he was his own worst enemy").

In the fall of 1978 James fell ill with bronchial pneumonia. True to form, he kept the ambulance men waiting as he finished primping his face and *tenue* (James regularly touched up his graying hair with what was supposedly shoe polish). "It may not mean anything to you," James told them as they waited to take him to the hospital, where he would die later that night, "but I am what is popularly regarded as the greatest couturier in the Western world." —HAMISH BOWLES, *VOGUE*, MAY 2014

IN THE ENTRANCE HALL, A MASSIVE SPIRAL-FORM
CASCADE OF FRESH ROSES EVOKED THE SWIRLING
CONSTRUCTION THAT WAS A FAVORITE THEME OF
THE CURVE-LOVING COUTURIER. **PREVIOUS PAGES:**
ACTORS BRADLEY COOPER AND SARAH JESSICA
PARKER WERE GALA COCHAIRS. SHE ARRIVED IN AN
OSCAR DE LA RENTA DRESS SHORED UP BY A MAJOR
CRINOLINE—WITH GRIDLIKE MARKINGS IN BLACK
VELVET MEANT TO EVOKE A DRESS FORM. COOPER,
PHOTOGRAPHED BY MARIO TESTINO, WORE TOM FORD.

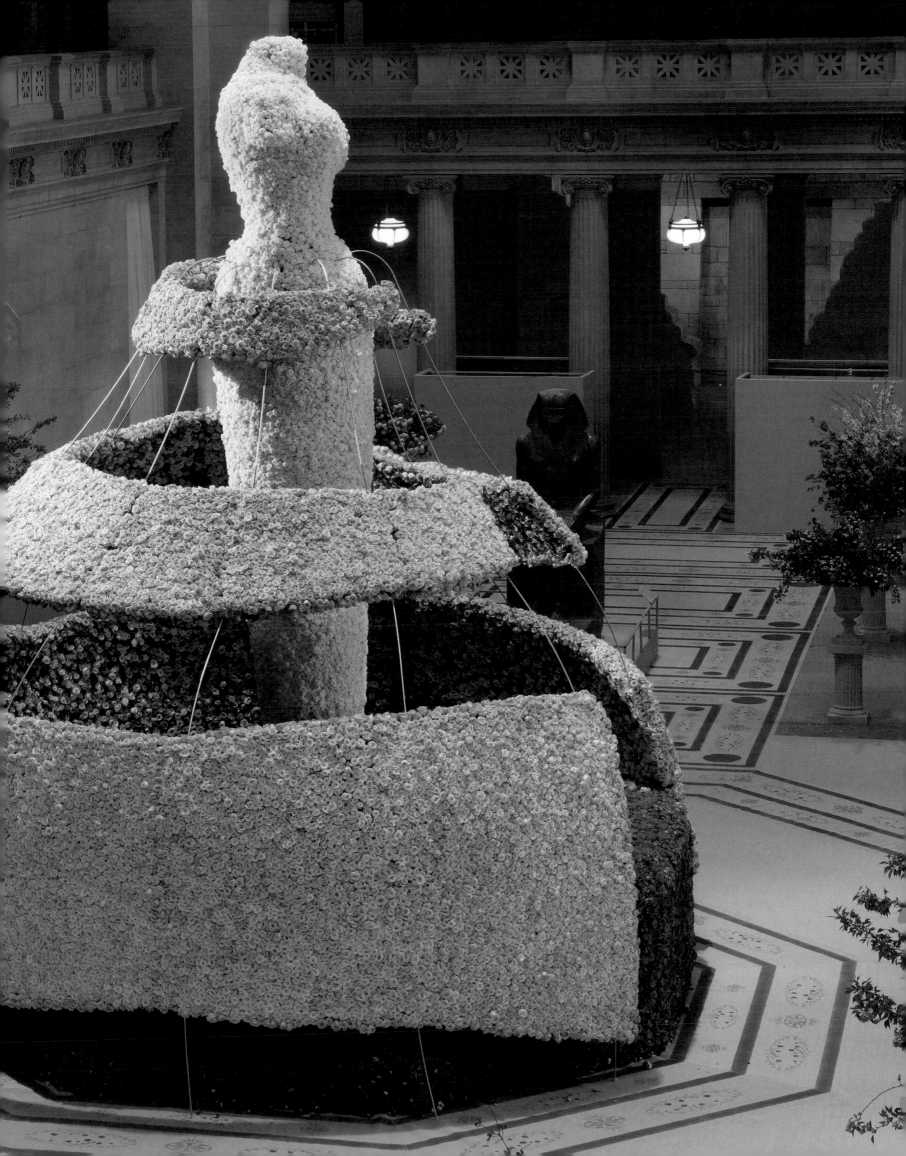

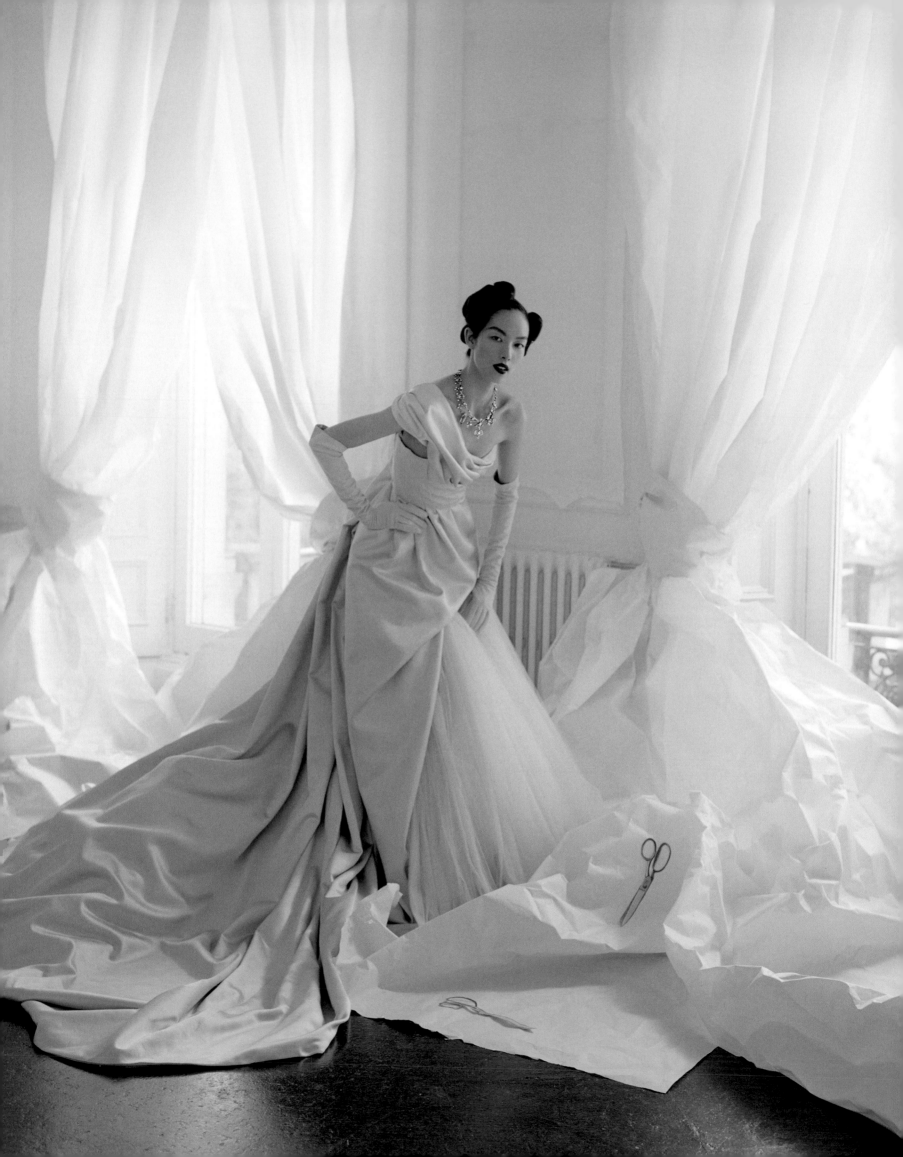

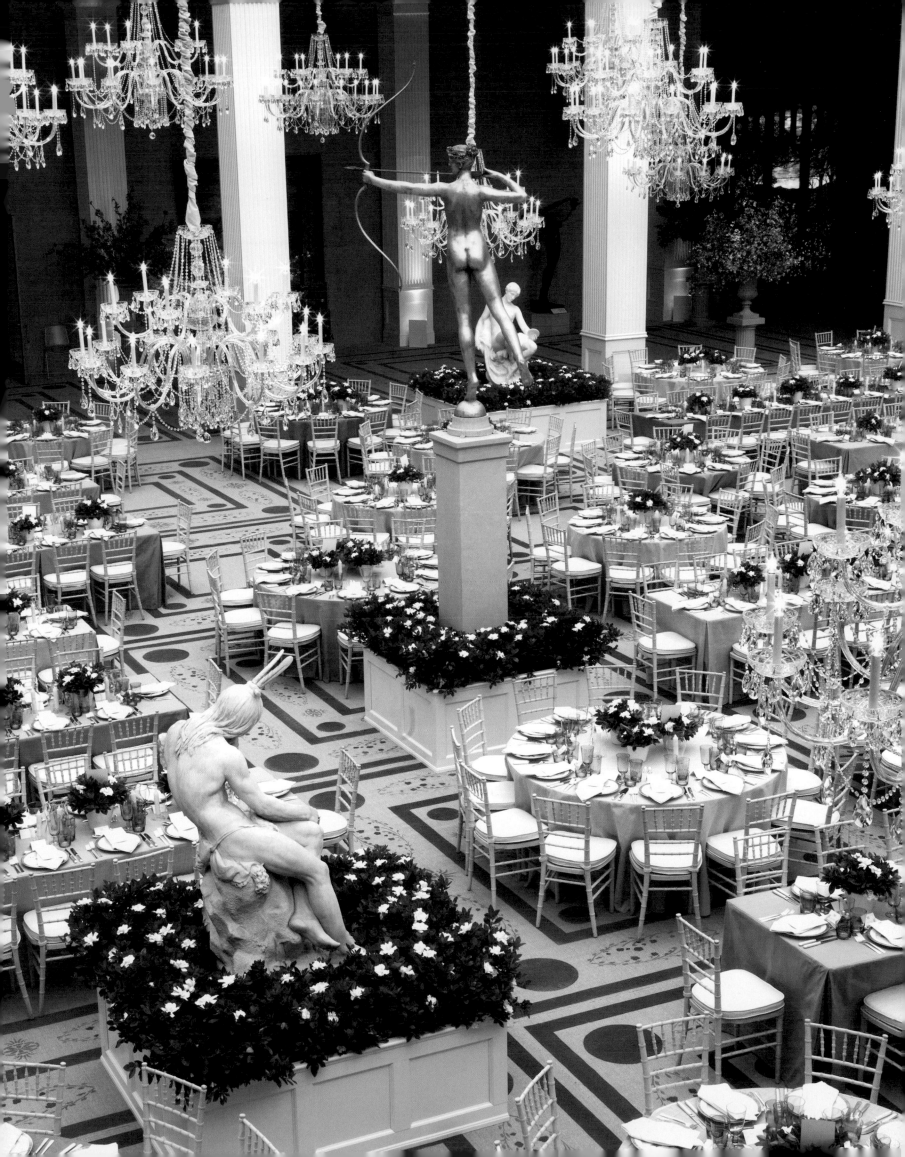

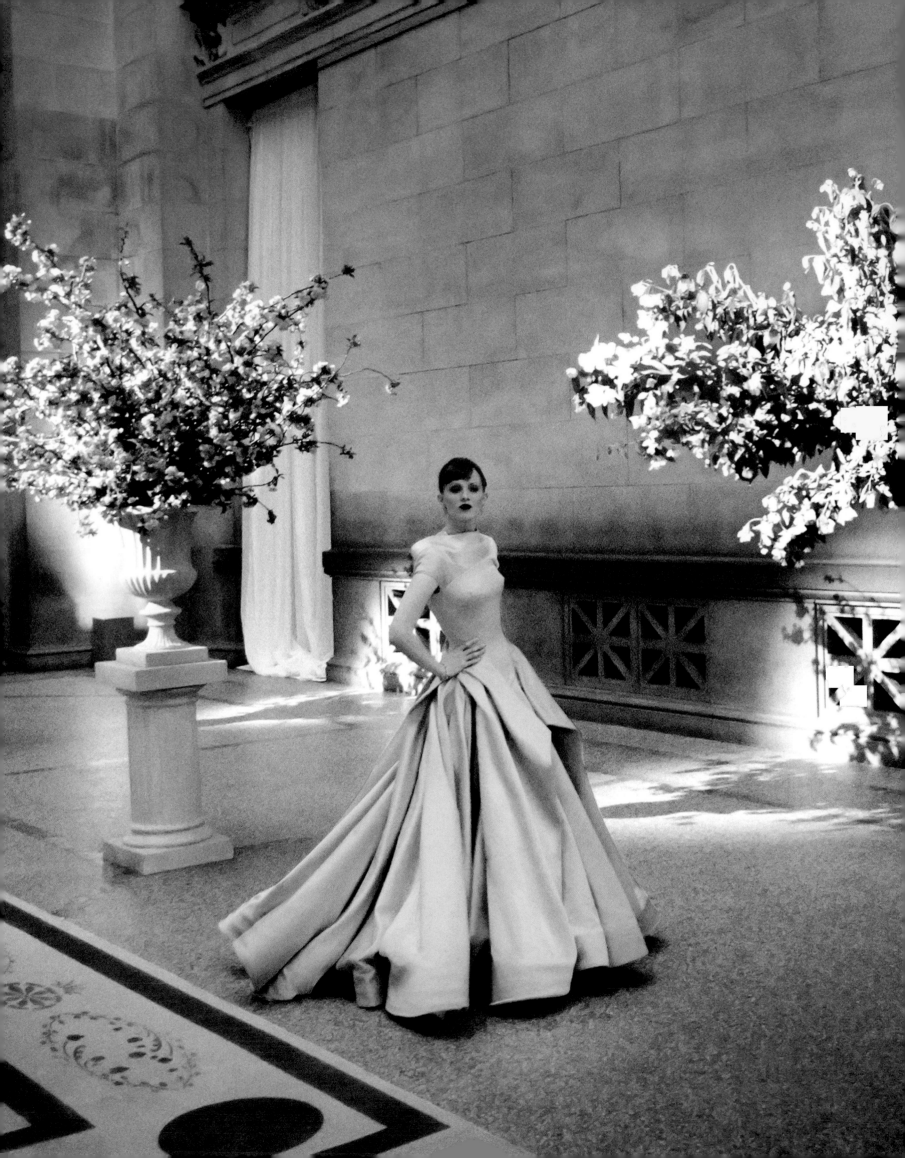

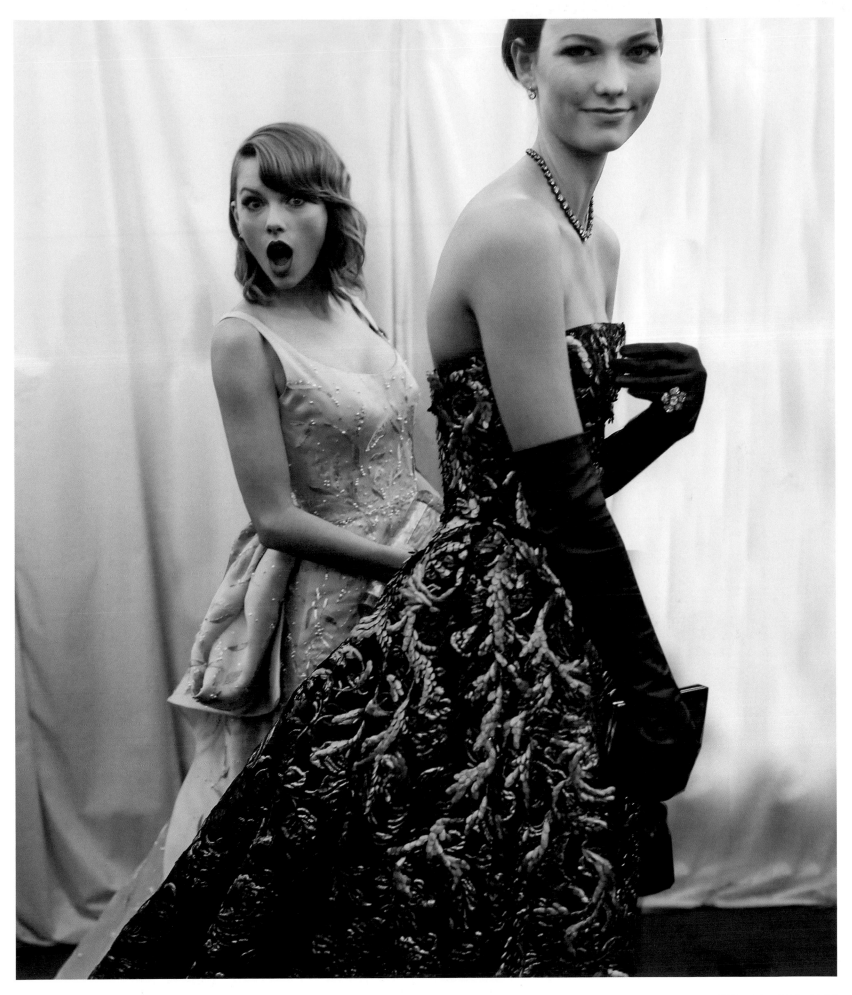

SINGER TAYLOR SWIFT MUGGED FOR THE CAMERA BESIDE KARLIE KLOSS (BOTH IN DE LA RENTA). **OPPOSITE:** KAREN ELSON POSED FOR MARIO TESTINO BENEATH THE CHERRY-BLOSSOM AND MOCK-ORANGE BOUGHS IN A DRESS BY ZAC POSEN, WHOSE FALL 2014 COLLECTION WAS EXPLICITLY INSPIRED BY JAMES. **PREVIOUS PAGES:** LEFT, FEI FEI SUN WORE SUMPTUOUS SWATHS OF SEA FOAM IN *VOGUE*, MAY 2014—A MODERN SPIN ON JAMESIAN ELEGANCE FROM THE HOUSE OF ALEXANDER McQUEEN. RIGHT, 20 HANGING CRYSTAL CHANDELIERS ILLUMINATED THE SCENE AT DINNER IN THE ENGELHARD COURT.

FIGURE-CONCEALING
DOLMAN COAT, RECALLING
POIRET, EARLY 1950s.

CUTAWAY TRAVEL SUIT MADE FOR
ARTIST LEE KRASNER, 1961–62.

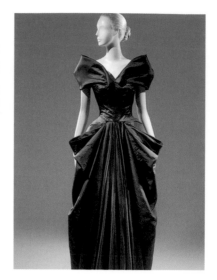

CONTRAST LAYERS SUGGEST
AN 18TH-CENTURY ROBE
À LA FRANÇAISE, 1946.

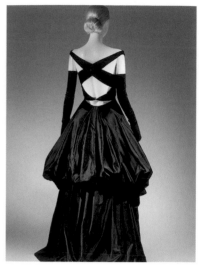

EXPOSED HARNESS BACK OVER
AIRILY POUFED SKIRT, 1948.

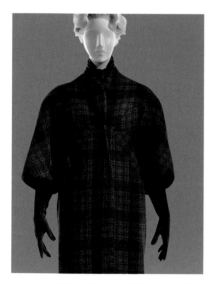

PLAID GREAT COAT WITH COMPLEX
SEAMING OVER BUST, C. 1961.

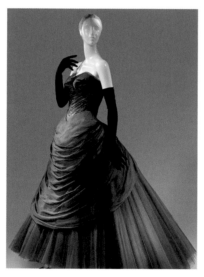

THE SWAN WAS DESIGNED
IN THE EARLY 1950s, AT THE
APOGEE OF JAMES'S INFLUENCE.

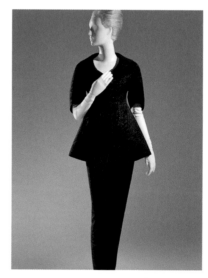

CLEAN-LINED MATELASSÉ DINNER
SUIT, FLARING OVER HIPS, 1956.

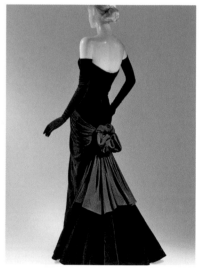

LIGHTLY BONED, STRAPLESS DRESS
OF BLACK AND BROWN, 1947.

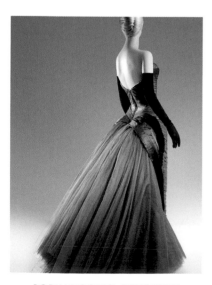

BODY-HUGGING, DELICATELY
TUCKED BUTTERFLY DRESS, 1955.

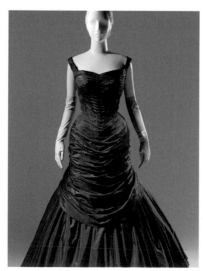

INTRICATE DEEP-PINK FOLDS,
DESIGNED FOR MARIETTA TREE, 1955.

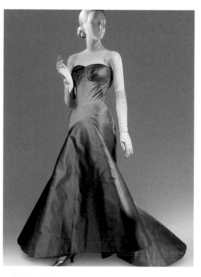

BALL GOWN WITH CIRCULAR SKIRT
FOLDED INTO FRONT FLUTE, 1954.

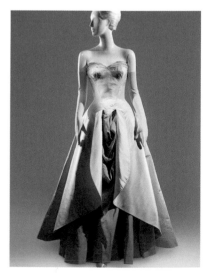

AUSTINE HEARST AND MILLICENT
ROGERS WORE THIS 1948 LOOK.

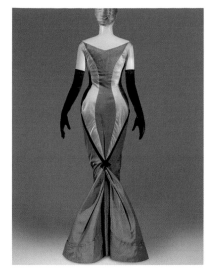

THE DIAMOND DRESS DREW EYES
TO THE REAR VIEW, 1957.

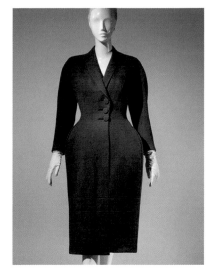

CIRCULAR TULLE CAPE OVER
INFLUENTIAL SWAN DRESS, 1951.

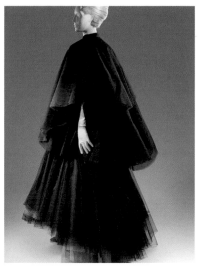

AN EXAGGERATED
(SHAPE-SHIFTING) HOURGLASS,
EARLY 1950s.

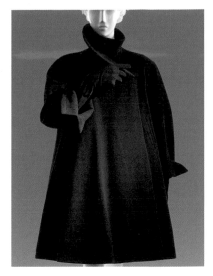

SWING COAT WITH INNOVATIVE
ASYMMETRICAL COLLAR, 1951.

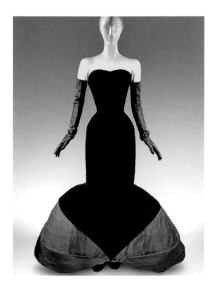

SHEATH WITH DRAMATIC
BELL-SHAPED HEM, C. 1955.

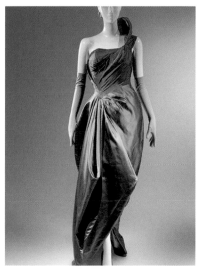

UNCONVENTIONAL IN COLOR
AND CONSTRUCTION, 1951.

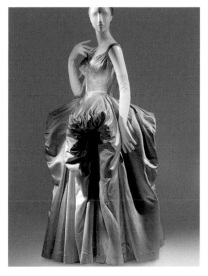

AN EXCESS OF SATIN,
CUT INTO PILLOW-LIKE
CRESCENTS, 1951.

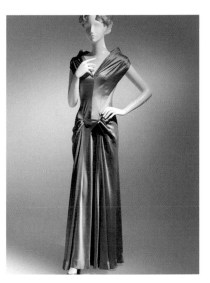

PEACH CHARMEUSE, ACCENTING
THE PELVIS, 1945.

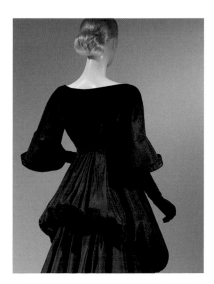

THE FAMOUS BALLOON WAS ALSO
DONE AS MATERNITYWEAR, C. 1956.

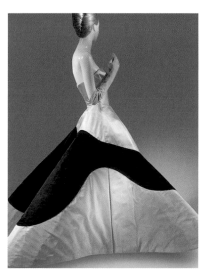

HIS CROWNING ACHIEVEMENT:
CLOVER LEAF DRESS, 1953.

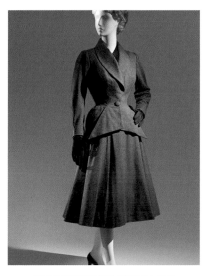

ECCENTRICALLY PIECED BUT
LADYLIKE FLANNEL SUIT, 1948.

COAT WITH LYRE-SHAPED SEAMING
(A RECURRING MOTIF), 1945.

PHOTOGRAPHY CREDITS

Contents: Steven Meisel: **4–5. Foreword:** © The Metropolitan Museum of Art, Courtesy of Burberry: **6. Introduction:** Eric Boman: **9.** Robert Fairer: **10–11.**

JACQUELINE KENNEDY: THE WHITE HOUSE YEARS, 2001

Bettmann/© Corbis: **13.** Apic/© Getty Images: **14.** Hulton Archive/© Getty Images: **15.** John F. Kennedy Library/Archive Photos/© Getty Images: **17.** © John F. Kennedy Library Foundation, Inc.: **18, 24–25.** Robert Knudsen. White House Photographs. John F. Kennedy Presidential Library and Museum, Boston: **18–19.** © 2001 Mark Shaw/MPTV: **22–23.**

EXTREME BEAUTY: THE BODY TRANSFORMED, 2002

© Rex USA: **27.** *Femme Turque et Son Esclave,* 18th-century (pastel on paper), Jean-Étienne Liotard/ Musée d'Art et d'Histoire Geneva, Switzerland/Giraudon/The Bridgeman Art Library: **29.** Irving Penn/ Condé Nast Archive: **30–31.** © The Metropolitan Museum of Art, purchase, Irene Lewisohn Bequest, 1965 (C.I.65.13.1a–c): **32.** *Les Adieux, from Le Monument du Costume,* 1777, after Jean Michel Moreau the Younger (1741–1814), engraved by Robert de Launay, etching and engraving, 10 ⅝″ x 8 ⁹⁄₁₆″, The Metropolitan Museum of Art. Purchase, 1934 (34.22.1): **33. The designs, page 34:** (Row 1, left) The Museum at the Fashion Institute of Technology, New York. Gift of Richard Martin (87.16.1). Photograph: Karin L. Willis, the Photograph Studio, © The Metropolitan Museum of Art. (Row 1, center) © The Metropolitan Museum of Art, gift of Miss Jessie Rosenfeld, 1943 (C.I.43.40.59a, b). (Row 1, right) © The Metropolitan Museum of Art, Costume Institute Benefit Fund, 1999 (1999.395.1). (Row 2, left) © The Metropolitan Museum of Art, purchase, Irene Lewisohn Bequest, 2001 (2001.472a, b). (Row 2, center) © The Metropolitan Museum of Art, purchase, the New-York Historical Society (by exchange) and Louise Moore Van Vleck Gift, 1985 (1985.27.4). (Row 2, right) © The Metropolitan Museum of Art, gift of Salvatore Ferragamo, 1973 (1973.282.2). (Row 3, left) Glenn Roberts Collection. Photograph: Karin L. Willis, the Photograph Studio, The Metropolitan Museum of Art. (Row 3, right) © The Metropolitan Museum of Art, gift of Mr. Lee Simonson, 1939 (C.I.39.13.211, C.I.39.13.206a, b). **The designs, page 35:** (Row 1, left) © The Metropolitan Museum of Art, the Jacqueline Loewe Fowler Costume Collection, gift of Jacqueline Loewe Fowler, 1988 (1988.356.2). (Row 1, center; left to right) © The Metropolitan Museum of Art, gift of Mrs. Robert K. Baker, 1963 (C.I.63.12.1); gift of Miss Marian H. Smith, 1979 (1979.53.2); gift of Lee Simonson, 1938 (C.I.38.23.281). Photograph: Karin L. Willis, the Photograph Studio, © The Metropolitan Museum of Art. (Row 1, right) © The Metropolitan Museum of Art, gift of Mrs. William R. Witherell, 1953 (C.I.53.72.17). (Row 2, left) © The Metropolitan Museum of Art, gift of Mrs. J. Randall Creel, 1963 (C.I.63.23.3a, b). (Row 2, center) The Museum at the Fashion Institute of Technology, New York, gift of the Victoria and Albert Museum (71.202.16). Photograph: Karin L. Willis, the Photograph Studio, © The Metropolitan Museum of Art. (Row 2, right; left to right) The Museum at the Fashion Institute of Technology, New York, museum purchase (P82.1.12); the Museum at the Fashion Institute of Technology, New York, gift of Mrs. Benjamin Hinkley Riggs (69.221.1); The Metropolitan Museum of Art, the Costume Institute, purchase, Hoechst Fiber Industries Fund, 1982 (1982.316.8). Photograph: Karin L. Willis, the Photograph Studio, © The Metropolitan Museum of Art. (Row 3, left) Courtesy of Mark Walsh. Photograph: Karin L. Willis, the Photograph Studio, © The Metropolitan Museum of Art. (Row 3, center; left to right) The Metropolitan Museum of Art, the Costume Institute, gift of Mrs. James Sullivan, in memory of Mrs. Luman Reed, 1926 (26.250.2a–d); Courtesy of Museo de la Moda y Textil, Santiago, Chile. Photograph: Karin L. Willis, the Photograph Studio, © The Metropolitan Museum of Art. (Row 3, right) The Museum at the Fashion Institute of Technology, New York, purchase (P92.8.1). Photograph: Irving Solero.

GODDESS: THE CLASSICAL MODE, 2003

© Steven Meisel/Art + Commerce: **37.** Photograph by Tsutomu Wakatsuki/Courtesy of Miyake Design Studio: **38.** SCALA/Art Resource, NY: **39.** © The Helmut Newton Estate: **41.** Steven Klein: **42–43.** Bruce Schwarz/ © The Metropolitan Museum of Art: **44.** Photograph: Karin L. Willis, the Photograph Studio, © The Metropolitan Museum of Art, Courtesy of the House of Jean-Louis Scherrer: **45.** Steven Meisel: **46.** Tom Grimes: **46–47. The designs, page 48:** (Row 1, left) Photograph: Karin L. Willis, the Photograph Studio, © The Metropolitan Museum of Art, Courtesy of Sandy Schreier. (Row 1, center left) Photograph: Karin L. Willis, the Photograph Studio, © The Metropolitan Museum of Art, Courtesy of Donna Karan New York. (Row 1, center right) Photograph: Karin L. Willis, the Photograph Studio, © The Metropolitan Museum of Art, gift of Hillie (Mrs. David) Mahoney, 1996 (1996.498.2a, b). (Row 1, right; left to right) Photograph: Karin L. Willis, the Photograph Studio, © The Metropolitan Museum of Art, Gift of Chessy Rayner, 1997 (1997.116.38a–c); © The Metropolitan Museum of Art, gift of Mrs. Oscar de la Renta, 1994 (1994.192.12). (Row 2, left) Photograph: Karin L. Willis, the Photograph Studio, © The Metropolitan Museum of Art, Courtesy of Douglas Ferguson. (Row 2, center left) Photograph: Karin L. Willis, the Photograph Studio, © The Metropolitan Museum of Art, gift of Anne H. Bass, 1993 (1993.345.15a–c). (Row 2, center right) © The Metropolitan Museum of Art, Courtesy of Pierre Balmain Haute Couture. (Row 2, right) © The Metropolitan Museum of Art, Courtesy of Norma Kamali for OMO/Norma Kamali, Inc. (Row 3, left) © The Metropolitan Museum of Art, purchase, Janet A. Sloane Gift Fund, 1994 (1994.414.6). (Row 3, center left) © The Metropolitan Museum of Art, Courtesy of Rosina Rucci. (Row 3, center right; left to right) © The Metropolitan Museum of Art, anonymous gift (1973.139); photograph: Karin L. Willis, the Photograph Studio, © The Metropolitan Museum of Art, Courtesy of Giorgio Armani. (Row 3, right) © The Metropolitan Museum of Art, purchase, gifts from Various Donors, 1985 (1985.155). **The designs, page 49:** (Row 1, left) Photograph: Karin L. Willis, the Photograph Studio, © The Metropolitan Museum of Art, Courtesy of Yves Saint Laurent Rive Gauche. (Row 1, center left) Photograph: Karin L. Willis, the Photograph Studio, © The Metropolitan Museum of Art, Courtesy of Dolce & Gabbana. (Row 1, center right) Photograph: Karin L. Willis, the Photograph Studio, © The Metropolitan Museum of Art, Courtesy of Sandy Schreier. (Row 1, right) Photograph: Karin L. Willis, the Photograph Studio, © The Metropolitan Museum of Art, lent by the Museum at the Fashion Institute of Technology, New York, gift of Lauren Bacall (76.69.17; 76.118.3). (Row 2, left) Photograph: Karin L. Willis, the Photograph Studio, © The Metropolitan Museum of Art, Courtesy of Nicole Kidman. (Row 2, center left; left to right) Photograph: Karin L. Willis, the Photograph Studio, © The Metropolitan Museum of Art, Courtesy of Gucci; Photograph: Karin L. Willis, the Photograph Studio, © The Metropolitan Museum of Art, Courtesy of Milan Tainan, Justsaywhen.com. (Row 2, center right) © The Metropolitan Museum of Art, gift of Mrs. Anthony Wilson, 1979 (1979.344.11a, b). (Row 2, right) Photograph: Karin L. Willis, the Photograph Studio, © The Metropolitan Museum of Art, lent by the Museum at the Fashion Institute of Technology, New York, gift of Mr. and Mrs. Adrian McCardell (72.61.181). (Row 3, left) Photograph: Karin L. Willis, the Photograph Studio, © The Metropolitan Museum of Art, Courtesy of Mark Walsh, Yonkers, New York (left, chlamys); © The Metropolitan Museum of Art, gift of Clare Fahnestock Moorehead, 2001 (2001.702a) (right, dress); © The Metropolitan Museum of Art, gift of Chessy Rayner, 1997 (1997.116.1a, b) (right). (Row 3, center left) © The Metropolitan Museum of Art, gift of Estate of Lillian Gish, 1995 (1995.28.6a). (Row 3, center right) © The Metropolitan Museum of Art, gift of A.M. Tenney Associates, Inc. and Tennessee Eastman Corporation, 1949 (C.I.50.21.12). (Row 3, right) Photograph: Karin L. Willis, the Photograph Studio, © The Metropolitan Museum of Art, Courtesy of Mrs. Veronica Hearst.

DANGEROUS LIAISONS: FASHION AND FURNITURE IN THE EIGHTEENTH CENTURY, 2004

© The Metropolitan Museum of Art, purchase, Irene Lewisohn Bequest, 2001 (2001.472a, b) (dress); gift of Miss Agnes Miles Carpenter, 1955 (C.I.55.43.17) (fan): **81.** Michael Lisnet: **52–53, 62.** *The Masked Ball at the Galerie des Glaces, 17th February 1745* (pen, ink, and watercolor on paper), Cochin, Charles Nicolas II (1715–90)/Louvre, Paris, France/Giraudon/The Bridgeman Art Library: **54–55.** Tim Hout: **57.** Annie Leibovitz: **58–61, 63–65.** John Barrett/Globe Photos, Inc.: **66.** CATUFFE/SIPA: **67. The designs, page 68:** (Row 1, left; left to right) Courtesy of Lillian Williams; purchase, Irene Lewisohn Bequest, 1961 (C.I.61.13.1a, b); purchase, Irene Lewisohn Bequest, 1959 (C.I.59.29.1a, b). (Row 1, right; left to right) Purchase, Isabel Shults Fund and Irene Lewisohn Bequest, 1991 (1991.204a, b); purchase, Irene Lewisohn Bequest, 1964 (C.I.64.33a, b); purchase, Irene Lewisohn Bequest, 1966 (C.I.66.39a, b); purchase, Irene Lewisohn and Alice L. Crowley Bequests, 1976 (1976.149.1). (Row 2, left) Purchase, Isabel Shults Fund and Irene Lewisohn Bequest, 1991 (1991.204a, b). (Row 2, right; left to right) Isabel Shults Fund, 2005 (2005.61a, b); Courtesy of Lillian Williams; purchase, Irene Lewisohn Bequest, 1959 (C.I.59.29.1a, b). (Row 3, left) Gift of Mrs. Frank A. Zunino, 1966 (C.I.66.1.2a–c). (Row 3, center) Courtesy of the Kyoto Costume Institute. (Row 3, right; left to right) Gift of Fédération de la Soirie, 1950 (50.168.2a, b); purchase, Irene Lewisohn Bequest, 1961 (C.I.61.34a, b); Fletcher Fund, 1938 (38.30.1a, b); Courtesy of the Kyoto Costume Institute; purchase, Irene Lewisohn Bequest, 1961 (C.I.61.13.1a, b). **The designs, page 69:** (Row 1, left) Rogers Fund, 1932 (32.40a–c). (Row 1, center) Purchase, Irene Lewisohn Bequest, 1960 (C.I.60.5a–c). (Row 1, right; left to right) Purchase, Irene Lewisohn Bequest, 1961 (C.I.61.34a, b); Fletcher Fund, 1938 (38.30.1a, b); gift of Fédération de la Soirie, 1950 (50.168.2a, b). (Row 2, left; left to right) Gift of Mrs. Frank A. Zunino, Jr., 1966 (C.I.66.1.2a–c); purchase, Irene Lewisohn Bequest, 1960 (C.I.60.39.2a, b); Fletcher Fund, 1961 (C.I.61.14.2a–c); purchase, Irene Lewisohn Bequest, 1960 (C.I.60.39.2a, b); Courtesy of Lillian Williams. (Row 2, center) Gift of Mrs. Robert Woods Bliss, 1943 (C.I.43.90.49). (Row 2, right) © The Metropolitan Museum of Art, gift of International Business Machines Corporation, 1960 (C.I.60.22.1a–c). Purchase, Mr. and Mrs. Alan S. Davis Gift, 1976 (1976.146a, b). (Row 3, left) Gift of Fédération de la Soirie, 1950 (50.168.1a, b). (Row 3, center) Rogers Fund, 1942 (42.105.1a–c). (Row 3, right; left to right) Purchase, Irene Lewisohn Bequest, 1954 (C.I.54.70a, b); purchase, Rogers Fund, 1926 (26.56.63a–c).

CHANEL, 2005

Stan Honda/AFP/Getty Images: **71.** Michael Lisnet: **72, 78–79.** Courtesy of the Cecil Beaton Studio Archive at Sotheby's: **73.** Steven Meisel: **75** (left), **77.** Karl Lagerfeld: **75** (right). Mario Testino: **78.** Catalog: Photography by Karin L. Willis of The Metropolitan Museum of Art Photograph Studio. Double-transfer photograph artwork by Karl Lagerfeld and Gerhard Steidl. © 2005 by Karl Lagerfeld: **80–81. The designs:** Courtesy of Chanel: **80** (row 1, left, right; row 3, right), **81** (row 1, left, center left; row 2, left; row 3, center). Purchase, New-York Historical Society by Exchange, 1983 (1984.29a–c): **80** (row 1, center left). Courtesy of Kent State University Art Museum, Silverman/Rogers Collection (1983.1.1252a,b): **80** (row 1, center right). Courtesy of the Museum of the City of New York: **80** (row 2, left). Gift of Mrs. Charles Wrightsman, 1993 (1993.157.7a, b): **80** (row 2, center left). Courtesy of the Collection of Phoenix Art Museum, gift of Mrs. Wesson Seyburn (1968.c.649.a, b): **80** (row 2, center right). Purchase, Irene Lewisohn Bequest and Catherine Breyer Von Bomel Foundation, Hoechst Fiber Industries, in honor of Diana Vreeland, and Chauncy Stillman Gifts, 1984 (1984.30): **80** (row 2, right). Courtesy of the Collection of Phoenix Art Museum, gift of Mrs. Wesson Seyburn (1968.c.650): **80** (row 3, left). Courtesy of Kent State University Art Museum, the Helen O. Borowitz Collection (1987.71.71a, b): **80** (row 3, center left). Courtesy of Mark Walsh Leslie Chin: **80** (row 3, center right), **81** (row 3, right). Gift of Mrs. Georges Gudefin, in memory of Mrs. Clarence Herter, 1965 (C.I.65.47.1a–c): **81** (row 1, center left). Gift of Mrs. John Chambers Hughes, 1958 (C.I.58.34.18a–c): **81** (row 1, right). Courtesy of the Museum at the Fashion Institute of Technology, gift of Mrs. Samuel M. V. Hamilton (78.55.36): **81** (row 2, center left). Courtesy of the Museum at the Fashion Institute of Technology, gift of Mrs. Walter Eytan (89.160.1): **81** (row 2, center right). Gift of Chanel, 1993 (1993.104.2a–j): **81** (row 2, right). Gift of Isabel Shults, 1944 (C.I.44.64.7): **81** (row 3, left).

ANGLOMANIA: TRADITION & TRANSGRESSION IN BRITISH FASHION, 2006

© The Metropolitan Museum of Art: **83.** Robert Fairer: **84–85, 96** (left), **97.** Michael Lisnet: **86–87, 94–95.** Jeff Harris: **89.** Mario Testino: **90–91.** *Mrs. Grace Dalrymple Elliott* (oil on canvas), Thomas Gainsborough (1727–88)/ © The Metropolitan Museum of Art, bequest of William K. Vanderbilt, 1920 (20.155.1): **92.** BEImages/Matt Baron: **93.** Mary Hilliard: **96** (right). **The designs, page 98:** (Row 1, left; left to right) Courtesy of Royal Ontario Museum, gift of Kathleen Mary Savory (2001.81.1); purchase, Irene Lewisohn Bequest, 1959 (C.I.59.54a, b); Courtesy of Cora Ginsburg, LLC; bequest of Catherine D. Wentworth, 1948 (48.187.709a, b); Rogers Fund, 1934 (34.108). (Row 1, right) Courtesy of John Galliano. (Row 2, left; left to right) Courtesy of Burberry; Courtesy of John Galliano; Courtesy of Bernard Weatherill; Courtesy of Burberry; Courtesy of Vivienne Westwood; Courtesy of John Galliano. (Row 2, right; left to right) Purchase, Richard Martin Bequest, 2006 (2006.158a, b) (shirt); Courtesy of PunkPistol (pants); Courtesy of John Lydon (jacket); purchase, Richard Martin Bequest, 2006 (2006.160, 2006.165, 2006.162a, b) (T-shirt, trousers, boots). (Row 3, left) Courtesy of Alexander McQueen. (Row 3, center) Courtesy of Hussein Chalayan. (Row 3, right; left to right) Gift of Manolo Blahnik, 2006 (2006.512.6) (shoe); Courtesy of Alexander McQueen (shoes); Courtesy of Shaun Leane and Alexander McQueen (body jewelry); Courtesy of Alexander McQueen; Courtesy of the Museum of London; Courtesy of Alexander McQueen (dress); Courtesy of Philip Treacy London Haute Couture (hat). **The designs, page 99:** (Row 1, left) Courtesy of Vivienne Westwood. (Row 1, center) Courtesy of Timothy Everest. (Row 1, right; left to right) Purchase, Richard Martin Bequest, 2006 (2006.164a, b); Alfred Z. Solomon–Janet A. Sloane Endowment Fund, 2006 (2006.206, mohawk); Courtesy of Resurrection, Alfred Z. Solomon–Janet A. Sloane Endowment Fund, 2006 (2006.205, barb wire); Courtesy of Resurrection (sweater); purchase, Richard Martin Bequest, 2003 (2003.479a–c, trousers); Courtesy of John Lydon (jacket), purchase, Richard Martin Bequest, 2006 (2006.160, 2006.165, 2006.162a, b, trousers, shirt, and boots). (Row 2, left) Courtesy of Vivienne Westwood. (Row 2, center left) Gift of Miss Eva Drexel Dahlgren, 1976 (1976.258.1a, b). (Row 2, center right) Courtesy of John Galliano. (Row 2, right) Courtesy of the Stolper Wilson Collection (shirt); purchase, Richard Martin Bequest, 2006 (2006.159a–e) (jacket). (Row 3, left) Courtesy of Cora Ginsburg, LLC. (Row 3, center left) Courtesy of Hussein Chalayan. (Row 3, center right) Courtesy of Hussein Chalayan. (Row 3, right) Gift of Manolo Blahnik, 2006 (2006.512.6).

POIRET: KING OF FASHION, 2007

Robert Fairer: **101, 104, 113.** Marko MacPherson: **103** (left); *Portrait of Paul Poiret* (1879–1944) French dress designer (oil on canvas), André Derain (1880–1954)/Musée de Grenoble, France/Peter Willi/The Bridgeman Art Library/© 2014 Artists Rights Society (ARS), New York/ADAGP, Paris: **103** (right). © The Metropolitan Museum of Art, purchase, Irene Lewisohn Trust Gift, 1983 (1983.8a, b): **105.** Michael Lisnet: **107.** Steven Meisel: **108, 109, 111.** *Madame Poiret in a dress by Paul Poiret* (1879–1944), 1919 (b/w photo), Delphi Studio (20th century)/Private Collection/Archives Charmet/The Bridgeman Art Library: **110.** Kristen Somody Whalen/*WWD*: **112.** Peter Kramer/Getty Images: **114–115. The designs:** Photographs: (All) Karin L. Willis, the Photograph Studio, © The Metropolitan Museum of Art, gift of Mrs. Kenneth Maconochie, 1951 (C.I.51.47): **116** (row 1, left). © The Metropolitan Museum of Art, gift of Mrs. Alfred Rheinstein, 1950 (C.I.50.117): **116** (row 1, center left). © The Metropolitan Museum of Art, gift of Leone B. Moats, in memory of Mrs. Wallace Payne Moats, 1979 (1979.428): **116** (row 1, center right). © The Metropolitan Museum of Art, purchase, Judith and Gerson Leiber Fund, 2005 (2005.191, 2005.208): **116** (row 1, right), **117** (row 3, left). © The Metropolitan Museum of Art, Millia Davenport and Zipporah Fleisher Fund, 2005 (2005.205, 2005.190a, b, 2005.198a, b, 2005.197a–c): **116** (row 2, left; row 3, right), **117** (row 1, left; row 2, center left). © The Metropolitan Museum of Art, gift of Mrs. David J. Colton, 1964 (C.I.64.7.2): **116** (row 2, center left). © The Metropolitan Museum of Art, gift of Mary Van Rensselaer Thayer, 1978 (1978.367.3a, b): **116** (row 2, center right). © The Metropolitan Museum of Art, gift of Miriam K. W. Coletti, 1995 (1995.588.3a, b): **116** (row 3, center right). © The Metropolitan Museum of Art, gift of Mrs. Robert L. Dodge, 1951 (C.I.51.48.4a, b): **116** (row 3, left). © The Metropolitan Museum of Art, purchase, Friends of the Costume Institute Gifts, 2005 (2005.386, 2005.367a, b): **116** (row 3, center left), **117** (row 2, center right). © The Metropolitan Museum of Art, Catharine Breyer Van Bomel Foundation Fund, 2005 (2005.196, 2005.204a–c, 2005.209): **116** (row 3, center right), **117** (row 1, right; row 2, right). © The Metropolitan Museum of Art, Isabel Shults Fund, 2005 (2005.200, 2005.201): **117** (row 1, center left, center right). © The Metropolitan Museum of Art, gift of Mrs. Muriel Draper, 1943 (C.I.43.85.2a, b): **117** (row 2, left). © The Metropolitan Museum of Art, gift of Mrs. John Campbell White, 1988 (1988.226.2): **117** (row 3, center left). © The Metropolitan Museum of Art, gift of Mrs. Robert A. Lovett, 1951 (C.I.51.70.19a–c): **117** (row 3, center right). © The Metropolitan Museum of Art, Alfred Z. Solomon–Janet A. Sloane Endowment Fund, 2008 (2008.288): **117** (row 3, right).

SUPERHEROES: FASHION AND FANTASY, 2008

Michael Lisnet: **119.** Artwork from *Mythology: The DC Comics Art of Alex Ross™* and © DC Comics. Used with permission: **121.** © Craig McDean/Art + Commerce: **122–127.** Batman, Catwoman, and Poison Ivy™ and © DC Comics: **122, 124, 126–127.** Camera Press/Tina Paul/Redux: **129.** © The Helmut Newton Estate: **130–131.** Mario Testino: **132–133. The designs:** Schohaja/Courtesy of threeAS-FOUR: **134** (row 1, left). Walter Van Beirendonck archive: **134** (row 1, center left). Maria Ziegelblöck/Courtesy of Bernhard Willhelm: **134** (row 1, center right). Christopher Moore/Catwalking.com: **134** (row 1, right; row 2, left, center left, center right), **135** (row 1, all). William Claxton/Courtesy of Demont Photo Management: **134** (row 2, right). © firstVIEW: **134** (row 3, left, center left), **135** (row 2, all; row 3, center right). Marcio Madeira/Style.com: **134** (row 3, center right). Patrice Stable: **134** (row 3, right). Blommers/Schumm/Viktor & Rolf: **135** (row 3, left).

THE MODEL AS MUSE: EMBODYING FASHION, 2009

Irving Penn/Condé Nast Archive: **137, 144.** Arthur Elgort: **138–139.** Juergen Teller: **140–141.** Marko MacPherson/© The Richard Avedon Foundation: **143.** Patrick Demarchelier: **145.** Steven Meisel: **146–147.** CAMERA PRESS/Tina Paul/Redux: **148, 156** (The designs, row 1, left; row 2, center left). Robert Fairer: **149, 157** (The designs, row 1, center, right). © The Helmut Newton Estate: **151.** Michael Lisnet: **152–153.** Billy Farrell/PMc: **154.** Hannah Thomson: **155. The designs:** © The Metropolitan Museum of Art, gift of Léon Bing and Oreste F. Pucciani, 1988 (1988.74.2a–e): **156** (row 1, center). © The Metropolitan Museum of Art, gift of Rudi Gernreich Revocable Trust, 1985 (1985.374.12): **156** (row 1, right). © The Metropolitan Museum of Art, gift of Mr. and Mrs. Henry Rogers Benjamin, 1965 (C.I.65.14.12a, b): **156** (row 2, left). © The Metropolitan Museum of Art, purchase, Gould Family Foundation Gift, in memory of Jo Copeland, 2008 (2008.305): **156** (row 2, center left). © The Metropolitan Museum of Art, gift of Eleanor Lambert, 1957 (C.I.57.31.1): **156** (row 2, right). © The Metropolitan Museum of Art, gift of Bernice Chrysler Garbisch, 1979 (1979.329.6a–d): **156** (row 3, left). © The Metropolitan Museum of Art, gift of Jane Love Lee, 1993 (1993.427): **156** (row 3, center left). © The Metropolitan Museum of Art, gift of Mrs. Byron C. Foy, 1953 (C.I.53.40.2a–c): **156** (row 3, center right), **157** (row 3, left). © The Metropolitan Museum of Art, gift of Mrs. William Rand, 1969, 1975 (C.I.69.23, 1975.145.7): **156** (row 3, right), **157** (row 2, left). © The Metropolitan Museum of Art, gift of Marietta Tree, 1965 (C.I.65.36.1): **157** (row 1, left). © The Metropolitan Museum of Art, gift of Muriel Rand, 1964 (C.I.64.4.3): **157** (row 2, center left). © The Metropolitan Museum of Art, gift of Gianni Versace, 1993 (1993.52.4): **157** (row 2, center right). © The Metropolitan Museum of Art, gift of Martin F. Price, 1998 (1998.493.84): **157** (row 2, right). © The Metropolitan Museum of Art, gift of Paco Rabanne, 1967 (C.I.67.60): **157** (row 3, center left). © The Metropolitan Museum of Art, gift of Mrs. Leon L. Roos, 1973 (1973.104.2a, b): **157** (row 3, center right). © The Metropolitan Museum of Art, gift of Martin F. Price, 1998 (1998.493.244): **157** (row 3, right).

AMERICAN WOMAN: FASHIONING A NATIONAL IDENTITY, 2010

Brooklyn Museum Costume Collection at The Metropolitan Museum of Art, gift of the Brooklyn Museum, 2009; Mr. and Mrs. Morton Sultzer, 1979 (2009.300.532a–d), Brooklyn Museum Costume Collection at The Metropolitan Museum of Art, gift of the Brooklyn Museum, 2009; in memory of Mrs. Arthur Rideway Ryan (née Katherine Browne) from her children, Katherine B. Ryan, Marcella Burnell and Arthur Martin Ryan, 1983 (2009.300.547a, b): **159.** Eric Boman: **160–161, 166.** Joshua Bright: **170–171.** David Sims: **162–163, 167.** Marko MacPherson: **165** (left). *Lucile Brokaw, Piping Rock Beach, Long Island, Harper's Bazaar*, 1933: © Martin Munkácsi Estate/Courtesy of Howard Greenberg Gallery, New York: **165** (right). Mario Testino: **168–169. The designs, page 172:** (All) © The Metropolitan Museum of Art, Brooklyn Museum Costume Collection at The Metropolitan Museum of Art, gift of the Brooklyn Museum, 2009. (Row 1, left) Gift of the Princess Viggo in accordance with the wishes of the Misses Hewitt, 1931 (2009.300.640a–g). (Row 1, center left) Gift of Madame Eta Hentz, 1946 (2009.300.119). (Row 1, center right) Gift of Mrs. C. O. Stumpf, 1949 (2009.300.1155a–l). (Row 1, right) Gift of the estate of Mrs. James S. Croll 1952 (2009.300.1173a, b). (Row 2, left; Row 3, right) Gift of Mercedes de Acosta, 1954 (2009.300.1202). (Row 2, center left) Gift of Anna May Wong, 1956 (2009.300.1507). (Row 2, center right) Gift of the estate of

Mrs. Arthur F. Schermerhorn, 1957 (2009.300.1250a, b). (Row 2, right) Gift of Howard B. and Mary Bavetta Hanning, 1976 (2009.300.1358). (Row 3, left) Gift of the estate of Mrs. William H. Crocker, 1954 (2009.300.1192). (Row 3, center left) Gift of Jane Mead von Salis Funtanella, 1984 (2009.300.551). (Row 3, center right) Designated Purchase Fund, 1984 (2009.300.1364a–c). **The designs, page 173:** (All) © The Metropolitan Museum of Art, Brooklyn Museum Costume Collection at The Metropolitan Museum of Art, gift of the Brooklyn Museum, 2009. (Row 1, left) Gift of Mrs. Walter H. Page, 1979 (1979.251.4a, b). (Row 1, center left) Gift of the estate of Mary Boocock Leavitt, 1974 (2009.300.512). (Row 1, center right) The C. Helme and Alice B. Strater Collection, gift of C. Helme Strater, Jr., John B. Strater, and Margaret S. Robinson, 1976 (2009.300.520). (Row 1, right) In memory of Mrs. Arthur Rideway Ryan (née Katherine Browne) from her children, Katherine B. Ryan, Marcella Burnell, and Arthur Martin Ryan, 1983 (2009.300.547a, b). (Row 2, left) Purchased with funds given by Mrs. Carl L. Selden, 1985 (2009.300.1368). (Row 2, center left) Gift of Mrs. A. E. Laurencelle, 1956 (2009.300.219a–e). (Row 2, right) Gift of Mark Walsh, 1984 (2009.300.1365). (Row 3, left) Gift of the estate of Mrs. Arthur F. Schermerhorn, 1957 (2009.300.243). (Row 3, center left) Gift of Mrs. C. Oliver Iselin, 1961 (2009.300.1290a, b). (Row 3, center right) Anonymous gift, 1964 (2009.300.1316). (Row 3, right) Gift of C. Otto v. Kienbusch in memory of Mildred Clarke v. Kienbusch, 1968 (2009.300.1342). (Row 2, center right) The Metropolitan Museum of Art, gift of Miss Eva Drexel Dahlgren, 1976 (1976.258.5a–c).

ALEXANDER McQUEEN: SAVAGE BEAUTY, 2011

Eric Boman: **175.** © Don McCullin/Contact Press Images: **177** (top). Tim Hout: **177** (bottom). Steven Meisel: **178–183.** Annie Leibovitz: **184–185.** Andrew H. Walker/Getty Images: **186.** David Sims: **187.** © The Metropolitan Museum of Art: **188–189.** © Sølve Sundsbø/Art + Commerce: **190–193, 198–199 (The designs).** Mario Testino: **194–195.** © Hannah Thomson: **196–197.**

SCHIAPARELLI & PRADA: IMPOSSIBLE CONVERSATIONS, 2012

Eric Boman: **201, 204–205, 218–219.** © The Metropolitan Museum of Art: **202–203.** Marko MacPherson: **207.** Steven Meisel: **208–209, 211.** George Hoyningen-Huene/Condé Nast Archive: **210** (left). Manuela Pavesi: **210** (right). Timothy A. Clary/AFP/Getty Images: **212–213.** Mario Testino: **214–215.** Julian Mackler/BFANYC.com: **216–217. The designs:** Eric Boman: **220** (row 1, left; row 2; row 3), **221** (row 1, left, right; row 2, center right, right; row 3). AP Photo/Mark Lennihan: **220** (row 1, right), **221** (row 1, center; row 2, left). Anthony Behar/SIPA USA: **221** (row 2, center left).

PUNK: CHAOS TO COUTURE, 2013

Eric Boman: **223–231, 239, 240–241, 244 (The designs).** David Sims: **232.** Irving Penn/Condé Nast Archive: **233, 236–237.** Annie Leibovitz: **234–235.** Marko MacPherson: **238.** Norman Jean Roy: **242–243. The designs:** Eric Boman: **245** (row 1, all; row 2, left, center; row 3, left, right). Jennifer Graylock/FilmMagic: **245** (row 2, right). Thomas Iannaccone/*WWD*: **245** (row 3, center).

CHARLES JAMES: BEYOND FASHION, 2014

Eric Boman: **247, 252–253, 260–261, 263.** Cecil Beaton/Condé Nast Archive: **248–249.** Tim Walker: **254–255, 262.** Courtesy of the Cecil Beaton Studio Archive at Sotheby's: **256.** Gift of Homer Layne, Charles James Collection, the Irene Lewisohn Costume Reference Library, the Costume Institute, The Metropolitan Museum of Art; © Charles B. H. James and Louise D. B. James: **257.** Mario Testino: **258, 264.** Larry Busacca/Getty Images: **259.** Phil Oh: **265. The designs, page 266:** Photographs: (All) Karin L. Willis, the Photograph Studio, The Metropolitan Museum of Art. (Row 1, left) Purchase, Costume Institute Benefit Fund, Friends of the Costume Institute Gifts, and Acquisitions Fund, 2013 (2013.380). (Row 1, center left) Gift of Lee Krasner Pollock, 1975 (1975.52.5a, b). (Row 1, center right) Brooklyn Museum Costume Collection at The Metropolitan Museum of Art, gift of the Brooklyn Museum, 2009, gift of Arturo and Paul Peralta-Ramos, 1954 (2009.300.3516). (Row 1, right) Brooklyn Museum Costume Collection at The Metropolitan Museum of Art, gift of the Brooklyn Museum, 2009, gift of Millicent Huttleston Rogers, 1949 (2009.300.734). (Row 2, left) Brooklyn Museum Costume Collection at The Metropolitan Museum of Art, gift of the Brooklyn Museum, 2009, gift of Muriel Bultman Francis, 1967 (2009.300.451). (Row 2, center left) Brooklyn Museum Costume Collection at The Metropolitan Museum of Art, gift of the Brooklyn Museum, 2009 (2009.300.8523). (Row 2, center right) Purchase, Costume Institute Benefit Fund, Friends of the Costume Institute Gifts, and Acquisitions Fund, 2013 (2013.281a, b). (Row 2, right) Brooklyn Museum Costume Collection at The Metropolitan Museum of Art, gift of the Brooklyn Museum, 2009, gift of Millicent Huttleston Rogers, 1949 (2009.300.751). (Row 3, left) Purchase, Friends of the Costume Institute Gifts, 2013 (2013.591). (Row 3, center left) Brooklyn Museum Costume Collection at The Metropolitan Museum of Art, gift of the Brooklyn Museum, 2009, gift of Mrs. Douglas Fairbanks, Jr., 1981 (2009.300.991). (Row 3, center right) Brooklyn Museum Costume Collection at The Metropolitan Museum of Art, gift of the Brooklyn Museum, 2009, gift of Jean de Menil, 1955 (2009.300.3522). (Row 3, right) Brooklyn Museum Costume Collection at The Metropolitan Museum of Art, gift of the Brooklyn Museum, 2009, gift of Arturo and Paul Peralta-Ramos, 1954 (2009.300.2787). **The designs, page 267:** (Row 1, left) Brooklyn Museum Costume Collection at The Metropolitan Museum of Art, gift of the Brooklyn Museum, 2009, gift of Marguerite Piazza, 1984 (2009.300.1015). (Row 1, center left) Brooklyn Museum Costume Collection at The Metropolitan Museum of Art, gift of the Brooklyn Museum, 2009, gift of Mrs. William Randolph Hearst, Jr., 1959 (2009.300.839, cape); Brooklyn Museum Costume Collection at The Metropolitan Museum of Art, gift of the Brooklyn Museum, 2009, gift of Mrs. William Randolph Hearst, Jr., 1961 (2009.300.850, dress). (Row 1, center right) Purchase, Costume Institute Benefit Fund, Friends of the Costume Institute Gifts, and Acquisitions Fund, 2013 (2013.375a, b). (Row 1, right) Purchase, Costume Institute Benefit Fund, Friends of the Costume Institute Gifts, and Acquisitions Fund, 2013 (2013.367). (Row 2, left) Brooklyn Museum Costume Collection at The Metropolitan Museum of Art, gift of the Brooklyn Museum, 2009 (2009.300.8522). (Row 2, center left) Gift of Eleanor Searle Whitney McCollum, 1975 (1975.246.7a). (Row 2, center right) Brooklyn Museum Costume Collection at The Metropolitan Museum of Art, gift of the Brooklyn Museum, 2009, gift of Mr. and Mrs. Robert Coulson, 1964 (2009.300.1311). (Row 2, right) Brooklyn Museum Costume Collection at The Metropolitan Museum of Art, gift of the Brooklyn Museum, 2009, gift of Arturo and Paul Peralta-Ramos, 1954 (2009.300.1860). (Row 3, left) Purchase, Costume Institute Benefit Fund, Friends of the Costume Institute Gifts, and Acquisitions Fund, 2013 (2013.327). (Row 3, center left) Gift of Elizabeth Fairall, 1953 (C.I.53.73). (Row 3, center right) Brooklyn Museum Costume Collection at The Metropolitan Museum of Art, gift of the Brooklyn Museum, 2009, gift of Arturo and Paul Peralta-Ramos, 1955 (2009.300.199a, b). (Row 3, right) Brooklyn Museum Costume Collection at The Metropolitan Museum of Art, gift of the Brooklyn Museum, 2009, gift of Millicent Huttleston Rogers, 1949 (2009.300.133).

Acknowledgments: Courtesy of Guido Palau: **271.** Tim Walker: **272.**

ACKNOWLEDGMENTS

Foremost, it is imperative to highlight the many designers whose work constitutes the Collection of The Metropolitan Museum of Art's Costume Institute, without which the exhibitions and this book would not exist—along with the brilliant curators, Harold Koda and Andrew Bolton, who continue to bring these clothes so vividly to life. We are also indebted to writers Joanne Chen, Mark Holgate, Sarah Mower, and Jonathan Van Meter for their contributions.

In addition to photographs from the exhibitions and their catalogs, this book is graced with images from the *Vogue* editorial spreads that each year accompany the article about the exhibition. For those images and others, we thank Grace Coddington and Tonne Goodman, as well as the gifted photographers Eric Boman, Arthur Elgort, Robert Fairer, Steven Klein, Annie Leibovitz, Craig McDean, Steven Meisel, Norman Jean Roy, David Sims, Juergen Teller, Mario Testino, and Tim Walker. Thank you also to the following estates for their cooperation and the use of their timeless images: Cecil Beaton Studio Archive at Sotheby's, Chanel, the John F. Kennedy Presidential Library and Museum, Helmut Newton Foundation, and Irving Penn Foundation.

Alberto Orta, *Vogue*'s Art Director, managed—with the invaluable oversight of Design Director Raúl Martinez—to seamlessly blend all the visual elements, from celebrity arrivals to Grace's exquisite fashion images to photographs of the exhibitions themselves, into a rich and arresting tableau.

This book would not have made its way to the printer without the unflinching attention and expertise of David Byars, as well as Jennifer Donnelly, Sara Hall, Timothy Herzog, Ivan Shaw, and Maureen Songco—and, of course, the sharp eyes and bright ideas of Jon Gluck and Christiane Mack.

Further thanks to those who pored over the text and captions, ensuring that their perfection matched that of the exhibitions: Bess Rattray, along with Alyssa Betker, Julie Bramowitz, Joanne Camas, Jennifer Conrad, Alexa Elam, Diego Hadis, Lindsay Herron, Elizabeth Inglese, Caroline Kirk, Matthew Kitchen, Leslie Lipton, Amelia Mularz, Heather Rabkin, Sara Reden, Joyce Rubin, Ellen Shea, Mimi Vu, and Leslie Yudell.

Without the tireless assistance of Nancy Chilton at The Met, along with Christine Coulson, Jessica Glasscock, and Julie Zeftel, this book would have never reached completion. We are deeply indebted to Metropolitan Museum of Art director Thomas P. Campbell for his eloquent foreword, and for all that he does for both The Costume Institute and The Museum itself. Our gratitude is also due to Campbell's forebear, the unforgettable Philippe de Montebello, and to Met president Emily Rafferty. And of course we are grateful to Sylvana Ward Durrett and Stephanie Winston Wolkoff for their military-like precision and attention to detail in the planning of The Costume Institute's annual gala, along with The Met's team led by Nina Diefenbach, Kristin MacDonald, Bronwyn Keenan, and Ashley Potter Bruynes.

Last, but hardly least, our great thanks to Anna Wintour for her insight and vision, which have guided this book from its infancy.

—HAMISH BOWLES AND CHLOE MALLE

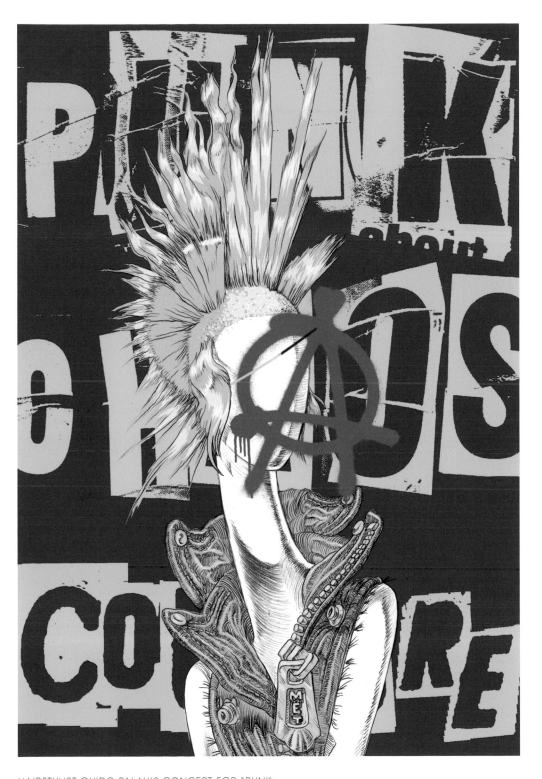

HAIRSTYLIST GUIDO PALAU'S CONCEPT FOR "PUNK:
CHAOS TO COUTURE" (2013) WAS REALIZED WITH 113
CAGES THAT SAT ATOP THE MANNEQUINS TO HOLD
SPIKY COIFS UPRIGHT FOR THE THREE MONTHS OF
THE EXHIBITION. **OVERLEAF:** PAPER DRESSES BY RHEA
THIERSTEIN STOOD IN FOR CHARLES JAMES COUTURE
IN PHOTOGRAPHER TIM WALKER'S RETAKE OF THE
FAMOUS 1948 IMAGE BY CECIL BEATON, *VOGUE,* 2014.

EXHIBITION SPONSORS

**Jacqueline Kennedy: The White House Years—Selections
from the John F. Kennedy Library and Museum**
May 1–July 29, 2001
The exhibition was made possible by L'Oréal.
Additional support was provided by Condé Nast.

Goddess: The Classical Mode
May 1–August 3, 2003
The exhibition was made possible by GUCCI.
Additional support was provided by Condé Nast.

**Dangerous Liaisons: Fashion and Furniture in the
Eighteenth Century**
April 29–September 6, 2004
The exhibition was made possible by Asprey.
Additional support was provided by Condé Nast.

Chanel
May 5–August 7, 2005
The exhibition was made possible by CHANEL.
Additional support was provided by Condé Nast.

AngloMania: Tradition and Transgression in British Fashion
May 3–September 4, 2006
The exhibition was made possible by Burberry.
Additional support was provided by Condé Nast.

Poiret: King of Fashion
May 9–August 5, 2007
The exhibition was made possible by Balenciaga.
Additional support was provided by Condé Nast.

Superheroes: Fashion and Fantasy
May 7–September 1, 2008
The exhibition was made possible by Giorgio Armani.
Additional support was provided by Condé Nast.

The Model as Muse: Embodying Fashion
May 6–August 9, 2009
The exhibition was made possible by Marc Jacobs.
Additional support was provided by Condé Nast.

American Woman: Fashioning a National Identity
May 5–August 15, 2010
The exhibition was made possible by Gap.
Additional support was provided by Condé Nast.

Alexander McQueen: Savage Beauty
May 4–August 7, 2011
The exhibition was made possible by Alexander McQueen™.
Additional support was provided in partnership with
American Express and Condé Nast.

Schiaparelli and Prada: Impossible Conversations
May 10–August 19, 2012
The exhibition was made possible by Amazon.
Additional support was provided by Condé Nast.

Punk: Chaos to Couture
May 9–August 14, 2013
The exhibition was made possible by Moda Operandi.
Additional support was provided by Condé Nast.

Charles James: Beyond Fashion
May 8–August 10, 2014
The exhibition was made possible by AERIN.
Additional support was provided by Condé Nast.